D0214624

Veronica and Her Cloth

To Florence, my Word
To Helmut, my Image
And to Wanda,
My President of Vice

Veronica and Her Cloth

History, Symbolism, and Structure
of a "True" Image

Ewa Kuryluk

Basil Blackwell

R0121036618
HUMCA

Copyright © Ewa Kuryluk 1991

First published 1991

Basil Blackwell, Inc. **HOUSTON PUBLIC LIBRARY**
3 Cambridge Center
Cambridge, Massachusetts 02142, USA

Basil Blackwell Ltd
108 Cowley Road, Oxford, OX4 1JF, UK

All rights reserved. Except for the quotation of short passages for the purposes of criticism and review, no part of this publication may be reproduced, stored in a retrieval system, or transmitted, in any form or by any means, electronic, mechanical, photocopying, recording or otherwise, without the prior permission of the publisher.

Except in the United States of America, this book is sold subject to the condition that it shall not, by way of trade or otherwise, be lent, re-sold, hired out, or otherwise circulated without the publisher's prior consent in any form of binding or cover other than that in which it is published and without a similar condition including this condition being imposed on the subsequent purchaser.

Library of Congress Cataloging in Publication Data

Kuryluk, Ewa, 1946–
 Veronica and her cloth : history, symbolism, and structure of a "true" image / by Ewa Kuryluk.
 p. cm.
 Includes index.
 ISBN 0-631-17813-9
 1. Veronica, Saint, 1st cent. – Legends. 2. Veil of Veronica.
3. Icons – Cult – History of doctrines. I. Title.
BR1720.V43K87 1991
246′.53 – dc20 90–40914
 CIP

British Library Cataloguing in Publication Data
A CIP catalogue record for this book is available from the British Library.

Typeset in 10 on 12 pt Trump Mediaeval
by Hope Services (Abingdon) Ltd.,
Printed in Great Britain by T. J. Press Ltd., Padstow, Cornwall.

Contents

Contents

Acknowledgements

This book is the product of almost a decade of research, generously supported at each stage by various institutions and individuals. Early in 1982, my first year in the United States, I received a three-month Fellowship of the European Exchange Program at the Institute for the Humanities at New York University. In the academic year 1982–3, thanks to the interest of the Institute's Fellows – Jerome Bruner, Anne Hollander, Hide Ishiguro, Temma Kaplan, Linda Nochlin, Michael Scammell, Carl Schorske, Richard Sennett, Susan Sontag, William Taylor, Luisa Valenzuela, Tomas Venclova, Aileen Ward, and Edmund White – and to the understanding of the Institute's Trustees, Aryeh Neier and George Soros, I was able to conduct a seminar on "The Shadow, the Mirror, and the Double" – and to outline this book.

Instrumental in my turning "Veronica" from loose notes into a more coherent text was my 1984–5 Hodder Fellowship at the Humanities Council of Princeton University, where my work received attention and help from Robert Connor, Carol Rigolot, and Alison Cook. My arrival in Princeton coincided with the publication of "Mirrors and Menstruation" – my first major essay on Veronica and my first substantial piece of writing in English – in the magazine *Formations*. The encouragement of its editors, Jonathan Brent and Frances Padorr Brent, was decisive in my switching from my native Polish to English. In addition, Jonathan Brent, a literary critic and a scholar of the Jewish Bible, has been my personal

Acknowledgements

"rabbi" in questions concerning the linguistic symbolism of the Old Testament. In 1986 "Mirrors and Menstruation" won the General Electric Award for Younger Writers.

Veronica and Her Cloth would never have been finished had I not received the Rockefeller Fellowship at the National Humanities Center in North Carolina. During the academic year 1988–9, which I spent in this heaven for scholars, I was daily supported by kind and knowledgeable members of the staff. My warmest thanks are extended to everyone who shared this year with me, in particular to Kent Mullikin, Executive Director, who tolerated my habits with angelic patience; to Alan Tuttle, a living encyclopedia of a librarian; to Richard Schramm who, first thing in the morning, discussed God and the world with me; to Corbett Capps, Sandra Copeland, Jean Anne Leuchtenburg, Nan Martin, Mary Donna Pond, Wayne Pond, Val Rogers, and Pat Schreiber – contributors to my well-being; and to George Brett, an artist and friend of the Center, who initiated me into the secrets of the Macintosh Plus.

I acknowledge with gratitude the scholarly assistance of Ernst Badian, Elizabeth Clark, Jaroslav Folda, Thorkild Jacobsen, and Janet Knapp, and the inspiring influence of Richard Abel, Alan Brinkley, Jack Cell, Walter Dellinger, Jonathan Dollimore, Rita Dove, Howard Erskine-Hill, Lilian Furst, Henry Louis Gates, Daniel Gunn, John Higham, Barbara Hogdon, Larry Jones, Joe Loewenstein, Barry Loewer, Robert Martin, Sarah Maza, Pat O'Brien, Nicolaas Rupke, Philip Schuyler, Patricia Spacks, Lynne Tatlock, Fred Viehbahn, Roy Weintraub, Michael White, and Zhouhan Yang, our dear co-fellow from Peking University, whose premature death shocked us all.

In the transformation from first draft to book, Marina Warner and Nicholas Wadley played decisive roles.

I want to thank all my friends who for years have been active on behalf of the Veronica–Jesus exchange: Jean H. Hagstrum, Eva Hoffman, Leszek Kotakowski, Jan Kott, Michael Kott, Marta Petrusewicz, Julia Przyboś, Alice Quinn, Jasia Reichhardt, Ann Snitow, Edward Stankiewicz, A. Richard Turner, Jerzy Warman, and Claude Weiss. My book is dedicated to Florence Stankiewicz, my editor; to Helmut Kirchner, my collector of images; and Wanda Rapaczyńska, who convinced me that there is no imprint without matter.

List of Plates

Cover: Hans Memling, *St Veronica*, obverse, (ca.1470–5), oil on oak. Washington, National Gallery of Art.

1 Cariani (Giovanni Busi, ca.1480–1547 or 1548), *Meeting with Veronica*, oil on canvas. Brescia, Civici Musei d'Arte e Storia (courtesy of the Civici Musei d'Arte e Storia di Brescia).

2 Jaime Huguet (Valls, 1415–Barcelona, 1492), *Flagellation* (detail), tempera on wood. Paris, Musée du Louvre, RF 1967–6; photo: Ewa Kuryluk.

3 Above: *Abgar's Messenger Receives from Christ the Linen Bearing Christ's Likeness*. Below: *The City of Hierapolis* (where the messenger stopped and hid the cloth for safe-keeping between two bricks), miniatures 10 and 11 from "Letter to Christ, Preceded by Psalms 91 and 35 and Followed by Christ's Reply and the Story of the Holy Image," roll on seven joined pieces of thin vellum (Constantinople, second half of the fourteenth century). New York, Pierpont Morgan Library, Greek MS 499 to. 10, 11.

4 *Our Lady of the Sign* (*Známenie*) with metal work (seventeenth century). Moscow, Russian Museum; photo after Nikodim Pavlovich Kondakov, *The Russian Icon* (Oxford: Clarendon Press, 1927), Plate 58.

5 Rogier van der Weyden (Tournai, 1399 or 1400–Brussels, 1464), *Crucifixion*, tempera on wood. Vienna, Kunsthistorisches Museum.

6 Mrs Canedo, one of the "Mothers of the Plaza de Mayo," demonstrating against the disappearance of her son, Arturo Canedo (Buenos Aires, Argentina, October 1986). Photo: Ewa Kuryluk (courtesy of Mrs Canedo).

7 *The Beheading of St John the Baptist*, illumination on vellum (Bruges, 1445–60). New York, Pierpont Morgan Library, MS 675, fo. 43v.

8 Lorenzo Lotto (ca.1480–1556), *Venus and Cupid*, oil on canvas. New York, Metropolitan Museum of Art, Mrs Charles Wrightsman Gift, 1968.

9 Provençal Master, *The Fountain of Blood* (ca.1460), tempera on wood. Avignon, Musée du Petit Palais (deposit of Musée Calvet).

10 Statuette of a mother-goddess (*Kurotrophos*) (Selinunte, end of sixth century BC). Paris, Musée du Louvre, CA 2944; photo: Service Photographique de la Réunion des Musées Nationaux.

11 *Athena, called the Peaceful* (detail), marble, adaptation of a bronze statue in the National Museum, Athens (350–340 BC). Paris, Musée du Louvre, Ma 530, 9840309 AGR, Collection Mattei, later Collection Cardinal Fesch; photo: Ewa Kuryluk.

12 Left: *Christ Cursing the Fig Tree*; right: *Christ Healing the Hemorrhissa*, marble sarcophagus (Rome, mid-fourth century AD). Vatican, Grottoes of St Peter's; photo: Ewa Kuryluk.

13 Silesian Master (Jacobus Beinhardt?), *The Virgin Working on the Seamless Tunic and St Luke Painting Her*, wood, polychromy destroyed, ca.1500, from St Mary Magdalene's Church, Wroclaw. Warsaw, Muzeum Narodowe.

14 Simon Marmion (d. 1489), *St Helena Assisting at the Miracle of the True Cross*, tempera on wood. Paris, Musée du Louvre; photo: Roger-Viollet.

15 *Mary as the* Mulier amicta sole *of the Revelation*, The Rothschild Canticles, illumination on vellum (Franco-Flemish, late thirteenth or early fourteenth century). New Haven, Conn., Yale University, Beinecke Rare Book and Manuscript Library, MS 404, fo. 64v.

du Louvre, RF 580, former Collection Timbal acquired in 1882; photo: Service Photographique de la Réunion des Musées Nationaux.

28 Mirror (Greece, fifth century BC), bronze. Paris, Musée du Louvre, 1691; photo: Service Photographique de la Réunion des Musées Nationaux.

29 Antonio Corradini (1668–1752), *Veiled Woman* (Allegory of Faith?), marble. Paris, Musée du Louvre, RF 3088, acquired 1976; photo: Ewa Kuryluk.

30 *The Omnipresent and Omnipotent God*, The Rothschild Canticles, illumination on vellum (Franco-Flemish, late thirteenth or early fourteenth century). New Haven, Conn., Yale University, Beinecke Rare Book and Manuscript Library, MS 404, fo. 92v.

31 German School, *Angel Holding a Cloth with the Head of John the Baptist* (eighteenth century), terracotta. Buenos Aires, Museo Nacional de Bellas Artes; photo: Ewa Kuryluk.

32 Silesian Master, *Pietà* polychromed and gilt wood, ca.1370, from Lubiąz (Silesia). Warsaw, Muzeum Narodowe.

33 Giovanni Capassini, called Jean Capassin (Florence, date not known–Tournon, 1579), *Supper at Emmaus* (detail), left wing of the Resurrection Triptych, tempera on wood. Paris, Musée du Louvre, RF 1980–183; photo: Ewa Kuryluk.

34 Head of God–Phallus, broken from a vase or lamp (Hellenistic period), terracotta. Delos, Archeological Museum; photo: Ewa Kuryluk (courtesy of the Greek Ministry of Culture, Director of Antiquities).

35 *Deposition and Entombment of Jesus Christ*, Lectionary, (Flanders, third quarter of twelfth century), written and illuminated on stiff vellum for the Abbey of St Trond, diocese of Liège. New York, Pierpont Morgan Library, MS 883, fo. 51v.

Explanations and Abbreviations of Frequently Cited Works

I cite most of the classical texts from the Loeb Classical Library, unless I find other translations more adequate and beautiful, or more useful for my purpose. In order to make my book accessible to non-specialist readers, I avoid burdening it with references to Greek and Latin originals. When I am not satisfied with existing translations, I supply my own. I use abbreviations for frequently cited works, for separate books as well as series, which are then given either in notes or in parentheses, with either book (poem, homily, etc.), chapter, paragraph, or line indicated by arabic numbers, or with volume and page numbers. I use as abbreviations either author's name or title of book, or a combination of the two.

Age of Spirituality, Catalogue, Metropolitan Museum of Art, November 19, 1977 through February 12, 1978, ed. Kurt Weitzmann (New York: The Metropolitan Museum, 1979) = *Age of Spirituality*

A Select Library of Nicene and Post-Nicene Fathers of the Christian Church, second series, trans. under the editorial supervision of Philip Schaff and Henry Wace, reprint of the 1800–1900 edn, 14 vols (Grand Rapids, Michigan: Wm. B. Eerdmans, 1978–9) = *Nicene and Post-Nicene Fathers*

Court of Constantine Porphyrogenitus, "Story of the Image of Edessa" (AD 945), the English translation of the official history of the Edessene mandylion by Bernard Slater and boys of the Bradford Grammar School, West Yorkshire, assisted by the Revd John

Jackson, in Ian Wilson, *The Shroud of Turin. The Burial Cloth of Jesus Christ?* (Garden City, NY: Image Books, 1979), Appendix C, pp. 272–90 = "Story of the Image of Edessa"

Ernst von Dobschütz, *Christusbilder. Untersuchungen zur Christlichen Legende* (Leipzig: J. C. Hinrichs'sche Buchhandlung, 1899) = Dobschütz

Eusebius, *The History of the Church*, trans. G. A. Williamson (Harmondsworth: Penguin Books, 1983) = Eusebius, *Church History*

J. G. Frazer, *The Golden Bough*, 3rd edn, rev. and enl., 12 vols (New York: Macmillan, 1935) = *Golden Bough*

Edward Gibbon, *The History of the Decline and Fall of the Roman Empire*, 5 vols (Philadelphia: John C. Winston, 1845) = Gibbon

André Grabar, *La Sainte Face de Laon. Le mandylion dans l'art orthodoxe* (Prague: Seminarium Kondakovianum, 1931) = *Sainte Face*

Carl Joseph von Hefele, *Conciliengeschichte*, 9 vols (Freiburg im Breisgau: Herder'sche Verlagsbuchhandlung, 1855–90) = Hefele

Edgar Hennecke, *New Testament Apocrypha*, ed. W. Schneemelcher, English translation ed. by R. McL. Wilson, 2 vols (Philadelphia: Westminster Press, 1963–4) = *NT Apocrypha*

Hesiod, *The Homeric Hymns and Homerica*, trans. Hugh G. Evelyn-White, Loeb Classical Library (London: W. Heinemann, 1936) = Hesiod, *Homerica*

Irénée de Lyon, *Contre les hérésies*, Latin-French, ed. Adelin Rousseau and Louis Doutreleau, 3 vols (Paris: CERF, 1979) = Irenaeus, *Against the Heresies*

Jacques de Voragine, *La Légende dorée*, trans. J. B. M. Roze, 3 vols (Paris: Edouard Rouvyre, 1902) = *Golden Legend*

Ewa Kuryluk, *Salome and Judas in the Cave of Sex. The Grotesque: Origins, Iconography, Techniques* (Evanston, Ill.: Northwestern University Press, 1987) = *Salome and Judas*

Cyril Mango, *The Art of the Byzantine Empire 312–1453* (Toronto: University of Toronto Press, 1986) = Mango

J. P. Migne, *Patrologiae cursus completus*, Latin series, 221 vols (Paris, 1844–55) = Migne, *PL*; Greek series, 165 vols (Paris, 1857–66) = Migne, *PG*

George Ostrogorsky, *History of the Byzantine State*, trans. Joan Hussey (New Brunswick, NJ: Rutgers University Press, 1969) = Ostrogorsky, *Byzantine State*

Paulys Realencyclopädie der classischen Altertumswissenschaft, neue Bearbeitung von Georg Wissowa, 23 vols. Stuttgart: J. B. Metzlersche Verlagsbuchhandlung, 1894–1957 = Pauly-Wissowa.

Karl Pearson, *Die Fronica. Ein Beitrag zur Geschichte des Christusbildes im Mittelalter* (Strassburg: Karl J. Trübner, 1887) = Pearson

Gertrud Schiller, *Iconography of Christian Art*, trans. Janet Seligman, 2 vols (Greenwich, Conn.: New York Graphic Society, 1972) = Schiller, *Iconography*

The Apocryphal New Testament, ed. Montague Rhodes James (Oxford: Clarendon Press, 1924) = *Apocryphal New Testament*

The Doctrine of Addai, the Apostle, ed. and trans. George Phillips (London: Trübner, 1876) = *Doctrine of Addai*

The Encyclopaedia Britannica, 11th edn (New York: Encyclopaedia Britannica Company, 1910) = *Britannica*

The Nag Hammadi Library in English (San Francisco: Harper & Row, 1977) = *Nag Hammadi Library*

Theodoret and Evagrius, *History of the Church*, Bohn's Ecclesiastical Library (London: Henry G. Bohn, 1854) = Theodoret, Evagrius, *Church History*

Wolfgang Fritz Volbach, *Early Christian Art*, trans. Christopher Ligota (New York: Harry N. Abrams, 1962) = Volbach, *Christian Art*

Kurt Weitzmann, *The Icon. Holy Images – Sixth to Fourteenth Century* (New York: George Braziller, 1978) = Weitzmann, *Icon*

Introduction

Wherever you go in Europe, if you should drop into the local church of the most obscure of villages, you are likely to see on its walls paintings or reliefs of the way of the cross and find, at station number six, a man facing a woman who holds a piece of white cloth in her hands. The cloth may be blank or it may bear the portrait of a man, and if you are from a Catholic background or versed in European art, you'll recognize the couple as Jesus and Veronica and the cloth as her vernicle. You'll probably also recall the legend of Veronica who, as Christ passed on his way to Golgotha, wiped his sweating and bleeding face with her napkin, which received his impression – the only "true" portrait Jesus left to humanity (Plate 1). Pondering the vernicle, you may connect it with the famous shroud of Turin, a linen sheet covered with the "true" impressions of a man's front and back, supposedly representing the body of Jesus Christ. The connection is justified. Both the vernicle and the shroud of Turin belong to the so-called "true" images – known under the Greek name *acheiropoietos* (not made by hand) and under various Latin and Latin-Greek hybrids (*vera imago, vera icon, veronica*) – as well as to a broader group of traces and relics testifying to Jesus' actual presence on earth: "the marks of his knees" on the stone on which he prayed, the "last prints in the dust of our Lord's feet" on that spot on the Mount of Olives from which he ascended to heaven, or the blood-covered column of flagellation (Plate 2).[1]

Once there were many *acheiropoietoi* and *veronicae* in circulation,

but in the course of time most of them were destroyed and the remaining ones turned out to be mere artefacts. The only exception is the shroud of Turin, whose existence has been recorded since the mid-fourteenth century and whose curious nature we do not understand.[2] Therefore the subject keeps coming up in newspaper articles about ever-new teams of specialists and the most up-to-date techniques for determining the nature of the image and the approximate age of the linen. Some of the results obtained in the 1960s and 1970s were so extraordinary that they convinced the general public of the shroud's authenticity and led to a flood of articles and books, popular as well as semi-scholarly, suggesting that the shroud was the burial cloth of Jesus Christ, thus certifying the biblical accounts and offering the ultimate proof of the Lord's existence, crucifixion and – the most daring speculation – resurrection, divine energy having served as an "X-ray" for fixing the image on the cloth.[3] However, the most recent experiments have undermined earlier evidence, and on October 13, 1988 Anastasio Ballestrero, the archbishop of Turin, announced that according to carbon 14 tests the linen was fabricated between 1260 and 1390.[4]

This verdict reintroduces the late nineteenth-century perception of the Turin shroud as a fake whose credibility was then restored by photography. In 1898, in connection with the 50th anniversary of the Piedmont charter, the future Italian constitution, the shroud was to be exhibited, and someone suggested to its owner, King Umberto I, that he have it photographed. The monarch wasn't enthusiastic, but he could be persuaded, and he let a certain Secondo Pia, a lawyer and amateur photographer, take pictures of the shroud. Pia was shocked when he developed his pictures: on the glass negative appeared not the shadowy figure he remembered from the shroud – a "negative," as he then realized – but a distinct photographic likeness – a "positive" of a man's front and back.[5] A minor miracle had occurred: the photographic negative brought out the hidden positive, making everyone see an image that in principle had always been on the cloth but that only photography made accessible to the human eye. Needless to say, Pia's revelation hit the press. His pictures were reproduced all over the globe and returned the shroud to the orbit of public interest. The mysterious piece of cloth has ever since remained the object of scrutiny by scientists and scholars (who met at the International Sidonology Congresses in Turin and published their *Acts*), and a topic of dispute among theologians, journalists, and a multitude of believers.[6]

2

The shroud did not disappoint the twentieth-century experts who were and still are interested in it. In fact, their research has yielded fascinating results. The man on the cloth seems to be the same age as was the crucified Christ; the figure shows absolute anatomical correctness, with the right type of wounds at the right spots. There are signs of flagellation and severe beating (a broken nose), and injuries from the crown of thorns and nails. This baffling fact inspired experiments, with artists being asked to come up with a similar image. Of course no artist ever succeeded, since it required creating in one's mind first an anatomically correct positive and then reversing it into an anatomically correct negative – a task only one artist on earth might have accomplished: Leonardo, that genius of anatomical drawing and mirror-writing (however, as we know, even his drawings are anatomically incorrect). Electron microscopy finds no brush strokes on the shroud, while on the other hand chemical analysis has detected traces of blood saturated with bilirubine, a pigment secreted by the liver under conditions of extreme suffering.

Were the *veronicae* riddles similar to the shroud or were they simply painted pieces of cloth imbued with an aura of the miraculous? Since they no longer exist, the question cannot be answered. But we still have in European churches devotional artefacts that are regarded as the "true" images of the Lord, and so we can assume that most vernicles were just pieces of painted canvas. However, some, like the shroud, may have been produced by strange processes. Then they must have confronted people with problems similar to today's in regard to the Turin shroud. Mystified by a phenomenon they could not understand, our predecessors looked for explanations in magic, mythology, and religion – the "science" of their day. Does it mean that the enormous bulk of legends concerned with "true" icons came from the sudden appearance of inexplicable images? Not at all. Although we don't know how, by whom, and for what purpose the Turin shroud was produced, one thing is certain: its production made sense only in the Christian context, with people believing in the existence of a shroud impregnated with the Lord's features, and eager to possess it. Thus not even a macabre hypothesis can be excluded: that in the thirteenth or fourteenth century a man might have been put to exactly the same torture and death as Jesus Christ, and then wrapped in a sheet in order to produce a relic.[7]

In the period indicated by the latest carbon tests Europe was

flooded with religious treasures and acquired some of its first "true" images.[8] After the sack of Constantinople in 1204 the imperial collection of relics was looted by the crusaders, who probably got hold of, among other things, the mandylion of Edessa, a towel or napkin impregnated with Jesus' face, which shortly afterwards appeared in the West.[9] This miraculous image, the most famous of all the *acheiropoietoi* then known, was supposedly given by the living Jesus to Abgar, the pagan king of Edessa. The historical existence of the Edessene image was attested at the end of the sixth century, but its mythical presence is much older. It dates back to the late fourth- or early fifth-century Syriac *Doctrine of Addai*, a legendary narrative of Edessa's christianization, which tells the story of the sick pagan King Abgar. Hoping to be cured by Jesus, he writes a letter asking him to come to Edessa. Abgar's messenger, an archivist and artist, arrives in Jerusalem shortly before the crucifixion, reads the letter to Jesus, and receives from him an oral message for his king. While Christ is speaking, he executes a likeness of Jesus which arrives back in Edessa – a replacement for pagan representation and a reminder of the difference between the abstract God Father of the Old Testament and God Son – a visible reproduction.

The Edessene painting later metamorphosed into an *acheiropoietos*, a "photographic" impression made by Jesus himself, which proved his historical existence, symbolized his incarnation, endorsed depiction, and played an important role in the iconoclastic controversy (Plate 3). Christ's portrait was referred to as *mandylion* (from the Latin *mantele*, "towel, napkin", and Arabic *mandil*, "veil, handkerchief"). The use of cloth is not surprising. Cloth, a particularly suitable medium for (re)producing images, enjoyed special popularity in Byzantine art. What stone was to the ancient Greeks, cloth was to the Christian Greeks of Byzantium who revelled in representation but felt uneasy about producing "graven images," explicitly forbidden by Old Testament law. But cloth was favored for yet another reason. A synonym for dress and skin, it represented the perfect material for visualizing God's "clothing" in Mary's flesh. The Christian association of the Virgin's immaculate body with spotless white stuff was rooted in the traditional Jewish and Greek perception of matter and earth as a female – "without form and void" (Gen. 1:2) – to be shaped by man.[10]

At the time of the sack of Constantinople the West already possessed its own "true" image of Christ. It was kept in St Peter's in Rome, was mentioned for the first time in connection with a

procession in 752, and was referred to as *acheropsita*.[11] In the following centuries several sources mention *imagines salvatoris* which are either *non hominis manu picta* or attributed to the apostle Luke. Were the Roman icons products of a local or foreign tradition? The term *acheropsita* indicates the Greek origin of this particular image, which most likely was not an impression on cloth but a Byzantine icon. The first Christ picture termed *veronica* was mentioned only at the beginning of the twelfth century. It was kept in the chapel of the *Sancta Maria ad Praesepe* of St Peter's and called *sudarium* (cloth for wiping off perspiration, handkerchief). The relic disappeared in 1527 during the sack of Rome and we lack exact clues to its nature. The name suggests that it was a loose piece of cloth, but perhaps it was just a Byzantine painting on canvas. In the twelfth and thirteenth centuries the number of Eastern Christ portraits increased in the West, but many of them were still treated not as paintings but as *acheiropoietoi*.

The Veronica myth is derived from a New Testament episode which was given further attention in the apocryphal Syriac and Greek texts written during the first Christian centuries in Asia Minor and often connected to the city of Edessa in Syria. The relevant biblical scene (Mt. 9:20–2; Mk. 5:25–34; Lk. 8:43–8) is the curing of the Hemorrhissa, the anonymous woman with the issue of blood, a permanent menstruation, whose flux stops when she touches the hem of Jesus' dress. The story, frequently illustrated in early Christian art, was given substance in the *Church History* of Eusebius, who identified the Hemorrhissa as a native of Caesarea Philippi (Paneas) and related her to a reproduction: two bronze statues facing each other. One of them represented the Hemorrhissa resting on one knee in a pose of supplication, the other a man, who supposedly resembled Jesus, stretching his hand out to the woman. In the fourth-century *Acts of Pilate*, an apocryphal account of Jesus' trial, the Hemorrhissa, one of the witnesses, is for the first time called Berenice, a Macedonian version of the Greek name Pherenice (= Phere-nike = bearer [of] victory) – an appropriate name for the bearer of Christ's *vera icon*.

The name Veronica, the Latin form of Berenice, was not derived, as one might have suspected and as was occasionally suggested, from *vera icon*. But since *nomen est omen*, the popularity of Veronica and her vernicle was certainly increased by the false etymology. Why was the Hemorrhissa chosen as the recipient of Christ's likeness? The answer does not seem too difficult. The

Hemorrhissa's flux comes to a halt when she touches Christ. Menstruation stops when a woman is made pregnant by a man. This obvious physiological fact could not be made explicit in Christian theology and scholarship. It was only hinted, obscuring the proper meaning of the biblical scene and its development into the Veronica legend.

The healing of the Hemorrhissa looms large because Jesus stresses his contact with the woman, by declaring that power has left him, and insists on identifying the person to whom it has gone. The divine "power" suggests a mystical conception like the Holy Virgin's and relates the Hemorrhissa to the mother of Jesus, and her curing to the incarnation. The affinity incited the imagination of innumerable generations of Christians and enticed them to pursue the exciting reverie of what happens to an earthly woman when she becomes involved with Man-God. The fantasy developed according to common sense. A symbolic pregnancy was followed by the birth of a symbolic son – initially not a "true" image but just a statue of Jesus. However, in life as in legend, the appearance of a thing has more impact than its actual form. Once it was established that the Hemorrhissa was the originator of Christ's portrait, the myth was drafted and one could proceed toward more elegant solutions, increasingly simple and more dualistic. In Eusebius's account the statues of Christ and the Hemorrhissa faced each other at the entrance to the woman's house. Were they alive, one might say that they were reflected in each other's eyes. The mirrorlike setting influenced the legend's final symmetry – formal as well as symbolic.

Edmund Leach has drawn our attention to the "markedly binary" patterns of legends, their opposing categories and mirrorlike correspondences.[12] Every student of myth knows that he is right. But what is the source of this drive toward duality and symmetry? The development of the Veronica legend offers an answer. Myth, not unlike art and science, replaces life's accidents and complexities with form and structure. The mythologizing mind constructs models of reality which, the simpler they are, the stronger their appeal. Humans delight in symmetry and duality, probably because of their bodies' symmetrical nature, the division into two sexes, the duplicating character of procreation, and their sense of separation into body and mind.[13]

As the biblical Hemorrhissa episode develops into the Veronica legend, new pairs of opposites emerge, joining and replacing the old. First, we have a bleeding woman touching the hem of Jesus' dress.

Since in the New Testament his garment is associated with purity and whiteness, her touch suggests staining his cloth with blood and producing a red image on a white background. Second, Hemorrhissa's flux becomes linked with the passion of Christ, and her bloodstained skin (clothing) with his blood-covered body (garment). Out of these correspondences the medieval version of the myth is distilled – a marvel of symmetry: the man whose cloth has stopped the woman's bleeding has his own flux of blood which she arrests with her cloth. The sexual symbolism of the exchange between Jesus and Veronica was fortified by ancient beliefs that procreation results from mixing sperm with menstrual blood. But it took humanity almost a millennium to arrive at the concept of a blood-image. The shift coincided with a growing interest in Jesus' passion and crucifixion. Abgar's old Christ portrait was given new origins in the tenth-century Byzantine "Story of the Image of Edessa." What had once been a painting, then a miraculous impression (made by nothing in particular, water or sweat), became now a napkin impregnated by the bloody sweat of Jesus in the garden of Gethsemane (Lk. 22:44).[14]

Today the two main icons of Christianity are the madonna with child and the crucifix. Illustrations of Christ's beginning and end, they seem to have always been with us. But, in fact, they were not. The madonna was in vogue earlier than the crucifix, when attention was focused on Christ's incarnation and birth, and not his crucifixion. The analysis of the two icons reveals an affinity between them. The Jesus child appears against the middle of his mother's body (Plate 4); the dead Christ is symmetrically spread out on the cross (Plate 5). The woman bears the babe, the cross the corpse. But while Mary holds Jesus or, as on early Byzantine icons, contains his embryonic figure within herself, Christ's dead body hangs loosely from the arms of the cross – like the vernicle suspended between Veronica's outstretched hands. The similarity and difference between the madonna and the crucifix makes us realize the change of character undergone by the textile *acheiropoietoi* in the West. Once a token of triumph, in the Middle Ages the "true" cloth became a symbol of suffering and death. The serene mandylion turned into a sad shroud, and Veronica into a *pietà* – mourning her dead son like an Argentinian mother (Plate 6).

But the sexual symbolism of the vernicle was not lost. It was even increased by the mystical eroticism and the artistic realism of the late Middle Ages. The fifteenth-century double portraits of Veronica and Christ show a human pair but evoke a cosmic couple, with the

7

woman-cloth functioning as the womb and earth, and Jesus' head as the sun, penis, child. The presence of blood alludes to the red rays of the setting sun, to sacrifice (through circumcision, castration, and decapitation), to the fertilization of the earth (by means of male effusion), and to menstruation, defloration, and childbirth. The sense of sacrificial sexuality is reinforced by the similarity between Veronica, Judith, and Salome – with the Baptist's body resembling a lamb (Plate 7);[15] the theme's popularity reflects the fascination with a sado-masochistic eroticism of torture and physical destruction.

In Judaism, a non-iconic religion, menstruation is tied to reproduction and tabooed, the blood males shed at circumcision is treated as sacred ink for the signing of the covenant with God – a masculine divinity, invisible and linguistic – and for writing the Word. In Christianity, a religion of incarnation, i.e. of material reproduction, menstruation is needed, and so it is rehabilitated in the Hemorrhissa episode. As physical femininity is added to spiritual masculinity, language is joined by vision. Dissenting from Judaism in a late Hellenistic world saturated with images, Christianity is initially reluctant to embrace icons. But the existence of Jesus, a *vera icon* of divinity created in Mary's flesh, calls for representation. The New Testament adds to the linguistic God Father, who prefers to talk to men, a visual God Son, a good friend of women, who after his resurrection appears to Mary Magdalen, signaling his interest in femininity even from beyond the grave.

The evangelists chose to present the new God as a kind of feminist – a strategy that yielded results. Women flocked to Christianity, became leading martyrs and saints, strengthened the new religion in terms of numbers and grassroots influence, and might have even played a role in defeating Mithraism, a monotheistic religion of the Persian god of light whom the Chaldeans identified with Shamash, their own sun-god, and the Greeks of Asia Minor with Helios.[16] During the first century BC the cult of Mithras reached Rome and gradually gained a firm foothold as a result of the increasing exchanges between the capital and its Asian provinces. At the close of the second century AD the cult of Helios, the Roman Sol Invictus, became the predominant religion of the Roman army. The Emperor Nero celebrated himself in a colossal golden statue of the Invincible Sun, and even in the fourth century the Emperor Constantine, the legalizer of Christianity, had himself represented as a sun-god.[17] In the middle of the third century Mithraism was on the verge of becoming a universal religion, and Christianity found

itself in danger, since the two faiths resembled each other in their teachings and rituals. Both were based on a fraternal and democratic spirit, and insisted on strict moral conduct and self-control. A sacred communion of bread, water, and possibly wine, which probably commemorated a banquet of Mithras and Helios, was administered by a priest to mystics upon their admittance to one of the advanced degrees. However, Mithraism, a product of the autocratic oriental world and a military culture, was a strictly male cult. Under no circumstances might women be admitted, while males might belong even as children.

The pro-feminine attitudes of Christianity began to change after its victory. Now a state religion and an institution, Christianity returned to more conservative positions, and the Church proceeded to eliminate women from participation in ritual and office. Gradually, women disappeared from the Church hierarchy and were chanelled to nunneries. This inferior branch of the monastic movement was active in evangelizing, in devotion, and in the icon cult, but had little say in theology and ecclesiastical politics. This discrimination against women was compensated by a symbolic glorification of femininity. With time the cult of the Virgin – for which there was little foundation in the gospels – gained enormous importance. By undoing the original sin committed by Eve, the madonna provided women with credibility and came to be regarded as the new mother of humanity and the chief mediator and intercessor before God: a veil-vernicle spread between heaven and earth.

The textile *acheiropoietos* of Jesus is a Christian invention with a long history (to which the first part of this book is dedicated). But the "true" image phenomenon has its roots in Judaism and Platonism, in religious beliefs and mimetic representation – common in ancient Greece and Rome, in Egypt and in the Far East – which manifest universal mythological patterns of male-female reflecting and reproducing, doubling and fusing. We encounter the *vera icon* in legends of the sun and moon, in strange stories of mirrors and menstruation, in creation myths involving solar energy and blood, matter and soul, head and body, sunrise and sunset, in accounts relating beheading and skinning to love-making and procreation. Like every new religion, Christianity put enormous effort into presenting itself as absolutely unique, but at the same time it tried to stay in touch with tradition by assimilating the very stuff it wanted to suppress.

Using methods derived from anthropology, comparative religion

and literature, structuralism, iconography, and psychoanalysis, I try to explore the various possible origins, meanings, and functions of Christ's portrait – a significant token of the transition from Jewish non-iconism to Christian iconism, and to elucidate the *vera icon* concept – a central concern of human imagination. My interdisciplinary study in culture is not intended to exhaust a vast topic that has been well researched, although not recently. I am not interested in duplicating old but good scholarship. Instead, I focus on structure and functional complexity, and draw conclusions that in the past scholars might have intuited, but did not dare to formulate for fear of challenging religious orthodoxy and breaking taboos.

This book could not have been written without easy access to early Christian Syriac and Greek manuscripts discovered, deciphered, translated, published, critically edited, and compiled by nineteenth-century scholars. On the basis of these primary sources, Ernst von Dobschütz wrote his *Christusbilder* (1899), a dissertation on the oriental *acheiropoietoi* and the Latin vernicles. A *tour de force* of knowledge and superhuman scrupulousness, it has remained the best piece of scholarship in the field. But Dobschütz fails to properly organize his enormous material, to describe the *vera icon* in terms of its structure, and to convey its cultural meaning. His book was preceded by *Die Fronica* (1887), Karl Pearson's solid and useful but uninspiring study on the medieval Veronica legends and their representations in art. *La Sainte Face de Laon* (1931) by André Grabar is the most illuminating work written in this century on the mandylion in Graeco-Slav art and its transference to the West. These erudite books helped me outline my territory. The flash of inspiration was provided by personal drama, my own artistic pursuits concerned with the fixation of traces on cloth, and the disinterested interest of an atheist fascinated by religion.

Part I

From Word to Image – History

1

Image and Word – Greeks and Jews

Then the Lord spoke to you out of the midst of the fire; you heard the sound of words, but saw no form; there was only voice.

<div align="right">Deuteronomy, 4</div>

... when the Only-begotten of God ... of her womb was made man, by an inscrutable miracle she became both the hand-maid of man by reason of the divinity and the mother of the Word by reason of the flesh.

<div align="right">St Gregory the Great[1]</div>

It is an old tradition of European culture to perceive the distinction between images and words in terms of "natural" and "conventional" signs. Plato was the first to discuss the difference in *Cratylus*, where he pointed out that reality can be represented either by vision or by language: the portrait of a man or his name – "an imitation, just as a picture is" (*Cratylus*, 430E);[2] and where he stressed that words require absolute correctness in order to be meaningful, while images must remain imperfect, otherwise they turn to physical doubles. "If some god should not merely imitate your colour and form, as painters do," Socrates explains to Cratylus, "but should also make all the inner parts like yours, should reproduce the same flexibility and warmth, should put into them motion, life, and intellect, such

<div align="center">13</div>

as exist in you," there would be not a Cratylus and his portrait, but "two Cratyluses" (432 BC).

Mimetic images aspire to copy reality and thus are not unlike the camouflaging colors of animals: they make a representation blend with nature, disguising its artificiality and conventionality. The more likenesses resemble their models, the more they give humanity intellectual headaches. The "natural" looks of pictures allow them to assume a life of their own, and to confuse and mystify the beholder. At the heart of a mimetic image lies a paradox. The more an image imitates a thing, the better, more directly, and rapidly are we informed about it. But, on the other hand, it can the more also mislead us into believing that painted grapes can be eaten. Images appeal to our senses, they arouse us, and when they reproduce beautiful and desirable aspects of reality, they make us long to actually consume them. Looking at the appetizing lobsters of Dutch still-lifes and TV commercials, we lick our lips; and *Playboy* is produced for contemporary Pygmalions falling in love with a "true" image of a statuesque blonde. At first sight an image provides immediate knowledge better than words do. But as we are captivated by a likeness, we also begin to experience its manipulative power and mistrust the charm of visual representation. When the spell of images turns threatening, words appear safer – only, however, to those who can read. The mimetic icon, on the other hand, is truly democratic and offers itself to everyone who has eyes.

The ancient identification of image with nature, and word with culture has had far-reaching consequences. Since nature has been felt as feminine and culture as masculine, image and word have been imbued with features and values derived from the experiences, prejudices, and metaphors of sexuality. This symbolism is reinforced by the spatial character of visual representation, which contrasts with the temporality of language, a difference summarized by William Blake, writing in the *Vision of the Last Judgement*: "Time & Space are Real Beings / Time is a Man Space is a Woman."[3] Since a female character has been projected onto the image, the icon has been hailed as real as nature itself. But the image has also been dismissed as mere appearance without depth or spirit, dumb, silent, but, like a woman, pleasant to look at. The equation of imagery and femininity resulted in the allegorization and reification of the female body which, as Marina Warner has already observed, has been considered the most suitable stuff for symbolic representation

and the ideal medium for the messages of men; thus maidens were turned into monuments – statues of victory or liberty.[4]

The choice of the female body as a medium for representation has resulted not only from the nature–image equation, but from an even more elemental identification of matter and femininity. Plato calls the universal substance which receives the forms of all beings "Mother" and "Receptacle," because "it is proper to liken the Recipient to the Mother, the Source to the Father, and what is engendered between these two to the Offspring" (*Timaeus*, 50). He defines the mother as a kind of clay or wax which, in order to "receive . . . over its whole extent the copies of all things intelligible and eternal should itself, of its own nature, be void of all forms" (51). In the same vein Aristotle writes: "the female always provides the material, the male provides that which fashions the material" and, more explicitly, "the physical part, the body, comes from the female, and the Soul from the male" (*Generation of Animals*, 2. 4. 25).[5]

Classical Greek philosophy did not invent the femaleness of matter. It is an old and universal concept. But Plato's and Aristotle's clear formulations established a definition of culture with which we still live today: culture as the product of masculine energy activating, animating, and shaping female matter. Who wouldn't agree with an ancient epigram, which asks: "Who gave a soul to marble?" and answers: "This must be the work of Praxiteles' hands."[6] Derived from the experience of sexuality and therefore extremely persuasive, this definition has been deeply interiorized, appearing absolutely natural: not a construct but an eternal canon present even in dreams. Long before Freud, we read in Artemidorus's *Interpretation of Dreams* (second century AD) that "a writing tablet signifies a woman, since it receives the imprints of all kinds of letters. And in colloquial speech we also call children 'imprints.' "[7] In the *Greek Anthology* a writing-tablet is called "the mystic receptacle of the Muses" (14. 60), and Amor is ploughing and sowing "the wheat-bearing furrow of Demeter" (16. 200) – marking female surface, as in a famous painting by Lorenzo Lotto (Plate 8).

The pupil of the eye – the receptive physiological mirror and duplicator – has female gender both in Greek and Latin and means a girl or doll. The surface of water, an element inhabited by femininity, is a mirror ready to trap not only a Narcissus: "The dumb image of himself attracted Archianax the three year old boy, as he was playing by the well. His mother dragged him all dripping

15

from the water, asking herself if any life was left in him. The child defiled not with death the dwelling of the Nymphs, but fell asleep on his mother's knees" (*Greek Anthology*, 7. 170).

Throughout centuries artists, art lovers, and all visual types keep stressing that one picture is worth a thousand words Thus Leonardo declares painting superior to poetry, because "poetry places things before the imagination in words, while painting really places the objects before the eye, and the eye accepts the likenesses as though they were real" (*Treatise on Painting*, 1. 21).[8] The great master of mimetism asks the rhetorical question: "what poet can put before you in words the true image of your adored one with as much truth as the painter?" (1. 22), argues that "the eye . . . the window of the soul, is the principal way through which the mind can most copiously and magnificently consider the infinite works of nature" (1. 30), and concludes that "therefore it appears that God loves painting and loves him who loves and cherishes it, and He delights to be adored in it rather than in any other form representing Him" (1. 18).

This view was contradicted by iconophobes. Focusing on the limitations of visible and material images, they argued that the strength of pictures lies in their ability to display, but that language alone can articulate ideas. In the iconoclastic interpretation, images appeared superficial and inferior to the eloquence and spirituality of words. Whenever language was preferred to imagery, the arguments in its favor tended to associate the flow of words with such masculine ideals as energy and intellect, change and progress, and to oppose them to the stereotypes of the female condition – stable, passive, and obeying the cyclical laws of nature. Aristotle perceived "the male as possessing the principle of movement and of generation, the female as possessing that of matter," considered heaven and the sun as the sources of spirit and energy, and called them "generator" and "father" (*Generation of Animals*, 1. 2. 5–15).

Since Plato's day the image–word debate has played an important part in European philosophy and theology, art and literary criticism.[9] In certain periods the controversy was perceived as central to religion, morality, and politics, and was turned into a deadly serious conflict in which the friends and enemies of imagery fought and exterminated each other. Although in Christian culture iconoclastic periods were only episodic, some support for iconoclasm has stayed alive at the back of the European mind, at times surfacing and inspiring a philosophical, religious, and moral puritanism – male-

oriented, faithful to the letter of the law, and unsympathetic to representation and womanhood. Is non-iconism linked to the awe of nature and femininity? I believe that it is, and I would like to suggest the reasons for this connection by comparing Greeks, the visual artists, to Jews, the linguists.

Polytheism and iconism are the keywords of Greek culture. Its religion of incarnate divinities and its mimetic art developed out of specially favorable geographical and climatic conditions and reflected a sedentary way of life, with city-states becoming intellectual and artistic centers. The richness of the Greek landscape and the spectacular changes of seasons resulted in a symbiotic relationship of people and nature. Offering endless sensual stimulation, nature inspired the creation of stable cultural structures — visual, material, and illusionistic. They reflected the richness of nature and contrasted with its flow. Favored by natural conditions, the Greeks paid tribute to nature, deifying her as Athena or Aphrodite, Artemis or Demeter.

A linguistic monotheism defines Judaism. Traditionally, the Jewish rejection of images has been related to nomadism. "The purpose of the law forbidding images," writes Joseph Gutmann, "seems to have been to assure loyalty to the invisible Yahweh and to keep the nomads from creating idols or adopting the idols of the many sedentary cultures with which they came in contact during their desert sojourn."[10] This does not exhaust the problem. The Jewish non-iconism has to be also associated with the predominance of language whose development might have been stimulated by movement, the blankness of desert, and the intensity and hardship of nomadic life; and it is connected to the perception of nature in terms of trouble and threat with which the nomads coped by means of culture. A common tongue, providing the wandering tribes with unity and identity, might have led to the worship of a single God-Word, a symbolic "leader" of all of them. Indeed, the Jewish Logos seems to be the deified product of people who, in order to survive in a harsh environment and to preserve their cultural autonomy, had to obey the voice of their literate elite. The Old Testament keeps reminding the reader that nature is the cause of pollution, infection, and disease — language the source of purity, spirituality, and salvation.

The Jews viewed nature with extreme caution. This produced complicated dietary laws, and since blood was considered the juice of life, the eating of any flesh containing it was forbidden (Lev.

17:14; 19:26). Women were probably not more discriminated against by the Jews than by other ancient cultures. But the exclusively masculine and linguistic character of Judaism seems to have intensified the male fear of the reproductive and iconic character of femaleness which manifests itself in menstruation. Furthermore, because of leprosy, a disease endemic from earliest historical times in the Nile valley and delta, a negative link was established between discharge and the horrible illness which begins with "stains" on skin. Providing Moses and Aaron with legislation, God first gives them regulations concerning people whose various diseases (in particular leprosy) make their bodies run "with discharge" (Lev. 15:1–15), and then proceeds to define sexual impurity in men and women. An emission of semen makes a man "unclean until the evening" (Lev. 15:16); an intercourse with a woman which results in ejaculation pollutes both partners for the same amount of time (Lev. 15:18), and it makes unclean "every garment and every skin on which the semen comes" (Lev. 15:17). Consequently, every contact with sperm is to be followed by the bathing of one's whole body and the washing of bedding and clothing. Stricter rules are applied to the female discharge. Menstruating women remain impure and infectious for seven days, and the same is true for men who lie with them (Lev. 15:19–24). Females suffering from hemorrhage are considered polluted for the entire duration of their illness and are treated as social outcasts (Lev. 15:25–7).

The staining of skin and garments with blood, semen, and other bodily fluids can be perceived as depiction. This reveals, perhaps, one of the hidden links between the rejection of imagery and the fear of discharge, particularly of female flux. But representation and menstruation are related to each other in a more fundamental way. The bleeding is symptomatic of a woman's ability to reproduce, and representation equals reproduction. The connection is reflected in the story of Rachel. She steals the household idols of her father Laban (in Hebrew "white") and hides them in the camel saddle. When Laban enters Rachel's tent to search for them, she remains seated on the saddle with the idols and explains that she cannot rise and greet her father because of her period (Gen. 31:19–35). "Unclean" (leaking) women are made whole – and pregnant with a likeness – by men blocking their menstrual blood with sperm. This is hinted at in the story of Bathsheba.

> It happened, late one afternoon, when David arose from his couch and was walking upon the roof of the king's house, that he saw from the

roof a woman bathing; and the woman was very beautiful . . . So David
sent messengers, and took her; and she came to him, and he lay with
her. (Now she was purifying herself from her uncleanness.) Then she
returned to her house. And the woman conceived.

(2 Sam. 11:2–5)

In the Confraternity-Douay version of the Old Testament, which is
based on the Latin Vulgate, the hint is made explicit: "And David
. . . took her, and she came in to him, and he slept with her: and
presently she was purified from her uncleanness, and she returned
to her house, having conceived" (2 Kgs. 11:4–5).[11] It seems that this
translation was inspired by Jesus' incarnation and the biblical
Christ–Hemorrhissa episode – two instances of God's purifying and
sealing off earthly females. Both Testaments reflected the ancient
belief, expressed by Aristotle and reported by Pliny, that menstrual
blood is required for reproduction:

Not only does this pernicious mischief occur in a woman every
month, but it comes in larger quantity every three months . . . just as
in certain women it never occurs at all. The latter, however, do not
have children, since the substance in question is the material for
human generation, as the semen from the males acting like rennet
collects this substance within it, which thereupon immediately is
inspired with life and endowed with body.

(*Natural History*, 7.15. 66)[12]

In the Old Testament reproduction is related to vision. King
David's seduction through sight resembles the original sin. Eve was
tempted to eat from the tree of knowledge because "it was a delight
to the eyes" (Gen. 3:6). The delight was followed by Adam and Eve
consuming the fruit together. This resulted in the improvement of
their vision and the realization of their condition: "Then the eyes
of both were opened, and they knew that they were naked" (Gen.
3:7). The knowledge acquired through vision led to their expulsion
from paradise and their introduction to sexuality. The David–
Bathsheba episode represents a similar sequence of vision–seduction–
reproduction.

Menstrual blood is associated with natural reproduction and
iconic representation; blood shed in ritual (sacrifice of animals,
circumcision) is connected to divinity and language. The Old
Testament frequently juxtaposes culture and procreation. God first
orders Abraham to offer him animals, then makes with him the

covenant of circumcision (Gen. 15:9–10 and 17:10). While menstrual blood pollutes, cultural blood purifies. After having killed "the ram of ordination," Moses marks Aaron with its blood by smearing it "on the tip of Aaron's right ear and on the thumb of his right hand and on the great toe of his right foot" (Lev. 8:22–3). And God orders Aaron to do the same with the altar: "he shall take some of the blood of the bull, and sprinkle it with his finger on the front of the mercy seat . . . then he shall kill the goat . . . and bring its blood within the veil . . . sprinkling it upon the mercy seat" (Lev. 16:14–15).

Sacrificial blood is the sacred ink with which the contract between man and God is signed. Moses first "told the people all the words of the Lord" (Ex. 24:3), then "wrote all the words of the Lord" (Ex. 24:4). Subsequently, he built an altar, sacrificed an ox, and

> took half of the blood and put it in basins, and half of the blood he threw against the altar. Then he took the book of the covenant, and read it in the hearing of the people; and they said, "All that the Lord has spoken we will do, and we will be obedient." And Moses took the blood and threw it upon the people, and said, "Behold the blood of the covenant which the Lord has made with you in accordance with all these words."
>
> (Ex. 24:6–8)

The pattern is established in Genesis of men's closeness to language and culture, women's affinity to nature and reproduction. God first tells Abraham about the law of circumcision and then announces that his 90-year-old wife will bear him a son, ordering that her name be changed from Sar'ai to Sarah (Gen. 17:15). Sarah's role is limited to procreation, and her passive participation in language brings to mind Plato's remark in *Cratylus* that one frequently changes the name of one's slave, since it's all convention and the habit of the user. God receives women into the community of the faithful by naming them, and he lets them participate in language by allowing mothers to name their children (Gen. 29:32–5). The "Canticle of Deborah" (Jgs. 5:1–31), the famous judge, accounts for women's sharing in the legal language of the later Judaism. But the very fact that women remain "uncircumcised" (*arel*), a word which figuratively means "obstructed" and describes the lips of someone who does not speak fluently and the heart and ear of people incapable of listening to the voice of reason, leaves them out of cultural discourse and religious ritual.[13] Women's reproductive role

renders them unfit for the cult of the Word and makes them resemble the uncircumcised foreigners and unfaithful co-religionists: "thus says the Lord God: 'No foreigner, uncircumcised in heart and flesh . . . shall enter my sanctuary. But the Levites who went far from me, going astray from me after their idols . . . shall bear their punishment'" (Ezek. 44:9–10).

Women's tendency to "go astray" (= after likenesses) starts with the appearance of menstruation. From then on they are ready to procreate – and to compete with God's creation. The hatching of life in female matter makes men feel out of control, envious of the womb, and compelled to prove the inferiority of natural creation – female and iconic – vis-à-vis divine creation – masculine and linguistic. In each society the proofs are many. In Judaism the covenant of circumcision seems to be, among other things, such a proof. Hence the enormous importance of the circumcision mark, an "inscription" on the male sexual organ linking maleness to divinity. No wonder the scar is interpreted as a source of linguistic inspiration and "true" speech. According to the Midrash, when King David examined his naked body he was upset by its bearing no evidence of a commandment fulfilled, until he discovered his circumcision mark. The sight of it filled him with joy and made him compose Psalm 12 ("On the eighth," a reference to circumcision which is undertaken on the eighth day after birth): a prayer against the "lies" of the unfaithful which suggests to God that they be silenced by means of a radical "circumcision" performed on their false lips and tongues:[14]

> Help, Lord; for there is no longer any that is godly;
> for the faithful have vanished from among the sons of men.
> Every one utters lies to his neighbor;
> with flattering lips and a double heart they speak.
> May the Lord cut off all flattering lips,
> the tongue that makes great boasts.
>
> (Ps. 12:1–3)

Early Christianity, on the other hand, linked sacrificial blood not to word and culture but to image, body, and reproduction. St Ephraim (d. ca.373) the influential Syrian theologian, interpreted "their" (Jewish) circumcision as "your" (Christian) sealing mark and considered the sealing an infusion of divinity into humanity, transforming bodies into "temples for God." Consequently, the

Jewish ritual in which blood is used as sacred ink and applied to surfaces, metamorphosed into a physical process evocative of insemination: "As for the anointing of Aaron my brethren, it was the vile blood of beasts, *that* is sprinkled in the horns of the altar . . . wherein the living and all-lifegiving Blood, is sprinkled inwardly in your bodies, is mingled in your understandings, is infused through your inmost chambers" (*Hymn for the Feast of the Epiphany*, 3.11).[15] Since the Virgin is frequently referred to as the "house" and "temple" of God, the metaphor of the faithful impregnated with God's juice is clearly modelled after incarnation.

In his "Semiology of Sexuality" Pierre Guiraud observes that the divine Logos, whom he interprets not so much as Word but, more specifically, as Verb, is a vehicle of action equivalent to the semen and its ejaculation.[16] The same seems to apply to circumcision, a sudden release of blood which imitates, if anything, ejaculation (time, speech), and not the slow and steady (spatial) flow of menstruation. The language of Genesis creates at least a poetic connection between male blood and male creation, as opposed to female blood and procreation. *Adam*, the name of the first man, is evocative of *dām* (blood) and the verb *dāmā(h)* (to resemble). Adam is made after God's "likeness" (*kīdĕmûtēnû*). The verb "to resemble" and the noun "likeness" have the same root: *dāmā(h)*. All this amounts to little more than a play on words. But on the other hand the biblical flow of poetic allusions may echo the Babylonian tradition of man's creation out of divine blood. On a badly mutilated Babylonian tablet God Marduk announces:

> My blood I will take and bone I will [form].
> I will set up man that man . . .
> I will create man to inhabit [the earth].[17]

Judaism has its roots in the Babylonian–Assyrian tradition with which it shares many aspects – last but not least the importance of language. Enlil, "Lord of the true word," plays a central role in the Babylonian pantheon; and Nabu, the son of Marduk and originally a water-god, is credited with the invention of writing, understanding, and wisdom, and has the stylus of a scribe as his attribute. "The original personification of Enlil," writes Morris Jastrow, "as the mighty onrushing storm whose voice is heard in the roar of the thunder leads to an elaborate symbolism of the 'word' of the deity, which becomes a synonym of his power":[18]

The word which rages in the heavens above,
The word which causes the earth below to quake,
The word which strikes terror among the Anunnaki.
Beyond the seer, beyond the diviner,
An onrushing storm which none can oppose.[19]

Greek iconism is easier to explain than the unique position of Jews, surrounded by and moving between the iconic cultures of antiquity, and still (or therefore) resisting representation – even equating the invisible with the unspeakable by giving their God a name that can neither be uttered nor written, i.e. made into representation. Continuing this tradition, the Mandaeans conceived their Redeemer as the Word or the Son of the Word, and identified his coming with a cry and its reply.[20]

But this is only one side of the coin. On the other side one has to remember that the Old Testament proscriptions about representation lack consistency. God himself appoints the craftsmen Bez'alel and Oho'līab "to devise artistic designs, to work in gold, silver, and bronze, in cutting stones for setting, and in carving wood . . . that they may make . . . the tent of meeting, and the ark of the testimony, and the mercy seat . . . and all the furnishings of the tent . . . and the finely worked garments" (Ex. 31:4–10). The degree of tolerance towards imagery depended on various circumstances, differed from place to place, and changed in the course of Jewish history, with periods of relative acceptance of figurative representation being followed by iconoclastic fervor and then again by iconophilic attitudes. Among the famous third-century AD mural paintings at a Dura Europos synagogue we find, for instance, a Jewish equivalent of Veronica with her cloth: Moses spreading between his hands a scroll covered with writing.[21] When we compare the two icons, we grasp the difference between the two religions. The man with the divine Word conveys the essence of Judaism, the woman with the "true" portrait of the incarnate Word the core of Christianity.

23

2

Depictions of Christ – Early Christianity

The idols of the nations are silver and gold, the work of men's hands.
They have mouths, but they speak not, they have eyes, but they see not,
they have ears, but they hear not, nor is there any breath in their mouths.
Like them be those who make them! – yea, every one who trusts in them!

<div align="right">Psalm 135</div>

The second person of the Trinity had been clothed with a real and mortal body; but that body had ascended into heaven; and, had not some similitude been presented to the eyes of his disciples, the spiritual worship of Christ might have been obliterated by the visible relics and representations of the saints.

<div align="right">Gibbon</div>

Early Christians mistrusted images. Although they dissented from Judaism, they felt bound by the second commandment: "You shall not make for yourself a graven image, or any likeness of anything that is in heaven above, or that is in the earth beneath, or that is in the water under the earth; you shall not bow down to them or serve them" (Ex. 20:4–5). The rejection of representation served an

<div align="center">24</div>

important practical goal. It helped the new religious community to set itself apart from the pagan world of late antiquity with its pictorial propaganda, as Jews had done in the past. According to the early second-century "Apocalypse of Peter," which echoes the Old Testament, a special section of hell is reserved for the worshippers of images:

> and beneath them shall the angel Ezraël prepare a place of much fire: and all the idols of gold and silver, all idols, the work of men's hands, and the semblances of images of cats and lions, of creeping things and wild beasts, and the men and women that have prepared the images thereof, *shall be* in chains of fire and shall be chastised because of their error before the idols, and this is their judgement for ever.[1]

(i) *Symbols and Types*

Reading early Christian theologians, one realizes that they worried less about the violation of the second commandment, and more about the faithful being seduced away from spirituality and asceticism by the sensuality of Hellenistic culture. In his *Exhortation to the Greeks*, Clement of Alexandria (d. ca.211) condemns the splendid marbles of Zeus and Venus, Heracles and Leda with an almost lewd fervor, arguing that under the guise of charming forms they sanction not goodness and virtue but licentiousness, voluptuousness, and perversion, and that those who enjoy seeing them "commit fornication" and "adultery," and "prostitute themselves."[2] The *Exhortation* is the text of a man who believes that in order to defeat pagan cults one must destroy their visible foundations – the entire imaginary museum of the past. In order to get rid of religious competition, Clement chooses the iconoclastic approach, vulgarizes and demonizes depiction, and frightens his potential readers. Adoration of idols, he says, reflects your craving after evil; and succumbing to the smile of a statue, you prevent the salvation of your soul. However, to reject pagan representation is one thing, to reject all representation another. Clement denounces the seductive illusionism of Greek and Roman art. But he fears not only the impact of large-size sculpture but even the magic of tiny realistic representation, such as gems with portraits of lovers or mistresses reminding people of their erotic passions. He recommends to Christians – as an antidote – rings engraved with a dove or a fish, a

ship or a lyre, an anchor or a fisherman (*Paedagogus*, 3. 11. 59:2–60:1). Clement's attitude was in keeping with the earliest stage of Christian art. It covered the first two centuries, was dominated by symbolic or ideographic representation, in particular by the most common ideograms of Christ (fish, lamb, vine, and cross), disregarded classical skills and ideals, and mirrored the clandestine conditions of a battered religion. The simplicity and small scale, the amateurish, childlike and doodling quality of the Christian *arte povera* was, when seen against the sumptuous and monumental naturalism of the late Roman empire, an artistic provocation.

In the development of Christian art, geography has to be taken into account. As it moves from Palestine, the non-iconic place of its birth, to Italy and the Hellenized territories of Asia Minor, Christianity becomes embedded in the world of representation, and the Church leaders soon recognize the importance of figurative depiction as an excellent tool for bringing the faith to the broad mass of people – illiterate, but raised in the rich pictorial tradition of the Roman empire. Thus a distinct move towards figuration can be seen as the third century progresses. Produced by recent converts from the various pagan religions, the Christian art of that era works by means of analogy, as classical types and the formal vocabulary of the Graeco-Roman world are used to evoke the God of the New Testament. Jesus is presented as a handsome, beardless youth in the attire of a shepherd, doctor, magician, musician, lover, and hero. He is modelled after Orpheus taming the wild beasts with the sound of his lyre; after Hercules feeding the dragon with poppy seed; after Amor, whose love affair with Psyche is interpreted as God's love for the human soul; after the Sol Invictus, the sun-god of the Roman legions, riding in his carriage through the sky; and, in particular, after the Good and Fair Shepherd. Equally familiar to Christians and pagans, the biblical figure was inspired by the Greek imagery of the shepherd-god Aristaios or Apollo Nomios, and of Hermes Kriophoros, the ram-bearer at Tanagra, and it was further popularized by the early second-century *Shepherd of Hermas*, a hortatory Christian text representing the Church in Rome.

Symbolism and camouflage ended in 313 with the Edict of Milan. The Church went public and lost its fear of being submerged by pagan representation. From now on it was in control – able to forbid unacceptable depiction and destroy pagan art. The fourth- and fifth-century illustrators of the Bible began to develop their own iconography and style by applying classical models to Old and New

Testament stories. Early theology was obsessed with the idea of correspondences between the two Scriptures, and so was the art of the era. Moses striking the rock represented Christ of the Living Water; the story of Jonah stood for Jesus' resurrection; as Daniel in the lions' den, Jesus incarnated the victory of innocence and the soul's deliverance from sin and death; and in the sacrifice of Abraham, he appeared as the victim. But the most popular themes were the gospel miracles, and in particular the resurrection of Lazarus.

Had Jesus been part of the classical world, his looks might have caught the eye of an artist and he might have been portrayed while he was still alive. But since no portrait of him existed, early Christian art depicted him not as a particular man but a type. As the extraordinary tale of Christ's life and death spread throughout the Roman empire, people's curiosity was aroused and legends of his "portraits" as well as the "portraits" themselves began to appear as early as the second century. Since sensitivity to the second commandment was still considerable, the producers and owners of Jesus' pictures were denounced as enemies of Christianity, pagans, and heretics. In a way characteristic for the creation of legends, Pilate, the persecutor of Christ, was also condemned for portraying his victim. Repeating probably malicious gossip, St Ireneaus (b. ca.137) assails the Carpocration Gnostics for having images – painted as well as executed in other media – which they hold for Christ's portraits made by Pilate, and for exhibiting and worshipping them together with the busts of Pythagoras, Plato, and Aristotle (*Against the Heresies*, 1. 24. 5). Farrar suggests that from these pseudo-likenesses the Emperor Alexander Severus (208–35), an open-minded Syrian prince, derived his statue of Jesus Christ which, according to Lampridius, he kept in his *lararium* with others of Abraham, Orpheus, and Apollonius of Tyana.[3]

In the first quarter of the fourth century the first portrait of Jesus sponsored by a biblical woman made its appearance. Grateful for her healing, the Hemorrhissa had commemorated herself and Jesus in "a wonderful memorial of the benefit the Saviour conferred upon her" (Eusebius, *Church History*, 7. 18:1). There can be hardly any doubt that Eusebius saw the double portrait and was told its story. However, we shall never know when the statue was actually made and whom it really depicted. It might have belonged to the popular genre of votive sculpture and been erected by the city of Caesarea to an emperor, with the inscription "to the Saviour (*Soter*)" or "to the

Benefactor (*Euergetes*)" – a traditional way of addressing rulers – or it might have shown Asclepius or some other healer or hero.[4] It is quite likely that after Constantine's Edict of Toleration a piece of old pagan junk was "rediscovered" and given a new meaning by the local Christian community eager to show that from the very beginning it had been in touch with Jesus.

Eusebius's account is not only crucial for the formation of the *vera icon* legend, but also significant in respect to Christ's portraiture. Eusebius is known for his disapproval of depiction, his doubting of the assumed content of "holy" pictures, and his discouraging of people eager to acquire icons. But in this particular case he does not dismiss as nonsense the possibility that the monument might indeed depict Jesus and the Hemorrhissa. To the contrary, he seems to sanction this view. Why? Is Eusebius so convinced of the sculpture's authenticity? Hardly. More likely, he finds that in view of the Christian victory the time is ripe for this specific portrait of Jesus – one that comes from biblical times, establishes a link between divinity and femininity, and is associated with healing, the breaking of the menstrual taboo, and incarnation. Eusebius's sympathetic treatment of the Jesus–Hemorrhissa story looks like a shrewd move by a Church politician keen to have the past fit the needs of contemporary history. In his *Life of Constantine* Eusebius keeps stressing the straight line leading from God to the emperor. Here he conveys a similarly direct contact between Christ and a disadvantaged woman – the least of the least becoming the first owner of God's portrait. The acceptance of the Jesus–Hemorrhissa image signals the Church's changing attitude towards the depiction of the living Jesus: once pagans and heretics were blamed for portraying him, now the wish to obtain his likeness is interpreted as a sign of devotion. In the *Apocriticus* of Macarius Magnes, an apology for the faith written ca.410, the cured Hemorrhissa is an Edessene princess called Berenice. She leaves the monument – "the record of the deed" – to her son to remind him of "something done recently."[5]

(ii) *The* Acheiropoietos

L'appétit vient en mangeant. As the number of figurative images of Jesus increased, so did the hunger to see him not as he might have

been but as he really was. It seems that around the middle of the sixth century this desire for the specific had a share in the appearance of a new kind of representation: a likeness derived directly from Christ, and therefore called *acheiropoietos* (ἀχειροποίητος, "not made by [human] hand").[6]

The term *acheiropoietos* does not come from classical Greek but from the *koine* of the Judeo-Christian community, since it has not been traced any further back than the New Testament.[7] *Acheiropoietos* was first used as a designation of the godmade and permanent as opposed to the manmade and perishable in the letters of Paul and the Gospel of Mark. "For we know," Paul writes, "that if the earthly tent we live in is destroyed, we have a building from God, a house *not made with hands* [my italics], eternal in the heavens" (2 Cor. 5:1). In a similar vein he compares Adam, the first man and "a living being," with Christ, "the last Adam" and "a life-giving spirit," and explains that "it is not the spiritual which is first but the physical . . . The first man was from the earth, a man of dust; the second man is from heaven" (1 Cor. 15:45–7). Paul also uses *acheiropoietos* in reference to the spiritual Christian circumcision which has replaced the Jewish custom: "in him [Jesus] also you were circumcised with a circumcision *made without hands* [my italics]" (Col. 2:11). In the Gospel of Mark the distinction between the manmade and the divine is attributed to Jesus by the false witness who at the Lord's trial asserts that "we heard him [Christ] say, 'I will destroy this temple that is made with hands, and in three days I will build another, *not made with hands*' [my italics]" (Mk. 14:58).

In early Christian writings *acheiropoietos* was used rarely and mostly in reference to the quoted New Testament passages; it had then a broad sense and designated everything that had resulted from divine creation – including nature and humanity. The concept of the *acheiropoietos* has its origins in the Platonic and Neoplatonic philosophy according to which all earthly things have their prototypes in heaven; these prototypes, the product of God's spirit, were termed *acheiropoietoi* and became the subject of the third-century controversy between the realists (Methodius of Olympus) and the spiritualists (school of Origen) who quarrelled about the right interpretation of Paul's words in 2 Cor. 5:1. But *acheiropoietos* turned from a fairly obscure theological term to a more common word only in Byzantine days, when it began to be used as a designation for images "not made by hand."

The creation of the miraculous *acheiropoietoi* was modelled after

the physical phenomena of projection and reflection; it was associated with perception and dreaming, imagining and art-making; it alluded to real and spiritual birth and rebirth, to sexuality and procreation, baptism and resurrection, and to Jesus' incarnation and return from the dead. The divine production of the *acheiropoietoi* involved excretion and/or emanation. Water and other fluids, light, fire, and spiritual energy played the role of agents and were applied to various kinds of matter (textiles, wood, stone, etc.) which were marked by them: stained and wetted, impressed and impregnated, cast, burnt, dyed, incised, engraved, etc. The miracle was mediated by women.

The Byzantine *acheiropoietoi* echo the ancient divine images which were believed to fall from the sky. Their mythology was indebted to the existence of meteors, and they were treated as powerful phylacteries. In ancient Greece these godmade representations were referred to as *diipetes* (fallen from the sky) and were mostly associated with Pallas Athena who "shot through the sky as some brilliant meteor" (*Iliad*, 4. 73);[8] hence the name *palladion* (statue of Pallas). The most famous palladium of Athena belonged to Troy. It was thrown from heaven by Zeus at the founding of the city and kept as a pledge of Troy's safety. In order to induce the goddess to protect the town, Hector asked his mother to take out "the largest robe, and the one that was most beautifully enriched with embroidery, as an offering to Minerva" (*Iliad*, 6. 295). Later legends tell us that the palladium was carried off from the goddess's temple by Odysseus and Diomedes, who thus made the capture of Troy possible, and they mention a second palladium which was taken to Italy by Aeneas and kept in the temple of Vesta in Rome.[9] But the Roman capital possessed also its own divine object: the *ancile* of Numa, a shield which descended from the sky in response to the king's prayers.[10]

In the second half of the sixth century a portrait of Christ fell from heaven to make God's existence credible to a pagan woman, Hypatia, who claimed that she could not believe in what she did not see. A native of Camuliana (or Camulia), a small city in Cappadocia, northwest of the capital Caesarea-Mazaca, she found in the pond of her park a painted canvas on which she immediately recognized the likeness of Christ. She took the picture out of the water, realized that it was completely dry, and wrapped it in her mantle. A second wonder occurred then: the image impressed itself on her dress, producing a faithful replica of the Lord's portrait.

Convinced by the miraculous apparition of God's existence, Hypatia was converted to Christianity.

The oldest version of the Camuliana picture story was written in Syriac after 560 but before 574, the year when the icon was transferred with pomp to Constantinople.[11] The legend does not tell us when the miracle happened, and the fact that Hypatia was a pagan does not necessarily mean that it should be dated back to the pre-Constantine era, since until the time of Justinian there was a considerable number of pagans in Asia Minor, especially among the rural population. A later version of the legend cites the time of Emperor Diocletian (AD 284–305) for the origins, and the rule of Theodosius I (379–95) for the rediscovery of the portrait, but this also proves nothing, since Diocletian's violent persecution of Christians had rendered this period particularly suitable for legends. Had the picture existed before the legend was written? Perhaps, but probably not for very long. In any case, it did not play then the role it came to play in the last quarter of the sixth century. The fame of the portrait increased when its first copy – produced directly on Hypatia's mantle – was transferred to Caesarea, the capital of Cappadocia, and when subsequently a second copy was added to the first. It was obtained through the devotion of a Christian woman from Diobulion (in the Amaseia diocese of Pontus) who had a church built in honor of the holy icon. In 554 Diobulion was raided by barbaric hordes but, although the church was razed to the ground, the picture survived. Eager to rebuild the sanctuary, the local population was supported by the emperor, and in connection with this, one of the imperial officials had a clever idea – to make the icon earn its own income. In the years 554–60 Christ's portrait was paraded in procession through the whole area, raising the hopes of the Savior's imminent advent in the Christian community. Interestingly enough, the author of the story refers only to the copy from Diobulion as *acheiropoietos*, an indication, perhaps, that this was still a new term at the time of his writing. But the use of *acheiropoietos* in respect to the copy might have also meant that the original was considered an image that fell from the sky, while "not made by hands" seemed a term appropriate for an icon miraculously reproduced on earth.[12]

In 574 the original Christ portrait from Camuliana was transferred to the imperial collection of relics at Constantinople simultaneously with parts of the Holy Cross from Apameia in Syria.[13] In the capital the Lord's likeness impregnated new fabric and gave birth to another

copy. In the days of the Emperor Tiberius II (578–82) Mary, a sick widow, who hoped to be cured by means of the Holy Face, asked that the "true" image be lent to her for forty days. Because of Mary's patrician origin and piety, her wish was granted. When she obtained the canvas, she covered it with a cotton sheet of identical size and put it into a drawer in her house-chapel. Soon after, her condition deteriorated, and since she could not get up any more, she asked her maid to bring her the drawer. The servant, however, was prevented from fulfilling her mistress's wish by flames burning at the very spot where the icon was kept. The miraculous event attracted a crowd, which included a priest, and everyone saw the fire. When it subsided, the holy picture appeared untouched by it, and in addition an exact copy of the original was visible on the cover sheet; Mary touched it, and was immediately healed. Before her death the widow presented her own copy to a nunnery in Melitene in East Cappadocia. During the Persian wars under the Emperor Heraclius (610–41) the nuns fled to Constantinople, taking the icon with them. In the capital they were received by the Patriarch Sergius, who confiscated their treasure; but as misfortune befell him and heavenly visions admonished him to return the relic, he restored the icon to the nuns, who then kept it in their convent in the capital.[14]

In the first half of the seventh century Constantinople thus possessed two Cappadocian Christ *acheiropoietoi*, one in the imperial collection of relics, the other in a nunnery. But by the time the Melitene icon arrived in the capital, the Camuliana picture had become the main palladium of the Byzantine empire, and during the Persian wars was often carried by the army. The field marshal, Philippicus, fighting under the Emperor Maurice (582–602), displayed Christ's Camuliana *acheiropoietos* before his troops to raise the spirits of the soldiers. Also under the Emperor Heraclius Jesus' holy portrait assisted the army. This central position of the palladium might have been the reason for interpreting the Melitene portrait not as just another original impression, but as a copy of the Camuliana *acheiropoietos*.[15]

As they were paraded in processions through the countryside, displayed in church at religious festivals, shown to the army before battles, brought out for purposes of healing and salvation, the *acheiropoietoi* and their copies replaced Jesus and reproduced his miracles. The "true" images, their number steadily increasing because of easy reproduction (multiplication through mere touching), represented a new type of portraiture. They were "xerox" copies of

God fixed by his divinity — not human action. From this time on we need, however, to distinguish between the "proper" *acheiropoietoi* and their artistic reproductions. The first were supposed to be truly mimetic and were therefore executed in approximately the same size and medium as the original; the second were more or less exact renditions of the *acheiropoietoi* in drawing, painting, mosaic, relief, sculpture, weaving, embroidery, etc., which had either the form of separate pictures or were included in pictorial programs. Whenever an artistic reproduction constituted an autonomous image, the borderlines between an *acheiropoietos* and its depiction were easily blurred and the artefact ended up being worshipped as if it were "not made by hand," especially when the depiction found itself in a place far removed from the original location. Clearly, everyone longed to have the real thing, and thus *acheiropoietoi* were manufactured by clever craftsmen and traded around by shrewd businessmen, as are today's "original prints" — "miraculously" printed by a deceased Chagall or Dali in a Soho loft.

(iii) *From Presence to Passion*

Early Christianity looked for victory on earth and *sub specie aeternitatis*, and thus for images of Christ's presence, power, and triumph, and it backed away from visions of Jesus' suffering and death. Although Jesus' shroud, provided by Joseph of Arimathea, assumed a significant position in the Bible, the so-called *sindones* (burial sheets) with the impressions of Christ's entire body appeared later (towards the end of the seventh century) than the "true" portraits of the living God.[16] The worship of Christ's shrouds and the idea that his images were made by blood, not water or sweat, was related to a shift in the perception of the Lord reflected in Christian art. The bucolic imagery of a youthful shepherd, famous doctor, and brilliant teacher was increasingly abandoned in favor of Christ as a bearded and serious ruler, a Last Judge and Pantocrator — and the theme of suffering began to move closer to center stage. Of course, the essential deed of Jesus' life was his death. Since the crucifixion established Christ as the divine head of a new religion, the authors of the New Testament never forgot about death hovering above his head. The evangelists condense Jesus' biography to less than a hundred days, "but for the last two or three days of his

life, they provide a detailed, almost hour-by-hour scenario. And the climax of that scenario is the account of Good Friday and of his three hours on the cross."[17]

In early Christianity the cross functions as a symbol of triumph and a talisman. The way to the faith leads through the cross. Thus the life of the militaristically gifted Constantine who defeats Maxentius at the battle of the Milvian Bridge in 312, converts to Christianity, issues the Tolerance Edict of Milan in 313 and makes Christianity into a state religion, a *vita* which is not a *via crucis*, is intimately tied to the cross (the discovery of the *vera crux* is attributed to his mother). The Church Fathers interpret the cross as a sign of salvation and a medium for immortality that wards off evil and defeats death. Ephraim points out that Jesus "is the Son of the carpenter, Who skillfully made His cross a bridge over Sheol that swallows up all, and brought over mankind into the dwelling of life" (*Homily* 1.4). And he contrasts the cross of life with the tree of death: "To the first Tree that which killed, / to it grace brought forth a son, / O Cross offspring of the Tree, / that didst fight against thy sire! / The Tree was the fount of death; / the Cross was the fount of life" (*Nisibene Hymn*, 14. 8).

In early Christian art the cross, a symbol, attribute, and emblem of Christ, tends to be omnipresent. Many compositions are inspired or dominated by the shape of the cross, the coherence of others is provided by the repetition of the cross sign. Christ is equipped with a cross-staff, angels carry crosses, and in the good shepherd scenes the cross provides the beholder with a sense of premonition. A golden cross-staff introduces a mood of melancholy into the otherwise idyllic mosaic lunette in the Mausoleum of Galla Placidia (d. 450) at Ravenna, where Jesus, a handsome young shepherd with a pensive look, holds the cross with his left hand, while caressing the soft muzzle of a white sheep with his right hand. In the mid-sixth-century mosaic in the apse of Sant'Apollinare in Classe at Ravenna, crucifixion is blended with transfiguration. The picture is dominated by a luminous, jewelled cross emerging from a cloudy sky spread above a blooming earth. The cross is enclosed in a star-studded blue circle and carries Christ's small bust, which resembles a medallion worn around the neck. The Savior's head, a tiny circle, marks the center of the universe and brings to mind the archaic Chinese pictograph of the sun, a circle with a dot in the middle, and the identical Egyptian hieroglyph. In the cosmic solar landscape

surrounding the Savior matter appears as islands of white – clouds, sheep, and the white tunic of St Apollinaris.

The cross is everywhere, but the first crucifixion scene comes relatively late. It dates from about 420–30 and is to be found on a Roman ivory plaque.[18] The composition juxtaposes Jesus' crucifixion with the suicide of Judas, the Savior with the Traitor, and the cross, the new tree of salvation, with the tree of evil from whose branch Jesus' ex-pupil hangs.[19] Christ's straight body and arms form a right angle, his loincloth has the shape of a cross, and his entire figure, shown in perfect frontality and symmetry, follows the shape of the cross. This calm and emblematic *homo-crux* is contrasted with the tormented silhouette of Judas, whose face, turned towards Jesus, is depicted in profile, and with the aggressivity of Longinus, whose raised arm holds the lance piercing the Lord's side.[20] The set of oppositions infuses drama into the relief. Agony, however, is absent from the figure of Christ. A victor over sin and death, he is shown with his eyes wide open (Judas's eyes are closed) – a tranquil, immortal ruler whom Mary and John quietly adore rather than mourn.

Crucifixion was not a frequent motif in early Byzantine art, but it seems that the monastic painters of the East were the first to transform Christ from a victorious solar youth into a suffering man. A miniature in the late sixth-century Syriac *Rabbula Gospels* shows a worn-out bearded Christ hanging on the cross in his seamless tunic, whose body and dress are being pierced with the Roman soldier's lance.[21] This transformation might have been influenced by the ascetic aspect of oriental monasticism, and by the artists' reaction to Monophysitism, which interpreted Christ's nature as purely divine and thus not subject to pain.[22] Syria was the homeland of men who aspired to resemble living crosses even before the arrival of Christianity. Long before Simeon the Stylite (who took up residence atop a column in 423), a pagan ascetic in Hierapolis mounted a column twice a year to meditate in perfect peace (Lucian, *De dea Syria*, 28–9).

In the *Utrecht Psalter* (ca.830) Christ is shown on the cross for the first time with his eyes closed.[23] The oldest type, the *Christus triumphans* with open eyes, feet and hands fitting the shape of the cross, and a regal crown was not abandoned, but it was superseded by the suffering types, the *Christus patiens* with his head bent and eyes closed and the *Christus dolorosus*, dying or dead, his face, body,

and loincloth covered with blood and distorted by agony, and with a crown of thorns on his head.[24] These types influenced the medieval Veronica veils. From the thirteenth century onwards the Holy Face was shown either alive (serene or suffering) or dead (calm or disfigured by torture), with or without the crown of thorns and drops or traces of blood.

Byzantium

3

Icon Addicts – Icon Foes

(i) *King Abgar and Edessa*

In Eusebius's *Church History* King Abgar, a successful monarch dying from an incurable disease, hears about Jesus Christ who, because of his miracles, "became in every land the subject of excited talk and attracted a vast number of people in foreign lands very remote from Judaea" (1. 13:1). Hoping for relief, Abgar sends a messenger to Jesus with a letter in which he writes: "I . . . beg you to come to me, whatever the inconvenience, and cure the disorder from which I suffer. I may add that I understand the Jews are treating you with contempt and desire to injure you: my city is very small, but highly esteemed, adequate for both of us" (1. 13:7–9). Jesus replies, promising Abgar to have one of his disciples come to Edessa and cure the king. This promise is fulfilled, when after Christ's resurrection and ascent into heaven the Apostle Thomas (or "Judas, also known as Thomas," 1. 13:11), sends Thaddaeus, one of Christ's seventy disciples, to Edessa.[1]

In Jesus' reply the first two sentences are particularly significant. Before starting the letter proper, Jesus stresses the importance of faith that can do without appearances. The first sentence, "Happy are you who believed in me without having seen me!" (1. 13:11), alludes to Thomas (or Thomas Judas, the Twin Judas), who lacks such faith. Eight days after the resurrection Christ visits his pupils, has Thomas put his finger in the wound in his side, and scorns the

incredulous apostle: "Have you believed because you have seen me? Blessed are those who have not seen and yet believe" (Jn. 20:29). The second sentence, "For it is written of me that those who have seen me will not believe in me, and that those who have not seen will believe and live" (1. 13:11), reinforces the point by referring to the Old Testament, where God says to Isaiah: "If you will not believe, surely you shall not be established" (Is. 7:9). Thus Jesus first praises Abgar for relying solely on *words* and only then explains that he is busy completing his mission on earth and therefore cannot come.

In the *Church History* Jesus' short letter is followed by a subjoined Syriac document describing the apostle's arrival at Abgar's palace, a remarkable scene which introduces an *image*: "At the moment of his entry a wonderful vision appeared to Abgar on the face of Thaddaeus. On seeing it Abgar bowed low before the apostle, and astonishment seized all the bystanders; for they had not seen the vision, which appeared to Abgar alone" (1. 13:14–15). Then Thaddaeus lays his hands on the king and cures him instantly. This is the beginning of Edessa's evangelization: "So Abgar instructed his citizens to assemble at daybreak and hear the preaching of Thaddaeus . . . All this happened in the year 340" (1. 13:21–2) of the Seleucid era, ca.AD 30, the probable year of the Ascension.

Abgar's illness is not specified, but his surname "Uchama" (black) suggests that he might have been suffering from leprosy or, more precisely, from either the "black" or, on the contrary, the "white leprosy" – in accordance with the *per antiphrasin* tendency of all mythology to treat opposites as synonyms. In later versions of the legend leprosy is often ascribed to the king. But so is gout, an illness probably suggested by Eusebius, who mentions not only the curing of Abgar, but also of a certain "Abdus son of Abdus, who had gout" (1. 13:18).

Eusebius finished his *Church History* ca.325. The exact date of the *Doctrine of Addai* (Addai=Addaeus=Thaddaeus), a much longer and more detailed account of the Abgar–Jesus correspondence, is still not established. In 1848 the first, incomplete version of the text was discovered by W. Cureton in two British Museum manuscripts, dating probably from the fifth and sixth centuries, and published in *Ancient Syriac Documents* under the title *The Doctrine of Addaeus, the Apostle*.[2] Cureton believed that he had found

> a considerable portion of the original Aramaic document, which Eusebius cites as preserved in the archives of Edessa, and various

passages from it, quoted by several authors . . . which seem to be sufficient to establish the fact of the early conversion of many of the inhabitants of that city, and among them, of the king himself, although his successors afterwards relapsed into Paganism.[3]

Cureton's fragment confirms the existence of an Abgar–Jesus correspondence, but it does not narrate the story of the initial contacts between the two men, since it begins after Addaeus's arrival in Edessa and deals mostly with his apostolic activity. George Phillips, the President of Queen's College in Cambridge, was luckier than the curator of the British Museum. Browsing through the manuscripts of the Imperial Public Library of St Petersburg, he came across the entire Syriac text of the *Doctrine*, more than the double of what had been published by Cureton. His *Doctrine of Addai, The Apostle* (1876) contains the narrative of the Jesus portrait executed by Hannan, the king's archivist and painter, and the story of the invention of the "true" cross by Protonice (Petronice). Phillips recognized the invention legend as a later interpolation, but otherwise assumed that his find was the text Eusebius had "before him, when he wrote the thirteenth chapter of the first book of his Ecclesiastical History."[4]

Phillips's belief was not shared by others. The German scholar Richard Adelbert Lipsius undertook a critical analysis of the *Doctrine of Addai*, and other existing texts mentioning the Abgar–Jesus relationship, in his *Edessenische Abgar-Sage* (1880) and arrived at the conclusion that Eusebius's account preceded Phillips's version, which he dated to the middle of the fourth century.[5] While Phillips maintained that the Protonice interpolation, almost identical with the story of the cross invention by Helena, the mother of the Emperor Constantine, was the legend's original version, Lipsius claimed the opposite.[6] In his "Origins of the Edessene Church and the Abgar Legend" (1888), the French theologian L.-J. Tixeront tried his best to date the story of Edessa's christianization as far back as possible insisting that the *Doctrine of Addai* was the "lightly retouched and interpolated" text seen by Eusebius.[7] But he admitted that both the story of Christ's portrait and that of Petronice had to be regarded as additions from "the year 380 or even 390."[8] Dobschütz assumed that the *Doctrine of Addai* was written ca.400, a prevailing view in the twentieth century, although Steven Runciman, for instance, disagreed with it in his "Some Remarks on the Image of Edessa" (1931). Placing the text "somewhere in the middle of the

fourth century," he considered it as "definitely . . . post-Nicene in its theology, that is to say, to have been written after 325, though on the other hand it clearly antedates the religious problems of the fifth century."[9]

In the *Doctrine of Addai* – whose author identifies himself at the end as Labubna, the king's scribe – the story begins three years later than in Eusebius's *Church History*.[10] Abgar, the son of King Ma'nu, a contemporary of the Roman Emperor Tiberius, sends on October 12, 343 of the Seleucid era (AD 33) two of his courtiers and Hannan, his "tabularius" and "sharrir," with important state papers to the Roman procurator Sabinus, the governor of Syria, Phoenicia, and Palestine, residing in Eleutheropolis. On their way back the travellers encounter a great crowd of people who, attracted by the news of Jesus' miracles, head for Jerusalem. The three join them and visit Jerusalem for ten days. During that time Hannan "the keeper of the archives," writes down "everything which he saw that Christ did" (*Doctrine of Addai*, p. 3) and upon his return to Edessa gives his notes to Abgar. They arouse the king's interest and make him think of a journey to Jerusalem. But he is too afraid of getting into a conflict with the Romans, and instead writes a letter to Jesus and gives it to Hannan. The secretary leaves Edessa on March 14 and arrives in Jerusalem on April 12. He finds Christ in his house at Gamaliel and hands him the letter. It starts with the words: "Abgar Ukkama [the Black], to Jesus, the Good Physician, who has appeared in the country of Jerusalem. My Lord: Peace. I have heard of Thee and Thy healing, that it is not by medicines and roots Thou healest, but by Thy word Thou openest the eyes of the blind." The king warns Jesus "that the Jews murmur against Thee and persecute Thee, and even seek to crucify Thee" (*Doctrine of Addai*, p. 4) and invites him to Edessa.

Jesus receives the letter and delivers to Hannan a verbal message. Its content mostly coincides with the text reported by Eusebius and the "subjoined" Syriac document. Christ explains that

that for which I was sent here is now finished, and I am going up to my Father, who sent me, and when I have gone up to Him, I will send to thee one of my disciples, who will cure the disease . . . and restore thee to health; and all who are with thee he will convert to everlasting life. Thy city shall be blessed, and no enemy shall again become master of it for ever.

While Jesus speaks, Hannan paints his portrait. Then the archivist-artist returns to Edessa, relates to the king everything he has heard from Jesus, and gives him the portrait which Abgar receives "with great joy, and placed . . . with great honour in one of his palatial houses" (*Doctrine of Addai*, p. 5).

The image episode illustrates the transition from the linguistic to the iconic tradition. Eusebius's account is focused on Jesus' letter – God's written word. The *Doctrine of Addai*, on the other hand, introduces God's picture and diminishes the significance of divine communication by changing script into a spoken message. The acceptance of Christ's image requires the rejection of pagan representation. This point is made in the following story of Protonice, who sets out for Jerusalem after she has "denied the paganism of her fathers . . . and the idolatrous images which she had worshipped" (*Doctrine of Addai*, p. 11), and in several other passages. The text also establishes a connection between depiction and incarnation. Addai, "the disciple of Jesus Christ . . . who came down from heaven, and was clothed with a body and became man" (*Doctrine of Addai*, p. 18), explains the nature of his teacher:

> For the will which inclined Him to the birth from a virgin, also made Him condescend to the suffering of death, and He humbled the majesty of His exalted divinity, who was with His Father from eternity, He of whom Prophets of old spake in their mysteries; and they represented images of His birth, and His suffering, and His resurrection, and His ascension to His Father . . . His body is the pure vestment of His glorious divinity, by which we are able to see His invisible Lordship.
>
> (*Doctrine of Addai*, p. 19)

Jesus has to be recognized as the new "head" of the world and thus the subsequent disruption of Christianity is related to this part of the body: Aggai, the successor of Addai, and the maker of chains and silks at the King's court, refuses to produce a headband for Abgar's son, who has converted back to paganism, and is killed. Rebuking both the Jews, who insist on an invisible God, and the pagans, who pray to other "heads," the Syriac legend prepares the ground for the transformation of Jesus' portrait into a miraculous *acheiropoietos* by stressing that God's likeness is "not made by hands." Addai tells the Edessene crowd that the reason for his inability to cure some people with Christ's word is their cult of "the work of their hands;" and he admonishes them to "flee . . . from things made and created

. . . that in name only are . . . called gods . . . and draw near to Him, who in His nature is God . . . and is not made as your idols, and also not a creature, and a work of art" (*Doctrine of Addai*, pp. 26–7).

The subsequent history of Christ's portrait has to be seen in the context of Christianity gaining a foothold in Edessa, and of pro- and anti-iconic movements in the Eastern Church. An important center of early Christianity, Edessa (today Urfa, Turkey) is the Greek name of Urhai ("Western" in Aramaic), an ancient city in Northwestern Mesopotamia, some 70 miles east of the Euphrates, which played already some role in the early Babylonian-Assyrian times, when it was populated by Hittites and Semites. In the later Assyrian age the population was mostly Aramaic-speaking and there is some evidence that Jews settled in the vicinity of Urhai towards the end of the seventh century BC. The town was renovated and called "Edessa" in 304 BC by Seleucus I Nicator. In 132 BC Edessa became the capital of the Osroene state and the seat of a local dynasty of kings, most of whom bore the name Abgar.[11] Theirs was a delicate position between two contending empires, Parthian and Roman. For a time Parthian predominance yielded to Armenian, and at the time of the expeditions of Lucullus, Pompey, and Crassus, Edessa was an ally of Rome. In AD 114 King Abgar VII entertained Trajan, but in 116 the city rose against Rome and was sacked by the imperial army. Hadrian restored Edessa as a dependency of Rome, but when under Marcus Aurelius Mesopotamia was recovered from Parthia, Harran and not Edessa was chosen as the capital of the Roman colony.

A city on the crossroads, Edessa shared in the Hellenistic culture of Syria but was influenced by the West and the Near and Far East – Palestine, Arabia, Egypt, Babylonia, Persia, India and, China. It had a mixed population of Jews, Arabs, Syrians, and Greeks, and a multireligious identity. The common language was Aramaic. A Roman garrison was stationed in the city, and synagogues coexisted with sanctuaries of various astral divinities, the sun-god Shamash, the twins Nergal and Sin, represented perhaps by a pair of pillars and connected with the Greek Dioscuri, Aziz and Monim, probably identical with the Phosphorus (morning star) and Hesperus (evening star), and Bel (Jupiter) and Nebo (Mercury), the favourite gods of Abgar the Black, against whom Addai preaches: "For I saw in this city that it abounded greatly in paganism, which is against God. Who is this Nebo, an idol made which ye worship, and Bel, which ye honour? . . . Bath Nical . . . also the sun and the moon . . . Be ye not led away captive by the rays of the luminaries and the bright star"

(*Doctrine of Addai*, pp. 23–5).[12] Astarte-Venus was worshipped in Edessa under the name of Atargatis, and fish, perhaps sacred to her, were kept in the pools of the citadel. Christianity reached Osroene in the course of the second century. Parts of the New Testament were then translated into Syriac, a dialect of Aramaic which was spoken in the area. At the onset of the third century AD King Abgar IX bar Ma'nu (179–214) was converted to the new faith and soon the country followed in his footsteps. The early Syriac-speaking Church used not the gospels, but Tatian's *Diatessaron*, "a harmony of our Four Gospels, made into one narrative by combining, rather than by selecting, the words of Matthew, Mark, Luke and John."[13] Only at the beginning of the fifth century, under the episcopate of Rabbula, bishop of Edessa from 411 to 435, the Peshitta, a Syriac version of the canonical Scriptures of the New Testament, began to replace the *Diatessaron*.

The Christian culture of Edessa and, more generally, of Syria and Cappadocia was shaped by the clash of two major traditions: the non-iconic attitude of the Semitic population, which was prone to succumb to the Monophysite heresy questioning the dogma of Christ's dual existence as God and Man and thus hostile to representation, and that of the Greeks, devoted to depiction and hence supporting the orthodox line.[14] Consequently some of the first religious disputes between the old Judaic way of the Word and the new Christian way of the Incarnate Word – Image – were carried out in and around Edessa, with Jewish, Arab, and Syrian circles mostly dismissing representation, and the Greek community strongly supporting it.

The controversy was reflected in the legends of Jesus' letter and portrait. They dated the origins of Christianity – in a way typical for all mythology – to the times when Jesus was still alive, so that by the fourth century it was generally believed that the Edessene church had started in his lifetime, when Osroene was ruled by King Abgar V the Black (AD 13–50).[15] The existence of a letter of Jesus – whatever this piece of writing might have been – was documented from the end of the fourth century. The pedantic pilgrim Egeria, who visited the region between 381 and 384 and met with the bishop of Edessa, reports that he led her to the gate through which Abgar's messenger had arrived from Jerusalem and read her "the actual letters" (she has nothing to say about Christ's portrait).[16] The Edessenes considered Jesus' letter as the city's main prophylactic, and although a Roman synod of 494–5 declared it a fake, the letter

continued to be accepted as authentic for much longer in the Eastern Church.[17]

Edessa was spared assault for a long time and this good fortune was attributed to the presence of Christ's letter. But in the first half of the sixth century conflicts flared up between the Romans and the Persians, during which King Chosroes I of Persia advanced into Mesopotamia and attacked Edessa. In 540 he twice laid siege to the city, and had twice to withdraw, once because of a rheumatic pain in his face, another time because of a bad omen. However, in 544 he returned and this time the situation grew critical. This was not any more, as Procopius puts it, a campaign against the Roman empire, but "against the God whom the Christians reverence" and his promise to protect Edessa through the magic power of his letter inscribed above the city's gate.[18] To overtop the high, strong walls and penetrate the town from above, the Persians started to build a huge tower. But before it was finished, the defenders burrowed underneath it, made a chamber, filled it with inflammable material, and set it on fire. The elaborate Persian construction began to burn from below and, as it was consumed, Chosroes withdrew.

Some forty years later Evagrius (ca.536–600), a church historian and bishop of Edessa, repeated Procopius's account to the point of the underground chamber set on fire, and then gave it an unexpected turn. The fire, he says, did not catch and, in "utter perplexity", the Romans brought out

the divinely wrought image, which the hands of men did not form, but Christ our God sent to Abgarus on his desiring to see Him. Accordingly, having introduced this holy image into the mine, and washed it over with water, they sprinkled some upon the timber; and the Divine power forthwith being present to the faith of those who had so done, the result was accomplished which had previously been impossible: for the timber immediately caught the flame, and being in an instant reduced to cinders, communicated with that above, and the fire spread in all directions . . . On the third day the flames were seen issuing from the earth, and then the Persians on the mound became aware of their unfortunate situation . . . [and] endeavoured to extinguish the pile, by turning all the water-courses . . . The fire, however, receiving the water as if it had been oil or sulphur . . . continually increased, until it had completely levelled the entire mound and reduced the aggestus to ashes.

(*Church History*, 4. 27)

Evagrius's report implies that Edessa possessed Jesus' "true" image. If so, why was it not mentioned by Procopius? Since Procopius was based in Constantinople and close to imperial circles, he might have been reluctant to present the victory of the Roman army as due to a miracle rather than military strength. But Dobschütz suggests that Evagrius deliberately introduced Christ's *acheiropoietos* – the first time the term was used in respect to the Edessene image – as an argument against anti-iconic sentiments.[19] Profiting from the tradition established by the *Doctrine of Addai*, the clever bishop might have wanted to create the impression that the picture had been in the city ever since it had been brought back from Jerusalem.

Why do we assume that Evagrius falsified history? At the time of the Persian attack Jacob bar Addai (or Baradaeus, 541–78) acted as the bishop of Edessa.[20] The Syrian theologian was known as an aggressive organizer of the Monophysite Church. Its doctrine disputed the duality that had arisen from Jesus' incarnation and thus found itself counter to the doctrine of the Council of Chalcedon (451) – which declared that Christ was endowed with two natures, each perfect and distinct from the other, and was at once God and Man – and counter to the ecclesiastical center in Constantinople.[21] In this situation the local Greek community may have decided to circulate rumors of the actual presence of Abgar's picture, and Evagrius, famous for his scholarship and orthodoxy, may have wanted to lend his pen to the pro-iconic cause and introduced *en passant*, the best way to suggest that something has been around for ever, an image which before had existed only in legend. His account makes clear that the army badly needed a powerful talisman in order to defend Edessa against external enemies. It is therefore not unlikely that Christ's miraculous portrait was created with an eye to military circles. But the imperial army and Greeks close to Constantinople needed Christ's *acheiropoietos* also as an amulet against an internal enemy.

In the seventh century the image of Edessa assumed a historical presence. Jesus' gift to Abgar did not remain in the niche over the city gate, but was moved to St Sophia, the main church of the Greek community, where it was kept in a golden shrine. On major Church festivals the cloth was exhibited and seemed to have been the cause of much visual excitement, although it is hard to distinguish what people saw on it from what they projected onto it. Obviously the worshippers animated the likeness on the cloth with their own

fantasies, so that the portrait appeared alive and in constant metamorphosis. Thus on Easter Sunday some pilgrims witnessed how the face of Christ changed its age: at six in the morning he looked like a child, at nine he resembled a boy, at twelve a youth, and at three he was an adult ready to take up the cross for humanity's salvation.[22] The icon soon began to overshadow the letter, so that in subsequent centuries Edessa, once famous for being under the protection of Jesus' Word, came to be mostly associated with his Image.

Before the end of the sixth century *acheiropoietoi* had a solid presence in the camps and cities of the Eastern empire. "Of these pictures, the far greater part, the transcripts of a human pencil, could only pretend to a secondary likeness and improper title; but there were some of higher descent, who derived their resemblance from an immediate contact with the original . . . The most ambitious aspired from a filial to a fraternal relation with the image of Edessa."[23] Abgar's icon was commemorated in new legends. We hear that the daughter of King Chosroes, the very same whose army had been defeated at Edessa with the help of Christ's "true" portrait, was possessed by a demon. Her father tried to get hold of the Edessene image but was tricked by the local population: they made an exact copy and sent it to him instead of the original. Nevertheless, as soon as the replica reached Persian soil, the demon felt it and, terrified by its holy power, abandoned the girl's body. Another duplicate was worshipped by the Persian King Khavad I, the husband of Chosroes's mother, in gratitude for a victory that had been foretold to him by Christ.[24] It seems that at the end of the seventh or the beginning of the eighth century the Edessene Monophysites, competing with the Greeks, acquired their own "true" image of Christ, a surprising event if one considers their dislike of representation.[25]

(ii) *Icon Cult*

In the fourth, fifth, and sixth centuries the worship of Christ portraits, encouraged by the emperors, came to resemble the cult of the imperial images, an old tradition that had hardly been disrupted by the triumph of Christianity. The Emperor Constantine (b. 288?– 337) liked to combine the visible cult of himself and his family with the cult of Christian signs and apparitions, to present himself as a

providential man singled out by heaven, and to promote Christ at the same time as himself. This is reflected in the spectacular legend of the emperor's conversion, reported by Eusebius who professes to have heard it from Constantine himself. The monarch

> said that about noon, when the day was already beginning to decline, he saw with his own eyes the trophy of a cross of light in the heavens, above the sun, and bearing the inscription, *Conquer By This.* At this sight he himself was struck with amazement, and his whole army also, which followed him on this expedition, and witnessed the miracle . . . And while he continued to ponder and reason on its meaning, night suddenly came on; then in his sleep the Christ of God appeared to him with the same sign which he had seen in the heavens, and commanded him to make a likeness of that sign which he had seen in the heavens, and to use it as a safeguard in all engagements with his enemies.
>
> (Eusebius, *Life of Constantine*, 1. 28–9)[26]

On the following day Constantine had his vision made into a luminous image and a talismanic weapon of the victorious God and the triumphant emperor:

> A long spear, overlaid with gold, formed the figure of the cross by means of a transverse bar laid over it. On the top of the whole was fixed a wreath of gold and precious stones; and within this, the symbol of the Saviour's name, two letters indicating the name of Christ by means of its initial characters, the letter P being intersected by X in its centre; and these letters the emperor was in the habit of wearing on his helmet at a later period.
>
> (1. 31)

The solar shine of the cross was complemented by the symbolism of cloth, evocative of Jesus' humanity – something the imperial family could share with the incarnate God:

> From the cross-bar of the spear was suspended a cloth, a royal piece, covered with profuse embroidery of most brilliant precious stones; and which, being also richly interlaced with gold, presented an indescribable degree of beauty to the beholder. This banner was of a square form, and the upright staff . . . bore a golden half-length portrait of the pious emperor and his children on its upper part, beneath the trophy of the cross.
>
> (1. 31)

This clever icon of Christ-cum-Constantine was used by the emperor as a safeguard against adversary forces. The cross was carried at the head of the imperial armies and was impressed on the shields of the soldiers. The same sort of political magic was applied by Constantine in the choice of site and name for his capital. He called the city after himself, but claimed that the site for the future Constantinople had been revealed to him in a dream. He dedicated the city to the Holy Virgin, but had his own likeness carried in procession on the anniversary of his new capital's inauguration on May 11, 330. Constantine never tired of demonstrating his unique divine connection, insisting that God, "the Supreme Governor of the whole universe, by his own will appointed Constantine . . . so that, while others have been raised to this distinction by the election of their fellow-men, he is the only one to whose elevation no mortal may boast of having contributed" (1. 24). Hungry for divinity as much as his pagan predecessors, Constantine had himself shown on coins in the act of ascending to heaven.

What the early Christian theologians feared and preached against – the confusion of Christ's portraits with pictures of the pagan gods, heroes and rulers – took a new turn as Constantine decided to suspend a cloth with his own image on the cross. The ambition of the Christian sovereign and his family threatened to uproot the privileged position of Jesus, and soon of Mary too. This tendency toward divinization continued through the fifth and sixth centuries with emperors eager to bring themselves close to God. Around 473 the Emperor Leo I had himself, his wife, daughter, and grandson painted around the throne of the Virgin.[27] Half a century later Justinian I and his wife Theodora were shown in two symmetrical representations on the curtains in the choir of St Sophia: on one they were blessed by Christ, on the other by the Virgin.[28] New in terms of Christian iconography, such depictions revived the old Graeco-Roman tradition of gods mixing with humans, and served the emperors' personal piety. Portrayed in the company of the holy, the ruler shared in as well as competed with divinity.

In the sixth century strong pro-iconic appeals were issued by the capital's bureaucracy. Hypatius of Ephesus, from 531 to 536 the chief adviser for ecclesiastical affairs to Justinian I, played a major role around 531, when the emperor invited Monophysite leaders to Constantinople to accept the Christological formula of the Council of Chalcedon, and in 536 at the Council of Constantinople, when Monophysitism was banished. In his "Mixed Enquiries," answers to

questions asked by Julian, bishop of Atramution in western Asia Minor, preoccupied with the second commandment, Hypatius took a commonsense approach. He explained that God opposed idolatry, but not the usage of images by the uneducated and weak, who had nothing but their eyes and needed to be "led by the hand."[29]

The cult of icons, relics, and miracles revived the ancient sympathetic magic which had never disappeared, but until the fifth century led a somewhat subdued existence. Its renewed strength becomes clear when Eusebius's original report on the Hemorrhissa is compared with the Latin translation made by Rufinus ca.402–3. Writing about the Christ–Hemorrhissa monument in Paneas, Eusebius mentions "an exotic plant, which climbed up to the hem of the bronze cloak and served as remedy for illnesses of every kind" (*Church History*, 7. 18:2). Rufinus emphasizes this point by stating that the plant derived its healing powers from its contact with the figure of Jesus.[30]

In the sixth century tales of magic multiplied and branched out. Around 530 Theodosius, a visitor to the Holy Land, tells us of the impression of Christ's chest, hands, and face left on the column of the flagellation in the Sion Church in Jerusalem; 40 years later Antoninus Martyr, another pilgrim, recalls in addition to Jesus' chest and hands the imprints of his feet on the floor of the praetorium where he stood during his interrogation by Pilate.[31] From these impressions *mensurae* were taken, an expression whose meaning is not well understood. They may have been strings, strips of papyrus or cloth used for measuring Christ's figure, or wax impressions which then served as talismans and were applied to the relevant limbs of sick people or worn around the neck;[32] possibly, the *mensurae* or numerical values were transcribed on small tablets suitable for suspension and used as amulets.[33] The account of the miracles of St Artemius, composed in the second half of the seventh century, tells us that body parts were cured by the melted wax from a seal bearing the saint's portrait; as the patient awoke from his sleep, he found the seal in his hands or, alternatively, received the wax drink from the saint.[34]

Gradually the reverence given to the icons of God, the Virgin, the saints, and the Christian emperors came to resemble ancient idol worship. Around the beginning of the fifth century the statue of Christ and the Hemorrhissa at Paneas was transferred from a place near the public fountain to the diaconal church. The statue of the Emperor Constantine I in the Forum Constantini was worshipped

with burning candles, incense, and prayers. In the wilderness hermits began to develop the habit of praying to the icons of Mary with the child and lighting candles in front of them. While in the fourth century *proskynesis* was practiced only before the cross, by the first half of the sixth century icons of Christ and saints were worshipped that way too.[35]

The icon worship made it possible for pagans, Jews, and Muslims to charge Christians with idolatry. Identical accusations were brought by Christians against pagans and, since the former were in power, resulted in persecution. Under Justinian pagans were imprisoned, carried in public procession, and saw their books and the icons of "their foul Gods" destroyed.[36] Jewish criticism was taken more seriously and provoked the Church Fathers to appeal to them for understanding. At the beginning of the seventh century Leontius, bishop of Neapolis in Cyprus, wrote a remarkable defense against the Jews, pointing out those passages of the Old Testament which legalize and even require representation. Indeed, God commands Moses to "make two cherubim of gold" (Ex. 25:18); and he has an angelic architect, "with a line of flax and a measuring reed in his hand" (Ezek. 40:3), show to Ezekiel a heavenly temple, on whose "walls round about . . . were carved likenesses of cherubim and palm trees" (Ezek. 41:17–18). On the basis of God's command to Moses, King Solomon builds the sumptuous temple decorated with carved and molten images (I Kgs. 6:14–36). Even though Solomon might have exaggerated in his desire for figurative sculpture, he was not condemned for this. Therefore, wrote Leontius, "if you wish to condemn me on account of images, then you must condemn God for ordering them to be made."[37]

Trying to establish a compromise between Old and New Testament, Leontius argued that Christians who worship icons behave like Jews who do obeisance to the words contained in the Bible, but not to parchment and ink; he compared the cult of relics to the sentiments of Jacob who, kissing the bloody coat of Joseph, felt as if he held his son in his arms; and he concluded with an appeal to everybody's emotion: "haven't you, when wife or children have died, taken some garment or ornament of theirs and kissed it and shed tears over it and were not condemned for doing so? You did not do obeisance to the garments as to God; through your kisses you did but show your longing for those who once had worn them."[38] This sounds not unreasonable. But the common sense that makes us sympathize with Leontius turns out to be not quite the driving force

51

behind his thinking. Ultimately, he believes in magic: "often blood will gush forth from the icons and the relics of the martyrs, and foolish folk, though they see this, are not persuaded; they treat the miracles as myths and fables."[39]

In the sixth century the imperial court endorsed the worship of images in its struggle against the Monophysitism flourishing in the provinces, and forged links between religious and imperial icons.[40] But in the eighth century Constantinople became the center of violent opposition to sacred images, and the emperors found themselves in conflict with the provinces, where holy objects and images, collected and administered by the monasteries, had become the means for gaining economic and political power. Using miracles, relics, and icons, the monks were able to control the mass of the faithful and to extract ever new payments. Thus the iconoclastic decrees of Leo III were immediately understood as attacks on the role and status of the monasteries.[41]

Volumes have been written on iconoclasm. It has been studied from the point of view of theology and interpreted as the climax of the old conflict between the Word and the Image, the Old and the New Testaments. It has been seen as the opening of the cultural gap that early Christianity attempted to bridge, when it held on to the non-iconic approach of the Jews, but on the other hand tolerated the pro-iconic tradition of the Greeks and increasingly encouraged the production of religious artefacts. Iconoclasm has been analyzed in terms of the competition between imperial and ecclesiastical power and, more specifically, in terms of the political and economic struggle between the central power of the emperor and the peripheral influence of the monasteries. The rejection of icons has also been regarded as due to Jewish and Muslim influence. The modern view combines the various approaches, but tends to stress the political and economic aspects of iconoclasm. Considering the tendency to place enemies without rather than within, today we take less seriously the Muslim and Jewish inspirations so often cited by the defenders of icons. There hardly existed an iconoclastic conspiracy directed against Christianity. Grabar points out that the first iconoclastic decrees issued in 726 by the Emperor Leo III were preceded by the anti-iconic measures taken a few years earlier by Caliph Yazid II.[42] But after the caliph's death in 724 his laws were obliterated, and when two years later iconoclasm flared up again, this happened not in Damascus but in Constantinople. There was no simultaneous action because neither of the two rulers wanted to

be accused of following in the footsteps of his opponent. This also explains why the caliphs, while fighting idolatry in their own religion, closed an eye when it came to representation flourishing in the large Christian community of their empire. The iconoclastic excesses of Constantinople gave them an opportunity to appear tolerant. Still, there is a certain irony in the fact that John of Damascus, the theoretician and leader of the iconodule party, was a resident of the Muslim state.

(iii) *John of Damascus*

John Damascene (d. before 754), one of the most eloquent theologians of his time, was actively involved in the struggle against the iconoclasts. In his last years he travelled through Syria preaching against them, and he risked his life going to Constantinople. Around 730, while living at the monastery of St Sabbas in Palestine which was then ruled by the caliph, John wrote several treatises in defence of images.[43] The astuteness of these remarkable texts was sharpened by the extent of the destruction going on in Byzantium under the iconoclastic Emperor Leo III. Regarding the veneration of icons as an inevitable consequence of the incarnation, John treated the Edessene mandylion as a central symbol of Christ's humanity and an essential proof of God's endorsement of icons.

Material representation followed from Jesus' presence on earth. Since Christ's divinity was clothed in flesh, the invisible was made visible. It was "impossible to make an image of the immeasurable, uncircumscribed, invisible God" (*Oratio* 1.7) of the Old Testament. But Christ has "become visible for our sakes by partaking of flesh and blood" (1.4), so that

> you may draw His image and show it to anyone willing to gaze upon it. Depict His wonderful condescension, His birth from the Virgin, His baptism in the Jordan, His transfiguration on Tabor, His sufferings which have freed us from passion, His death, His miracles which are signs of His divine nature . . . Show His saving cross, the tomb, the resurrection, the ascension into the heavens. Use every kind of drawing, word, or color.
>
> (1.8)

But what about the second commandment? Here John's strategy was attack. He argued that in the Old Testament representation was

forbidden because of the Jewish proneness to idolatry and that to Christians, more mature than their unsteady predecessors, the commandment was just given "to avoid superstitious error" and not to prevent depiction. We are "no longer children, tossed to and fro and carried about with every wind of doctrine . . . no longer under custodians, but we have received from God the ability to discern what may be represented and what is uncircumscript" (1.8). John's ostentatiously dualistic interpretation of the two Gods and two Scriptures was indebted to Platonic and Neoplatonic thought. The language and imagery of the Hellenized Syrian theologian replayed the concepts and metaphors of divinity which becomes accessible to humans through imperfect shadows and reflections and uses images to show them past, present, and future:

> Since the creation of the world the invisible things of God are clearly seen by means of images. We see images in the creation which, although they are only dim lights, still remind us of God. For instance, when we speak of the holy and eternal Trinity, we use the images of the sun, light, and burning rays; or a running fountain; or an overflowing river; or the mind, speech, and spirit within us; or a rose tree, a flower, and a sweet fragrance. Again, an image foreshadows something that is yet to happen, something hidden in riddles and shadows. For instance, the ark of the covenant is the image of the Holy Virgin and Theotokos, as are the rod of Aaron and the jar of manna. The brazen serpent typifies the cross and Him who healed the evil bite of the serpent by hanging on it. Baptismal grace is signified by the cloud and waters of the sea. Again, things which have already taken place are remembered by means of images.
>
> (1.11–13)

Seeing nature and culture, language and representation as phenomenal, John spoke about everything, including words written in books, in terms of images, but rejected even the slightest hint of the Manichean type of duality which distinguishes between spirit as the positive and matter as the negative principle. For him both spirit and matter represented divinity – the first the invisible Father, the second the incarnate Son:

> In former times God, who is without form or body, could never be depicted. But now when God is seen in the flesh conversing with men, I make an image of the God whom I see. I do not worship matter; I worship the Creator of matter who became matter for my sake, who

54

willed to take His abode in matter; who worked out my salvation through matter. Never will I cease honoring the matter which wrought my salvation.

(1.16)

The pro-iconic treatises of John Damascene are written with clarity and precision, but they also boil with emotion. Their passionate tone was due to John's temperament and the gravity of the iconoclastic threat. Indeed, there was much more at stake than in the past when Eusebius robbed a woman of her pictures of Peter and Paul in order to save her from idolatry and when Epiphanius tore a church curtain.[44] By the eighth century the Christian world was full of high-quality artefacts, and so John's words reflected not only the concerns of an orthodox theologian but also the anxiety of an art lover. Following in the footsteps of Plato, the Damascene regarded sight the noblest of the senses, observed how images stimulate the eye and the mind, and proclaimed that "what the book is to the literate, the image is to the illiterate" (1.17).

The Damascene did not write in defense of images only. He wanted relics to be protected too. Thus he described how matter acquires miraculous properties touching the body of Christ or the saints, compared this contact to the process of perception in the course of which the soul is penetrated by what the eyes see, argued in favor of magic, and revelled in a whole range of *acheiropoietoi*: Peter's shadow, Paul's handkerchiefs and aprons, "the cave and manger of Bethlehem, the holy mountain of Golgotha, the wood of the cross, the nails, the sponge, the reed, the holy and saving lance, the robe, the seamless tunic, the winding-sheet, the swaddling-clothes, the holy tomb which is the fountain of our resurrection" (*Oratio* 3.34).

Like every great iconophile, John of Damascus was extremely sensitive to the beauty of the world and the charm of pictures and poetical comparisons. Like every sensuous man with mystical inclinations, he strove to uncover divinity and communicate with it through visuality and tactility. His hunger for direct illumination resulted in a flood of metaphors of veiling and unveiling, clothing and undressing, seeing and touching, impressing and impregnating, penetrating and burning in. John's language reflects his delight in the physicality of God-Man and the materiality of creation: "after we have smelled or tasted, or touched, we combine our experience with reason, and thus come to knowledge" (3. 24). This sensuality

renders the eminent scholar sympathetic to simple people's need of images, relics, and miracles providing an immediate and spontaneous exchange between divinity and humanity.

A passionate defender of images and a believer in miracle and magic, John of Damascus was predestined to resurrect the mandylion of Edessa and to fill the Abgar legend with a new emotionalism. While Eusebius and the *Doctrine of Addai* present Abgar as a sick man who wants to be cured, the Damascene makes the king resemble himself. His Abgar

> was set on fire with divine love by hearing of the Lord, and sent messengers asking Him to visit him. But if this request were declined, they were ordered to have His likeness painted. Then He, who is all-knowing and omnipotent, is said to have taken a piece of cloth and pressed it to His face, impressing upon it the image of His countenance, which it retains to this day.[45]

This Christ did in order to make people understand his divinity through a material image. John's argumentation was echoed by the Council at Nicaea (787) where Abgar's portrait of Christ was invoked several times. The iconoclasts were equally aware of the Edessene mandylion's power of persuasion. They destroyed entire codices or those parts of them in which the miraculous image was mentioned; and they were probably also responsible for the disappearance of the *acheiropoietos* of Camuliana, which in the mid-sixth century was transferred to Constantinople, in the seventh century served as the capital's main palladium, but was not heard of any more in the eighth century.[46]

(iv) *From Drawing to Sculpture*

Come to me; in thee will I forget idols and all graven images.
Jacob of Sarug, "Canticle"[47]

After the victory of the iconodules the image of Edessa fell into oblivion. But when around the mid-tenth century military activity increased on the eastern frontier and the Byzantine army crossed the Euphrates, penetrating into Mesopotamia, the Emperor Romanus Lecapenus (920–44) remembered the mandylion. By then the imperial collection of relics and holy icons had acquired an

enormous reputation, and he was eager to have the famous icon join it. He decided therefore to capture the *acheiropoietos* from the Muslims, to whom Edessa had fallen. The imperial army laid siege to the city and the general, John Curcuas, informed the emir that in exchange for the portrait of Christ he would spare Edessa, and even release 200 Muslim prisoners. Consulted on the matter, Baghdad decided to give up the picture for 20,000 pounds of silver, and a year later Abraham, bishop of Samosata, received the icon in the name of the emperor, in spite of protests by both the Christian and Muslim inhabitants of Edessa. An angry crowd followed the bishop to the banks of the Euphrates and would have recaptured the icon, had not the bishop's boat been wondrously speeded across the river. On August 15, 944, the day of the Assumption of God's Mother, her son's *acheiropoietos* reached Constantinople, passed the night at the church of the Holy Virgin at Blachernae, was carried in a triumphal procession around the city walls and through the Golden Gate to St Sophia, and was deposited in the palace of Bucoleon, in the chapel called Pharos (the cloak).[48]

All this happened at a politically awkward moment. A quarter of a century earlier Romanus Lecapenus had usurped the throne of Constantine Porphyrogenitus (913–59), the son of Leo VI, who now saw the chance of recovering it. Ironically, although it was Lecapenus who had secured Christ's portrait for the capital, the icon's arrival coincided with an outbreak of popular resentment and was used by Constantine to drive the usurper out of power. First, rumors were spread that when the Edessene image had stayed at the monastery of the Holy Mother of God, a possessed man, upon seeing the icon, prophesied that Constantine Porphyrogenitus would regain power. Within months of the portrait's arrival in the capital, the prophecy was fulfilled. Grateful to the icon which seemed to have intervened on his behalf, Constantine commemorated the mandylion by a festive homily written for the first anniversary of its arrival in Constantinople. The text, entitled "Story of the Image of Edessa," was attributed to the emperor himself. According to Dobschütz, however, it was inspired by Constantine but written by a court official.[49] The homily was read on August 16, 945 during a special ceremony in St Sophia, and shortly after, a variant of the story was composed for the *menaeon*. With these two texts a firm tradition was established, and the day of the *acheiropoietos*'s arrival in Constantinople was turned into an important calendar feast-day.[50]

The "Story of the Image of Edessa" announced the triumphal

advent of a unique picture: not just another "true" image produced by an emanation or apparition of God, but a portrait made by the living Jesus himself. The imperial homily combined older legends and historical accounts, added new details, reported on the portrait's transfer, and mentioned the wonders performed by the image on its way to the capital and in Constantinople. The first official history of the Edessene image fully endorsed the cult of icons and served the political goal of inaugurating and legitimizing Porphyrogenitus's delayed takeover. According to Weitzmann's persuasive argument, the earliest representation of the Abgar legend and the mandylion was executed in Constantinople in the mid-tenth century under the supervision of the emperor. On a partly lost triptych, which was discovered in St Catherine's monastery on Mount Sinai, King Abgar, dressed in imperial regalia and proudly displaying the cloth with Christ's face, is Constantine Porphyrogenitus himself, the new owner of the image of Edessa and a monarch renowned for his love of art and his dabbling in painting.[51]

The imperial homily was written with the purpose of welcoming into the church all images, not only flat but also sculpted, and this is particularly clear in the passage relating how the miraculous impression of Christ's face first replaced a pagan statue and subsequently gave birth to a graven copy.

> A statue of one of the notable Greek gods had been erected before the public gate of the city by the ancient citizens and settlers of Edessa to which everyone wishing to enter the city had to offer worship and customary prayers . . . Abgar then destroyed this statue and consigned it to oblivion, and in its place set up the likeness of our Lord Jesus Christ not made by hand . . . And he laid down that everyone who intended to come through the gate, should – in place of that former worthless and useless statue – pay fitting reverence and due worship and honor to the very wondrous miracle-working image of Christ.
>
> ("Story of the Image of Edessa," 15)

As long as Abgar and his sons were alive, piety was displayed before Jesus' portrait. But their successors fell away from Christianity, reverted to paganism, and wished to remove the image from its prominent position. Fearing its destruction, the local bishop "lit a lamp in front of the image, and placed a tile on top. Then he blocked the approach from the outside with mortar and baked bricks and reduced the wall to a level in appearance" (ibid.).

As in Evagrius's *Church History*, the *acheiropoietos* resurfaced on

the occasion of King Chosroes's assault on Edessa. But this time the discovery had a romantic touch. In the last critical night of the Persian attack,

> there appeared to the bishop (Eulalius it was) a well-dressed, awe-inspiring figure of a woman, larger than human, who advised him to take the divinely created image of Christ, and with it to entreat that the Lord would give a complete demonstration of his marvelous acts. The bishop replied that he had no idea whether the image existed at all, or, if so, whether they or anyone else had it. Then the apparition in woman's form said that such an image lay hidden in the place above the city gates in a way which she described. The bishop was convinced by the clearness of the vision which appeared to him, and therefore at dawn he went . . . to the spot . . . and found this sacred image intact, and the lamp which had not been put out over so many years. On the piece of tile which had been placed in front of the lamp to protect it he found that there had been engraved another likeness of the image which has by chance been kept safe at Edessa up to the present time.
>
> ("Story of the Image of Edessa," 16–17)

Thus exactly on the same spot where during Jesus' lifetime a pagan statue had stood, and where subsequently his "true" likeness had been first venerated and then walled off, a graven portrait of the Lord was found. The sequence exemplifies the stages in Christianity's acceptance of representation. First, when pagan sculpture was rejected and figurative depiction mistrusted, a pagan statue was replaced neither by a sculpture nor by a painting of Christ but by an immaterial and shadowlike "true" impression of his face. Then the miraculous portrait took over the function of the pagan statue becoming a subject or worship and the city's phylactery. Finally, the cloth gave birth to a graven replica.

A brick copy burnt by fire, a symbol of divine energy, was not invented at Constantine's court. It is a reference to the so-called *keramidia*, "true" Christ portraits on tiles mentioned around 900 in various Syriac and later also in Armenian and Slavic legends.[52] The holy brickstones, a specialty of the region between Hierapolis and Edessa (both cities were reputed to possess them), had their origins in the fact that on his way from Jerusalem Abgar's messenger stopped in Hierapolis and hid Jesus' portrait in a heap of tiles (Plate 3). At midnight the tiles were set on fire which, however, did not damage the portrait. To the contrary, in addition to it Ananias

discovered "in one of the tiles nearby, another copy of the likeness of the divine face" ("Story of the Image of Edessa," 9). The brick copy was kept in Hierapolis, while he continued with the original to Edessa. In a Slavic version of this legend the name of Abgar's messenger, scribe, and painter is Lucas – a fusion of the *Doctrine of Addai* with legends of St Luke as painter and portraitist of the Virgin and her son.

Porphyrogenitus's "Story of the Image of Edessa" uses the rediscovery of the *acheiropoietos* to proclaim the total acceptance of Christ's images, flat and graven. But it also introduces a female element by making a woman responsible for the mandylion's invention. This contrasts with the legend's earlier versions, from which femininity is conspicuously absent. What is the reason of this innovation? Unlike the stories of the Camuliana, Dibulion, and Melitene *acheiropoietoi*, the Abgar myth was first concerned with Word, then with Image. The portrait's appearance was preceded by the correspondence between two men, not a relationship between Jesus and a woman. The image was originally a painting, not a *vera icon*, and thus the allusion to Jesus' incarnation in Mary's flesh remained subdued. But in the tenth century, after the victory over iconoclasm, the complete absence of femininity was untenable. Thus a female figure was added, if not to the creation, at least to the reinvention of the mandylion. The elegant apparition evoked the Holy Virgin as well as Edessa in whose womb (walls) Jesus' "true" image not only survived but also grew a twin – a solid brick.

The model for such personification of Edessa could have been provided by the sixth-century Syriac "Canticle" by Jacob of Sarug, a glorification of the city in the style of the Song of Songs. In this beautiful poem the sick King Abgar the Black is replaced by Edessa who "sent to Christ, by an epistle, to come to her and enlighten her. For all Gentiles she to Him made intercession that he would quit Sion which hated him, and come to the Gentiles who loved him. She sent to him and besought him that he would enter into friendship with her" ("Canticle," 15–19). Edessa admits that she is a prostitute. However, unlike the whore Jerusalem, she burns with desire to reform herself by abandoning her past and welcoming the Lord: "The harlot that was standing in the market-place heard of his fame from afar, as she was erring with idols, playing the girl with graven images. She loved, she desired him while he was far away, and begged him to admit her into his chamber" (ibid., 25–8). Giving herself to her "beloved bridegroom," Edessa asks him to

bless her "with the kisses of his mouth," and to "let Gabriel rejoice" by making her pregnant. Rejected by Jerusalem, Christ weds Edessa and makes her triumph:

> I am black and comely: ye daughters of Sion, pure is your envy, because the son the glorious one has espoused me to make me enter into his chamber. When I was odious he loved me, because he is able to make me clearer than water. Black was I in sins, and comely am I become, because I have turned and repented: I have cast away in baptism all that odious colour, because the Saviour of all creatures has washed me clean in his pure blood.
>
> (ibid. 23–9)

The transformation from blackness into clarity celebrates vision, illumination, and purification. Both in the "Canticle" and in the "Story of the Image of Edessa," the city has to free herself from the dirty dimness of pagan depiction first. Only then can it receive the God of Light or his image. Jacob's poem predates the rediscovery of Christ's portrait and does not mention the *acheiropoietos*. But the imagery of the reformed prostitute rejecting her old idols for the sight and touch of a new lover makes one feel that the legend of Christ's iconic gift to Edessa had a solid presence in the city, so that it was more than easy for Evagrius to "reinvent" Jesus' portrait.[53]

The "Story of the Image of Edessa" reinforced the Greek aspect of the Abgar legend. The disclosure of the secret hideout by a woman and the discovery of two images – one a shadowy impression on cloth, the other a tile – resembles a Greek legend which attributes the invention of mimetic painting and relief to the daughter of the Corinthian potter Butades. The girl "was in love with a young man; and she, when he was going abroad, drew in outline on the wall the shadow of his face thrown by a lamp. Her father pressed clay on this and made a relief, which he hardened by exposure to fire" (Pliny, *NH* 35. 43. 151).

(v) The Mandylion in Art

When did Christ's mandylia and *keramidia* enter the iconography of Byzantine art? Considering the variety of their legends, one would assume that it happened in the course of the sixth and seventh centuries. However, no documents mention frescos, mosaics, or

sculptures showing either one of the Cappadocian *archeiropoietoi* or the image of Edessa, and the first existing depiction of Abgar's portrait is the mid-tenth-century triptych from Mount Sinai. The painting is divided into two zones; the upper one shows the apostle Thaddaeus on the left and King Abgar on the right; both are seated on thrones and identified by inscriptions. The king wears on his head the Byzantine imperial crown with the pendulia, and on his feet pearl-studded purple shoes, another distinction of Byzantine emperors; and he holds in his hands the holy image of Edessa which has just been given to him by a messenger. The lower row depicts four monastic saints. The icon is framed in such a way as to appear as a unit, but in fact Thaddaeus and Abgar are painted on two separate vertical panels of equal size which are two wings of a triptych. The triptych has been reconstructed by Weitzmann who assumes that "the Mandylion which Abgarus holds in his hands is but a miniature version of the bigger one in the lost central plaque."[54]

The icon, the earliest representation of King Abgar and the sacred cloth, is a touchstone in the history of art. But it also arouses expectations in regard to the Lord's portrait. We hope that it will make us discover how the sixth century, and possibly an even earlier age, imagined and depicted Christ. However, our expectations are frustrated, since the icon turns out to be a product of its own time. The roundish face of Jesus, framed by loose strands of hair and a rounded beard, resembles other tenth-century Christ heads, "while for the original relic, rediscovered in 544 AD, we would assume quite a different type, i.e. the Syrian-Palestinian type with the pointed beard."[55] This proves that Dobschütz was right to believe that the various depictions of the Edessene *acheiropoietos*, which was seldom seen without its protective cover, were not based on real studies of the cloth but rather on legendary descriptions and the changing ideals of art.[56] Painters reproduced on the mandylion the current iconographic types of Christ's face, and thus their depictions tell us little about the original nature of the Edessene *acheiropoietos*. The pictorial programs convey the artists' fascination with Christ's simultaneous dual presence as a real man and as a relic, and with his letter and image as means of mediation between God and humanity.

To bring out the aspects relevant for the eleventh-century artists and their public, certain episodes of the Abgar legend were preferred to others, as can be seen in several illustrated *menologia* into which Constantine's homily has been incorporated. In one of them, from about the second half of the eleventh century, the illuminator chose

to illustrate the following three scenes from the "Story of the Image of Edessa": King Abgar in bed, handing the letter for Jesus to a messenger; Jesus surrounded by a crowd of people and the painter standing at a distance, the impressed cloth in his hands; and finally the baptism of Abgar by Thaddaeus, with a servant holding in his hands a towel, reminiscent both of the cloth with which Christ wiped himself after his own baptism and of the *acheiropoietos*.[57] Another *menologion*, from 1063, shows four episodes: Abgar on the sick-bed; Christ sitting on a hill and writing the letter; the messenger with the cloth standing in front of a seated Jesus whom a crowd surrounds; and the bringing of the portrait to the king.[58]

Since both Jesus' letter and his image were considered talismans, the descriptions and reproductions of the story were occasionally made into amulets too. This applies to the Pierpont Morgan Library scroll (Plate 3).[59] It contains, in addition to a list of perils which could be avoided and of illnesses which could be cured thanks to Jesus' letter, the following sentence: "the one who carries this letter in purity, away from uncleanness and all bad things, will obtain through this letter the salvation of his soul, and his body and will be kept in security."[60] The portable form indicated that the scroll functioned as a magically potent "true" copy of the letter and the image.

According to legend, Abgar's Jesus portrait was spread out on and attached to a board. This particular way of presenting the cloth was reflected in the first iconographic type of Christ's mandylion, which can be found in Graeco-Slav art of the twelfth and thirteenth centuries. In the second half of the thirteenth century a new type was introduced: the suspended cloth. It appeared almost simultaneously in the East and West, but Grabar suggests that its origins were occidental and might have resulted from how the Edessene mandylion was exhibited in the West.[61] Even if this is right, we still need to explain why the hanging type became the classical representation of the "true" image in Western art. The cause might have been the cloth's attribution to Veronica and the fact that the vernicle enjoyed its greatest popularity between the end of the fourteenth and the end of the seventeenth century, when the passion version of the Veronica legend prevailed and the bloodmade portrait could be seen in analogy to Christ's blood-covered body hanging on the cross. With time the illustrations of the Abgar legend became rare, but the mandylion remained one of the great themes of Byzantine art and until the late nineteenth century was depicted on

portable icons and frescos. In the mural cycles of churches and monasteries the depictions of the mandylion and the *keramion* often face each other, or the mandylion, the symbol of the beginning, is shown on a building's east side vis-à-vis the shroud, a token of death, pictured in the west.[62] In medieval Eastern and Western art the mandylion may be carried by two angels, their winged figures bringing to mind the ancient victories and accentuating the cloth's divine origin, or saints, usually Peter and Paul, a replacement for Abgar's forgotten ambassadors. The angel-type, which prevailed in Byzantium, did not achieve a great popularity in the West, where the Holy Face was made into an attribute of St Veronica. However, occasionally one comes across intriguing and moving variations of the predominantly Eastern theme in Western art. In a fifteenth-century *Flagellation* by Jaime Huguet a small angel-anima-amor arrives at Christ's face with a napkin in his (her?) hands, while two other heavenly companions collect the Lord's blood into their cups (Plate 2).

While in the East the mandylion was depicted in a standard iconographic form, in the West the development went in the opposite direction. As Latin art moved toward realism, Christ's portrait acquired personal features. This general trend was additionally supported by the presence of Veronica. Since she was modelled after actual women, the face of the man on her cloth was also adjusted to local types or ideals and made to fit her figure and her many roles as bride, wife, mother, widow, nun, or saint. In consequence Christ's "true" likenesses came to resemble the faces of peasants or noble chevaliers, young monks or worn-out beggars. This resulted in a richness of iconography, expression, and meaning.

4

Women and Icons

Byzantine mythology suggests women's particular fondness of Christ's portraits and *acheiropoietoi*. And so does history. In a letter to the sister of the Emperor Constantine, Eusebius rebuked the princess for her desire to possess a picture of Jesus. But he spoke not to her alone. The end of his letter indicates that he warned women in general and considered their delight in depiction a sign of ignorance and idolatry. "Once," Eusebius wrote,

> a woman brought me in her hands a picture of two men in the guise of philosophers and let fall the statement that they were Paul and the Saviour . . . With the view that neither she nor others might be given offence, I took it away from her and kept it in my house, as I thought it improper that such things ever be exhibited to others, lest we appear, like idol worshippers, to carry our God around in an image.[1]

Did women really feel a particular fondness for icons, or was this just one of men's prejudices about women? It is an uneasy question, and particularly delicate for female scholars, as has already been observed by Judith Herrin:

> When I first read Byzantine accounts of female devotion to icons, I dismissed them as yet another example of the common slurs on womankind perpetrated by uniformly male writers. After closer inspection, I feel that this opinion should be revised. For what we read about their attachment to icons is surely a reflection of their

homebound situation, their restricted access to churches and their frustrated religious passion.[2]

To this she added in a later book: "For women especially, possession of an icon permitted a most satisfying form of Christian devotion, independent of church liturgy, officials, or environment. In the privacy of their homes, women set up their icons and poured out their distress, prayer, and gratitude to the figure, whom they came to know in a very personal way."[3] Still, Byzantine women's devotion to icons remains a problem for a historian. No female testimonies exist, and so one has to rely on legendary narratives and men's stereotyped accounts of women. But since my study traces the genesis and structure of a myth, legends and stereotypes are my reality. On the other hand, I have no doubt that icons were essential to Byzantine women's religiosity, well-being, and intelligence.

In her study of medieval female mystics Caroline Walker Bynum observes that it was the physical, material side of Christianity and, in particular, of the human Christ that attracted them. Because of the traditional identification of femininity with body, masculinity with spirit, man signified "the divinity of the Son of God and woman his humanity."[4] No doubt, Byzantine women identified with the human Christ as much as Western mystics. In addition, seeing was essential to women because of their illiteracy and the visual austerity of their existence. In Byzantium women were deprived of vision even more than in ancient Greece and Rome – a deterioration due to Christian puritanism. A decent Byzantine woman was expected to be veiled in public and even at home, to keep away from the windows, and in company to keep her eyes fixed on the ground.[5] Married women were granted more freedom than unwed girls, but they were nevertheless extremely limited in what they were allowed to see. In fact, outside their homes, they might gaze intently at one thing only – at the holy icons of their religion. Contemplating pictures, women trained themselves in the art of seeing. They might not have realized the manifold implications of their attachment to icons, but their intuition told them to treasure and defend images. Protesting against the destruction of icons, women rebelled against the very premises of Byzantine culture which confined them to obliqueness.

(i) *The Holy Virgin*

The Byzantine women's image-worship is related to the cult of the
Holy Virgin which has little foundation in the gospels. In the New
Testament the mother of God plays a peripheral role and is denied
importance by Jesus himself. While he was preaching, she arrived
with his brothers and asked to speak to her son. But Christ refused
and "replied to the man who told him, 'Who is my mother, and who
are my brothers?' And stretching out his hand toward his disciples,
he said, 'Here are my mother and my brothers! For whoever does the
will of my Father in heaven is my brother, and sister, and mother' "
(Mt. 12:48–50). The passage suggests Mary's limited function. Her
womb was used to bring God into the world. But once this had been
accomplished, she was transformed back into just a woman – one of
the many females who ministered to Christ, accompanied him on
his way to Golgotha, and mourned his death.

The first important step toward the Virgin-cult was taken by the
Council of Ephesus in 431. It asserted the completeness of Christ's
humanity and entitled Mary to be considered the *Theotokos* (Bearer
of God). The debate at the Council was centered on how the Word
became flesh in the treasure-house and paradise of Mary's body and
how through her the world was provided with a filial replica of the
paternal original.[6] Endorsing the concreteness of the incarnation,
the theologians made an indirect decision about representation.
They embraced the notion of material reproduction and thus opened
the door for replication – from the miraculous multiplication of
relics and *acheiropoietoi* to the production of artefacts. Some years
later the first "true" portrait of the Virgin and child – allegedly
painted by St Luke – was discovered by Eudocia, the wife of the
Emperor Theodosius II (408–50), and in 450 found its way into the
imperial collection of relics in Constantinople.[7] This holy icon
inspired ordinary pictures, and the demand for them increased in
proportion to the popularity of the Virgin festivals.[8]

The cult of Mary was introduced by theologians, but flourished
through the piety of converts from various pagan religions dominated
by the Great-Mother divinities (Gē Themis, Aphrodite, Astarte, Isis,
Demeter, Kybele, Anaitis, Maia). The early Church Fathers were
aware of the appeal of these goddesses and therefore attacked them
with vehemence. Clement of Alexandria referred to Aphrodite as a
harlot deified by the king of Cyprus, called the king and other

sponsors of feminine cults "originators of mischief, parents of godless legends and deadly daemon-worship;" and he derided the "unutterable symbols of Gē Themis, marjoram, a lamp, a sword, and a woman's comb, which is a euphemistic expression used in the mysteries for a woman's secret parts."[9] The same tenor still prevailed in the sixth century. During the conversion of a pagan house into a chapel of the archangel Michael and the Immaculate Virgin, a young mosaicist infected his hand, while removing from the wall "the picture of the unclean Aphrodite" – and had to be cured by a saint.[10]

By establishing Mary as the escort of the Holy Trinity the Church filled the vacuum that had been left by the demise of the ancient goddesses. A new Great Mother who, however, procreated without sex, the Holy Virgin contrasted pagan sensuality and promiscuity with purity and abstinence, and stood for a perfect new woman – the opposite of Eve who had caused the Fall. In his twelfth *Homily* on the birth of the Lord, Ephraim, a pioneer of Mariolatry, defined the difference between the two women in terms of chastity reflected in clothing. Eve, who "sewed fig leaves together" (Gen. 3:7) into an apron, could not protect her virginity; Mary, on the other hand, received from God an enormous garment of glory and thus could cover the nudity of all mortals – in addition to her own.

Did the worship of Mary make women rise in the eyes of men, and in their own eyes? Did the Theotokos cult prompt Byzantine society to elevate the public standing of women? None of these questions can be answered with a clear yes or no. But we know that women enjoyed the greatest equality before the Edict of Toleration. In times of persecution, when everyone was needed, women were welcome to throw away their lives as martyrs and saints. Once the heroic days were over, the Church organized itself according to the old paternalistic patterns and admitted women only to its lowest ranks. They could climb no higher than the position of deaconess, and after the sixth century their presence declined even at that humble office. Since their only liturgical function was the baptism of girls, they became superfluous when baptism was performed immediately after birth.[11] The glorification of Mary, whose spotlessness no woman could attain, might have even rendered the deaconesses' situation more precarious. In any case, under the Emperor Justinian I (527–65) a draconian law was passed: a deaconess who broke her vow of chastity was punished by death.[12] While the Virgin was assumed into heaven, on earth women began to disappear from the

clergy and their ambitions were restricted to philanthropy. But even charity, being tied to money, was open mostly to wealthy women. The same applied to a woman's monastic career. In order to be accepted by a nunnery, she was obliged to make a substantial contribution in gold or land.[13] "Byzantium produced a number of female saints, many of them from wealthy backgrounds, very few of humble origins."[14]

The history of Mariolatry shows that the worship of ideal femininity does not imply women's emancipation. Still, the presence of the Theotokos must have reassured female Christians. Did they influence the instituting of the Virgin-cult? Hardly. Men ruled the world and the Church. But, on the other hand, images and legends remind us of the importance of Mary in women's lives and suggest that they strongly supported her cult. Women flocked to Sozopolis in Asia Minor where a Theotokos picture – a precursor of the innumerable madonna icons which work miracles to our day – was believed to cure them of infertility.[15] The sixth-century widow Turtura, standing at the feet of the Holy Virgin and holding in her hands a scroll with thanks to Mary, speaks for female devotion, and so does the story of Mary the Egyptian, a prostitute who at the sight of the Virgin's icon in Jerusalem repented, was converted, and metamorphosed into a saint.[16] In medieval iconography Mary the Egyptian – her hair her only dress – is treated as a twin sister of Mary Magdalen, with whom she occasionally guards the crucifix (Plate 9). Emperors were compared to Christ, empresses to his mother, and thus feminine imagery was injected into the masculine culture of Byzantium.

The Theotokos images were derived from the ancient figures of mother goddesses, such as the sixth-century BC statuette of the Greek *Kurotrophos* from Selinunte (Plate 10) or the Egyptian Isis with the Horus child; and they were influenced by various classical representations of females furnished with portraits or masks. In the period separating the rule of Justinian II (565–78) from that of Maurice (582–602) the Theotokos began to replace the ancient Victory (Nike), a deity that was still evoked in an epigram inscribed on a statue of Justinian I in the Hippodrome.[17] On gems engraved in the times of Justinian II and Tiberius II (578–82) one finds a frontal image of Nike with one or two crowns in her hands and flanked by two crosses. Later her place was taken by the Virgin with the child. The baby Jesus appears either in his mother's arms, lap, or in an oval medallion placed at the axis of Mary's body and suggestive of an

embryo, a painted or embroidered roundel sewn onto the Virgin's garment, and of a textile *acheiropoietos* – with the infant Jesus impressed on or shining through his mother's fabric. The medallion was derived from an *imago clipeata* – a buckler or shield frequently held by Nike which was to assure the victory of those carried by her.[18] In late antiquity the oval symbolized the transport of the soul to heaven. "When Christians employed this shape they may, at least at the beginning, have still been aware of the significance of the *clipeus* as associated with the lifting of the soul to heaven."[19] But the Byzantine Theotokos also echoed the veiled figures of the ancient Mnemosyne, the mother of the Muses, and her daughters, especially Melpomene and Thalia equipped with masks, and she was vaguely reminiscent of Athena carrying on her front the likeness of Medusa (Plate 11).

The early Byzantine Theotokos, straight and flat as a plank, carries the infant Jesus, her image of victory, in a ceremonial, triumphant way. She appears on flags flying from the masts of the ships that bring the Emperor Heraclius (610–41) from Carthage to Constantinople.[20] On a sixth-century icon two soldier saints, General Theodore Stratelates and St George, stand guard at the Virgin's throne, while a stream of light descends upon her head from the hand of God.[21] The Theotokos pictures do not illustrate affection or motherhood. They efface Mary as a person and instead draw attention to femininity as the locus of procreation. As Word turns to Image, God provides the message, the Virgin the medium, and the two are fused: "The Son of the Most High came and dwelt in me, and I became His Mother; and as by a second birth I brought Him forth, so did He bring me forth by the second birth, because He put His Mother's garments on, she clothed her body with His glory" (Ephraim, *Hymn on the Nativity*, 11).

A mediator between divinity and humanity, the Byzantine Theotokos grew into the official protectress of Constantinople. In 610 her likeness was imposed on the imperial throne, and in 626 the Virgin's icon of Blachernae was placed on the gates of the capital.[22] The Blachernae type, a Virgin *orans* with her hands raised in prayer and the Jesus medallion over her breast, was reproduced on Byzantine coins and survived in Russian art, for instance in Our Lady of the Sign (*Známenie*), the palladium of Novgorod from the fifteenth century until the October Revolution.[23] This famous twelfth- or thirteenth-century Russo-Byzantine icon was endlessly

copied and imitated and thus helped preserve the early *clipeus-acheiropoietos* madonna type until modern times (Plate 4).

From the sixth century the Byzantine cult of the Virgin was supported by the existence of her relics. The origins of Mary's dress, *maphorion* (long veil), girdle, shroud, and/or other graveclothes, were described in several confusing and contradictory legends.[24] Mary's clothing was either found in her tomb and sent to Constantinople by Juvenal, the bishop of Jerusalem, upon the request of the Empress Pulcheria who built for it the Theotokos church at Blachernae; or it was discovered by two Byzantine patricians, Galbius and Candidus, in a Jewish woman's house near Jerusalem (or at Capernaum) and deposited at Blachernae by the Emperor Leo I (457–74) and his wife Verina (or Veronica), after they had built for it a sanctuary. The Virgin's robe was described in a text written, perhaps, by a certain Theodore Syncellus in 619. He established a one-to-one correspondence between the Mother of God and her garment, which not only clothed her, but also wrapped "the Word of God Himself, when he was a little child;" and he stressed the robe's dual nature, at once material and divine. Although the dress was "woven from perishable wool," it "had suffered no destruction at all, but was completely intact, whole and indestructible, evidence of the indestructibility and untouchability of the wearer."[25]

In 619, when the Avars raided the outskirts of Constantinople where the Virgin's church of Blachernae stood, Mary's robe began working miracles. And in 626, when the capital found itself under the Avars' siege, the city felt protected by Mary's constant attention. She started appearing to her people – and even to their enemies – as a veiled lady or a warrior maiden fighting against the foreign invaders.[26] In those difficult days the icons of the Virgin were flanked by those of Christ, and the patriarch used to carry round the walls a likeness of the Theotokos together with the Camuliana *acheiropoietos* of her son.

(ii) *Portable Icons and Textiles*

The idea of Christ's mandylion was developed within the framework of Byzantine art which preferred two-dimensional images to sculpture and delighted in encaustic pictures, iconic fabrics, and

small reliefs in terracotta, marble, metal or ivory (to which the *keramion* was indebted). A wide distribution of icons was promoted by the development of the encaustic, an ancient method of painting in wax:

> It is not agreed who was the inventor of painting in wax and of designs in encaustic. Some people think it was a discovery of Aristides, subsequently brought to perfection by Praxiteles, but there were encaustic paintings in existence at a considerably earlier date, for instance those of Polygnotus, and Nicanor and Mnasilaus of Paros.[27] Also Elasippus of Aegina has inscribed on a picture *enekaën* ("burnt in"), which he would not have done if the art of encaustic painting had not been invented.
>
> (Pliny, *NH* 35. 39. 122–3)

Pliny further reports that

> in early days there were two kinds of encaustic painting, with wax and on ivory with a graver or *cestrum* (that is a small pointed graver); but later the practice came in of decorating battleships. This added a third method, that of employing a brush, when wax has been melted by fire; this process of painting ships is not spoilt by the action of the sun nor by salt water or winds.
>
> (*NH* 35. 41. 149)

In Byzantium the encaustic was developed later than fresco and mosaic, but existed already at the time of Eusebius, who mentions an encaustic panel above a palace gate, presumably in Constantinople, in his *Vita Constantini* (3. 3. 46). The flexible technique, which lent itself particularly well to portraiture, became popular in the second half of the fifth century and came to maturity at the time of Justinian I. One could paint in encaustic on ivory, polished wood, or canvas of every size and shape and produce large pictures as well as portable miniatures which facilitated and personalized worship. Executed in shimmering browns or mother-of-pearl nuances of exquisite greys, blues, and reds, the pictures expressed a wide range of feelings and conveyed immediacy and liveliness. The Byzantine *Painter's Guide* directed the artists to paint the Virgin as an attractive woman with the "complexion the colour of wheat, hair and eyes brown, grand eyebrows, and beautiful eyes, clad in beautiful clothing, humble, beautiful and faultless" (*Britannica*, 4:908).

The encaustic technique – with its quickly drying pigments and the rapidity of its brush strokes – inspired analogies between artistic creation and the appearance of mirror images and shadows; it suggested the mercurial speed of sexual impregnation – and of memorizing and remembering, with "the image imprinting itself on the *phantasia* like a seal . . . on wax."[28] Encaustic icons seemed so "true" that they made people cry. In his description of the portrait of the martyr St Euphemia, Asterius, the bishop of Amaseia, writes:

> The virgin stands dressed in a grey tunic and himation showing thereby that she is a philosopher . . . Two soldiers are leading her to the magistrate, one dragging her forward, the other urging her from behind. The virgin's appearance shows a mixture of modesty and firmness; for, on the one hand, she bows her head down as if ashamed of being gazed at by men, while on the other, she stands undaunted and fearless in her trial . . . The representation proceeds: a number of executioners, stripped down except for their short tunics, are beginning their work. One of them seizes the head and lays it down, thus preparing the virgin's face for punishment; another stands by and cuts out her pearly teeth. The instruments of torture are hammers and drills. But now tears come to my eyes and sadness interrupts my speech: for the artist has so clearly painted the drops of blood that you might think them to be trickling down in very truth from her lips, and so you might depart weeping.[29]

Asterius's reaction to the painting of St Euphemia is analogous to what we feel today when looking at color photographs of our contemporary martyrs and victims – but not when looking at Byzantine paintings. What was then considered mimetic appears stylized to us – and not only because our criteria have changed. The Byzantine approach to portraiture echoed the mimetic aesthetics of the Greeks which strove for the identity of the person – the beloved of the Corinthian girl – and his image – the shadow she outlined on the wall. When Byzantine painters could not copy their models, they dreamt about them or visited them in heaven. Thus St Mary the Younger, a local celebrity, "appeared in a dream to a painter who was a recluse . . . She was wearing a white robe and had a red veil over her head . . . the painter asked her who she was and . . . she answered . . . 'I am Mary from the city of Bizye . . . whom . . . until now you have not seen . . . So, as you see me now, paint my image.'"[30] And still in the fourteenth century Nicephorus Callistus wrote in the eulogy of a great painter: "Either Christ Himself came

down from heaven and showed the exact traits of His face to him who has such eloquent hands, or else the famous Eulalios mounted up to the very skies to paint with his skilled hand Christ's exact appearance."[31]

Mimetic painting produces a peculiar sensibility, and thus a culture dominated by illusionistic icons may be more prone to sudden outbursts of irrationality than a culture in which sculpture prevails. The materiality of sculpture stimulates, but also partly satisfies the desire to possess and consume. Under the touch of a Pygmalion, marble turns to flesh and a statue transforms into a mistress. Mimetic painting, on the other hand, ignites passions that cannot be satisfied, causing – as in the ancient Narcissus – destructive hallucinations and obsessions. Contemplating a sixth-century encaustic icon of a frontal and yet asymmetrical face of Christ, one is mesmerized by the intense gaze of his wide-open eyes – and gets a hint of the psychological intensity involved in the clash between iconodules and iconoclasts.

Did women work as professional painters in Byzantium? The answer is probably no, although painting was accessible to women in ancient Greece. Pliny mentions several Greek women artists:

> Timarete the daughter of Micon who painted the extremely archaic panel picture of Artemis of Ephesus, Irene daughter and pupil of the painter Cratinus who did the Maiden at Eleusis, a Calypso, an Old Man and Theodorus the Juggler, and painted also Alcisthenes the Dancer; Aristarete the daughter and pupil of Nearchus, who painted an Asclepius. When Marcus Varro was a young man, Iaia of Cyzicus, who never married, painted pictures with the brush at Rome (and also drew with the *cestrum* or graver on ivory), chiefly portraits of women, as well as a large picture on wood of an Old Woman at Naples, and also a portrait of herself, done with a looking glass.
>
> (*NH* 35. 40. 147–8)

In his *De claris mulieribus*, a compilation of stories about famous women, Boccaccio included the women painters recorded by Pliny. In the French translation of Boccaccio's book (Paris, 1403) we find charming miniatures of the ancient artists. Their names are slightly changed or misspelled, and they are dressed in contemporary outfits and dedicated to Christian subjects. Thamar paints a madonna with child; Irene works on a diptych; Cyrene covers with paint the robe of a Holy Virgin statue, while a finished picture of Christ's face leans against the back of her desk; and Marcia (Iaia) executes a self-

portrait with the help of a mirror.[32] The imaginary portraits were modelled after reality. By the beginning of the fifteenth century women painters, most of them nuns, had been contributing for some time to Western art and in particular to manuscript illumination. The most famous of them was Herrade of Landsperg, the prioress of the Saint-Odile nunnery, who toward 1170 illustrated the *Hortus deliciarum*.[33]

The early Greek and the late medieval activity of female artists makes one expect to find women painters in Byzantium. But not a single document refers to them, and the only hint that women might have dabbled in painting comes from the legend of the "true" portrait the Theotokos painted of herself. The picture was considered an *acheiropoietos* and in the tenth century was still in the possession of the Abramite monastery situated on the outskirts of Constantinople.[34] It is likely that the strictly domestic existence of women and the lack of visual stimulation and education prevented them from making a contribution to Byzantine painting. But they might have also been overlooked, since art was mostly anonymous: only a few wall paintings carried signatures, and icons almost never.[35]

Another kind of light and portable icon was created through weaving and embroidery. The walls and pillars of Byzantine churches were covered with rich textiles, a tradition inherited by Christianity from antiquity and occasionally opposed by anti-iconic theologians. Thus Epiphanius of Salamis (d. ca.403) entreated the Emperor Theodosius "that the curtains which may be found to bear in a spurious manner . . . images of the apostles or prophets or of Lord Christ Himself should be collected from churches, baptisteries, houses and martyria and that thou shouldst give them over for the burial of the poor."[36] But the custom survived and flourished, and in the sixth century the inner decoration of St Sophia included altar curtains on which

> art has figured the countless deeds of the Emperors, guardians of the city: here you may see hospitals for the sick, there sacred fanes. And elsewhere are displayed the miracles of heavenly Christ, a work suffused with beauty. And upon other veils you may see the monarchs joined together, here by the hand of Mary, the Mother of God, there by that of Christ, and all is adorned with the sheen of golden thread.[37]

Byzantium delighted in garments decorated with icons. An ivory plaque (ca.500) shows Ariadne, daughter of the Emperor Leo I,

wearing on her robe an embroidered panel with the likeness of a man, a prince or emperor depicted as consul;[38] and the bottom of the cloak of Theodora, the wife of Justinian I, as depicted in mosaic at San Vitale in Ravenna, is embellished with a line of figures perhaps representing the adoration of the Magi. The habit of wearing icons was first mentioned around AD 400 by St Asterius. He deplored the "wickedness" of those who

> have invented some kind of vain and curious broidery which, by means of the interweaving of warp and woof, imitates the quality of painting and represents upon garments the forms of all kinds of living beings, and so they devise for themselves, their wives and children gay-colored dresses decorated with thousands of figures . . . When they come out in public dressed in this fashion, they appear like painted walls to those they meet. They are surrounded by children who laugh among themselves and point their fingers at the pictures on their garments . . . You may see lions and leopards, bears, bulls and dogs, forests and rocks, hunters and [in short] the whole repertory of painting that imitates nature . . . The more religious among rich men and women, having picked out the story of the Gospels, have handed it over to the weavers – I mean our Christ together with all His disciples, and each one of the miracles the way it is related. You may see the wedding of Galilee with the water jars, the paralytic carrying his bed on his shoulders, the blind man healed by means of clay, the woman with an issue of blood seizing [Christ's] hem, the sinful woman falling at the feet of Jesus, Lazarus coming back to life from his tomb. In doing this they consider themselves to be religious and to be wearing clothes that are agreeable to God.[39]

Garments with biblical imagery created an immediate bond between strangers and defined them as a group. The habit testified to Christianity's strength as well as to religious tolerance. But why did the Byzantine Christians wish to identify themselves in the ostentatious way of college students? A mixture of decoration and devotion, the Byzantine iconic clothes make one suspect a relatively superficial religiosity that tries to cover up its insecurity and lack of depth with excessive ornamentation. But pictured clothes can also be interpreted as a symptom of desire for personal and direct forms of worship, and a sign of strong magical beliefs. The embroideries and weavings of Christ, the Virgin, the saints, and miracle-scenes might have functioned as phylacteries keeping away evil in a way similar to amulets, which still in the eighth century were suspended in the rooms of newborn children and around their necks.[40] This

would explain the popularity of healing and revival scenes. In addition to being magically potent, iconic garments acted as powerful tokens of memory by establishing an intimate bond between humanity and divinity, the living and the dead.

The pictured garments of early Byzantium have not been preserved. We know about them from descriptions and artistic depictions, and imagine them in accordance with the later tradition of Byzantine weaving and embroidery – probably not that different from its beginnings – which since the fourteenth century has been richly documented. It is not easy to speculate about the origins of the Byzantine iconic clothes and to decide whether they were just by-products of the woven and embroidered church curtains, or if they were influenced by oriental textiles or/and the painted shrouds produced in Egypt from the first century AD until the end of the fourth century.[41] But one can get an idea of how the Byzantines looked in their pictured dresses by contemplating some of the still existing Egyptian shrouds. They show bodies covered with pictorial textiles, with only faces, hands, and feet left naked. The contrast between the bare skin and the overall decoration creates – as in Gustav Klimt's portraits of women inspired by Byzantine art – a sense of vulnerability. Faces and limbs give the impression of yearning to escape from the prison of their hieratic clothing – and from the text–icon–skin of their existence. Burial shrouds and portraits dwindled in Egypt after 392, when the Emperor Theodosius had issued an edict penalizing pagan cults. But textiles with Christ and the Theotokos flourished in Coptic art. A well-preserved sixth-century Egyptian tapestry shows the Virgin with Christ in her lap between the archangels Michael and Gabriel; above her head a mandorla with Christ enthroned is being flown to heaven by two angels.[42]

The Egyptian skill in dyeing cloth might have influenced the production of Christian *acheiropoietoi*, not painted by hand but perhaps obtained in a secret procedure:

In Egypt they also colour cloth by an exceptionally remarkable kind of process. They first thoroughly rub white fabrics and then smear them not with colours but with chemicals that absorb colour. When this has been done, the fabrics show no sign of the treatment, but after being plunged into a cauldron of boiling dye they are drawn out a moment later dyed. And the remarkable thing is that although the cauldron contains only one colour, it produces a series of different

colours in the fabric, the hue changing with the quality of the chemical employed, and it cannot afterwards be washed out.

(*NH* 35. 42. 150)

Byzantine art inherited its interest in the human figure from antiquity, but it infused into the ancient tradition rigidity and frontality and replaced the softness and richness of the bodily expression with overornamented clothing. Faces, hands, and feet were still rendered with a considerable degree of realism but, as the rest of the body was neglected, they looked as if they had been cut out and inserted into a semi-abstract textile mosaic. This effect contributed to the spiritualization of the human likeness, but it also transported it from the world of the living to the eternal nowhere, a universe immersed in light but devoid of the pulsating warmth of life. Afraid of the sensuality conveyed through naked or lightly clothed bodies, Byzantium opted for the remoteness and stillness of figures ironed flat and covered with layers of heavy fabric. While flesh was denied, the expressive qualities of faces were stressed and eyes were given special attention. They were enlarged, opened wide, and lost in contemplation.

Byzantine painters were fascinated by drapery, but they used it for different reasons and effects than the Greek sculptors, to whom fabric was a medium for shaping a body and making flesh visible. In contrast to the light, often transparent Greek tunics, Byzantine artists piled on cloth in order to hide bodies under heavy garments. In life as well as in art, icons over clothes diverted attention away from the wearer's body toward holy portraits and scenes. Flesh was buried beneath real and symbolic covers, and bodily presence was replaced with elaborate depictions of bygone events and figures. People's unique existence was bound up in religious imagery and individual features were hidden under symbolic garments acting as holy armor and shields. Zeus and Aphrodite descended onto earth wearing nothing, Christ and the Virgin were veiled to their fingertips. As the veneration of flesh yielded to the worship of garments, the naked emperor of the past gave way to the emperor's richly decorated clothes. Where once a Venus stood, facing the world and displaying her unadorned beauty, now a Virgin sat, her eyes modestly cast down, a spindle or needle in her hands.

Mary spins and weaves in the second-century *Protevangelium Jacobi*; she is considered the creator of a woven cloth with pictures of Christ and the apostles kept in Jerusalem and seen by Arculf;[43]

and she is shown busy with textile work on Byzantine frescos, mosaics, and icons. The texts and pictures reflected typical female occupations and set examples. Although the professional textile producers mentioned by Asterius seem to have been men, we know that Theoctista (b. ca.740 in Constantinople), the mother of Theodor of Studion, wove clothes for the entire community;[44] and we can assume that in early Byzantium women were as involved with textiles as were those in the empire's latter days – from the eleventh century onwards – when "within the household, the model occupation for a woman was spinning, weaving, and making cloth."[45] Textiles and garments were made in Byzantine nunneries. And after the eleventh century women held a number of textile-related jobs such as making linen, carding wool, spinning and weaving. Interestingly, the dyeing of wool was reserved for men, an echo, perhaps, of the traditional perception of women providing the stuff, men the juice of life. But even then women who earned money by clothmaking were an exception and not the rule; female work was considered proper insofar as it met the needs of a household but did not enter the marketplace.[46] Thus the image of a woman spinning, weaving, and embroidering functioned for centuries as a powerful stereotype of domesticity, and as such it was frequently used by Byzantine men to remind women of their place. Writing about the origins of the second civil war, the historian Doukas tied it to Anne of Savoy's inability to govern, and had John VI's friends compare the empire under her rule to a weaver's shuttle that worked ineffectively and spoiled the cloth.[47] In his funeral speech George Tornikos praised the princess Anna Comnena (d. ca.1153), a student of philosophy and theology and a writer, for her extraordinary erudition which she achieved in spite of "belonging to the fragile and delicate sex, good only for weaving, the distaff and the spindle."[48]

The portable and intimate character of Byzantine art enabled people to carry and wear images as talismans and tokens of memory, and it created its own symbolism – especially evocative in regard to femininity. Women who carried or wore portraits, in particular of males, on or underneath their robes or in their hands were reminiscent of the Theotokos with the *clipeus* or Jesus in her arms, and they could be easily associated with pregnancy and motherhood. This contributed to the misogynist perception of iconodule women as girls fond of their dolls. Thus we are told that Irene, the wife of the iconoclast Emperor Leo IV (775–80) and after his death a

brilliant and ruthless ruler, kept icons under her pillows;[49] that Theodora, the wife of Theophilus (829–42), another enemy of images, used to hide the holy pictures under her clothes and, when interrogated by her husband, replied: "These are my dolls; they are pretty and I love them very much;"[50] and that the old Empress Euphrosyne, who after her retirement from the court kept venerating images in her cloister, had in her cell a case filled with "beautiful dolls" and taught Theophilus's daughters to kiss the icons each time they visited her.[51]

(iii) *Iconoclasm*

Byzantine iconoclasm coincided with the period of wars against the Arabs and the cultural downfall of the empire when intellectual brilliance, education, and art patronage — worlds accessible to women — were replaced by military goals and the crude puritanism of emperor-soldiers. Some of the horrors of iconoclasm might have been exaggerated or even invented after the iconodule victory, but there is hardly any doubt that a holocaust of precious buildings, books, icons, and relics took place, as monasteries, churches, libraries, and archives were turned to ashes. Directed against material representation, iconoclasm possessed an anti-feminine edge.

The iconoclasm of Byzantine emperors was preceded and accompanied by anti-iconic movements in the Muslim empire and the Jewish communities. The question to what extent these tendencies contributed to the zeal of Constantinople's rulers remains controversial. But one can probably assume that the emperors, as they engaged in a fight against their own people and heritage, were tempted to pluck whatever ideological support there was in the air. Thus Leo III (717–41) was nicknamed, presumably not without reason, the "Saracen-minded," and although he persecuted Jews and forcibly converted them to Christianity, he might have been influenced by them.[52] Since most Byzantine painters were monks, monasteries functioned as centers of icon production and cult.[53] We have much less information about the activity of nuns.[54] But even if they did not paint, their worship of images was certainly not less intense. Kassia (b. between 800 and 805), the founder of a nunnery named after her and the only woman of her time who achieved fame as a poet, was persecuted for her support of the iconodule cause and

1 Cariani (Giovanni Busi, ca.1480–1547 or 1548), *Meeting of Jesus with Veronica.*

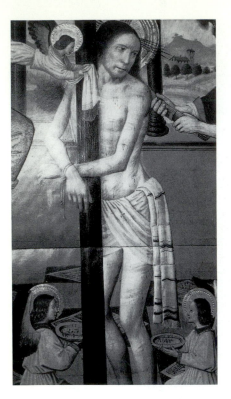

2 Jaime Huguet (1415–92), *Flagellation* (detail).

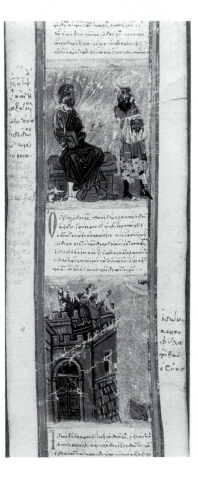

3 Above: *Abgar's Messenger Receives from Christ the Linen Bearing Christ's Likeness.* Below: *The City of Hierapolis* (where the messenger stopped and hid the cloth for safe-keeping between two bricks), Constantinople, second half of the fourteenth century.

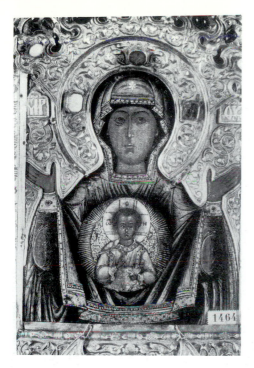

4 *Our Lady of the Sign* (*Známenie*), Russian icon, seventeenth century.

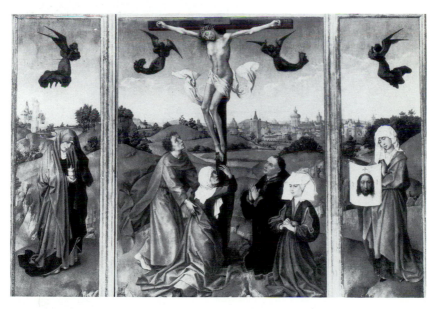

5 Rogier van der Weyden (1399 or 1400–64), *Crucifixion*.

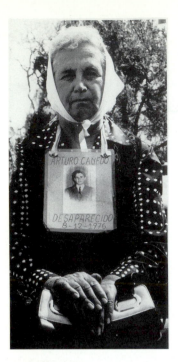

6 Mrs Canedo, one of the "Mothers of the Plaza de Mayo" (Buenos Aires, October 1986).

7 *The Beheading of St John the Baptist*, Bruges 1445–60.

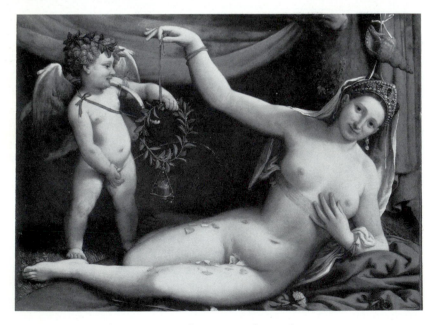

8 Lorenzo Lotto (ca.1480–1556), *Venus and Cupid*.

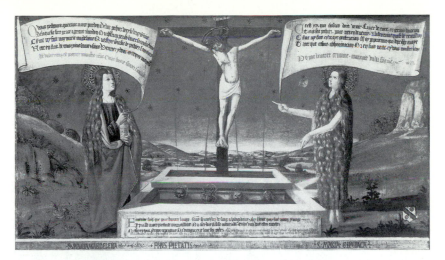

9 Provençal Master, *The Fountain of Blood*, ca.1460.

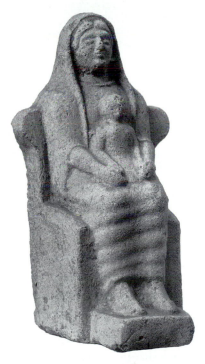

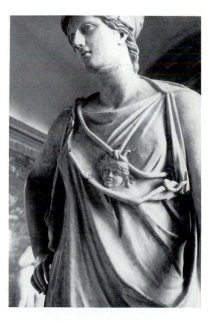

10 Statuette of a mother-goddess (*Kurotrophos*), Selinunte, end of sixth century BC.

11 *Athena, called the Peaceful* (detail showing the hide of Medusa) 350–340 BC.

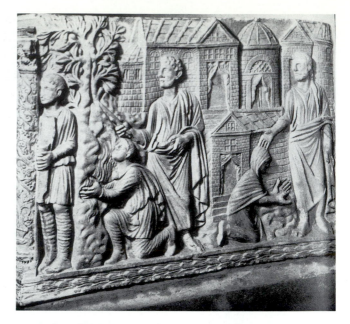

12 Left: *Christ Cursing the Fig Tree*; right: *Christ Healing the Hemorrhissa*, Rome, mid-fourth century.

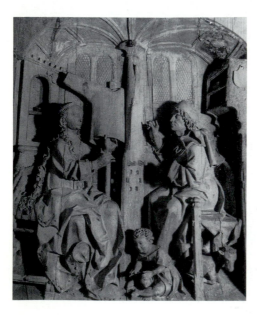

13 Silesian Master (Jacobus Beinhardt?) *The Virgin Working on the Seamless Tunic and St Luke Painting Her*, ca.1500.

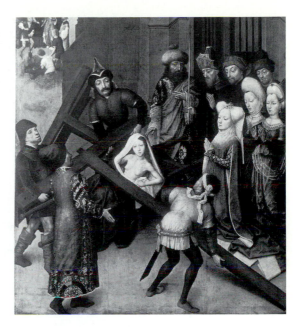

14 Simon Marmion (d. 1489), *St Helena Assisting at the Miracle of the True Cross.*

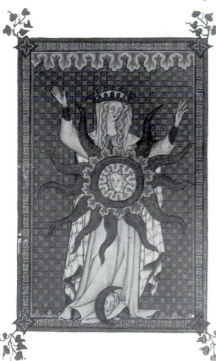

15 Mary as the Mulier amicta sole of the Revelation, Franco-Flemish, late thirteenth or early fourteenth century.

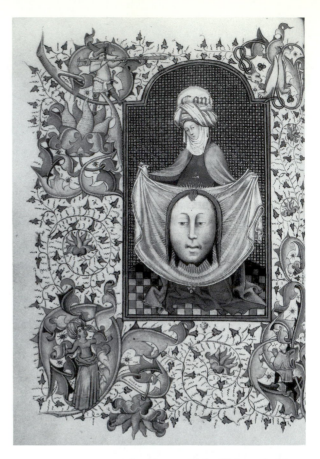

16 Master of Guillebert de Mets,
Master of the Lee Hours and
Master of Wauquelin's Alexander,
Book of Hours, Flemish, 1450–60.

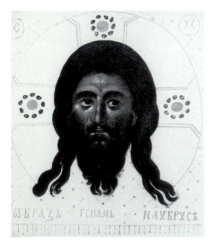

17 *The Holy Face of Laon*, Slavic
icon, early thirteenth century.

helped imprisoned and exiled monks.[55] And in the mid-eighth century, amidst iconoclastic fury, St Anthousa dedicated a nunnery to the Holy Virgin and had it built on an island in Lake Daphnousios. Later she added a monastery for men on the shores of the lake. She ruled both and had in both the veneration of icons preserved – a true demonstration of courage in those dangerous days.[56]

The beginning of the iconoclast controversy is usually dated to 726, when Leo III ordered the removal of a Christ picture from the Chalke (Bronze) Gate of the imperial palace. The gate was a large structure which "seems to have been adorned with many imperial statues . . . and ancient objects, such as four Gorgon heads from the Artemision at Ephesos, two philosophers from Athens, a cross erected by Justinian, and a statue of his general, Belisarios, with golden rays."[57] The icon of Christ was probably a painting commissioned and placed on the gate by the Emperor Maurice (582–602) who had dreamed of Jesus' likeness appearing on the Bronze Door. The picture was positioned above the emperor's statue and acted as an important phylactery for Constantinople. As the news of Leo's order reached the capital, a violent demonstration erupted and a crowd of "pious women" killed the officer whom the emperor had charged with the icon's removal. This is mentioned in the second letter of Pope Gregory II to Emperor Leo III which, however, may be a forgery.[58] But this does not concern us. To the contrary, a forgery would support our point that women were perceived as inherently iconodule. Iconoclasm certainly strengthened this perception, since it was directed not only against icon worship but also against the cult of the Holy Virgin, a campaign in which Constantine V (741–75) excelled.

Constantine's surname, Copronymus, was explained by Theophanes (b. between 752 and 760) as due to the fact that at his baptism the imperial infant "defecated in the holy font."[59] Theophanes, who held several offices under Constantine V but later retired from the world, founded a monastery, and became a leading exponent of the iconodule cause, is regarded as a strongly prejudiced historian. He is, however, an unsurpassed source of pro-iconic propaganda presented against the most fantastic iconoclast horrors, and he certainly gets one thing right: the massive popular discontent with the iconoclast rule – with its theological sophistry on the one hand and sheer brutality on the other. Constantine's violent persecution of the iconodules was tied to his anti-Mariolatry. Thus in 761 John,

the abbot of the Monagria monastery, was put into a sack and thrown into the sea upon his refusal to step upon an icon of the Virgin.[60] The emperor's most famous roundabout attack on Mary took the form of an obscene and – to our minds – eminently Freudian joke. To exemplify her merely temporary significance, he compared his purse, first filled with gold and then emptied of it, to Mary *in partu* and *post partum*.[61] Consequently, he wanted her to be called *Christotokos* (Mother of Christ) instead of *Theotokos* (Mother of God) and tried to forbid prayers to the Virgin and such exclamations as "Mother of God, have mercy on me" (*Chronicle of Theophanes*, September 1, 767–August 31, 768).

In Theophanes's report the dispersion and destruction of icons and relics (the corpse of St Euphemia, for instance, was thrown into the sea) are often juxtaposed to the torture and dismemberment of monks and nuns – a technique which links the crimes committed by the iconoclasts to the passion of Jesus. Other iconodule documents draw attention to the iconoclast intrusion into private life and Constantine's aim to eliminate not only artefacts but also religious language. People who possess relics or are caught wearing an amulet are punished as much as those who are intercepted in prayer. The inhabitants of the capital are forced to swear by Christ's blood and body that they won't worship icons. In the Acts of Constantine's iconoclastic council held in the capital in 754, Lucifer himself is denounced as the inventor of idolatry, and artists are portrayed as greedy fools: "How senseless is the notion of the painter who from sordid love of gain pursues the unattainable, namely to fashion with his impure hands things that are believed by the heart and confessed by the mouth!"[62]

According to Theophanes, Constantine's "fury against the holy churches and the revered icons" was punished with a plague which – how appropriately! – announced itself in the form of cloth *acheiropoietoi* and hallucinations turning into "true" images:

Suddenly and in some unseen fashion, a great number of small oily crosses began to appear on men's cloaks, on the holy garb of the churches, and on their curtains. People grew distressed and dismayed because they were perplexed by this kind of sign. The wrath of God mercilessly destroyed not only the folk in the city, but also those in all its suburbs. Many men had delusions and, as it seemed, while they were delirious they thought they were traveling with strange, harsh-faced men . . . The sick folk also saw these people entering houses,

killing some of their inhabitants, and wounding others with swords. Most of the things they said happened just as they had seen.

(*Chronicle*, September 1, 746–August 31, 747)

Popular discontent was realized and used by Irene (752–803), the wife of the Emperor Leo IV (775–80), who came to power after her husband's death, when she became regent for her ten-year-old son Constantine. Irene immediately demonstrated her sympathy for the iconodules by restoring famous relics: a crown that had been taken by her husband from St Sophia, and the corpse of St Euphemia, which had been saved by a miracle. Her activity was interpreted by Theophanes as the dawning of a new age:

The pious began to speak freely, the word of God began to wax, those who wished to be saved began to be appointed without hindrance, the monasteries began to be delivered, and everything good began to become manifest. At this time a man digging in Thrace found a coffin. He cleaned it and, looking inside, found a man lying in it. There were also letters inlaid on the coffin, whose content was this: "Christ was certainly born of the Virgin Mary, and I believe in Him. Sun, look on me again in the reign of the Emperors Constantine and Irene."

(*Chronicle*, September 1, 780–August 31, 781)

Irene suppressed a rebellion in favor of Nicephorus, the emperor's brother, which involved high officials sympathetic to iconoclasm, and proceeded to restore the veneration of images. But it took her almost four years to replace the iconoclast patriarch of Constantinople with Tarasius, her secretary, and two more years to prepare the Council of Constantinople which was to reverse the iconoclast legislation. It met in mid-786 in the church of the Holy Apostles, but was broken up by soldiers from the local guard regiments who had remained faithful to Constantine V. The failure did not discourage Irene. Pretending that there was an Arab menace, she transfered the iconoclast troops from Constantinople to Asia Minor, and brought in iconodule regiments from Thrace. Around that time the empress replaced the destroyed icon of Christ from the Chalke Gate with a portable mosaic showing his likeness, and in 787 she convoked the seventh ecumenical Council.[63] It opened in September at the church of St Sophia in Nicaea and served as the forum for a passionate plea on behalf of images. Iconoclasm was condemned as heresy, the writings of its proponents were ordered destroyed, the veneration of icons was restored, and Byzantium was formally

reunited with Rome. In the following years Constantine tried to snatch power from Irene, but failed and was punished. He died, after his eyes had been stabbed out by her orders. The blinding, which had been committed by a mother and a defender of images, had a horribly ironic touch and led to the creation of legends. Associating sight with light, the sun with masculinity, and the moon with femininity, they attributed a 17-day-long eclipse of the sun to Irene's crime.

Citing numerous earlier sources, Charles Diehl (along with other historians) claims that Irene's fight against iconoclasm was prompted by her coming from Athens, where in her youth she had supported the iconodule cause.[64] They argue that at her wedding the ambitious girl was forced to renounce her pro-iconic convictions by her future father-in-law, and thus entered the marriage with feelings of frustration and resentment. She continued to venerate images, but had to hide her devotion from her husband, conspired against him before his death, and fell into disgrace. "This," Judith Herrin believes, "is patently false. Constantine V would never have allowed his son and heir to marry into a known iconophile family."[65] Still, the crux of the matter is that Irene was a convinced iconodule who managed to temporarily restore icon worship and consequently became an extremely popular ruler. But she failed with the economy and foreign policy, and the iconoclast elements were not all dead either and awaited their revenge. In 802 a revolution swept Irene away. The empress was dethroned, exiled to Lesbos and forced to support herself by spinning.[66]

Irene's successor, the usurper Nicephorus I (802–11), was not an enemy of images, and under the rule of Michael I (811–13) the iconoclasts tried to seize power only once, but did not succeed.[67] But in the following period persecution resumed. Leo V the Armenian (813–20), a distinguished general of the two previous emperors, removed the Christ likeness, which had been reinstated by Irene, once again from the façade of the Bronze Door, and in 815 an iconoclastic synod was convoked by the emperor and held in St Sophia. It repudiated the Council of Nicaea and attacked Irene – and femininity – stating that

> the Church of God remained untroubled for many years and guarded the people in peace; until it chanced that the imperial office passed from [the hands of] men into [those of] a woman, and God's Church was undone by female frivolity: for, guided by most ignorant bishops,

she convened a thoughtless assembly, and put forward the doctrine that the incomprehensible Son and Logos of God should be painted [as He was] during the incarnation by means of dishonored matter. She also heedlessly stated that lifeless portraits of the most-holy Mother of God and the saints who share in His [i.e. Christ's] form should be set up and worshipped, thereby coming into conflict with the central doctrine of the Church. Further, she confounded our worship . . . by arbitrarily affirming that what is fit for God should be offered to the inanimate matter of icons, and she senselessly dared state that these were filled with divine grace, and by offering them candlelight and sweet-smelling incense as well as forced veneration, she led the simple-minded into error.[68]

Five years later Leo V was murdered and followed by Michael II (820–9), called Psellus (the stammerer), an even less sophisticated soldier-type. He could hardly read and write, but possessed a sense of moderation, something his educated son Theophilus lacked completely. An enthusiast of Muslim culture and a romantic puritan, Theophilus (829–42) dreamed of reviving iconoclasm and specialized in extravagant brutality. By his order the right hand of the monk Lazarus, a famous painter of icons, was cut off, and four infamous verses were branded with a red-hot iron onto the forehead of the priest Theodore Graptus.[69] But history repeated itself. The emperor's wife Theodora continued secretly to venerate icons, and after his death, when she became regent for her three-year-old son, she regarded the changing of her husband's religious policy as her single most pressing task.[70] In 843 she convoked a local synod, deposed John the Grammarian, the iconoclast patriarch of Constantinople, elected Methodius as his successor, confirmed the decisions of the Council of Nicaea, and compiled a blacklist of iconoclasts from which her husband, however, was excluded. Apparently the empress lied on behalf of Theophilus, pretending that on his deathbed the emperor had abjured the iconoclast heresy. This conjugal affection was further embellished in a legend telling of Theodora's dream in which she saw her husband condemned by the supreme court of heaven; it was presided over by the Theotokos, with the baby Jesus in her arms.[71]

Theodora returned the Christ mosaic, which had been hidden away by Leo V, to the Chalke Gate, thus completing the story of this prominent Christ icon.[72] Its saga can indeed be perceived as symbolic of women's opposition to iconoclasm. On February 19, 843, Theodora celebrated her victory with piety and pomp. All night

she prayed at the church of the Holy Virgin at Blachernae and in the morning proceeded from there, amidst a jubilant crowd, to St Sophia. The defeated iconoclasts participated in the procession and had the final anathema thrown at them. The Church recognized Theodora's role in the restoration of icons. She was sainted, and the Greek Church still celebrates her Feast of Orthodoxy on the first Sunday in Lent.[73]

The iconodule victory found the capital bare of icons – and painters. Lazarus, whose hands had been mutilated by Theophilus, was one of the few artists who survived, but after 843 his energy went into Church politics and not painting. For 20 years after the restoration of orthodoxy St Sophia remained without decoration, reminding people of the iconoclasts: "Those men, after stripping the Church, Christ's bride, of her own ornaments, and wantonly inflicting bitter wounds on her, wherewith her face was scarred, sought in their insolence to submerge her in deep oblivion, naked as she was."[74] These are words of Photius, patriarch of Constantinople (858–67 and 877–86), for whom "the real triumph over Iconoclasm occurred not in 843, but in 867, at the moment when the images were set up in St. Sophia" – and Ecclesia's naked body was covered with a splendid new dress.[75] The icon of the Virgin was the first to adorn the bare walls of the cathedral, and Photius celebrated it in a homily, written specially for this occasion, from which the previous quote is taken. His text honors womanhood and art, beauty and vision, the mystery of incarnation and representation:

> With such a welcome does the representation of the Virgin's form cheer us, inviting us to draw not from a bowl of wine, but from a fair spectacle, by which the rational part of our soul, being watered through our bodily eyes, and given eyesight in its growth towards the divine love of Orthodoxy, puts forth in the way of fruit the most exact vision of truth. Thus, even in her images does the Virgin's grace delight, comfort and strengthen us! A virgin mother carrying in her pure arms, for the common salvation of our kind, the common Creator reclining as an infant – that great and ineffable mystery of the Dispensation! . . . With such exactitude has the art of painting, which is a reflection of inspiration from above, set up a lifelike imitation.[76]

Photius glorifies the Virgin as the female medium of creation that has triumphed over men's destruction. Similarly, a miniature in the Byzantine *Khludov Psalter* (second half of the ninth century) compares the image-breakers to Christ's executioners by contrasting

an iconoclast – effacing a round icon of Jesus with a sponge attached to his lance – with the crucifix flanked by two Roman soldiers. The juxtaposition alludes to a popular pamphlet attacking Constantine V, whose anonymous author draws such a parallel: "As the lawless ones, mixing gall and vinegar, applied it to Christ's mouth, so also these, mixing water and lime and placing a sponge on a stick, have applied it to the incarnate face of the precious image and have obliterated it."[77] Jesus' nimbused head and the round Christ icon whose paint is being washed off look identical, and the gesture of the iconoclast mirrors that of the soldier with the sponge on his lance. A broad, feminine-shaped vase collects Jesus' fluids; the liquefied paint drips from the iconoclast's sponge into a twin receptacle. The female principle preserves what masculinity destroys. But, on the other hand, both scenes evoke insemination and sacrifice – the feeding of femininity and mother earth with male juice.

Between East and West

5

From the Hemorrhissa to Berenice

The Heavenly Circuit; Berenice's Hair;
Tent-pole of Eden; the tent's drapery;
Symbolical glory of the earth and air!
The Father and His angelic hierarchy
That made the magnitude and glory there
Stood in the circuit of a needle's eye.

Some found a different pole, and where it stood
A pattern on a napkin dipped in blood.
 W. B. Yeats, "Veronica's Napkin"[1]

The victory over iconoclasm cemented links between women and images, strengthened the position of the Holy Virgin, increased the symbolic value of femininity, and thus prepared the ground for St Veronica, a madonnalike female dedicated exclusively to the promotion of Christ's portrait. Veronica was sanctified by the Latin Church, but her legend originated in the Bible and was shaped by various traditions, Eastern and Western, pagan and Jewish, orthodox and heretical. Not unlike the Abgar myth, her story also supported Image against Word, but it shifted the focus from the image to the woman, and from iconism to incarnation. While King Abgar and Jesus communicated with each other by means of correspondence – language – the Hemorrhissa and Christ came into contact by touching each other. An official relation between two public men was

thus replaced with a private affair, intimate and even embarrassing – a love story of sorts; action moved from center to backstage; and a straightforward account about a sick king, a famous healer, and messengers travelling between Syria and Palestine turned into an erotic reverie. The fantasy involved the taboo subjects of female physiology and sexuality, it was soaked with speculations on the secret intercourse between a woman and an incarnate God, and it addressed the questions of women's religious and social status. The structure of the Veronica legend, which begins with a woman's and ends with a man's flux, reflects the plasticity and fluidity of a secret, apocryphal, and dreamlike inner dimension reminiscent of a "soft-walled labyrinth," to speak with Gaston Bachelard.[2] Finding one's way through this labyrinth, where sexes are fused and sexual relations obscured, requires the adoption of an open, mixed method that does not fear intuition and speculation.

(i) New Testament

In the New Testament various women seek and get Jesus' help, accompany the Lord and minister to him.[3] The anonymous Hemorrhissa (the bleeding one) belongs to this female entourage. Her curing takes place in Capernaum and is embedded in a larger episode: the revival of a young girl who has just died. The Hemorrhissa's touching Christ is followed by his touching the girl – a sequence that contributes to the rise of erotic associations. The dual miracle does not lack drama. Shattered by the apparent death of his daughter, Jairus, the head of the local synagogue, implores Jesus to return her to life. Fulfilling his wish,

> Jesus rose and followed him, with his disciples. And behold, a woman who had suffered from a hemorrhage for twelve years came up behind him and touched the fringe of his garment; for she said to herself, "If I only touch his garment, I shall be made well." Jesus turned, and seeing her he said, "Take heart, daughter; your faith has made you well." And instantly the woman was made well. And when Jesus came to the ruler's house, and saw the flute players, and the crowd making a tumult, he said, "Depart; for the girl is not dead but sleeping." And they laughed at him. But when the crowd had been put outside, he went in and took her by the hand, and the girl arose. And the report of this went through all that district.
>
> (Mt. 9:19–26)

Since in Jewish culture menstruating women and dead bodies were considered unclean, the scene, and in particular the touching of the Hemorrhissa, showed Jesus' disregard for religious law. He broke a central taboo responsible for a far-reaching exclusion of women from religious service and public life, and for limiting their contacts with men. Since no man could ever be certain that the women he encountered were not having their periods, the Jewish fear of menstruation resulted in an extensive separation of the sexes. Acknowledging that he had been touched by an unclean female, and touching a girl who in addition to being dead might have been menstruating, Jesus broke the law obliging men to stay out of reach of "her who is sick with her impurity" (Lev. 15:33).

The curing of the Hemorrhissa and the girl's resurrection represent two separate episodes which are, however, tied by "twelve" – a significant number in connection with female physiology. Since menstruation usually starts at 12, this was considered the nubial age for Jewish girls.[4] In the Gospel of Mark, in particular, the repetition of "twelve" stresses the sexual component and acts as the women's common denominator: the Hemorrhissa has been suffering from her flux of blood for 12 years (Mk. 5:25); the resurrected girl is 12 years old (Mk. 5:42). In Mark the Hemorrhissa's healing is also given greater prominence than in the other gospels. There Christ turns about in the crowd inquiring: "Who touched my garments?" and, despite his disciples' pointing out to him that it is merely the crowd pressing around him, he asks for a second time: "Who touched me?" At this point the Hemorrhissa "came in fear and trembling and fell down before him, and told him the whole truth" (Mk. 5:30–3). In the Gospel of Luke, Jesus' question: "Who was it who touched me?" is answered by Peter: "Master, the multitudes surround you and press upon you" (Lk. 8:45). (Peter's participation might have contributed to his presence in pictorial programs containing the curing of the Hemorrhissa. In Western art Peter and Paul occasionally appear with Veronica or hold the vernicle.)

The healing of the Hemorrhissa and the resurrection of the young girl may seem public and even theatrical. But their high visibility is misleading. What happens between Jesus and the two women is shrouded in secrecy, and hidden attraction and exchange are only hinted at. This is particularly true in the Hemorrhissa episode. Drawn to Jesus, the woman approaches the Lord from behind. Jesus does not see her, but feels her touch because of the reaction it

provokes in him: the "power" that goes out of him, penetrating the Hemorrhissa and stopping her bleeding. The incident takes a split second, but the speed does not diminish its significance. To the contrary, it suggests the imperceptible quickness of sexual arousal and conception. Like two strangers falling in love in the middle of a street, Christ and the Hemorrhissa become aware of each other through a mysterious coupling of male–female chemistry. The sexual aspect is reinforced by events progressing from the external and public to the internal and intimate. The cessation of the Hemorrhissa's bleeding occurs outdoors, the revival of the young girl indoors. Before entering Jairus's house, Jesus requested that the crowd be put outside, and "allowed no one to follow him except Peter and James and John the brother of James" (Mk. 5:37). Christ's way leads from an involvement with an adult woman straight into the bedroom of an adolescent who turns out to be "not dead but sleeping" (Lk. 8:52); and who, upon his magic touch, has "her spirit returned," and gets up at once (Lk. 8:55).

The resurrection of the 12-year-old girl echoes rites of initiation for the onset of puberty in which children lacking full sexual determination are submitted to a symbolic death, followed by a rebirth in which the child is replaced by a young male or female. The healing of the Hemorrhissa and the girl's revival form a symbolic sequence suggestive of conception and birth and are imbued with further significance in the Gospel of Mark. There the two women's involvement with Christ is followed by the story of Salome's involvement with the Precursor. Salome, the teenage daughter of Herodias, dances for King Herod, her stepfather, and arouses him so much that he vows to grant her whatever she wishes. She asks and receives "the head of John the Baptist on a platter" (Mk. 6:25). In contrast to the good females' "intercourse" with Christ, John's affair with the wicked Salome, the chief female villain of the New Testament, ends in death.[5] Still, the Jewish princess is introduced to sexuality, comes in contact with John's blood, and obtains, like the future Veronica, a holy man's disembodied head – a "true" likeness, a famous relic, and a solar trophy (Plate 7).

(ii) *The Hemorrhissa of Paneas*

Eusebius's account of the Hemorrhissa differs from the Bible in two important points. First, she is not a native of Capernaum but of

Paneas; second, the issue is not the miracle, but its representation in art. Let us begin with the change of place. Capernaum, a town situated about three miles southwest of the Jordan's entrance into the sea of Galilee, is mentioned 16 times in the gospels and enjoys considerable fame as a center of Jesus' mission. But Paneas, located at the source of the Jordan, was important too. Under the reign of Tiberius the city was extended by the tetrarch Philip and called Caesarea Philippi; and it was connected to a crucial New Testament passage. In the vicinity of Caesarea Philippi Jesus hinted at the Messianic purpose of his life and his resurrection, but he "strictly charged the disciples to tell no one that he was the Christ" (Mt. 16:20).

The Paneas revelation announces Christ's forthcoming transfiguration which will reveal the fundamental duality of the incarnate God by replacing the living Jesus with the resurrected Lord – a divine replica. This association with doubling might have been the mythological reason for considering Paneas the right place to possess Jesus' likeness: the double portrait of the Lord and the Hemorrhissa facing each other. From the fourth century onwards Edessa was famous for possessing Christ's letter to King Abgar, while Paneas derived its fame from Jesus' image which documented his involvement with a local woman. The mythical presence of the statue was more important than its actual existence. In fact, several stories suggest that Jesus' portrait was destroyed by the Emperors Maximin (308–14), Julian the Apostate (361–3), or other enemies of Christianity.[6] We hear of pagans who broke Jesus' statue and of Christians who managed to save the head, which was then kept in the local church.[6] The symbolic decapitation stresses the predominance of God's head over the rest of his body, links Jesus to other gods and heroes who lost their heads (Orpheus, Holofernes and, in particular, John the Baptist, Jesus' precursor), and is relevant for our understanding of how and why Jesus' entire figure became reduced to just his face.[7] In the legend of Julian the Apostate, the emperor ordered the statue of Jesus to be destroyed and replaced with his own likeness. But lightning hit the imperial monument and made it collapse, while at the same time Christians restored the statue of Jesus and returned it to its previous place.[8] In the sixth century pilgrims were apparently shown a statue of Christ in the church of Paneas and reported that it was made of golden bronze and that its face shone with miraculous light.[9] The various testimonies are not without contradictions. Asterius of Amaseia, writing towards the

end of the fourth century, seems to have believed that by his day the Christ–Hemorrhissa bronze no longer existed.[10] But his and other authors' doubts always went against the opinion of the Paneas people, who cherished their monument and maintained that it stood on their main square, next to the fountain – a suitable location for a sculpture devoted to flux.[11]

The popularity of the Hemorrhissa–Jesus encounter in fourth- and fifth-century Christian art might have been partly due to the fame of the Paneas statue. The healing episode is always embedded in a pictorial program whose various scenes complement each other. In a wall painting of the Catacomb of SS Marcellinus and Petrus (Rome, second quarter of fourth century) a slender, youthful Christ dressed in white extends his right hand to the Hemorrhissa kneeling behind him, her feminine roundness and heaviness accentuated by the earthy color of her tunic and palla. The composition appears suitable for a female tomb, since it contains a female orant and two other scenes of Jesus' encounters with women: Christ and the Samaritan woman (Jn. 4:7–30), and Christ healing the bent woman (Lk. 13:11–13), a rarely reproduced episode. The front of an ivory casket (second half of the fourth century) shows in the middle Christ as teacher and philosopher presenting the scroll of the law to his pupils. On the left he plays the doctor healing the Hemorrhissa (or the assumed gardener appearing to Mary Magdalen, as the scene is occasionally and, I believe, incorrectly interpreted) and on the right a shepherd addressing his dog.[12] Priorities are clearly set: the woman, kneeling at Jesus' feet, and the dog, jumping up to him, flank the centerpiece. On a mid-fourth-century sarcophagus (Vatican, Grottoes of St Peter's), to the left Jesus touches the fig-tree making it wither, to the right he puts his hand on the head of the Hemorrhissa (Plate 12). A similar symbolism is displayed on a Roman marble relief from around 400, also in the Vatican: on the right Christ stops female flux, on the left St Peter causes water to flow from the wall of his prison. But juxtapositions celebrate the spiritual strength of male saintliness capable of transforming femininity and matter. In the early sixth-century mosaic decoration of Sant'Apollinare Nuovo in Ravenna the scene of the Hemorrhissa's healing is placed between the Samaritan woman at the well and the healing of the blind man.

(iii) The Apocryphal Red Thread

Mary's first period, which is soon stopped by God's intervention, her pregnancy and Jesus' birth, are the main subjects of the second-century *Protevangelium Jacobi* (*Book of James*).[13] The Holy Virgin's apocryphal biography describes how she was brought to the temple at the age of three and remained there until 12, when she had to go, "lest she pollute the sanctuary of the Lord" (*Book of James*, 8:2); how, upon God's advice and under his supervision, she was instantly married to Joseph, a widower, selected for her by the Holy Spirit; and how she was subsequently mystically wed by God. As in the gospels, the significance of "twelve" was reinforced by repetition meant to ring a bell. Before asking the Lord about his plans in regard to the 12-year-old menstruating Mary, "the high priest took the vestment with the twelve bells and went in unto the Holy of the Holies and prayed concerning her" (*Book of James*, 8:3).

After having introduced menstruation, conception and pregnancy, the *Protevangelium Jacobi* disguises these delicate topics with the symbolism of spinning red thread and weaving red cloth – common metaphors for blood coagulating and solidifying into flesh.[14] Mary, already married to Joseph but still undefiled, is selected by a council of the priests to execute, together with six other virgins, a veil for God's temple. Lots are cast in order to assign each girl another part and color (gold, white, hyacinth) of the curtain. But "the lot of the true purple and the scarlet fell unto Mary" (*Book of James*, 10:1) who went home and began to spin. Her work was interrupted by the annunciation, which had a dual form, linguistic and iconic, and was structured by the opposition of the outdoors and indoors. First Mary was informed about her good fortune by word, then by image. As she made a brief break in her spinning and went to fetch water from outside, she heard a voice, but did not understand the meaning. Therefore a vision followed. As she returned "to her house and set down the pitcher, and took the purple and sat down upon her seat and drew out the thread . . . an angel of the Lord stood before her saying: Fear not, Mary, for thou hast found grace before the Lord of all things, and thou shalt conceive of his word" (*Book of James*, 11:1–2). The disembodied voice echoed the Old Testament tradition of God's conversation with men. But since the young girl could not grasp the abstraction of language, Word was followed by Image, and the action moved indoors – and right into the womb.

The *Book of James* contradicts the stereotype of the Virgin as an ideal of absolute purity and the exceptional woman who, alone of all her sex, is spared the uncleanness of the female condition. The second-century Mary does not yet coincide with the traditional figure of the Holy Virgin, unstained (*sine macula*) and seen in opposition to an ordinary woman "who belongs to time and flux."[15] In the future not only menstruation but even a visible pregnancy will be avoided in Mary's iconography. But in this early apocryphal gospel female physiology is not yet taboo, and Joseph is shocked by his young wife's pregnancy. Reading the description of the elderly husband's outrage, one realizes the degree of the author's own amazement and his desire to render the miracle more accessible by means of the blood-spinning and weaving metaphors – reflections of the ancient belief in the generative faculty of the menstrual discharge. But the production of the purple fabric functions not only as an effective symbol of Jesus' clothing in Mary's flesh. It suggests the royal purple of the world's future sovereign and the scarlet robe in which the Roman soldiers dress the King of the Jews. It also foreshadows medieval representations of Jesus' infancy which show Mary knitting for her child the seamless tunic (Plate 13) – the outfit worn by Jesus during his passion. The weaving of the "red thread" into the "red veil" conveys the transition from fluidity to solidity, from time to space, from a dot (sign, letter, word) to surface and texture, and from the immediacy of conception to the emergence of a "true" image. The annunciation is immediately followed by the Virgin's finishing and depositing the Lord's red veil in the temple. Taking the textile from the girl's hands, the priest treats Mary with such reverence as if she were already bringing him the baby Jesus.

Paradoxically, the very same text which is inspired by the intricacies of female sexuality also claims Mary's perpetual physical virginity – against the New Testament, which indicates that after Jesus' birth Mary's marriage with Joseph is consummated, as it mentions the Lord's brothers. The *Protevangelium* contrasts Mary's menstruation with her symbolic continence expressed in metaphors of sound vessels. They are used twice, each time at a crucial point of the narrative. Just before the annunciation, as Mary is about to be turned into God's receptacle, she fills a pitcher with water. That the pitcher stands for herself becomes clear when, doubting his wife's faithfulness, Joseph brings Mary to the temple to have her virginity tested. She is given "to drink of the water of the conviction of the

Lord . . . and sent . . . into the hill-country" and expected to be leaky;
but "she returned whole" (*Book of James*, 16:1–2).

Joseph was satisfied with this proof of his wife's purity; the author
of the *Protevangelium* wasn't. He introduced a skeptical woman by
the name of Salome who, upon hearing that a virgin had given birth
requested to insert a finger into Mary's vagina.[16] She found the
hymen intact, but was punished for her disbelief by divine fire
which burnt her hand. The idea to prove Mary's absolute purity by
means of an anatomical examination strikes one as rather drastic,
especially by Christian standards. It certainly renders the *Book of
James* a problematic reading. Therefore it is not surprising to learn
that Mary's apocryphal biography was considered heretical and
listed in the first index of forbidden books, attributed to Pope
Gelasius I but probably dating from the sixth century or later.

The *Protevangelium* reflects concerns and patterns of imagination
similar to those of the Hemorrhissa legend. Both deal with the
breaking of the Jewish taboo of menstruation and the "healing" of
unclean women through God's touch; both present female flux as a
pollution which, however, should not be dreaded but respected for it
leads to incarnation; and both are unable to resolve Christianity's
fundamental tension between a simultaneous insistence on physic-
ality and spirituality. The apocryphal story of Mary's anatomical
examination is based on the biblical disbelief of the Apostle Thomas
whose finger is inserted into the wounded side by the resurrected
Christ himself – a strange, at once immaterial and material double
of his former self: in the *noli me tangere* scene he is a divine enigma
inaccessible to human touch, in the Thomas episode a living corpse.

(iv) *Biblical Tactility*

Under the influence of the Virgin-cult, Christian theology began to
fuse and confuse the various biblical females, thus proceeding
towards a single feminine escort of Christ – a multifunctional
mother–spouse–bride–anima. A connection between the Hemor-
rhissa and Mary Magdalen, out of whom Christ casts seven devils
and who then becomes his devoted pupil, was established in a fourth-
century Greek text.[17] It identified the woman with the issue of
blood with the Canaanite woman's daughter from whom Christ
expelled a demon (Mt. 15:22–8). A reason for this identification
might have been an association between menstruation and redness

(or red earth). The etymology of *Phoinike*, an old Greek name for Phoenicia or the land of Canaan, points to "red" and "purple" – colors that were used as epithets of Astarte, the mother of the Phoenician gods.[18] A late fourth- or early fifth-century Latin sermon nursed similar analogies.[19] Arriving at Mary's and Martha's house in Bethany, Christ found the two women sick. And since he "loved Martha and her sister" (Jn. 11:5), he cured them both: Mary was exorcized and Martha's hemorrhage was stopped.

Religious imagination favored Mary Magdalen, the first witness of the resurrection and the addressee of Christ's "don't touch me" – an admonition which released a flood of erotic fantasy. Since in the New Testament most women remained anonymous, the Magdalen's big advantage lay in her having a name and being mentioned in each evangel. Her biblical significance inspired the Gnostic *Gospel of Mary* in which Peter says to her: "Sister, we know that the Savior loved you more than the rest of women."[20] Preparing the ground for the medieval anima mysticism, Cyril of Jerusalem (ca.315–86) fused Mary Magdalen and the Holy Virgin; and he compared Jesus to the bridegroom of the Song of Songs, and Mary Magdalen and other women to his bride-souls:

> But before He entered through the closed doors, the Bridegroom and Suitor of souls was sought by those noble and brave women. They came, those blessed ones, to the sepulchre, and sought Him Who had been raised, and the tears were still dropping from their eyes, when they ought rather to have been dancing with joy for Him that had risen. Mary came seeking Him, according to the Gospel, and found Him not . . . Are then these things also written? He says in the Song of Songs, *On my bed I sought Him Whom my soul loved.* At what season? *By night on my bed I sought Him Whom my soul loved*: Mary, it says, *came while it was yet dark. On my bed I sought Him by night, I sought Him, and I found Him not* . . . He not only rose, but had also the dead with Him when He rose. But she knew not, and in her person the Song of Songs said to the Angels, *Saw ye Him Whom my soul loved?* (*Lecture* 14. 12)[21]

In a homily by Gregory the Great (ca.540–604), Mary Magdalen is coalesced with the nameless but extremely affectionate prostitute who approached Jesus, an alabaster flask of ointment in her hands, as he dined in Simon's house.[22] Shocking Christ's entourage, the woman "standing behind him at his feet, weeping . . . began to wet his feet with her tears, and wiped them with the hair of her head,

and kissed his feet, and anointed them with the ointment" (Lk. 7:38). Simon in particular was so upset by the scene that "he said to himself, 'If this man were a prophet, he would have known who and what sort of woman this is who is touching him, for she is a sinner'" (Lk. 8:39). Jesus guessed Simon's thoughts and rebuked him with the famous remark: "her sins, which are many, are forgiven, for she loved much" (Lk. 7:47). Gregory's fusion was inspired by the fact that Mary, the sister of Martha, did exactly the same as the prostitute (Jn. 11:2) – and it transformed Mary Magdalen into a contradictory character, a hybrid of impurity and virtue, sensuality and spirituality.

The importance of Martha and Mary was also due to their relationship with Lazarus, whose return from the dead shows Jesus in solidarity with women and foreshadows Christ's own resurrection. The revival of Lazarus is preceded by a parable built around the number "twelve" which divides day (traditionally male) and night (traditionally female) as well as those who can see (=be clear in their heads=believe) from those who can't. In the Lazarus episode women see and believe, men don't – and thus have to be convinced by means of a miracle: "Then Jesus told them plainly, 'Laz'arus is dead; and for your sake I am glad that I was not there, so that you may believe'" (Jn. 11:14–15). While the apostles, led in their doubt by Thomas, the Twin, still hold Jesus for a man who together with them will be stoned to death in Bethany (Jn. 11:16), Martha considers him "the Christ, the Son of God, he who is coming into the world" (Jn. 11:27).

Lazarus's revival borders on the macabre, Jesus' resurrection is permeated with sublimity. But otherwise similarities abound. Martha removes the stone from Lazarus's tomb (Jn. 11:39–41); Magdalen Mary comes early in the morning to Jesus' tomb and sees that the stone has been taken away (Jn. 20:1). Lazarus discards the bandages with which his hands and feet have been bound and the fabric in which his face has been wrapped (Jn. 11:44), as he walks towards his sisters; Christ leaves his shroud and headcloth in the tomb (Jn. 20:6–7) and in the outfit of a common man meets Mary Magdalen, who takes him for a gardener.

The New Testament suggests that Jesus revived Lazarus because of his affection for Mary, whose lamenting the death of her brother "deeply moved" him (Jn. 11:33); it establishes a correspondence between Jesus' pity and the compassionate feelings of women who are present at his crucifixion, who observe the wrapping of his

corpse by Joseph of Arimathea, and who arrive at his tomb with spices to anoint the dead man; and it chooses women as the first recipients of the good news of Christ's resurrection. What is the reason for this choice? It seems to be due to combined stereotypes about women, the traditional naive believers in miracles and dealers in wondrous gossip. But, more importantly, women's devotion to Jesus reflects the evangelists' desire to link them to the incarnate God. Their presence connects Christ's death and rebirth to gods of vegetation mourned by goddesses.

A passionate woman with beautiful long hair searching for the dead Christ and lamenting his death, Mary Magdalen continued a familiar tradition (Plate 9). She resembled Venus, Ishtar, Isis, or Anaitis searching for the corpse of Adonis, Tammuz, Osiris, or Baal;[23] and as Adonis and Tammuz were gods of vegetation, the Magdalen's mistaking Jesus for a gardener reinforced the analogy with ancient mythology.[24] Coalesced with Mary the Egyptian and other reformed prostitutes, the relatively colorless New Testament Magdalen came to embody carnality, sensuality, and seductiveness. This added to Christian iconography the badly needed figure of an attractive and fleshly female contrasting and complementing the madonna. As the divinization of the Holy Virgin discouraged allusions to her physiology, female incontinence was projected onto the Magdalen – an attractive Madonna–Hemorrhissa. This link to flux might have inspired, as Marina Warner has already suggested, medieval legends in which after Jesus' death Mary Magdalen is put to sea together with her brother Lazarus, Mary Jacobi, and Mary Salome, and drifts in an unseaworthy boat from Palestine to Southern France.[25]

In the Coptic *Book of the Resurrection of Christ by Bartholomew the Apostle*, the Hemorrhissa is included among the women coming to the Lord's tomb:

> Early in the morning of the Lord's day the women went to the tomb. They were Mary Magdalene, Mary the mother of James whom Jesus delivered out of the hand of Satan, Salome who tempted him, Mary who ministered to him and Martha her sister, Joanna (*al.* Susanna) the wife of Chuza who had renounced the marriage bed, Berenice who was healed of an issue of blood in Capernaum.[26]

In medieval art Veronica and the Magdalen, each equipped with her respective attributes, often stand at the crucifix (Plate 5). Veronica displays a white cloth imprinted with the Lord's blood-red

"true" portrait, while Mary Magdalen, her splendid hair suggestive of a natural veil, holds in her hands a pyx evocative of Christ's anointment. The fabric stained with blood and the container filled with ointment hint at femininity consumed – deflowered, impregnated, infused with seed. In the Middle Ages St Mary Magdalen patronized the producers of wine and perfume, and the weavers.[27] And Veronica protected – under the name of Venice or Venisse – the female flux, and was celebrated on Mardi Gras by women offering her candles (symbols of Christ) and clean sheets.[28] Occasionally, the combined remembrances of the Holy Virgin, St Mary Magdalen and St Veronica resulted in such images as the mid-fourteenth century *Maddalena cristofora* by Paolo Veneziano.[29] In his Byzantine-like depiction of the Magdalen's assumption, Christ's portrait appears on her breast like a *clipeus* or Holy Face on, respectively, the front of the Theotokos and Veronica. But here the icon is borne not by cloth but by the Magdalen's sumptuous hair – yet another female medium suitable for being impregnated with Jesus' "true" likeness and yet another symbol of flux.

(v) *Egyptian Hair and Royal Relic*

In mythology *nomen est omen*, with names and their (mis)readings, (mis)spellings and (mis)translations influencing the development of characters and plots. A name's various readings and meanings, associations with other names (and words), and metaphors may define a personality as well as a legend's plot. Each mythological figure owes a lot to the real or invented people with whom it shares the same or similar name(s), as well as to words resembling or evoking its name(s). Up to our day the most famous of all the Berenices has remained the Egyptian Queen Berenice II (ca.269–221 BC), the daughter of Magas, king of Cyrene, and the wife of Ptolemy III Euergetes. We even possess her picture on a third-century BC coin showing a beautiful woman in profile, her head covered with a veil.[30] Berenice II is still remembered because of her hair. During her husband's absence on an expedition to Syria, she cut her locks and dedicated them to Venus for the king's safe return. They were deposited in the goddess's temple at Zephyrium, from which, however, they mysteriously disappeared. The mystery was solved in a way flattering to the queen by the court astronomer, Conon; he said that her locks had been carried to heaven and placed among the

stars, and he named a constellation he had just then discovered Coma Berenices – the Hair of Berenice.

The queen's sacrifice was commemorated by Callimachus (active ca.250 BC), the Greek poet and chief librarian of the Alexandrian library, in his poem *The Lock of Berenice*, which has been preserved as a small fragment. Its narrator is the hair complaining bitterly about its separation from the queen's head. Not even the honor of being assumed to heaven can "outweigh the distress which I feel that I no longer shall touch that head, from which when [Berenice was] still a maiden I drank so many frugal scents, but did not enjoy the myrrh of the married woman's [hair]."[31] Callimachus's verses are mostly known from the translation by the Roman poet Catullus (?84–54 BC), who studied in the school of the Alexandrian poets. In his own version of the *Coma Berenices* – the title of his 66th poem – Catullus used the analogy between Berenice's agony, caused by her husband's departure, and the despair of her locks, separated from her head, as a pretext to play an erotic hide-and-seek game, ambiguous and full of surprises. His Berenice, a woman consumed with passion and longing, is one of those "lovers" who "cannot bear to be far away from the side of him they love" (66. 31–2) and in his absence "brush away the tears" (66. 30).[32]

Catullus's verses are permeated with sexual imagery: with metaphors of the soft (female hair) yielding to the hard (steel); of delicate matter being carried away by male energy; of intimate and passionate contacts and dark pursuits. In his vision Berenice's hair resembles a luminous hymen, a woman's most precious membrane, and its lament evokes a female mourning her defloration. The dazzling flow of metaphors makes us realize that Berenice's cut hair, not unlike Veronica's veil, suggests the loss of virginity and the material manifestation of this loss – the blood-stained sheet which in Muslim countries is still exhibited after the nuptial night. The *vera icon* of Berenice's hair celebrates a femininity which is first consumed and then rewarded by men – assumed to their heaven where, however, a female may feel as uncomfortable as the hair of the Egyptian queen:

Then Venus – that among the various lights of heaven, not only should the golden crown taken from the brows of Ariadne be fixed, but that I also might shine, the dedicated spoil of Berenice's sunny head – me too, wet with tears, and transported to the abodes of the gods, me a new constellation among the ancient stars did the goddess

set . . . touching the fires of the Virgin and the raging Lion . . . But
though at night the footsteps of the gods press close upon me . . . I do
not so much rejoice in this good fortune, as grieve that parted, ever
parted must I be from the head of my lady; with whom of old, while
she was still a virgin, delighting herself with all kinds of perfumes, I
drank many thousands. Now, ye maidens, when the torch has united
you with welcome light, yield not your bodies to your loving spouses.

(66. 59–80)

Catullus's *Hair of Berenice* reflects the ancient taste for fluidity
and metamorphosis. But his poem must have also appealed to early
Christians who could see the biblical women connected to Jesus
through flesh and skin, hair and flux as Berenices reborn. The
memory of Queen Berenice was kept alive not only by the
constellation named for her and verses written about her but also
through the existence of two other Egyptian princesses: Berenice,
also called Cleopatra (d. 80 BC), and Berenice (d. 55 BC), the sister of
the great Cleopatra and the wife of Archelaus, who had been made
king of Comana in Pontus (or in Cappadocia) by Pompey. At the
beginning of the Christian era the name rang a bell because of two
Jewish princesses. Berenice, the daughter of Salome and sister of
Herod I; and Berenice (b. ca.AD 28), the daughter of Agrippa I, king
of Judaea, and a scandal of a woman.[33] Josephus reports that her
reputation was so bad that when her father died, the population of
Caesarea dragged her statues to brothels. She married her father's
brother, after his death lived with her brother, Herod Agrippa II, and
together with him participated in the trial of Paul (Acts, 25:23). In
66, at the beginning of the Jewish insurrection, Berenice found
herself in Jerusalem and interceded at the tribunal of the procurator
Florus. Josephus describes the episode in the style of a reformed-
prostitute-story:

> Now she dwelt then at Jerusalem, in order to perform a vow which she
> had made to God; for it is usual with those that had been either
> afflicted with a distemper, or with any other distresses, to make vows;
> and for thirty days before they are to offer their sacrifices, to abstain
> from wine, and to shave the hair of their head. Which things Berenice
> was now performing and stood before Florus's tribunal, and besought
> him [to spare the Jews].
>
> (*The Jewish War*, 2. 15. 313–14)[34]

As her compatriots struggled for independence, Berenice joined the
Roman party, gained the favor of the old Emperor Vespasian (AD

70–9), and conquered the heart of his son, the Emperor Titus (79–81), who carried out the siege of Jerusalem and destroyed the city. Agrippa and Berenice, to whom Titus had promised marriage, followed him to Rome and were allowed to reside in the imperial palace. This created such an outrage that Titus felt obliged to send Berenice back to the East.[35] In medieval legends both the father and the son are cured by means of Veronica's cloth from either leprosy or other skin illnesses, and convert to Christianity. For the sake of historical perspective we should remember that Pliny's *Natural History*, our main source of information on ancient menstruation beliefs, was written during Vespasian's reign, and dedicated to Titus.

The Byzantine chronicler John Malalas (ca. 491–578), a follower of Eusebius, the *Doctrine of Addai*, and Macarius Magnes, mentions in his *Chronographia* a prominent Hemorrhissa–Berenice from Paneas. In an obvious imitation of the Abgar–Jesus correspondence, she writes an official letter to the toparch Herodes Agrippa asking him for permission to erect a monument of Jesus and herself, and promptly receives a positive response.[36] The noble status of the biblical Hemorrhissa was also expressed by the Emperor Julian's reaction to the Paneas monument.[37] He first had the statues of Jesus and the Hemorrhissa destroyed and then replaced with a portrait of himself in the company of Zeus and Aphrodite. The appearance of aristocratic lady-friends of Christ reflects the ambitions and activities of the female members of the imperial family. Typical examples are the legends of Saint Helena (ca.247–ca.327), the mother of Constantine the Great, or Protonice (Petronice, Patronice), a fictional wife of the Roman Emperor Claudius (AD 41–54) – who was married four times, but to no woman by such a name. The Protonice account, contained in the *Doctrine of Addai*, was written, according to Phillips, earlier than the almost identical legend of the cross invention by St Helena.[38] He may be wrong, but this does not concern us here. Obviously, both legends are close in time and products of the growing fascination with relics: the *verae icones* and the *verae cruces*.

A relic usually looks perfectly ordinary but works miracles because of an imperceptible power derived from contact with the holy. The relic's "true" nature is invisible and thus reveals itself not through sight but through touch. Anything that comes in contact with God is injected with his divinity transforming objects and humans into relics. By "overshadowing" Mary, a Jewish girl, God

the Father turned her into the Holy Virgin – a relic. Jesus, the offspring of divine tactility, was a relic – and the origin of the Christian cult of relics.[39] Jesus looked like a man, but his touch wrought miracles, contradicting visible evidence and proving him a divinity. The Petronice legend deals with the question of how to recognize a relic. The "true" cross is found along the line of a logic that would have also worked for identifying Jesus. Imagine that you are seeking Christ, whom you have never seen. On your way you encounter three fellows, one of whom may be he. How do you figure it out? You touch each of them and see what happens. That is the story of Protonice. Impressed by "the signs and wonders, and marvellous works" done in Rome by Simon, one of Jesus' disciples, the pagan empress converted to Christianity; she "arose promptly and descended from Rome to Jerusalem, she and her two sons with her, and her one virgin daughter," in order to see "Golgotha, on which Christ was crucified, and the wood of His cross on which He was suspended by the Jews, and the grave in which He was placed" (*Doctrine of Addai*, pp. 10–12).

When the imperial family entered the grave, a miracle signalled to them that they had found the right spot. Protonice's "virgin daughter fell down and died, without pain, without disease, and without any cause of death" (p. 12). The princess was killed by God – very much with his traditional taste for untouched young girls – not without a reason. A dead female body was needed for a performance of resurrection and for the solution of the otherwise insoluble riddle: which one of the three crosses belonged to Jesus? This was realized by Protonice's bright son. Upon his suggestion the empress took one cross after the one other, placing each on top of her daughter. When the "true" cross touched the dead virgin, "in the twinkling of an eye . . . her daughter became alive, and she arose suddenly, and praised God, who had restored her to life by His cross" (p. 14).

In the cross, as in all great religious symbols, opposites coincide. It can symbolize the femininity of the world (mother) axis, bearing the crucified Jesus like a Theotokos or a medieval *vierge ouvrante*, or his masculinity. In this particular legend the cross acts as a phallus, and the episode borders on obscenity. A fifteenth-century French depiction of the miracle shows how the cross, placed right on the young girl's womb, makes her rise from the stretcher and pull apart the sheets with which her naked body has been covered (Plate 14).[40] The finding of the cross and other relics is not, as Peter Brown has

pointed out, an invention but an identification.[41] In the Protonice–Helena legend the "true" cross, which has been identified with a female body, can be subsequently perceived as God's gift to the girl. The reanimation of the Roman princess is modelled after the revival of Jairus's daughter, but the substitution of Christ by his cross makes it resemble sexual initiation even more than in the Bible. Since the resurrection is preceded by killing, with God acting as the girl's murderer, a sinister sexuality is introduced and the problem of Father delivering his Son – and every human being – is addressed. The identification of the "true" cross demonstrates the contradictory, good-evil character of divinity – and of our most common erotic reverie: the fantasy of first exposing the objects of our longing to mortal danger, and then rescuing the beloved.

(vi) *The Gnostic Flood of Blood*

In the second-century Gnostic cosmogonies the biblical Hemorrhissa appears under the name of Prunice (*Prounice, Prounicos, Prunicus, Pruneicos*, etc.).[42] She is regarded as a feminine principle of the universe and identified with Sophia (Wisdom) and Mother Achamoth – "the second Sophia . . . banished . . . to the region of emptiness and shadow," who is "the abortion, the mere negative side of the higher wisdom, at first wholly formless, then wrought to a form in substance, but not in knowledge."[43] Prunice's flux is seen in analogy and contrast to divine emission and Jesus' bleeding. But while God's emanations resemble the streaming of (sun)light and semen, Prunice's discharge is perceived as a form of procreation. Thus the Valentinian Gnostics use *Prunice* in the sense of "bearer," believe in several Prunices (each has a different name), and interpret the 12 years of her flux as her 12 emanations or children.[44] But Prunice's menstruation is also regarded as a global blood-flood endangering the existence of the world.

In the past the knowledge of Prunice was mostly derived from the treatises written against the heretics by Irenaeus, the late second-century bishop of Lyons, and the *Panarion* of Epiphanius (ca.315–402). Both ridicule the concept of Prunice, accuse the heretics of obscenity, and dismiss the Gnostic Hemorrhissa as a cover for pleasure and voluptuousness. Origen (ca.185–ca.254) mentions *Prunicus* in *Contra Celsum*, his refutation of *The True Word* by Celsus, a

second-century opponent of Christianity. Origen first quotes Celsus who writes:

> They have further added one on top of another sayings of prophets, and circles upon circles, and emanations of an earthly Church, and of Circumcision, and a power flowing from a certain virgin Prunicus, and a living soul, and heaven slain that it may have life, and death in the world being stopped when the sin of the world dies . . . And everywhere they speak in their writings of the tree of life and of resurrection of the flesh by the tree – I imagine because their master was nailed to a cross and was a carpenter by trade. So that if he had happened to be thrown off a cliff, or pushed into a pit, or suffocated by strangling, or if he had been a cobbler or stonemason or blacksmith, there would have been a cliff of life above the heavens, or a pit of resurrection, or a rope of immortality, or a blessed stone, or an iron of love, or a holy hide of leather. Would not an old woman who sings a story to lull a little child to sleep have been ashamed to whisper tales such as these?
>
> *(Contra Celsum*, 6. 34)[45]

Paradoxically, Celsus's confusion of Jewish, Christian, and Gnostic teachings reinforces his point by revealing the metaphorical core of religion and its origin in the imaginary. Bringing together emanation and flow, circumcision and Prunicus, Celsus shows the centrality of the light-and-blood (=emission) symbolism as ways of linking divinity and humanity. Celsus's brilliant and merciless critique suggests that the Gnostic obsession with blood-flux is derived from Judaism, Zoroastrianism, and Christianity. That's why Origen takes his argument so seriously and replies:

> The phrase about *emanations of an earthly Church and of Circumcision* was perhaps taken from some who speak of a certain heavenly Church, and say that the church on earth is an emanation from a higher world, and that the circumcision described in the Law is a symbol of a circumcision which has taken place in some heavenly rite of purification. *Prunicus* is the name given to Wisdom by the Valentinians, according to their own deceived wisdom; and they want to make out that the woman who had an issue of blood for twelve years is a symbol of Wisdom. It was because this fellow, who muddles together everything from Greeks, barbarians, and heretics, misunderstood this that he spoke of *a power flowing from a certain virgin Prunicus*.
>
> *(Contra Celsum*, 6. 35)

The Prunice mythology reflects the Gnostic idea of multiple worlds, spheres or periods of times which are called aeons (in Greek literally "period of time" or "lifetime") and conceived as God's emanations or thoughts. The first aeon was fully charged with divine power that was gradually lost as aeons kept breeding aeons. Gnostic writings differ in their explanation of aeons, but they usually maintain that their number increased proportionally to their distance from the divinity and that the lower aeons possessed proportionally less energy. In some systems the aeons were considered agents of illumination and divinity, in others they were interpreted as material hindrances, layers of time and space separating the human soul from its heavenly origins and obscuring the eyes and the mind. The aeons could be male (and include one or several Jesuses and Judas, the 12th aeon) or androgynous, but mostly they were female.[46]

In the *Apocryphon of John*, an important tractate composed before AD 185 and still used by heretical sects in the eighth century, *Pronoia* ("Providence," "Forethought"), God's first emanation, is a female aeon combining divine spirituality with earthly physicality. Pronoia is the "image of the invisible, virginal Spirit who is perfect" and "the womb of everything for she is prior to them all."[47] In the *Trimorphic Protennoia*, a treatise roughly contemporaneous with the *Apocryphon of John*, God's *Protennoia* ("the First Thought") acts as a heavenly redeemer. She descends three times from the universe of Life and Light into the mortal world, appearing first as Father or Voice, second as Mother or Sound, and third as Son or Word. The purpose of Protennoia's trips to earth is to reveal the hidden, to awaken those who sleep, to make remember those who have forgotten, and to bring salvation through knowledge and the "Five Seals" – five secrets which "complete the virtue of Intellect" and are perceived as a sort of spiritual or intellectual clothing achieved in the process of illumination: "he who possesses the Five Seals . . . has stripped off the garments of ignorance and put on a shining Light."[48]

The most popular aeon is *Sophia* (Wisdom). In *The Sophia of Jesus Christ*, a revelation discourse composed in the first two centuries AD, Sophia perfects her greatness by reflecting God "without a word," acts as the consort of the Immortal Man, and is called the "All-Begettress," "First-Begettress," "All-Mother," "Love-Sophia" and "Silence."[49] The *Apocryphon of John* and other Gnostic writings report about Sophia's fall, which is caused by her disobedi-

ence – her desire to bring forth without the permission of the Great Spirit. The fallen Sophia–Achamoth, whom Irenaeus compares to the unformed Platonic matter, becomes a source of corruption, emitting increasingly inferior aeons or elements. Her tears turn to water, her hysterical laughter to light, and her sadness to solid substance.[50] For the Barbelonites a Sophia–Prunice is the first emanation of the first angel – and a lonely single. Envious of married creatures, she flows to the very bottom (of matter), where she gives birth to Protoarchon, a creature of ignorance and presumption and the creator of the world.[51] The Ophites call their Sophia–Prounikos the "Left" and the "Male-Female" and consider her an emanation of the First Woman – mother of all living beings and spouse of God Father and God Son. She falls from the "domain of Fathers" into the inferior world of matter, becomes incarnate, floats on water, issues seven aeons, inspires the creation of Adam and Eve, introduces the couple to sexuality and death, and is responsible for the birth of John the Baptist and Jesus Christ.[52] In Gnostic cosmogonies the 12 years of the Hemorrhissa's flux transform into the 12th aeon or into in an apocalyptic 12-year-long passion-flood which, had Christ not appeared, would have annihilated the world. But as she touches the hem of his tunic – symbol of the last quarter of the moon – the flux stops and creation is saved.[53]

The vision of the terrible Hemorrhissa might have been influenced by the Zoroastrian myth of the Great Whore. She awakened Ahriman, the Destructive Spirit of the universe, who for 3,000 years had remained in "stupor for fear of the Blessed Man," and inspired him with her promise of destruction saying: " 'I shall afflict the water, I shall afflict the earth . . . I shall afflict all the creation . . .' And she related her evil deeds so minutely that the Destructive Spirit was comforted and . . . leapt forth and kissed the head of the Whore; and the pollution which is called menstruation appeared on the Whore."[54] The sight of her blood encouraged Ahriman. He took the form of a serpent and "trampled upon all the world and made it as dark as the darkest night . . . And upon the waters he brought brackishness . . . And upon the earth he let loose reptiles . . . And . . . he brought concupiscence and want, bane and pain, disease and lust . . . and sloth."[55]

The Zoroastrian myth of the Great Whore represents an exceptionally forceful confession of the male fear of female sexuality – a horror so intense that it needs cosmic dimensions to express itself.[56] While the gospels break through the magic spell of menstruation,

the mythology of a menstrual flood issued from a primordial whore is echoed in the Revelation. The Apocalypse presents global evil under the guise of female figures and metaphors in which obscenity is combined with flux and redness. Thus we have "the great harlot who is seated upon many waters, with whom the kings of the earth have committed fornication, and with the wine of whose fornication the dwellers on earth have become drunk" (Rev. 17:1–2); and the "woman sitting on a scarlet beast" who "was arrayed in purple and scarlet," was "holding in her hand a golden cup full of abominations and the impurities of her fornication," and who was "drunk with the blood of the saints and the blood of the martyrs of Jesus" (Rev. 17:3–6). Dominated by hatred of the material, physical, and female, Revelation presents the entire earth as an unclean and poisonous menstruating monster, the beginning and end of all evil, and opposes her to the good, full woman – "clothed with the sun" (Rev. 12:1) – i.e. pregnant with a male child (Plate 15). In order to accomplish salvation, Christ, the lamb-soldier of the Apocalypse – a bloodbath of a book – has to destroy the Whore and her satanic companion, the "great red dragon" (Rev. 12:3) pursuing God's bride. The narrative stresses the contrast between the deadly female flux and the salvatory character of blood shed in God's struggle against evil, and in consequence between the stained garments of sinners and the robes of martyrs made pure and white "in the blood of the Lamb" (Rev. 7:14). And it glorifies the holy juice of the Lord "who loves us and has freed us from our sins by his blood" (Rev. 1:5).

The legends of the Zoroastrian Whore, the Apocalypse Prostitute, and the Gnostic Sophia–Prunice–Achamoth identify the menstrual flux, unclean and dark, with evil femininity. Good femaleness, on the other hand, corresponds somewhat to the "face of the waters" over which "the Spirit of God was moving" (Gen. 1:2) – a fluidity that is illuminated and made into a mirror by divinity.

The Vera Icon *in the West*

6

St Veronica

(i) *The Roman Vernicles*

The appearance of an *acheropsita* in Rome in the middle of the eighth century was not accidental. The cult of the mandylion may have been introduced by the Greek Pope John VII (705–7), and the iconoclast controversy in Byzantium further popularized the "true" image concept in the West and made Rome, where the papacy consequently opposed the destruction of images, emerge as the new center of orthodoxy. In 1216 the Hemorrhissa's claim that she had obtained the impression directly from Jesus was acknowledged, her cloth (the one kept in St Peter's) was authenticated, and an office of the Holy Face, with its own invocations and dispensations, was instituted by Pope Innocent III, the initiator of the horrible crusade against the Albigenses.[1] The invocations, *Salve sancta facies* and *Ave facies praeclara*, were included in medieval prayerbooks (*Horae*) and illustrated with miniatures (Plate 16); and the number of Veronica depictions in Western art began to grow.

The Catholic Church celebrates St Veronica on 4 February and calls her a "matron." But in medieval calendars the day is often indicated as that of Veronica the Virgin.[2] The choice of the date reflects an ancient tradition. The name Februarius (since 452 BC the second month of the Roman calendar) is derived from *februare* (purify) or from *Februa*, the Roman festival of expiation and lustration, which was held in the second half of February. In this

month also the Lupercalia took place, a festival dedicated to the purification of women by the priests of Pan Lyceus. The Anglo-Saxons called February "Sprout Kale," for the seasonal sprouting of cabbage, and later it was known as Solmonath, in reference to the sun returning from low latitudes.[3] For this reason other saints related to the old opposition (and coincidence) of bleeding and purification (through solarity) are also remembered in February. Candlemas or the Purification of the Virgin, the most ancient festival in honor of Mary commemorating the presentation of Christ in the temple, is celebrated on the second (her feast is considered the day of homosexuals in Bulgaria), and in France St Fiacre, the patron of hemorrhoids, male flux, and gays, is occasionally fêted together with St Veronica on Mardi Gras.[4]

The historian Giraldus Cambrensis (1146?–1220) mentions two Roman "true" icons and attributes the picture from the Lateran Holy Savior's church to St Luke (whom the Virgin had asked to paint her son), the image from St Peter's to "Veronica matrona."[5] The description of the Sancta Maria ad Praesepe vernicle of St Peter's by Gervase of Tilbury, the Anglo-Latin writer and traveller of the late twelfth and early thirteenth centuries, seems to suggest that the cloth (canvas?) has shown not only Christ's face but also his shoulders.[6] Other Roman churches also boasted Christ's authentic portraits. San Silvestro in Capite, for instance, claimed to possess an *Abgarus* (another "true" *Abgarus* was in Genoa).[7] As masses flocked to the relics, the demand for copies reached such proportions that by the late Middle Ages the Roman *vera icon* copyists founded a guild.[8] But since replicas were treated not as paintings but as new *acheiropoietoi*, churches and cloisters throughout Europe acquired their own "vernicles" and organized their own cults of the Holy Face.

A special fame was achieved by the "true" image which Jacques Pantaléon de Troyes, the future Pope Urban IV, sent in 1249 as a gift to his sister Sybil, the abbess of the Montreuil-les-Dames nunnery near Laon (Plate 17). The arrival of the picture, which was to become the region's most precious relic, transformed the humble convent into an important center of worship and pilgrimage. The icon's celebrity reached its apogee in the second half of the fifteenth century, but Christ's likeness continued to attract crowds, promote the creation of Holy Face fraternities, and fuel the mass production of devotional articles until the French Revolution. It has been suggested that the Laon picture was a copy of the St Peter's

veronica, but Grabar has proved that the Laon *acheiropoietos* which, in fact, carries a Cyrillic inscription, was a Slavic icon from Serbia, Bulgaria or Russia brought to Rome as a present from one of these countries' rulers.[9]

As interest in the passion grew, and as the Veronica legends began to dwell on her obtaining the "true" image at the *via crucis*, the Roman mandylions of the living Jesus were joined by the *vera icon* of his dead face. It was covered with large drops of blood, had a macabre touch, and inspired a new kind of *sancta facies* invocation. It is not clear since when the relic had been kept in the sacristy of St Peter's. But it replaced the Sancta Maria ad Praesepe vernicle (lost since 1527), and it was widely circulated in ever cruder copies until the twentieth century. The existence of the various Holy Faces stimulated mystical and artistic visions. But in the West, unlike in Byzantium, the actual presence of Christ's "true" likenesses was overshadowed by the enormous bulk of the St Veronica legends – romantic, erotic, and propagandistic – which made the woman with the cloth a more popular subject than the vernicle alone.

(ii) *The Acts of Pilate*

The growing importance of Rome was mirrored in the legends of relics and icons travelling not any more to the East, but to the West. This change of direction brought into focus a whole set of new issues, the most important of them being the emperor's responsibility for what happened to Christ under Pontius Pilate, the Roman governor who came to Judaea from the household of Tiberius (42 BC–AD 37). This question is already raised in the *Doctrine of Addai* which contains a letter of the baptized King Abgar to the Emperor Tiberius urging him to punish the Jews for what they did to Jesus. To this Tiberius replies:

> With respect to that which the Jews have done with the cross, Pilate the governor hath also written . . . But because the war of the Spaniards who have rebelled against me is going on at this time, therefore I have not been able to avenge this matter; but I am prepared . . . to make a charge legally against the Jews, who have not acted legally. And because of this, as to Pilate, who was made by me governor there, I have sent another in his place, and I have dismissed him with disgrace, because that he departed from the law, and did the will of the Jews, and he crucified Christ for the gratification of the

Jews, who according to that which I hear of them, instead of the cross of death, it was fitting that He should be honoured, and . . . be worshipped by them, especially as they saw with their eyes all which He did.

(*Doctrine of Addai*, p. 37)

The notion of Tiberius's anti-Jewish stance was inspired by Suetonius ("Tiberius," 36), according to whom the emperor's fight against foreign cults in Rome included particularly severe measures against the Jews. Their religious vestments and accessories were burnt, men of military age were drafted into the army and removed to unhealthy regions, and those too old or too young for the service were expelled from the capital and threatened with slavery if they returned. The *Doctrine of Addai* echoes the Bible, which establishes Pilate as the criminal behind the stage through the metaphor of his washing the symbolic blood of Jesus off his hands (Mt. 27:24) – a cornerstone of Christian iconography and sensibility. When passion episodes were added to miracle scenes in the late Constantinian period, Pilate washing his hands became a leading theme, particularly popular on fourth-century Roman sarcophagi.[10] Quoting the "Greeks who have chronicled the Olympiads," Eusebius reports that "in the reign of Gaius . . . the governor of our Saviour's day, was involved in such calamities that he was forced to become his own executioner and to punish himself with his own hand: divine justice, it seems, was not slow to overtake him" (*Church History*, 2. 7. 1). The suicide of Pilate, modelled after that of Judas who "hanged himself" (Mt. 27:5), likens one to the other presenting both as targets of God's justice.

The most popular source of information on Pilate's reporting to the imperial authorities on Jesus' trial is the so-called *Acts of Pilate* which is mentioned already in first-century Christian sources, but was probably written much later.[11] Eusebius speaks of communication between Pilate and the Emperor Tiberius (*Church History*, 2. 2. 1), but he does not refer to Christian *Acts of Pilate*,

although some mention of them would have been natural. This is all the more striking in that he knows pagan Acts (anti-Christian), which were fabricated under the persecutor Maximin and which at his command had to be read in the schools and committed to memory . . . Accordingly the prevailing view today is that the Christian *Acts of Pilate* were first devised and published as a counterblast to the pagan Acts . . . and that previously there had been nothing of the sort.[12]

The existence of the *Grundschrift* of the Christian *Acts of Pilate*, known also as the *Gospel of Nicodemus*, is accounted for since ca.375 or 376. The date of the oldest of the extant Greek versions is given in the prologue as 425.[13]

In the *Acts of Pilate*, a brilliant piece of propaganda, the Roman governor (an apparatchik) and Jews (a bunch of criminals) are the accused. Jesus, on the other hand, has his divine sovereignty recognized by the Roman emperor himself – although the latter is only present *in effigie*. As Jesus comes into Pilate's office, passing the standard-bearers,

> the images of the emperor on the standards bowed and did reverence to Jesus. And when the Jews saw the behaviour of the standards . . . they cried out loudly against the standard-bearers. But Pilate said to them: "Do you not marvel how the images bowed and did reverence to Jesus?" The Jews said to Pilate: "We saw how the standard-bearers lowered them and reverenced him." And the governor summoned the standard-bearers and asked them: "Why did you do this?" They answered: "We are Greeks and servers of temples, and how could we reverence him? We held the images; but they bowed down of their own accord and reverenced him."
>
> (*Acts of Pilate*, 1:5)

The scene was inspired by Josephus's report about the opposition which Pilate met when he attempted to allow the legions to enter Jerusalem with their ensigns (=icons), and it was rendered still more impressive by repetition. Pilate orders the disbelieving Jews to select the 12 strongest men from among themselves and make them carry the standards, and then has Jesus re-enter.

> And Pilate summoned those who before carried the images, and said to them: "I have sworn by the safety of Caesar that, if the standards do not bow down when Jesus enters, I will cut off your heads." And the governor commanded Jesus to enter in the second time. And the messenger did as before and besought Jesus to walk upon his kerchief. He walked upon it and entered in. And when he had entered in, the standards bowed down again and did reverence to Jesus.
>
> (*Acts of Pilate*, 1:6)

The imperial portraits' transformation into the animated *acheiropoietoi* infused with the spirit of Tiberius demonstrates how his

incompetent administrator and the Jews fail to grasp Jesus' true nature. Pilate's threat to cut off the heads of the standard-bearers sounds like a joke, since only painted heads have enough brains to recognize and salute God. Jesus' entrance into Pilate's office is modelled after the *adventus* of the emperor, with Christ, the divine Caesar, greeted by the worldly ruler. The positive action of icons is followed by an equally positive – and iconic – intervention of femininity. The wife of Pilate appeals to her husband, as in the Bible (Mt. 27:19), to spare the "righteous man" because of a dream she had at night. But the Jews have the nerve to reject her plea on the ground that Jesus is a sorcerer – who "has sent a dream to your wife" (*Acts of Pilate*, 2:1). Furthermore, they denigrate incarnation, accusing Jesus that he was "born of fornication," that his "birth meant the death of the children in Bethlehem," and that his father Joseph and his mother Mary "fled into Egypt because they counted for nothing among the people" (ibid., 2:3). All this is contradicted by the appearance of 12 witnesses whose defence of Christ makes the governor exclaim: "I call the sun to witness that I find no fault in this man" (ibid., 3:1). Still, the trial continues with a Pilate–Jesus dialogue on truth (which, Jesus claims, comes from heaven), with the appearance of Nicodemus cured by Christ from a 38-year-long illness, and the voice of Berenice. The former Hemorrhissa is not allowed to participate but cries out from a distance about her healing from her 12-year-long flow. Her oral report is dismissed by the Jews: "We have a law not to permit a woman to give testimony" (ibid., 7:1).

In the *Acts of Pilate* the Hemorrhissa is called Berenice for the first time, and thus the text's significance for the development of the Veronica legend has been long recognized. But the astonishing sequence of events, which involves icons coming alive, female dreams and testimonies, blood and incarnation, has not been fully assessed. First, imperial icons become animate and revere Christ. Second, they are carried by 12 standard bearers who allude to Berenice's name (Pherenice="victory bearer"), to the 12 years of her flux and, possibly, to the Gnostic idea of 12 offspring. The 12 Greek men responsible for icons are followed by the 12 defense witnesses evocative of the 12 apostles. Third, Jesus walks on his kerchief (leaving on it, one guesses, the "true" traces of his feet). Fourth, Christ is defended by women. Fifth, pagan icons and both Roman and Jewish females are connected to incarnation and presented as good. Sixth, the Hemorrhissa's voice counts more than the legal

debate of Jewish scholars. Conclusion: Word has changed its place of residence. True divinity has abandoned men and their language and moved into images and women.

A masterpiece of mythological manipulation, the *Acts of Pilate* foreshadows the fall of evil men and the career of Berenice. She begins to rise in the legends of the *Healing of Tiberius* (*Cura sanitatis Tiberii*), whose manuscripts go back to the eighth century but probably date from the sixth.[14] Gravely ill, the Emperor Tiberius hears from Thomas, a Jew, about the wonders worked by Jesus, and sends his officer Volusianus to bring the famous doctor from Jerusalem to Rome. By the time Volusianus arrives in Jerusalem, Christ is no more. Pilate is arrested and forced to admit his guilt, and Volusianus is informed that Veronica (she is also called Basilla in some early copies), a Hemorrhissa from Tyre, possesses the *egona* of Jesus. This the woman first denies, but under threat she produces the image. Volusianus worships it and returns to Rome, taking with him Veronica, her picture, and Pilate. Upon their arrival Tiberius banishes the governor without seeing him, receives Veronica and, seeing her icon, is immediately cured. The Jerusalem woman is rewarded with money, and the emperor builds a shrine for Christ's portrait and is baptized.

In the *Healing of Tiberius* the figures of Pilate and Veronica form the two poles of the narrative, with him personifying the evil of doubt and opportunism, with her allegorizing the courage to support the persecuted God, to abandon Judaism, and to propagate Christianity. In Rome, Veronica assumes the role of a missionary from the Holy Land, and she signals with her emigration the doomed fate of Jerusalem. This is further elaborated in the *Vindicta Salvatoris*, a Latin prose work written in Aquitaine ca.700, in which, according to Dobschütz, the story of Veronica is for the first time presented against the background of a penal expedition to Palestine, and the destruction of Jerusalem (in AD 70 by Titus). The *Vindicta* and the French *Venjance*, which sprang from it in the late twelfth century, account for the increasingly aggressive character of the pilgrimage to the Holy Land which started as a penance and ended as a crusade.[15] In order to be admitted to the sacrament of the Eucharist, penance had to be performed through fasting, flagellation, or pilgrimage, and led to penitentiary pilgrimages which probably started around 700. In the tenth century, under the influence of the Cluniac revival, they became increasingly popular and numerous, and came to resemble military expeditions. In 1064 seven thousand

armed men marched to Jerusalem under the leadership of the archbishop of Mainz.[16]

The *Venjance* introduces a French king, Titus (the Emperor Titus reborn) or Tyrus.[17] He rules in Burgidalla (Bordeaux) and suffers from a cancer in his right nostril that has eaten away his face up to his eye. A ship carrying a Jewish messenger, Nathan, on his way to Rome to bear a treaty to Tiberius (who is also sick with ulcers and nine kinds of leprosy) is stranded on Titus's shore. From Nathan the king learns that he could have been cured by the prophet Emmanuel who, however, has meanwhile been crucified by the Jews. Hearing this bad news King Titus, adding hatred to Abgar's indignation, exclaims: "Woe to you, Tiberius, in whose realm such things are done. I would have slain these Jews with my own hand for destroying my Lord. At this word the wound fell from his face and he was healed."[18] The cured King Titus is converted to Christianity and sends for Vespasian to assist him. An army of 5,000 men arrives and they sail off to Jerusalem. After seven years of siege the starving Jews finally surrender and are punished in various ways imitative of Christ's passion: sold at 30 for a penny, cast lots upon and cut up into four parts, crucified head downwards, or pierced with lances. Then a search for the likeness of Christ is initiated, and Veronica is found. Titus sends a message to Tiberius asking him to have Velosian come to Jerusalem and examine the case. Velosian comes, puts Pilate in an iron cage and interrogates Veronica, who initially denies that she possesses Jesus' likeness. But under the threat of torture she confesses to having a linen cloth, which she worships daily, and produces it. Velosian robs the woman of her treasure, envelops the image in a golden cloth, locks it in a box, and prepares himself to return to Rome. But Veronica insists on coming with him, and so he takes her. In Rome the miraculous picture cleanses the emperor's body from leprosy and restores him to health. (The healing was rarely shown in art, but the Metropolitan Museum in New York possesses a Flemish tapestry from 1510 with Veronica curing the Emperor Vespasian with her veil.)

The medieval versions of the *Vengeance* are constructed around the destruction of Jerusalem and the pleasure of seeing its inhabitants suffer. Inspired by the crusaders' savageries and their taste for horror, they can be read as manuals in sadism. In a fourteenth-century French text, during the city's siege the starving Jews resort to cannibalism (women eat their children) and Pilate's death is preceded by his dismemberment. On each of 21 consecutive

mornings another part of his body is cut off (ears, hands, and arms are followed by the penis and the tongue); after every amputation he is smeared with oil and honey, to attract flies, and bound to a pillar on a public square. In order to justify the excess, Pilate is made to look like Satan in the company of devils – squatting on the walls of his prison like gargoyles on Gothic cathedrals.[19]

(iii) *The Cross and the Tomb*

The horrible requires the sweet. The more blood flows, the more sentimentality is projected onto the figure of the Hemorrhissa Veronica, the Good Woman of Jerusalem who prefers exile to abandoning Christ's portrait. Some medieval legends leave us with the impression that Veronica is the city's only survivor and that of Jerusalem's splendor nothing has remained but her likeness of the Savior. As the New Sodom is razed to the ground, the woman and the picture are preserved to bear testimony to God's presence on earth. Acting against the grain of her culture, Veronica, a Jewess for Jesus, is praised for the *grant amor* she feels for the Lord – and for becoming the first collector of Christian art.[20]

Veronica's acquisition of the Holy Face follows two basic scenarios. The first, older one, describes a casual or intimate encounter of Veronica, a "friend" of Jesus Christ, and the Lord in the streets of Jerusalem or at the woman's home.[21] In *Dit is Veronica* (ca.1160), a German poem, Veronica is so fond of Jesus that she comes to Luke and asks him to paint a portrait of Christ.[22] The evangelist executes the picture, but when Veronica compares it to Jesus' face, she finds that it doesn't resemble him. Luke excuses himself for his failure and tries again. After he has painted three pictures but has not satisfied Veronica, Jesus himself intervenes. He explains that in heaven alone, from where he has been sent, is his likeness known, and he suggests she invite him for a meal. Sitting at Veronica's table, the Lord washes his face and, as he dries it with a towel, the cloth is impregnated with his true features. In the *Vengeance*, Veronica meets Jesus on her way to the painter whom she wants to portray the Lord.[23] Christ understands her wish without words, takes the canvas out of her hands and, imprinting his face on it, leaves her a better picture than a painter could do. In the oldest version of the *Healing of Tiberius*, Veronica herself is the artist who has painted (*depinxit*) Jesus on her handkerchief.[24]

The second, more recent and popular variant of the legend, was introduced in the thirteenth-century French *Bible en françois* of Roger d'Argenteuil, a didactic prose compilation of Christian legends and doctrinal expositions, which in the fifteenth century was translated into English.[25] On his way to Golgotha Christ passes Veronica who carries her handkerchief to sell it on the market: "And when she saugh oure Lord so sweting and so vilan'ou'sly demened, she had gret sorou ... And she vnlappid the couerchif and sprad it to him & seid, 'Sir, holdith this couerchif and wipe the suete from youre visage" (*Bible en françois*, ch. 17, 18–24). The new version echoes the fact that since the twelfth century there existed in Jerusalem a *via sacra* or *dolorosa* which led from Pilate's house to the Mount of the Skull and was thought to correspond to Christ's last walk on earth. In the fourteenth century the Franciscans took control of it, identified the 14 stations at which Jesus stopped, and turned the *via crucis* into Jerusalem's most attractive sightseeing tour. According to William Wey's *Loca sancta in Stacionibus Jerusalem* (1483), at the station number six pilgrims were shown the house of Veronica, standing next to that of Pilate, in front of which Jesus broke down under the burden of his cross. No doubt, they were also told about blood and sweat streaming from Jesus' face, and about an admirable woman rushing out with her veil, handkerchief, napkin, or apron to assist the Lord:

> Das bluet vnd auch der swaisz
> Vber sein angesicht ran
> Feronica trang durch alle man
> Vnd wischet im sein antlicz wert.[26]

The Jesus–Veronica encounter is made into a melodrama in passion plays, which between the fifteenth and the eighteenth century function as religious soap operas and theatrical parallels to the contemporary pictorial programs of the *viae crucis* and calvaries. The passion plays contrast the torture and death of Christ with the feelings of compassion, love, and sorrow experienced by Veronica, a tearful young bride or a worn-out widow, whose words imitate the speech of ordinary women overcome by grief. Recurring motifs are love and separation, the features of Christ's face and the wish to remember them. A Veronica asking Jesus for a portrait to make sure she does not forget her "dearest Lord's" face brings to mind the Corinthian girl who outlined the shadow of her lover, especially

when the impression is referred to as a "token" or "sign of love."[27] Presenting Veronica with his likeness, Christ admonishes her to remember him.[28] Upon receiving the portrait, the Veronica of a French passion mystery speaks of herself as "full of grace," a phrase usually applied to a pregnant woman and the Holy Virgin with child.[29] But she also may assume a motherly role and wipe the face of Jesus of the dirt with which it has been covered by the Jews spitting at him.[30]

The Veronica legends influenced the iconography and composition of the sculpted and painted passion and calvary altars which began to appear in European churches in the first half of the fourteenth century.[31] In most of them Veronica is solidly present in the large crowd accompanying Christ and witnessing his crucifixion. Sometimes she is even present twice, as on the huge *Crucifixion* panel by Derick Baegert (active ca.1476–1505) who in the background shows Veronica approaching Christ with her napkin, and in front with the Holy Face suspended between her hands.[32] The woman who meets Jesus looks different from the owner of his picture – a suggestion of Veronica's transformation. In the back she wears a heavy dark outfit, in front she is shown in a light white dress – elegant and *décolleté* – and a solar turban, crimson-colored and embroidered with gold.

The drama reaches its climax in separate altar panels depicting the meeting of the two, and no painting is more suggestive, at least to modern sensibility, than Hieronymus Bosch's *Encounter of Christ and Veronica*, a study of sublimity and beastliness.[33] The artist draws our attention to humanity's two extremes. On one side we have the incarnate God and the compassionate woman, on the other the monstrous mob which surrounds them. The persecutors' eyes bulge out of their sockets, mouths gape wide, teeth are bared with cannibalistic greediness. The incredibly banal evil possesses an overpowering vitality – which the good face with total helplessness. Christ and Veronica keep their eyes shut, hold their lips tight. They seem to doze or, rather, he has already slipped away into an unworldly dream, while she embraces amidst the scum her delicate vernicle – a Platonic shadow. The blurred face of Jesus manifests the enigma of divinity, the unattractive face of Veronica the enigma of compassion. United in resignation, both seem insubstantial and pale, incapable of surviving amidst brutality whose contours are carved with the sharpness of a knife.

Strange reminiscences of the vernicle, the shroud, the crucifixion

and resurrection are included in Bosch's triptych of the hermits (Palazzo Ducale, Venice). On its right wing a white piece of linen shimmers in the cave of St Giles, a patron of lepers, beggars, and cripples, and next to it, detached from the cloth, floats Christ's face in the air, a veil-membrane of an icon and an anima-hallucination. On the left wing, dedicated to St Anthony, a large sheet is suspended on the branch of a bare tree. Under it appears a vision-temptation of a naked woman whose womb a snake approaches – an obvious allusion to the Fall caused by Eve's succumbing to the snake. A personification of physical nature, sin, and death, Eve, unlike St Veronica, is coupled not with fabric that has been impregnated by Christ, but with burial cloth – blank female matter prone to corruption.

The symbolism of Veronica as metaphysical wife and her cloth as spiritual child is evoked by Rogier van der Weyden in his triptych of the *Crucifixion* (Plate 5), an exceptionally beautiful painting and an excellent example of Veronica's role in medieval Europe. Its central panel with the crucifix, the Virgin, John, and the two donors is flanked by Mary Magdalen on his right, and St Veronica on his left. The dead Christ's head is bent and reposes on his right arm. Blood trickles from his side and stains the white loincloth. Mary kneels at the bottom of the cross, embracing it and almost touching blood streaming from the wound in her son's feet. Her blue dress corresponds with the blue outfits of two angels flying on both sides of the cross, and white cloth is draped around her head. John, all in red, supports the Holy Virgin; the donors pray. Mary Magdalen is completely covered with a dark green cloth and holds in her palm the pyx. Veronica, on the other hand, resembles the Virgin. Her head is draped in a white fabric, and one catches the glimpse of a blue dress under her red mantle. A white napkin with Christ's portrait is suspended between her fingertips.

The position of the two women vis-à-vis the crucifix and the colors of their garments symbolize the roles played by the Magdalen and Veronica. Standing to Christ's right, the traditional side of life, and blending with the landscape, the figure of Mary Magdalen suggests her affinity to physical nature and her position as the companion of the living Jesus. The pyx reminds the viewer of the care she took of the Lord's skin and the sensuality of her devotion. Veronica's outfit is dominated by red and white, the colors of the Eucharist. They contrast with nature's bloom, allude to passion and death, and point to the care she took of the Lord in his agony. Each

woman displays a tactile attribute, but Mary Magdalen suffers from a disadvantage. Hers is the intimacy remembered by the skin. She mourns her loss and the sorrow seems to be flowing into her tiny vessel, as if she wanted to transform into a meaningful object something Christ's death has rendered a mere shell. Her palms are saturated with memories, but she has nothing to show the world but an empty token of her affection. The Magdalen's grief contrasts with the pride of Veronica – a younger and more attractive woman than Mary Magdalen – designated by Christ's gift as his symbolic bride and mother.

The *Crucifixion* bears a similarity to Rogier van der Weyden's triptych illustrating the life of John the Baptist. On its central panel – all male – the Precursor baptizes Jesus, while on each wing a woman appears. In Magdalen's place we find the Virgin holding in her arms the newborn Baptist, while Elizabeth recovers in bed. In Veronica's place we encounter Salome with the Baptist's severed head – another famous relic. The juxtaposed scenes reflect the imaginary analogy between birth (being cut from a mother's body) and decapitation, the separation of head and body, as well as the traditional perception of women bearing men into life and receiving them into death.[34] A similar contrast is pursued by the Master of Flémalle. The left wing of his triptych (ca.1430) is missing, but the middle shows Mary breastfeeding Jesus, while on the right wing an old Veronica-*Pietà*, her face wrinkled and worn, mourns the death of her son – his face impressed on a small, transparent silk handkerchief that to us looks like a photograph.[35]

Medieval German and Central European depictions of the Veronica–Jesus encounter stress the sadistic features of Christ's tormentors and occasionally show, like the Hersfeld polyptych (Plate 18), Christ and Veronica holding the napkin between themselves like a couple walking their child; the Holy Virgin, as if blessing their union, stands behind her son's spouse pointing with her hand to her own womb. An almost identical composition is contained in *The Jerusalem Triptych* (ca.1490–7) by a Pomeranian Master.[36] While the parental pair is holding the symbolic offspring on the left wing's back, the front, rather appropriately, shows the slaughter of the infants, their white outfits sprinkled with blood (Plate 19). The triptych is constructed around the opposition of the staining blood and the purifying water related to Jesus and the Samaritan flanking the well, and to Christ's baptism in the Jordan.

In Italian art indebted to a Mediterranean sense of equilibrium,

Christ's tormentors appear vulgar but less monstrous than in the North, and explicit hints at sexuality and procreation are replaced with subtle eroticism. In Cariani's (Giovanni Busi, ca.1480–1547 or 1548) *Meeting of Jesus with Veronica* (Plate 1), the two come together up front and on the left, the traditional side of the good in Christian iconography, while on the right and further back, the Roman soldiers proceed – without excessive cruelty. Cariani shows Veronica and Jesus in profile and has them literally mirrored in each other's eyes. But he juxtaposes the worn-out figure of Jesus, his lips parted in agony, with the roundish silhouette of Veronica. Her face is sad and attentive, her lips are closed. The young woman's head is covered with a transparent veil which, flowing down her body, designates her as the mystical bride and creates a contrast to the crown of thorns. Jesus' face, blurred and frontal, is more a stain of a likeness than a portrait and does not resemble the handsome and intense man who, leaning forward, passionately addresses the woman. The two seem to have accidentally found each other in the middle of a crowd and, magically fused by mutual delight, forgotten how little time and space there is left for them. The artist depicts them magnetically drawn to each other, encapsulated in the soap-bubble of a split-second romance – with nothing between them but the vernicle, a sign of their togetherness and separation. In another version of Jesus' encounter with Veronica on his way to Golgotha, Cariani shows her with a huge and still blank linen sheet – a future shroud.[37]

Calvaries, sculptural representations of the crucifixion erected in and near churches, cemeteries, or on top of the hills one usually climbs following a *via crucis* (a sequence of sculptural groups or small chapels showing the stations of the cross) became popular in the late fifteenth century and inherited their iconography from the crucifixion and passion altars. In Southern, Central, and Eastern Europe calvary hills (*Sacro Monte, Kalvarienberg, Góra Kalwaria*) are frequent.[38] But in France, and especially in Brittany, calvaries were placed at the center of ecclesiastical complexes consisting of a church, a triumphal gate, and an ossuary or chapel. Many of the Breton calvaries were destroyed, but those that have been preserved – at Guimiliau (1581), Plougastel-Daoulas (1602), and Saint Thégonnec (1610) – are among the most famous in the world. Executed in granite by anonymous artists, they convey the down-to-earth robustness of a popular culture. Christ's ending is recreated on top of a platform where a large crowd (perhaps as many as 200 people as,

for instance, at Guimiliau), partly dressed in contemporary costume, surrounds the crucifix or three crosses. St Veronica, her flat front covered with an amulet-like mask of Christ, stands out everywhere – reminding one of the ancient heads of Medusa and of the Edessene *keramion*. But nowhere is the solar magic of Christ's face more apparent than on the voûte of the Breton St-Guénolé church in Batz-sur-mer, where a veiled Veronica and three angels save the sun-face from being buried in the ground by ascending with it to heaven (Plate 20).

Veronica and her cloth, or the vernicle alone, are included in sculptural entombment groups recreating the Holy Sepulchre in Jerusalem. Christ's grave, a cave cut into rock, was reshaped and enshrined by Constantine the Great, and later it was surrounded by a rotunda. The first descriptions of the Sepulchre go back to the first half of the fourth century and mostly correspond to what Bishop Arculf saw when he visited Jerusalem after the Persian (614) and Muslim (634) invasions, which seem to have left Christ's tomb untouched. He mentions that the stone, out of which the tomb is hewn, "is not uniform, but appears to be a mixture of white and red."[39] The detail, based either on the cleric's observation or his desire to symbolize, no doubt conveyed to the readers the vision of Christ's earthly nature. Upon their return home, some pilgrims felt compelled to commemorate their visit to Jerusalem by building architectural copies of the Sepulchre, mostly in cemeteries, of which the oldest is the seventh-century Mellebaudis Memorial in Poitiers.[40] In the eleventh century a number of such copies existed, and in addition whole churches were designed as imitations of Christ's tomb. Later, the sepulchres moved indoors, to ossuaries and chapels, and remained extremely popular through the seventeenth century.

The veneration of Christ's shroud at Lirey increased the interest in his burial. Its depictions focus on the linen sheet which is often contrasted with the vernicle. In the abbey at Solesmes-sur-Sarthe, a village in Western France, a remarkably lifelike and expressive sepulchre scene (1496) is sheltered by a stone niche with a beautifully carved front (Plate 21). The arched opening reveals a group of eight figures gathered at the tomb. Mary Magdalen mourns in front of the sarcophagus, while a small angel, the *vera icon* of the living Holy Face in his hands, flies up above Christ's dead head. A late echo of this famous sculpture can be found at the St Théogonnec chapel which is dominated by a baroque *Saint Sepulchre* (1699–1702), sumptuous and polychrome, the work of the

Breton sculptor Jacques Lespaignol. He has entrusted the vernicle to a melancholy but superbly dressed Veronica, not young but still beautiful — a local *belle* who has been to Paris at least once. Highlighted by her golden hair-ornaments and embroideries, Jesus' fresh and animated face looks ready to detach itself from the white fabric and to ascend. Immediacy and urgency are in the air, as if Christ had just expired and Veronica had quickly covered his face with her cloth, obtaining not a deathmask but the eternally brilliant cast of a solar God. In both French compositions, the vernicles allegorize resurrection, the shrouds death.

In eighteenth-century art Veronica's encounters with Christ begin to develop the emotional overflow — the surest sign of religious ossification — that leads to the kitsch of most nineteenth- and twentieth-century calvaries and stations of the cross. As mediocrity took over, iconographic and formal subtleties, complexities, and ambiguities were replaced with the false sentimentality designed to draw crocodile tears from indifferent eyes. An exception is the Station VI by Domenico Tiepolo (1727–1804) in the church of San Polo in Venice, an exquisitely colored and composed dynamic painting in which the crowd progresses from the left to the empty right. Depicted in the foreground but with her back to the beholder, Veronica faces Christ who, as he is being led on a rope by a true *zbirro*, breaks down under the burden of the cross. Turning to her — and us — he seems to address her and plead for mercy. One is particularly taken with Tiepolo's treatment of fabric, especially the garment of Veronica, smooth, soft, inviting touch — all silk and sheen. The artist's interest and strength are in surfaces and movement. The expression of Jesus' face, on the other hand, has the stereotyped and theatrical quality of overacting — a hint at the direction the theme will take in the future. Not far from San Polo, in the church of Santa Maria del Giglio, the sixth station by Gaspare Diziani moves a step closer to the Hollywood type of contemporary Christ pictures, with strong feelings flashing in and out of a crude chiaroscuro. The painting foreshadows the exhaustion of Christian art as a vehicle of formal and iconographic innovation, and makes us realize that in the approaching era of photography the Veronica theme has either to change radically or disappear.

The focus on the passion brought into the foreground the instruments with which Christ was tortured, transformed certain passion episodes into emblems of suffering, and resulted in the creation of the curious iconographic type of the *Arma Christi* — the

"arms of Christ." Since Jesus' victory over death culminated in his crucifixion, everything with which he had been tortured and killed was turned (a typical religious paradox) into the "weapons" of his triumph. The first and most decisive weapon, the *crux invicta*, was joined by the lance, crown of thorns, scourge and rod with sponge attached, and the symbolic men tearing Christ's garments – already present in the Utrecht Psalter *Crucifixion* (ca.830).[41] Later the *Arma Christi* iconography was enriched with the collagelike inserts of the kiss of Judas, Pilate washing his hands, the mocking and flagellation scenes, Peter hearing the cock-crow, ladder, nails, chalice, shroud, and vernicle. A prominent role was assigned to Christ's seamless tunic, a symbolic double, which often appears suspended on the cross.[42] A collection or selection of these objects and scenes constitutes the background of many *Pietà* or Man of Sorrow (*Vir dolorum*) representations – pictures bathed in blood.

(iv) *The Hemorrhissus*

He is clad in a robe dipped in blood.

Revelation, 19

Lord, you are my lover,
My desire,
My flowing fountain,
My sun,
And I am your mirror.

Mechthild of Magdeburg, *The Flowing Light of the Godhead*[43]

The obsession with Christ's passion culminates in late medieval literature and art, which revel in visions of Jesus working at the winepress, streaming with blood as a *fons pietatis*, and impregnating with his juice the earth, the skin of pious women, and his loincloth, shroud, and vernicle. Christ's transformation into a Hemorrhissus reveals the intensification of the Jewish blood mystique by Christianity, and makes us realize what a bloody book the Bible is. In the New Testament the word "blood" occurs around 100 times and refers mostly to the redemptive blood of Jesus which cleans, nourishes, and assures immortality.[44] The Revelation, a particularly blood-soaked text, presents Christ, somewhat in contrast to the gospels, as the lamb which has been transformed into an avenger punishing the

whole universe with a flood of blood. The Savior of the Apocalypse causes "hail and fire, mixed with blood" (Rev. 8:7) to fall upon the earth and makes the moon and sea, rivers and fountains, rain and wine metamorphose into blood. Leading the armies of heaven, he rides on a white horse wearing a blood-covered robe.

The basic color pattern of the Revelation consists of red-and-white, although the two colors are more often implied than named. The meaning of white is mostly positive. Red, on the other hand, denotes perfection whenever it refers to the blood of the Lord, badness when it is associated with female flux. In ancient mythology and early Christian theology a similar distinction applies to water. The water of the Lord purifies and spiritualizes, while terrestrial water can be either a blessing or a scourge. Ephraim contrasts the redeeming blood of Christ with the earthly flood: "it has been proclaimed, that that lowly blood which Noah sprinkled, wholly restrained Thy wrath for all generations; how much mightier then shall be the blood of Thy Only Begotten, that the sprinkling of it should restrain our flood." (*Nisibene Hymn*, 1.2).

Red and white are the colors of the Eucharist, the main ritual of Christianity introduced by Jesus himself, who

> took bread, and blessed, and broke it, and gave it to the disciples and said, "Take, eat; this is my body." And he took a cup, and when he had given thanks he gave it to them, saying, "Drink of it, all of you; for this is my blood of the covenant, which is poured out for many for the forgiveness of sins."
>
> (Mt. 26:26–8)

The sacrament of the Eucharist has its roots in Jewish tradition. Hebrews treated wine as a surrogate for blood and poured it out at the base of the altar.[45] Early Christians regarded the Eucharist as the only true and valid image of Christ and opposed it to pagan depiction and representation in general.[46] Following in the footsteps of this tradition, the Emperor Constantine V rejected all images of Christ with the exception of the Eucharist. But the Eucharist can be interpreted as an image in yet another sense. Wine stains bread in the same way blood does when it appears on skin or impregnates cloth. Opposing the *vera icon* of the Eucharist to sculpture and celebrating it as a sort of "true" painting, Ephraim has the Holy Virgin say to her child: "Lo! Thy Image is shadowed forth in the blood of the grapes on the Bread; and it is shadowed forth on the

heart with the finger of love, with the colors of faith. Blessed be He that by the Image of His Truth caused the graven images to pass away" (*Hymn on the Nativity*, 11). The Eucharistic bread sprinkled with wine reminds Ephraim of Jesus' wounded body on the cross – and an icon. But Theodoret of Cyrus (b. 393) compares the crucified Lord to a page covered with script: "on his body every man like letters marks the prints of his sins."[47]

In early Christianity the Eucharistic meal occasionally consisted of water instead of wine. The use of water was possible for all representatives of the docetic heresy, who denied the material reality of Jesus and interpreted him not as a man of blood and flesh, but merely as an apparition. Since all was semblance, one fluid could easily be substituted for another, and Christ himself could assume the form of water. In the Valentinians' view Jesus passed through Mary as water passes through a tube (Irenaeus, *Against the Heresies*, 1. 7. 2). But the interchangeability of water and blood was also prompted by the description of Christ's death on the cross. After his expiration "one of the soldiers pierced his side with a spear, and at once there came out blood and water" (Jn. 19:34). All this inspired the legend of the white pelican (a water bird) feeding its offspring with its own blood.

From Augustine's time the pelican functioned as a popular symbol of the Redeemer, and from the late Middle Ages the bird stood for the Eucharist, too.[48] The idea was influenced by the *Physiologus*, which tells us that the pelican

is an exceeding lover of its young. If the pelican brings forth young and the little ones grow, they take to striking their parents in the face. The parents, however, hitting back, kill their young ones and then, moved by compassion, they weep over them for three days . . . On the third day, their mother strikes her side and spills her own blood over their dead bodies . . . and the blood itself awakens them from death. Thus did our Lord speaking through Isaiah say: "I have brought forth sons and have lifted them up, but they have scorned me" [Is. 1:2]. The Maker of every creature brought us forth and we struck him . . . The Lord ascended the height of the cross and the impious ones struck his side and opened it and blood and water came forth for eternal life . . . blood because it is said, "Taking the chalice he gave thanks" [Mt. 26:27 and Lk. 22:17], and water because of the baptism of repentance [Mk. 1:4 and Lk. 3:3]. The Lord said, "They have forsaken me, the fountain of living water," and so on [Jer. 2:13]. Physiologus, therefore, spoke well of the pelican.[49]

The *Physiologus* passage relates both the male and female bird to Christ, but it particularly stresses the role of the mother pelican and thus associates the Lord with femininity. This interpretation is not surprising. Offering to nourish humanity with his own blood and flesh, Jesus takes on a maternal role and inspires visions of the Savior as an incontinent female. Imitating the Lord, Christian saints kept bleeding. When a sponge was introduced into the coffin of St Euphemia, it resembled, when it was drawn out, a sanitary napkin "covered with stains and clots of blood;" and "so great has been the quantity of blood thus extracted, that both the pious sovereigns and the assembled priests, as well as the congregated people, all share in a liberal distribution, and portions are sent to those of the faithful who desire them, in every place under the sun" (Evagrius, *Church History*, 2. 3).

Dreams of wounds, stigmata, and blood abound in the writings of medieval male mystics, some of whom even perceive themselves as "menstruating" in order to imitate the feminine and maternal physicality of Christ.[50] But the preoccupation with flux is even more pronounced in the texts of women. Following the ancient tradition, they glorify the sacrificial bleeding of Christ and interpret menstruation in negative terms, even when they regard it as necessary for generation. Hildegard of Bingen (1098–1179), the famous German scholar and mystic, believes that life is concocted from a mixture of semen and menstrual blood; and that menstruation has its origin in Eve's sin. As the first woman looked at the snake, she was flooded by a stream of desire which opened her blood vessels. She began to bleed and was made receptive for the influx of sperm, which, had she remained untouched and closed, could not have penetrated her.[51] Hildegard divides menstruation into four kinds, each corresponding to a woman's humoral temperament, and expresses her preference for the lighter flow of "sanguine" women, who "suffer only a moderate loss of blood, and their womb is well developed for childbearing, so they are fertile and can take in the man's seed;"[52] the extensively menstruating melancholics, on the other hand, are suspected of having "a weak and fragile womb," and of being unable to "lodge or retain or warm a man's seed."[53]

Female mystics often interpret Christ's redeeming blood as a sacrifice to women. This sacrilegiously eroticized idea is suggested – and made acceptable – by the role of the Holy Virgin, the prominent position of biblical women and female saints, and, most importantly, by the feminine gender of *anima* and *ecclesia*, holy cities and

Scriptures (*biblia*), and of the planet earth. As words become women, God's metaphorical brides, spouses, and mothers are born. The convention of an amorous discourse between the Lord and the Soul allows women poets and mystics to pursue their daring dreams of God overflowing with desire for his Anima or bleeding to death not for the general benefit of humanity, but for the particular delight of femininity. In order to provide his mistress with continuous ecstasy, the mystical Lord keeps filling her with his juice. To prove his absolute devotion, he offers himself on her altar – a lamb drained of the last drop of blood, and a Hemorrhissus.

In women's mystical dreams the divine lover never rests. All motion and emotion, he penetrates everywhere in his search for femininity – oppressed, obscured, hidden, and locked away – and he embraces and animates the most inferior of souls. In *Yonec*, a famous lay by Marie de France (flourished ca.1175–90), a young wife, kept atop a solitary tower and jealously guarded by her old husband, is visited by a bird, a traditional symbol of the Holy Spirit, which flies through her window and turns into a young man. They fall in love and spend their nights together, but are discovered by the husband who inserts splinters of glass into the window frame. The bird is caught and bleeds to death.[54] (The symbolic story brings to mind a real one: the castration of Abelard (1079–1142) as punishment for his affair with Heloise.)

In European mysticism the most passionate homage to divine flux is paid by the German mystic Mechthild of Magdeburg (ca.1212–ca.1294), a Dominican Beguine whose revelations, known as *Das fliessende Licht der Gottheit* (*The Flowing Light of the Godhead*), were widely distributed in thirteenth- and fourteenth-century Europe and might even have influenced Dante.[55] Mechthild's God is a stream of spirit, light, and fire. He is rain and dew, sweat and semen, blood and wine, milk and honey. He is pure energy – motion, emotion, and locomotion in one – and the only force that can activate the Soul by dissolving her solidity into the liquidity of longing. God makes the "little vessel" of the anima "overflow," "leap into love," "laugh," "sing," "dance," "fly," "swim," "climb." His light is the expression of love, and as he begins to shine, the soul starts to flow, and they unite: "Thus, Lord: Your blood and mine is one, immaculate; / Your love and mine is one, undivided; / Your dress and mine is one, unsoiled."[56]

The power of Mechthild's poetry comes from the fusion of the abstract and cosmic with the concrete and human, and the

mercurial speed of changing metaphors. In one line God appears as the eternal flood, in another as the dew dripping into the flower. Here he is a charming young groom from the Song of Songs, there an agonizing Jesus Christ. And the Soul transforms constantly, too. She is a fish swimming in God's water, a bird flying in his air, and an elegant bride who wants to please him as much as he wants to appeal to her:

> Vide mea sponsa:
> Look, how beautiful my eyes are,
> How lovely my mouth is,
> How burning my heart is,
> How fine my hands
> And how quick my feet are.
> Come and follow me!

(Flowing Light, 1. 29.)

The Soul follows, arrives at the bed of love, and hears God say:

> Stop, Lady Soul!
> *Soul*: What do you command, Lord?
> *God*: You shall be naked!
> *Soul*: Lord, why shall this happen?
> *God*: Lady Soul, you are assumed into my nature,
> There shall be nothing between me and you.

(Flowing Light, 1. 44)

Each of Mechthild's revelations aims at mystical union which is modelled after physiology and sexuality (copulation, pregnancy, lactation), alchemy, and astrology, the fertilization of earth by rain and light, the burning of matter by fire and sun, and after reflection and projection, staining and impressing, painting and writing.[57] Hers is a *panta rei* poetry in which everything begins and ends in flow. The flux is caused by love which opens "his wounds and her breasts" (*Flowing Light*, 1. 22). And the world's axis is determined by two icons of liquidity: the bleeding Christ and the Holy Virgin streaming with milk. This juxtaposition inspired medieval iconography and, in particular, German painting, in which blood and milk are often complemented with streaming hair. Thus the left wing of a Danzig diptych (ca.1435) shows Jesus filling the chalice and Mary feeding the child (Plate 22), while to the right Mary Magdalen – dressed in her hair – is assumed to heaven.

From Mechthild's glorification of fluids, menstruation alone, a

curse caused by Eve's sin, was exempt. A nun and a writer, she had no use for menstrual blood. Her poetry was inspired by physiology, but her life's business was not sex but its sublimation into text. A linguist and creator of culture, she wanted God to make her ejaculate, not menstruate, and she renounced her iconic and reproductive stance – instead turning to script and time. Mechthild's dress did not bear a "true" image, it was covered with words. Granting the Soul's wish, God rewarded those who helped her put together her book with a textile text: "They have written the book in golden script, / Now all the words / Shall stand on their outermost dress" (*Flowing Light*, 2. 26).

Mechthild, her book against her breast, saw herself as a prophetess, equal to Moses with God's tablets in his hands. Her text was divine too. It "flowed from the living godhead into sister Mechthild's heart" and was "written by her hand" (*Flowing Light*, 6. 43). But to her, God did not speak about legal matters. He dictated an erotic *opus magnum*, a poetic reverie of touching, coupling, mixing, and fusing, which swirls with images derived from the mythology of Mary Magdalen and the Hemorrhissa. The Soul – a skin–dress–page–vernicle – dies for the impregnation with divinity.[58] She wants her menstrual blood-flood transformed into ink – and a stream of words. Regarding herself as a medium for God's cultural communication with humanity, Mechthild and her heroine, the Soul, represent the opposite of a hermetically sealed vessel or a closed book.

A book, Mrs Jameson tells us, symbolizes the Bible and wisdom, when the infant Jesus holds it in his hands.[59] But "in the hands of the Madonna, it may have one of two meanings. When open, or when she has her finger between the leaves, or when the Child is turning over the pages, then it is the Book of Wisdom . . . When the book is clasped or sealed, it is a mystical symbol of the Virgin herself."[60] The nineteenth-century British writer delights in the Virgin's closed and blank nature – an ideal of femininity she considers her own. One has to recall such attitudes, still common today, in order to appreciate Mechthild's desire to identify herself with divine energy – and to liquefy into language. Rebelling against millennia of menstrual opaqueness and silence, a religious poet finally claims the right to write a sacred text. Still, her extraordinary collection of mystical love poetry exemplifies the paradox of a woman's participation in culture. On the one hand, Mechthild revels in femininity – the link to God's humanity. On the other hand, aspiring to culture, she denounces her own physiology. Her

dilemma is still with us, and so is her achievement. Cultural contribution begins with lucidity and language.

Mechthild's poetry influenced the iconography of Christ as *fons vitae* or *puteus aquarum viventium*, a fountain of living water, and as *fons pietatis*, a font of blood. In the 1460 *Fons pietatis* by a Provençal Master (Plate 9) the crucifix, spread out against a vast landscape and a cloudless sky, rises out of a sarcophagus-shaped fountain. Its upper basin is furnished with four heads (of an eagle, bull, lion, and angel), emblematic of the four evangelists, through which blood is discharged into a lower container. The *Fons* is flanked by Mary Magdalen and Mary the Egyptian – two saints particularly popular in Provence, their long golden hair running down their bodies and joining the blood running out of God; and it is surrounded by writing. A white scroll covers the front of the fountain's base, two white page-flags fly above the women's heads, and a small white shred with Christ's monogram is nailed to the cross above his head. Executed partly in red, the script extols divinity's "human image" – and frames it in Word.

Allusions to the fusion of sexes, the symbolic masculinization of women, and the feminization of Christ permeate fifteenth-century literature and art. Julian of Norwich (d. ca.1413), addressed the Savior as "my kind Mother, my gracious Mother, my most dear Mother," and wrote: "For the flood of mercy that is his most dear blood and precious water is plenteous to make us fair and clean. The blessed wounds of our Saviour are open, and rejoice to heal us. The sweet gracious hands of our Mother are ready and diligent about us" (*Revelations*, 61).[61] Mystical fervor inspired art. In the *Vir dolorum* (Plate 23) painted ca.1405 by the Master of the Strauss Madonna, Christ rises from the tomb streaming with blood. Above his head a pelican feeds its young and the *Arma Christi* are displayed in the background. The picture's horizontal axis is given by the edge of the sarcophagus, the vertical by Jesus' body. On the right he is supported by his mother, her body and head wrapped in a dark blue mantle; on the left Mary Magdalen, dressed in glowing reds and pinks and with her sumptuous blond hair flowing down her body, holds him by the arm and rests her head on his hand. In the center of the sarcophagus the vernicle is suspended from the edge in such a way that it seems to prolong Christ's body and functions as his loincloth; at the level of the genitals, the head appears.

The picture's color scheme offers an apotheosis of solar glory and redeeming blood. On the golden background, reds, pinks, rusty

violets and browns predominate. Patches of vivid purple and crimson, distributed throughout the painting, integrate the composition, and red is omnipresent in the *Arma Christi* emblems. There Jesus wears a purple coat and cap, his tunic, hanging on the ladder, is of a rusty hue, slightly lighter in shade than the color of the headgear worn by the soldier arresting him; a torch in the executioner's hand and the cockscomb flame; Pilate's sleeves are lined with red, and he washes his hands in a rusty bowl into which water is poured from a red-brown pitcher. This symbolic redness is strengthened by the omnipresence of actual blood. It marks the spots where nails have been driven into the cross, trickles from Jesus' forehead, stains his right hand – close to where his mother's lips touch it. There are blood traces on his arms, breast, stomach, hair, and the rope tied around his neck; his nimbus resembles a reddish cloud. Mary Magdalen's head reposes in the wound of Jesus' left hand, while from his right side blood flows into the chalice and down the belly – impregnating the vernicle.

An orgy of medieval blood mysticism, the *Vir dolorum* brings to mind Mechthild's and Julian's visions. While the blood of Christ (and of the pelican, his symbolic extension) feeds the sacramental vase and creates the vernicle, the Savior offers his body not so much to humanity as to femininity – with the women's lips touching his skin. This is conveyed by the painting's horizontal division which separates it into male and female spheres. The users of the *Arma Christi* are all men. Equipped with their phallic instruments, they torture Jesus, or, at best, betray (Judas) or deliver him. Thus the picture's superior level, the traditional side of sky and heaven, is occupied by a men-sponsored hell. Below lies the earth where Jesus' pain is shared and lamented by women. Getting stained with his blood, they establish a communion between themselves and God and participate in his resurrection and transfiguration.

In order to avoid being carried away by the pathos of the *Vir dolorum* and similar scenes uniting the Hemorrhissus and the various Hemorrhissae, one should compare it with a frivolous painting by Lorenzo Lotto (ca.1480–1556) which also deals with a woman's marking by a male. A symbolic marriage scene, it shows a reclining naked Venus onto whose exposed belly, already covered with loose petals torn from a rose (defloration), a winged infant Amor is urinating through a marriage wreath, a symbolic hymen, from which a candle is suspended in such a way that it appears burning inside a shiny triangle created by the candlestick and chain

(Plate 8). A vaginal shell above Aphrodite's head and two large pearls dangling from her left ear manifest her aquatic origins, fluidity, and fertility. Her welcoming pose demonstrates her readiness to reproduce, and in this the Renaissance painter seems to delight as much as Cupid. But the Christian in him reminds him of Eve and the Fall. Obeying his faith's moral obligation, he includes a viper hissing its tongue at the ancient goddess of love.

(v) The Double Portrait and the Holy Face

In the fifteenth, sixteenth, and seventeenth centuries the figure of Veronica with Christ's likeness gained popularity as an autonomous and almost profane subject: a portrait of a woman (shown either whole, as bust, or reduced to face and hands) with the portrait of a man. Depending on the sizes of Veronica's and Jesus' faces, their proportions in relation to each other, and the way Christ is depicted – as suffering, bleeding and dead or serene and full of life – the *Veronica cum Christo* pictures convey either a ritual and symbolic meaning or assume the character of private portraiture. The larger Christ's head in relation to Veronica's face, the more it suggests divinity and solarity. This aspect is often accentuated by a nimbus, rays, or trickles of blood, and occasionally it is supplemented with water symbolism.[62] A fifteenth-century miniature of a slight, veiled Veronica, completely covered and dominated by Christ's huge radiating face suspended over a well, seems to assure cosmic fertility through the marriage of fire and water; the cloth and well are flanked by two rabbits – animals assigned to both Venus and Mary as goddesses of nature.[63] The fifteenth-century Master of the Holy Veronica evokes in his vision of the dark, thorn-crowned and bleeding head of Christ – solar and terrestrial at once – the black Holy Faces of Byzantine art, reinforces the vernicle's monumentality through the contrast with tiny angels squatting at the bottom, and creates a cosmic portrait reminiscent of contemporary depictions of the Baptist's head floating in the air amidst angels (Plate 24).

From the fifteenth century onwards the double portraits of Veronica and Jesus focused increasingly on the human individuality of the pair and their particular relationship, tragic or almost idyllic. The single most serene picture of the couple was painted by Hans Memling. His *St Veronica* (Cover) is conceived as a virgin-bride lost in memories of her handsome Jesus and an allegory of the *vita*

contemplativa. Sweet and young, she kneels under a hazy but cloudless sky in a solitary meadow amidst a peaceful landscape transfused with golden light and crowned at the horizon with the silhouette of a city. She is attired in the fashion of her day, modestly but finely. White cloth is draped around her neck, a transparent veil covers her forehead, and a white linen turban hints at her eastern origins. Her dress is purple, her mantle dark blue, and the white napkin, which she holds with the tips of her fingers, is made of the same material as her neck- and headgear. Christ's face is framed by shiny blond hair with a tint of copper, and a delicate blond beard. It is slightly larger and darker in complexion than Veronica's but otherwise almost its twin. The two are approximately the same age and match each other in every respect. Their faces, soft and calm, are illuminated from within, but Jesus has a stronger presence. While Veronica's eyes are cast down to the ground, Christ faces the beholder with melancholy. His sadness and the flow of Veronica's red dress create a slight tension in the otherwise perfectly idyllic picture. Suspended over the purple of Veronica's womb, Jesus' face, fresh and quite untouched by pain, celebrates union and incarnation. Alone with each other in the grand solitude of nature, the pair personifies Platonic harmony and reverie *à la recherche du temps perdu.* Look, the artist seems to say, Veronica has caught on her cloth the most desirable man on the planet earth. But alas – he lives on only on her napkin. She touched him for a split second, then lost him for ever and was left with nothing but his portrait – and her memory of their brief meeting and quick parting.

A daydreaming female was a popular motif of the *minne*-saturated late medieval art, and so was the theme of a woman with a mirror (image). As long as her dream was concerned with the adoration of a (divine) man reflected in her mirror, the woman stood for virtue and her action for reproduction. Incarnation was symbolized not only by Veronica but also by the Lady with the Unicorn, another personification of the Holy Virgin, catching with her mirror the "true" image of the immaculately white animal with a huge miraculous horn – a popular figure of Jesus.[64] If, on the other hand, a seductive or naked female reflected herself, and not a man, in a setting suggestive of luxury and fluidity, she was likely to embody sin and sterility. In the famous "Apocalypse Tapestry" (executed in Paris by Nicolas Bataille between 1375 and 1380) the charming girl sitting on a tiny island in the sea, combing her long blond hair, and contemplating her face in a mirror, signifies the Great Prostitute of

the Revelation.[65] And *Vanity*, attributed to Hans Memling – and indeed a twin sister of his Veronica – is pictured against a bucolic landscape that alas is neither austere nor bathed in metaphysical light.[66] Flowers spring up under her feet and instead of divine memories, two dogs keep their mistress company. Vanity is naked, except for sandals and the pearls in her loosely floating hair, and she admires herself in a looking-glass.

In the Spanish art of the sixteenth and seventeenth century El Greco (1541–1614) and Francisco de Zurbarán (1598–1664) explored in their vernicle pictures subtle oscillations between life and death. Zurbarán executed five versions of the *vera icon*, but his masterpiece is *Veronica's Sweatcloth* (Plate 25) – a "photo" of an enigma.[67] El Greco's Veronica has many faces. He painted her as a middle-aged Martha-*Pietà*, common, sorrowful, with a linen napkin whose edges are embroidered with red and whose Christ, his hair matted with blood, resembles a Medusa (Toledo, Museo de Santa Cruz). Or he painted her as an aristocratic bride, dressed in red silk with a blue silk scarf thrown over her left shoulder, holding in her slim hands a white napkin, all silk and lace, through which the colors of her garments shimmer; where the red meets the blue, the face of an emaciated but handsome and well-groomed Jesus appears; a southern cavalier, dark-haired, black-eyed, and full of temperament, he is a good partner for his Hemorrhissa–Princess (Munich, Alte Pinakothek). El Greco also rendered the *Holy Face* alone (Prado); a portrait of Christ resurrected, it shows his forehead marked with thorns. The popularity of vernicles in Spain influenced the vocabulary of the corrida: the bullfighters' red cloth is called "veronica."[68]

In the eighteenth and nineteenth centuries paintings and sculptures of St Veronica and the Holy Face were mostly confined to church decoration and executed by minor artists. The process reflected the abandonment of traditional Christianity and religiosity by Europe's cultural elite. While Veronica with the Lord's disembodied head remained the delight of country priests and female devotees and the obligatory subject for provincial craftsmen and Sunday painters, Salome with the Baptist's head moved to center-stage. She was transformed into the *à rebours* icon of terrible femininity by German Romantics and French Symbolists; she was adored by *fin de siècle* decadents and dandies throughout Europe; and she was admired on the covers of avant-garde books and magazines, and in theaters and art salons by the contemporaries of Oscar Wilde and Aubrey Beardsley.[69] In fact, I know of only two nineteenth-century

French vernicle paintings that seem worth mentioning, because of their unorthodox iconography.[70] One is the *St Veronica* by Paul Delaroche (1797–1865), the picture of a woman sleeping on the floor of her poor abode; above her head the vernicle is suspended – a Christian woman's dream. The *Vision of Judas* (Plate 26) by Yvon Adolphe (1817–93) pursues a similar idea and revives the medieval *Arma Christi* motif. Startled by the apparition of Satan, Judas faces the tortured "true" likeness of his teacher – the mirror and token of his crime – while blood money slips out of his linen sack. Linking the devil and his pupil, the vernicle conveys a pessimistic view of humanity – a collection of suspects requiring supervision. It was donated to the Musée du Havre by the French Ministry of the Interior – a proper police present revealing relations between sacred icons and secular law, and pointing to the sense of shame and guilt at Christianity's core.

7

From History to Mythology

The history of Christianity shows that John of Damascus was right: incarnation implied representation. But in a world saturated with incarnate divinities and their depictions, this created a problem. Christianity found itself in competition with a multitude of pagan cults and had to prove that there was a difference between Jesus and the many Apollos and Amors. In order to establish Christ, masses of potential converts had to be convinced of the actual existence of a unique Man-God. Material proofs of his presence on earth were highly desirable; photographs would have been extremely helpful. Thus were *achieropoietoi* invented – traces, relics, and likenesses of the one and only "true" God.

The Christian *vera icon* was derived from the mimetic culture of antiquity. The Byzantine mandylion and *keramion* are twins of the drawing and the mask produced by a Corinthian girl and her father, the ceramicist Butades. The story of a female outlining her departing lover's shadow is congruent with both the Abgar and the Hemorrhissa legends, and it parallels our habit of photographing those who are close to us before their departure, and of taking snapshots of celebrities. The Greek legend, like its Christian counterparts, links physiological and artistic reproduction, relates eroticism to the urge to replicate, and suggests that mimetic depiction is stimulated by a fear of loss. Capturing her lover's contour, the girl produces a naturalistic token of memory evocative of procreation. Had he "overshadowed" her, her body would bear a

143

living duplicate – and an artistic copy, a compensation, would not be necessary. Pliny's anecdote reminds us of what we know quite well: that we render with greatest faithfulness what we are bound to lose or cannot obtain. In keeping with the Platonic vision of reality as a mere shadow-play preserved in the perishable fabric of life by women and artists, the Greek myth ascribes the origin of art to a girl in love, Veronica's Corinthian cousin.

The *acheiropoietoi* mythology achieved two goals: it proved Jesus' historical existence, with "true" images serving as photographs, and it visualized the Word's incarnation, in opposition to the invisible and immaterial Jewish God. But incarnation was considered the essential issue. Therefore the early versions of the Abgar and the Hemorrhissa legends were concerned with Christ's reproduction, not with a *vera icon*. While the Abgar legends added depiction to language, the Hemorrhissa stories focused on divinity's replication in female flesh. The first accounted for theological debates between men and displayed a theoretical edge; the second reflected popular piety – people's fascination with female mediation between divinity and humanity – which was soon supported by theologians. The development of the Berenice legend paralleled the establishment of the Virgin-cult. While Mary was divinized as the locus of incarnation, the Hemorrhissa began to transform into a symbolic madonna. A bearer of God's "true" likeness and the main propagandist of representation, she became a saint, while Abgar, who had corresponded with Jesus and replaced pagan statuary with Christ's painted portrait, was forgotten. The Edessene forms of depiction – Christ's mandylion and *keramion* – have kept their popularity until our day, and the Paneas monument was revived as the sixth station of the cross.

The Greek *acheiropoietoi* of Edessa signaled the transition from mimetic statuary, the dominant art form of classical antiquity, to painting, mosaic, weaving, embroidery, and small reliefs, the main arts of Byzantium. Ultimately the mandylion overshadowed all other *acheiropoietoi* because of its light and portable nature and the appeal of its symbolism. Reminiscent of clothing and skin, the textile "true" image was ideal for illustrating the paradoxical duality-unity of God-Man and for connecting the dogma of incarnation to the sacrament of the eucharist. Jesus' impression on cloth was conceived as "true" not only in resemblance but also in substance. The impression was "true" as Christ's shadow and blood. The cloth was as "true" as his body and skin. On the one hand more mimetic

than any classical marble statue, on the other hand less solid than any conventional artefact, the mandylion – everything one moment, nothing the next – enjoyed a singular position, did not collide with the second commandment, and effectively conveyed both physicality (through materiality) and spirituality (through ephemerality).

The "true" image was intimately related to Christ's death and resurrection. In the *Doctrine of Addai* the portrait was obtained just a day before the crucifixion, while in medieval legends it was deposited in Veronica's hands at the very last moment. Thus both the Eastern mandylion and the Western vernicle were seen in analogy to Jesus' burial clothes and his corpse. But Christ was resurrected, and so was his shroud. What seemed dead became animated, what appears material became spiritualized. Turning into an *acheiropoietos*, the cloth metamorphosed into a double of Jesus: the image of his soul. The body–shroud–anima metaphors inspired iconic textiles. But the development of the Christian cloth culture was also determined by the textile tradition of antiquity, and especially of Egypt where still in the Christian era the deceased were provided with painted shrouds and masks – second skins and dresses for their journey to eternity. One could think of the Christ *acheiropoietoi* in terms of spiritual doubles removed from the dead for the benefit of the living. The ancient Egyptian practice in the preservation of dead bodies and in shrouding them suggests Egypt as the place where the shroud of Turin might have been fabricated, in a complicated process based on secret knowledge that might have involved some special treatment of the corpse (obtained in a murder based on the *imitatio Christi*), and of his skin, as well as of the fabric in which he was wrapped.

With time the blood that had impregnated the mandylion began to receive ever greater attention. Christianity inherited the centrality of blood from Judaism, but the history of the *vera icon* shows that originally menstruation – female blood responsible for incarnation – attracted attention, while the blood of Jesus started to be significant only in the Middle Ages. Why? Several explanations come to mind. That the mass of recent converts had a deep horror of blood and thus avoided blood imagery. That as long as Christians had to give their own blood for a cause that might be lost, they did not want to be confronted with the passion and death of their God and leader. On the contrary, they wished to be comforted and encouraged by visions of his miraculous career and resurrection. But after Christianity was instituted as a state religion and the faithful began

to shed the blood of the unfaithful, the icons of Christ's martyrdom acquired a new function: they justified what Jesus' followers did to others. The crucifixion was first depicted after the Edict of Milan. Veronica's sanctification coincided with the extermination of the Albigenses. Stressing the terrible fate suffered by the Lord and contrasting pagan and Jewish cruelty with Christian compassion, the medieval theater of horror proved the right to commit atrocities in the name of Christ. But the growing centrality of Jesus' blood followed, perhaps, also a theological logic. Once well established, Christianity could allow itself to revive and reinforce the Judaic tradition of male sacrificial blood. But as the sacred ink of the Jews – the stuff of their culture and language – was transformed into the natural (=human) paint of physical and iconic reproduction, as Christ's "power" was identified with his blood, and as the incarnate God's "true" likeness was produced out of his own and the Hemorrhissa's combined effusions – a massive hemorrhage might have appeared as absolutely necessary for having the world go around.

The presence of the Hemorrhissa episode in three gospels and the early metamorphosis of the anonymous woman with the issue of blood into "a victory-bearer" exemplify the abolishment of the Jewish menstruation taboo and the rehabilitation of women's flow, which in the Jewish Bible had been identified with the ills of nature and humanity. The evangelists decided to tackle the delicate issue of female bleeding not in connection with God's mother. But they modelled the healing of the Hemorrhissa after Mary's infusion with divinity as well as after the Old Testament scenes linking menstruation to reproduction. Sealed off by God Father, Mary became the Holy Mother of God Son. Sealed off by God Son, the Hemorrhissa turned into St Veronica – the Holy Bearer of his *Vera Icon*.

The divinization of Mary and the sanctification of Veronica helped women acquire cultural visibility, but did little for their social status. The exceptional position of the madonna, a Virgin-Mother, confronted Christian females with an absurdity – and the choice of just two ways of life. They could be mothers, but then not virgins, and give birth, but not to Jesus Christ. Or they could be nuns espoused to God and pregnant with his spirit – but not with babies or "true" icons. The obscene joke of the Emperor Constantine V, who demonstrated the nothingness of Mary *post partum* by taking gold out of his purse, offended the worshippers of the Theotokos. But even today the joke would be generally approved were it applied

not to the Holy Virgin but to some Christian housewife. The curing of the Hemorrhissa loses much of its appeal when we realize that it revives ancient stereotypes of femininity and results in the birth of a propagandistic pre-photograph of Jesus, the new God of Light. Still, the way to emancipation leads through acceptance and visibility. The presence of females in the New Testament contributed to the presence of women in Christian culture. The cult of the Virgin and the legend of the Hemorrhissa inspired Byzantine women with iconodule feelings, made Byzantine empresses struggle against the iconoclasts, and prepared the ground for medieval female mystics assimilating themselves to language, culture, and energy, and rejecting the traditional icon—nature—space equation.

Christian iconism, with its abundance of painting, small sculpture, and textile icons, facilitated private worship by women, providing them with the illusion of being in touch with the godhead. But, on the other hand, portable icons also perpetuated women's social isolation, reinforced their domestic role, and condemned them to contemplation and passivity. We confront here a paradox. Since self-recognition and reflection require vision, we have to acknowledge the positive role of Christian icons. But when self-recognition results in the confirmation of stereotypes, its achievement is dubious. There can be hardly any doubt that in the first place the Christian inclusion of women and feminine icons strengthened women's sense of identity. But later Christian pictures contributed to femininity's freezing in the Virgin—Veronica stereotype – the archaic vision of femaleness as the reproducer and propagator of masculinity.

But the vernicle, matter impregnated with divinity, symbolized not only the inferiority of femininity. A prototypical religious image, it exemplified the claylike quality of humanity – a passive, ignorant body to be illuminated and molded by divinity, and to be crowned and led to salvation by the one and only "true head." Similarly, the mixing of divinity and humanity in the Virgin's body had repercussions for the entire Christian community, inspiring both men and women with the wish for union with deity, and eroticizing religious language and practice. In Christianity sexuality acted as an equalizer, with male mystics dreaming of menstruation and female mystics losing themselves in reveries of ejaculation. Thus differences of sex and social status were bridged and effaced, heaven and earth were happily married, and the ecstatic happy few floated to paradise in a stream of love.

Christianity's democratic approach – its acceptance of the sick,

blind, and lame, the *hemorrhissae* and the lepers, all of whom were promised vision and visibility, the restoration of their skins and souls – was based on Christ's readiness to touch everyone. The evangelists tied tactility to vision, affirmed the utopia of divine–human togetherness, and filled the New Testament with sensuality and potential eroticism. But they also insisted on purity and spirituality, tendencies which were later stressed. Denying its own sexual and physical implications, Christianity created insoluble contradictions. The woman who gave birth to God remained a Virgin; the woman whose menstruation was arrested by God, became pregnant with his picture; the God of love was butchered like a sacrificial sheep; and he was resurrected both as an untouchable ghost and as a macabre living corpse. Oscillating between materiality and abstraction, Christianity at once incited and denied carnal appetites. It revived an archaic mix of cannibalism, human sacrifice, and sexuality, and then tried to heal the wound inflicted by its own sado-masochistic fantasy with an innocent ritual of bread and wine or God's romantic shadow on a woman's veil. The contradictions were reflected in the history of the Eastern *acheiro-poietoi* – embedded in wars, iconoclastic folly, and military expeditions to recapture relics. And they were mirrored in the medieval legends of the heartbreaking encourter of Christ and Veronica on the way to Golgotha. Created by the guilty conscience of the crusaders, the sentimental stories inflamed the faithful with feelings of hatred and revenge, fueling and perpetuating anti-Semitism and religious intolerance.

But the historical approach does not exhaust the complexity of the "true" image. Many of the icon's aspects are rooted in the mythology of the sun and the moon – pre-Christian, archaic, and fairly universal – and the related vast body of legends dealing with active and passive mirrors, creation and reproduction, blood and skin, body and soul, birth and death, human sacrifice and resurrection – i.e. with sexual and cosmic symmetries and psychophysical dualities that further illuminate the *vera icon* phenomenon. Christ's solarity and terrestriality, Veronica's opaqueness and luminosity, and the changing character of the vernicle correspond to a variety of legends obsessed with the sun's rising from, travelling through, and reposing in female matter. In mythology the sun is represented by a mirror-disk, a face or a head. Red light at sunset is usually metaphorized as the blood of a dying man, a decapitated hero or warrior, but it is also connected to menstrual blood – a

fertile reproductive flux as well as a corrupt chthonic fluid which is suspected of polluting mirrors, obscuring light and blocking vision.

The solar–lunar mythology reflects two central anxieties. The fear that the sun may be eclipsed for good by the moon, like the son blinded by the Empress Irene; and the equal horror that it may not be able to rise from the womb-tomb of the earth. In Japanese mythology the sun is personified by a goddess and symbolized by a mirror, but this does not diminish the fear of the eclipse, which is conveyed in the legend of the goddess shutting herself in a cave and leaving the world in darkness. That the sun does not have to be masculine is also suggested by the Greek mythology of Medusa, possibly a solar monster, whose head appears on the luminous front of the sky goddess Athena and on the shield of her father Zeus. In the East the popularity of Jesus' heads as potent phylacteries was enhanced by the omnipresence of the heads of Medusa. Her legends elude easy interpretation but seem to indicate the possibility of a belief in two suns, the luminous day-sun of heaven, and the black night-sun of the underworld, associated with bleeding, blindness, and reproduction.

Mirror mythology confronts us with a huge bulk of legends describing the soul as a reflection and the marriage between body and soul. The erotic character of the mirror in religion and poetry finds its expression in the actual shapes of mirrors, which in turn influence new forms and concepts. It is not easy to decide which parts of the universal mirror mythology are relevant to the effigies of Christ. Obviously, the Platonic and post-Platonic tradition based on shadow and mirror symbolism and the Egyptian solar religion have to be taken into account; and one has to consider the actual mirror fabrication of the Mediterranean world. But the borderline position of Edessa, the birthplace of the Byzantine mandylion and a city influenced by the Far East, makes it reasonable to offer a brief survey of those aspects of the Indian, Chinese and Japanese sun, moon, and mirror mythologies that show some affinity with the Christ *vera icon*.

Intercultural patterns make us better understand why the *acheiro-poietoi* with God's face played a more significant role than those showing his entire body, explain the affinity between heads and bodies (vaginas, wombs, or skins) and between the blood shed in sex, death, and birth and the cosmic phenomena of rain, dew, and sunlight. For millennia sunrise and sunset have been described as death and rebirth. The evening bloodbath is followed by the

morning resurrection, as the solar head emerges from our planet's maternal womb clothed in blood vapors. Fear about the sun's non-appearance was probably the main reason for sacrificing animals and humans to solar divinities – their blood acting as the vital juice with which the earth was impregnated and fed. Human sacrifice or, more precisely, the sacrifice of skin and blood, body and head is treated in the last two chapters of Part II. Because of the textile nature of the Christian *acheiropoietoi*, the chapter on skin is preceded by that on cloth, our second skin. The coincidence and opposition between skin and cloth has to be realized before we can deal with flayed skin, the most perfect of all "true" images.

Part II

Symbolism and Structure

8

Mirrors

(i) Medusa–Minerva

Initiation begins at the first menstruation. This physiological symptom imposes a break, the girl's forcible removal from her familiar world; she is immediately isolated, separated from the community. The segregation takes place in a special cabin, in the bush, or in a dark corner of the house. The catamenial girl is obliged to remain in a particular and quite uncomfortable position, and must avoid exposing herself to the sun or being touched by anyone.

Mircea Eliade, *The Sacred and the Profane*[1]

Religions come and go; images persist. A popular icon is more likely to survive than to disappear. The "true" faces of Christ were preceded by the masks of Medusa. It is certain that her omnipresence in Graeco-Roman antiquity contributed to the popularity of Jesus' and the Baptist's disembodied heads which, like those of Medusa, were depicted as either dark or light, and often with serpentine hair. Medusa's heads – horrible as well as beautiful, and occasionally furnished with beards – persisted throughout the Byzantine period, and at the beginning of the second millennium they could still be found on Russian amulets called *zmeeviki* (images with snakes).[2]

Medusa or the Gorgon was an ancient deity of the underworld (*Odyssey*, 11. 633). Her monstrosity and fluidity were conveyed by

153

her hair, which consisted of live snakes curling around her head. The "true" likeness of the Gorgon's face decorated both the aegis of Zeus (*Iliad*, 5. 741) and the shield of his daughter Pallas Athena (=Minerva). The mythology of Medusa is constructed around mirrors and menstruation and goes back to Hesiod, the Homeric Hymns, and Pindar. But her most popular legend is told by Ovid (43 BC–AD 17). Medusa "was once most beautiful in form, and the jealous hope of many suitors. Of all her beauties, her hair was the most beautiful" (*Met.* 4. 794–7).[3] Upon her defloration the charming young girl was transformed into a creature so appalling that whoever gazed at her was turned into stone. Medusa was raped by Neptune, the god of the sea, in the temple of Minerva, and polluted with her blood the goddess's sanctuary. "Jove's daughter turned away and hid her chaste eyes behind her aegis. And, that the deed might be punished as was due, she changed the Gorgon's locks to ugly snakes" (*Met.* 4. 798–801).

Let us visualize the scene: Minerva, a goddess who in her purity and masculinity so much resembles her father Jupiter as if she were his "alter ego," hides behind her aegis, while the highly polished surface of her armor-mirror catches the reflection of the bleeding Medusa. Ovid's idea of one woman mirroring the other at the moment of sexual initiation comes from his knowledge of the mythical identity between Minerva and Medusa.[4] Athena, the luminous goddess of sky, is described as a pure film of light comparable to aether, the dawn or the twilight. Medusa, the other self of Athena, stands for the staining and corruption of the virginal membrane. She personifies her menstruating femininity which is first demonized and then eliminated. The trapping of Medusa's reflection-soul in Minerva's mirror is followed by the girl's transformation, exile, and death. Minerva expels the leaky monster to the western outskirts of the world and has her beheaded by Perseus, whom she guides to Medusa's hiding place. The goddess equips him with her own aegis, a solar shield–mirror–weapon, which saves Perseus from being killed by Medusa's terrible sight. He looks "upon the image of that dread face reflected from the bright bronze shield his left hand bore" and, while she is sound asleep, he smites "her head clean from her neck" (*Met.* 4. 782–5).

As Medusa lay bleeding to death, her dreadful likeness was caught again by Minerva's mirror – to stay there forever. The Gorgon's severed head became the main symbol and attribute of Minerva who, "to frighten her fear-numbed foes . . . still wears upon her

breast the snakes which she has made" (*Met.* 4. 802–3). Perseus executed Medusa, but the moving spirit behind the act was Minerva, the honorary male of the Greek Olympus. By murdering Medusa, she shed off her female physiology, sexuality, and destiny which would have collided with her power as the virgin-goddess of heaven. The monster's fluid, serpentine reflection at once tarnished and shielded – like the soul-portrait of Dorian Gray – the immaculate goddess. Minerva remained a hermetically sealed virgin, but her aegis was marked with female flux and fertility. Out of the dying Medusa's blood twins were born, the "swift-winged Pegasus and his brother" (*Met.* 4. 785–6).

In order to realize the various implications of Ovid's tale, one has to recall the mythology of Pallas Athena, Medusa, Poseidon (Neptune), and Perseus.[5] Athena is best known as a masculine goddess of heaven, wisdom, war, and the protectress of cities. Hesiod's *Theogony* and the Homeric Hymn *To Athena* tell us that she was born immaculately, not from her mother's womb, but from her father's head. Zeus had inseminated Metis (Thought), the daughter of Okeanos, before he learned that the son born from her would threaten his power. Therefore when Metis was about to bring forth the child, he transferred it to himself by swallowing his pregnant wife; then his head was split by Hephaestus (Prometheus or Hermes), possibly a metaphor of a cloud split by lightning, and Athena emerged from it: a bright-eyed maiden, "equal to her father in strength and in wise understanding" (*Theogony*, 895–6).[6] The goddess's birth was accompanied by thunderstorm and lightning, and gold rained from the sky. A true warrior, Athena came forth in full armor,

> sprang quickly from the immortal head and stood before Zeus who holds the aegis, shaking a sharp spear: great Olympus began to reel horribly at the might of the bright-eyed goddess, and earth round about cried fearfully, and the sea was moved and tossed with dark waves, while foam burst forth suddenly: the bright Son of Hyperion stopped his swift-footed horses a long while, until the maiden Pallas Athene had stripped the heavenly armour from her immortal shoulders.
>
> (*To Athena*, 28. 7–14)

This heroic entrance announced a divinity of storm and war, but Athena embodied also female virtue. Greek art represented her with a spear in her right hand, in her left a distaff and spindle or

shield. The legends of Athena's weaving allegorized domesticity and alluded to her peaceful, lunar character and her appearance as clouds. Athena, the goddess of heaven and culture, was contrasted by Medusa, an archaic deity of nature – physical and terrestrial, aquatic and animalistic – whose "true" image was displayed on her aegis. This duality resulted in a double name and in legends permeated with contradictions and confusions. Athena's surname *Pallas*, used by Homer and Hesiod, was explained in various ways. Pallas was either a male giant – occasionally Athena's father himself – whom the goddess had defeated, or a woman, the daughter of Triton, whom Athena had accidentally slain.[7] The latter was obviously identical with Medusa. The bronze shield with the image of Pallas or Medusa developed from a hide and garment: a goatskin worn by the goddess. With time the skin of the horned animal, which in Greek mythology was associated with voluptuousness and fertility (and in Christianity with badness), came to be regarded as the flayed-off skin of the Gorgon (Plate 11).[8] So the dead creature which had originally clothed Athena metamorphosed into her panic-provoking emblem and shield.

The figure and mythology of Athena combine the opposites: high and low, sky and earth, pure masculinity and impure femininity. She was born from Zeus's head, but on earth and near water – on the banks of the river Trito after which she was called "Tritogeneia." She was a virgin, but snakes and male divinities of fire and water abounded in her company, signaling sexuality, fecundity, and menstruation.[9] In one of Athena's oldest legends Hephaestus (Zeus's "midwife" at her birth) passionately pursued the goddess and ejaculated his semen on her. In order to avoid insemination, Athena enveloped his ejaculate in a cloud, a symbol of herself, and let it fall to the earth where Erichthonios or Erechtheus was born of it. A man with the head of a snake, he was equated with the first man and the sea-god Poseidon (Neptune). Other stories presented Poseidon as the father of Athena whom he had engendered together with Koryphe, the daughter of Okeanos.[10]

The myths suggest a dual threat to Athena's purity. She is endangered from without by the appetite of men who desire her – and whom she tries to scare to death by wearing on her breast a monstrous image suggestive of decapitation, castration, and menstruation; and she is threatened from within, by her own Medusan nature yielding to sex. Descriptions that aim at conveying Athena's hermetically sealed chastity dwell on her armor, shield, and

helmet. Medusa, on the other hand, seems to consist of nothing but naked skin, hair, and flux; poison emanates from her eyes, and she bleeds in sex and death. But there are allusions to incontinence and blood in Athena's legends too.[11] Because of a spear wound, she was portrayed with her leg bound in a red cloth.[12] The statue of Athena Parthenos at Athens turned round from east to the west and spat blood.[13] Pandora, the beautiful First Woman who opened the box filled with filth and thus polluted the earth, belonged to Athena's entourage.[14] And in order to guide Odysseus to the palace of Alcinous, the goddess disguised herself as a young girl with a pitcher (*Odyssey*, 7. 26).

Preserving the likeness of Medusa in the appearance of Athena, Greek mythology acknowledged that this divinity of culture was still endowed with the Medusan power of nature. A personification of the *Urgrund*, the material source of all being, the Gorgon represented the terrible side not only of Athena, but also of Aphrodite and Artemis. A double-winged Medusa with two black swans, the sacred animals of Aphrodite, is depicted on a seventh- or sixth-century BC plate from Rhodes.[15] A bloodthirsty demon of fertility, she is endowed with huge hanging breasts, two pairs of wings, and locks that resemble snakes. Her eyes and mouth gape wide open, her tongue protrudes, her fangs stand up, and her hands squeeze the birds' necks. But the swans look as if they were enjoying her cruelty, their feet clinging to the legs of their *dame sans merci* – not *belle* but potent. This ancient portrait of Medusa celebrates a female sexuality that appears beastly and appalling as well as admirable and triumphant. The Gorgon's everlasting *élan vital* is stressed by the repeated use of the swastika, a sign of the life/death cycle (similar to the life/death wheel and the *orobouros*, the snake biting its tail). The Gorgon's leg is tattooed with a swastika, swastikas mark the swans' bodies and the background, and the shape of the Gorgon itself is vaguely suggestive of a swastika. Similarly, a Medusa, flanked by two lions and equipped with a serpent girdle, assumes a swastika form on the pediment of the sixth-century BC Artemis temple in Corfu.

Medusa is banished by Minerva to the shores of the Western ocean, where the sun's journey ends in the underworld. The obscure periphery is described as "back" in terms of time and space; it is primordial and primitive, and the backstage of the world. To reach Medusa's exile, Perseus has to travel "far through trackless and secret ways, rough woods, and bristling rocks" (*Met.* 4. 777–8). The

killer of the monster – the son of Danae whom Zeus has penetrated disguised as a golden shower – is Athena's half-brother. He is a splendid solar hero, the opposite of Poseidon, the archaic and aquatic lover of Medusa.[16] Perseus's luminosity is highlighted by the presence of Minerva's aegis. A sun-shield and extra eye, it reinforces the contrast between the executioner and his victim, semi-blind female trash vegetating in the silent darkness of the cosmic backyard. The entrance to Medusa's place is guarded by her relatives, the daughters of Phorcys (the parent of a whole collection of female monsters: the Graeae, the Gorgons, and Scylla). They had no sight of their own but shared the eye of their father: "this eye by craft and stealth, while it was being passed from one sister to the other, Perseus stole away" (*Met.* 4. 776–7).

Medusa's death transformed Minerva into an artist. Upon hearing her mortal scream, Athena invented flute-playing by weaving "into music the dismal death-dirge of the Gorgons bold, – the dirge, that Perseus heard, while it was poured forth, amid direful woe, from beneath those maidens' awful serpent-heads."[17] The surname Pallas hides monstrosity. *Minerva*, Athena's Roman name, hints at menstruation. The etymology of *Minerva* (old orthography *Menerva*) is traditionally derived from *mens* (mind). But the goddess's name is also related to *mensis* (month, female period), and the verb *menstruo*. The words have a common root in the Indo-European *me* – "idea of measure."[18]

Minerva's shield, a magic mirror and *acheiropoietos*, is not a *speculum exemplare* shining with the face of a victorious god of culture, but a *speculum terribile* of a defeated and demonized goddess of nature. Medusa's "true" image is created not by a male emission, wholesome and purifying, but by a female secretion, unclean and poisonous. The aegis confronts us not with a public front, but with a private back, not with god's face or head, but with a goddess's "underface" – emblematic of a menstruating vagina, decapitation, and castration.[19] The *vera icon* of Medusa does not cure. Flashed at the beholder, it petrifies him with terror, offering Minerva the best protection from male assault. The shield's deadly potency is derived from the combined mirror and menstruation mystique. The aegis demonstrates "the mysterious and awful power of the menstruous discharge itself . . . if this female power should issue when the moon or sun is in eclipse, it will cause irremediable harm; no less harm if there is no moon; at such seasons sexual intercourse brings disease and death upon the man" (Pliny, *NH* 28.

158

23. 77). In ancient Greece and Rome Medusa's severed head was considered a talisman, and as such it was reproduced on shields, helmets, armor, cloths, objects of daily use, and in architecture. Medusa's serpentine hair, of which some was cut by Athena, guarded the town of Tegea in whose local sanctuary the goddess was worshipped as *Athena Poliatis* (Keeper of the City).[20]

Greek mythology and philosophy make us realize that in pagan antiquity, similarly as in Judaism, a menstruating woman is perceived, and consequently perceives herself, as a terrible threat. Thus she is condemned to an invisible ghetto and the obscurity of a social outcast. She is not to be seen and she is prevented from seeing others and herself. Thus she cannot not proceed from vision to reflection. Kept away from light and illumination, a menstruating woman's gaze is clouded, and she experiences herself the way she is supposed to – as a semi-blind creature separated from the rest of the world by a layer of blood. The red film is the product of Hemorrhissa's victimization – of the shame, humiliation, and confusion that govern her "menstruating" mind. Forbidden to face the world, she keeps "spinning," "staining," and "poisoning" it with her blood.

Approaching Christ from the back, the biblical Hemorrhissa observed the restrictions imposed on her. Facing the menstruating female, Jesus broke a taboo. He saved the Hemorrhissa from a Medusan fate and brought her out of the closet. But, on the other hand, the scene of the Hemorrhissa's healing, with her touching Jesus, the divine mirror, from the back, might have also echoed the ancient mirror purification magic: "a mirror which has been tarnished by the glance of a menstruous woman recovers its brightness if it is turned round for her to look at the back" (Pliny, *NH* 28. 23. 82). What did the evangelists want to convey? Was Jesus a revolutionary acting against Jewish and pagan prejudice? Or was he a quack doctor using popular magic? The answer may be that a taboo is broken most effectively by means of a miracle which makes use of existing superstition. The success of the Christian dissent was determined, as is the fate of every revolution, by its ability to convince people that the traditional laws, taboos, and magical practices were no longer necessary because Jesus could remove threats and fears through wonders of which each rang a bell. Therefore the Hemorrhissa episode was narrated in such a way as to make it appear grounded in the contemporary mythology and magic. Not accidentally, perhaps, the most detailed account of the healing

is given by Mark, whose evangel, generally believed to be the oldest of the four, uses a proverbial mode. "Mark's Jesus," writes John Drury, "is typically a folktale hero, a wanderer going through ordeals which commandeer, disrupt, and reorder the established myths. He is unaccommodated and unofficial. He performs the miracles beloved of popular piety because they change lonely misery to social happiness at a touch."[21] The Hemorrhissa's acceptance into Christianity requires a disruption of ancient tradition. But her "healing" is performed along the lines of the ancient mirror symbolism and recreates in reverse the Gorgon legend – with Jesus turning an incontinent and unclean Medusa into a whole and pure Minerva.

Berenice–Veronica carrying on her front the portrait of Jesus resembles Minerva with the image of Medusa. In Christian art Jesus and Veronica form a couple; in ancient art Perseus and Athena are a pair. A Roman silver plate depicts Athena assisting Perseus. As he raises his sword to cut off the Gorgon's head, the goddess – standing opposite Medusa curled on the ground – catches with her shield the sleeping woman's reflection.[22] In order to establish the purity and solar primacy of Athena, Medusa, the menstruating alter ego of the goddess of heaven, is slain by Perseus. The affinity between the Minerva–Medusa mythology (and representation) and the Jesus–Hemorrhissa story suggest that we deal here perhaps with both a solar–lunar (=terrestrial) doublet and an archaic belief in two female suns, the day-sun, responsible for light and vision, and the night-sun – black and bathed in blood. There is no reason why the effusion of red light should not be likened to menstruation, and why a female mirror-face should not serve as a symbol of sun.

Medusa's mythology and imagery survived in the medieval legends of Melusine, a charming woman who periodically turns into a siren with a fish- or snaketail instead of feet, and similar monsters.[23] Often equipped with mirrors, they seduce men away from the dry land of virtue into a sea grotto of sex. John Mandeville, whose extremely popular French travelogue was produced between 1357 and 1371, recounts a contemporary Greek legend dealing with the idea of the female condition as a cyclical sickness and linking the Medusa to the Hemorrhissa. On the island of Lango (Cos), which Mandeville passes after Crete, there lives in a cave the daughter of Ypocras (Hippocrates, who was in fact born on Cos). Once "a fair damsel," she was changed into a "great dragon" by Diana, the masculine and virginal goddess of hunting. In order to "turn again to her own nature," the monster needs a Jesus, a good doctor and lover,

"who shall be so bold that he dare come to her and kiss her on the mouth."[24] But the men landing on the island are no heroes; they panic and are killed by the dragon. But even without the kiss of a "knight" (a common man won't do), at times the monster becomes a normal female who, if a man is not afraid of her, does not do any harm. Once a young sailor "that knew not of the dragon" entered her cave, saw

> a damsel who was combing her head and looking in a mirror . . . and he believed that she had been a common woman, who dwelled there to receive men to folly; and he abode till the damsel saw the shadow of him in the mirror, and she turned . . . and asked him, what he would? And he said, he would be her paramour. And she asked him if he were a knight? And he said, nay. And then . . . she bid him go again unto his fellows and get him knighted, and come again upon the morrow, and she would come out of the cave before him; and then he should come and kiss her on the mouth, and have no fear.[25]

The fellow got himself knighted but, alas, he returned to the island at a wrong period, and was scared out of his wits by a dragon "so hideous and so horrible" that he fled and died leaving his lady to her impurity. Still, we are in Christian times here, when even a Medusa can be saved. Mandeville's tale ends with the optimistic conclusion that ultimately there will appear a "knight" whose touch "shall turn the damsel into her right form."[26] A charming fourteenth-century French statuette makes clear what that form is. It shows the Holy Virgin who, while being crowned by the infant Jesus, tramples a pretty siren with her feet (Plate 27).

(ii) *Mirrors and Menstruation*

The Medusa–Melusine mythology reflects the fear of menstruation which Pliny tries to rationalize:

> But nothing could easily be found that is more remarkable than the monthly flux of women. Contact with it turns new wine sour, crops touched by it become barren, grafts die, seeds in gardens are dried up, the fruit of trees falls off, the bright surface of mirrors in which it is merely reflected is dimmed, the edge of steel and the gleam of ivory are dulled, hives of bees die, even bronze and iron are at once seized by rust.
>
> (*NH* 7. 15. 64)

161

Still today some nomadic tribes in Turkey isolate menstruating women in special huts from which all shiny surfaces are banned, and which are furnished with eating utensils made from non-reflecting materials.[27] The superstition can be traced to Aristotle, who writes:

> If a woman looks into a highly polished mirror during the menstrual period, the surface of the mirror becomes clouded with a blood-red colour (and if the mirror is a new one the stain is not easy to remove, but if it is an old one there is less difficulty). The reason for this is that . . . the organ of sight not only is acted upon by the air, but also sets up an active process, just as bright objects do; for the organ of sight is itself a bright object possessing colour. Now it is reasonable to suppose that at the menstrual periods the eyes are in the same state as any other part of the body; and there is the additional fact that they are naturally full of blood-vessels. Thus when menstruation takes place, as the result of a feverish disorder of the blood, the difference of condition in the eyes, though invisible to us, is none the less real (for the nature of the menses and of the semen is the same); and the eyes set up a movement in the air. This imparts a certain quality to the layer of air extending over the mirror, and assimilates it to itself; and this layer affects the surface of the mirror. Now the cleaner one's clothes are, the more readily they become stained, because a clean object exhibits distinctly any mark which it receives; and the cleaner the object, the better it exhibits even the slightest effects produced upon it. In the same way the bronze surface of the mirror, being smooth, is peculiarly sensitive to any impact (and one must regard the impact of the air as a kind of friction or impression or washing); and because the surface is clean, any impact upon it is clearly apparent. The reason why the stain does not readily come off from a new mirror is that the surface is clean and smooth; in such cases the stain penetrates deeply all over, deeply because the surface is clean, and all over because it is smooth. The reason why it does not persist in old mirrors is that it does not penetrate so deeply, but is comparatively superficial.[28]

Unlike Plato, who seems to have shunned the company of the opposite sex, Aristotle was married twice and had an opportunity to get firsthand information about menstruation.[29] He very likely inquired about it and was probably assured by the women that their periods prevented them from having proper reflections. But why would women confess such a thing? The explanation might be that menstrual superstition had resulted in such a self-horror that when

162

women accidentally caught a glimpse of themselves in a mirror, they were blinded by fear. One has also to realize that both their anxiety and Aristotle's explanation parallel primitive perceptions of shadows and reflections as substances emanating from objects or living beings – i.e. as people's spirits or souls. Projection and reflection are feared because they empty out the body, transforming it into mere clothing, and expose the spirit or soul, externalized and made visible, to outer danger.[30] There are countless examples of beliefs that human beings and animals can be effectively exterminated by means of an attack on their shadows and reflections.[31] In ancient India and Greece, contemplating one's reflection was considered perilous. Dreaming of one's reflection foreshadowed death to the Greeks. Because of their ability to "draw out" people's spirits or souls, all shiny surfaces, including the pupil of the eye, were approached with caution. The Upanishads believed that from a person's pupillian "soul" yet another soul could be born, a tiny independant humunculus which was associated with the index finger and the penis, and was expected to wander around in the body.[32] Shadows were feared as much as reflections, and occasionally even more, especially in the South, where their outlines are particularly sharp. Since one could injure or kill a person by striking or treading on his/her shadow, endless precautions were taken in dealing with shadows. In India pregnant women fled from the shadows of men, afraid that the child would take after them. In Palestine Jesus was born after Mary had been "overshadowed" by God.

Studies in children's psychology have shed light on the reflection and projection paranoia of primitive people. The French psychologist, Jean Piaget, has shown that children interpret the phenomenon of shadows in terms of emanation, and he has discerned four distinct stages of the development. During the first, which usually occurs at the age of five, "shadows are conceived as due to the collaboration or participation of two sources, the one, internal (the shadow emanates from the object), the other, external (shadows come from trees, from night . . . etc.);" during the second stage at age six to seven, "shadows are believed to be produced by the object alone," and to be "a substance emanating from the object;" after the third stage has been reached around the age of eight, "the child is able to predict the orientation of shadows" and even to say "that shadows will be formed where there is no light, no sun;" finally, the fourth stage is achieved around age nine, when "the correct explanation is found".[33]

Asked the question, "Where does the shadow come from?", a seven-year-old boy replies: "it comes out of the person, we have a shadow inside us;" pressed to explain what he means by that he says: "it falls on to the ground;" another boy of the same age believes that the shadow is a "portrait" which keeps us company all the time: "in the night you can't see it, but it's beside you all the same."[34] Very much in the vein of Aristotle talking about the cloud of blood on the surface of the mirror, a seven-year-old remarks that a shadow "hides the white," meaning that it covers paper with black.[35] Failing to predict on which side the shadow will appear, an eight-year-old treats it as an autonomous creature and explains that the shadow "likes best to be on this side."[36]

Piaget concludes that children perceive a shadow as a substance and part of an object or person, a sort of vapor that clings to things, or a fluid that emanates from them and moves about like a living conscious being. They cannot properly understand the nature of the shadow because they lack the capability of relational logic which they would need in order to interpret the facts they observe. Instead, they invent "the principle of a shadow in accordance with an ontology that is foreign to the pure observation of phenomena . . . a substantialist ontology" which can "only lead to an exclusive use of conceptional imagination."[37] But what causes the substantialist ontology? Here Aristotle's example may be revealing. His idea of blood emanating from a menstruating woman's eyes is derived from an association with excretion. Therefore the philosopher uses cloth as an example of how the mirror is stained. What makes him fall into this trap is the seductive simplicity of the analogy and the fact that it fits into his own system as well as into Platonism – preoccupied with the duality of essence and existence, the original and the replica, the real and the illusory. While Plato likes to explain the relationship between prototype and copies in terms of projection and reflection, Aristotle, who is highly interested in biology, uses metaphors derived from the flow of organic life.

Aristotle's theories echoed popular beliefs in the ominous power of menstruation and in the duplicating character of menstrual blood; and they were influenced by substantialist mirror and shadow mythologies. The philosopher certified the fiction of blood flowing out of women's eyes and staining mirrors with the authority of his name, thus providing inspiration for new blood–mirror legends. The idea that menstrual blood is infused into the eyes, transforming the pupils into a bloody mirror, implies that whatever

is reflected in them is bathed in blood. According to this theory, Christ's reflection in the Hemorrhissa's pupils is a blood-image, and so is every reflection or projection of his image caught by an external mirror or blank surface. Consequently, the creation of Christ's bloodmade "true" portrait on the woman's napkin can be interpreted as the projection of Jesus' mirror-image out of her bloodshot pupils onto cloth. Since Aristotle mentions explicitly a cloud of blood forming on the mirror's surface, it requires only a small step of the imagination to transform a shapeless stain into an exact likeness. To take such a step is more than logical if Plato's dualism, so popular with early Christian theologians, is blended with Aristotle's theory of menstrual emanation.

(iii) *Sun and Moon*

The Abgar and Veronica legends ascribe a luminous quality to Jesus' face and image. When the apostle Thaddaeus appeared before the king with Christ's "portrait on his own forehead like a sign . . . Abgar saw him coming in from a distance, and thought he saw a light shining from his face which no eye could stand, which the portrait Thaddaeus was wearing produced" ("Story of the Image of Edessa," 12). The scene is modelled after the Old Testament: "When Moses came down from Mount Sinai, with the two tables of the testimony in his hand . . . the skin of his face shone because he had been talking with God" (Ex. 34:29); and it follows earlier legends which, like the *Acts of Thaddaeus* (550–600), report about the painter's incapability to portray Christ – a radiating solar mirror.[38] The impossibility to paint the divine source of light justifies the *achieropoietos* – a reflection fixed in a mirror. Since God, the sun, could not be faced, he needed a medium through which his otherwise unbearable luminosity could be conveyed. Thus he found Veronica, a receptive mirror, and reproduced himself in her – very much in accordance with classical Greek philosophy and ancient mirror mythology.

Mirror symbolism was shaped by actual mirrors: the materials of which they were produced, their quality, their forms, the predominance of certain mirror types (plane, convex, or concave); and it was influenced by their use in cult, magic, and divination, for making fire and toilette. The more mirrors made in a culture and the better their quality, the richer the mirror symbolism. Mirrors, attractive

pieces of merchandise, travelled around the globe, and so did their mythology – a dense network of cross-influences and references which up to our day remind us that the experience of reproduction and duplication resides at the center of our psychology. In his 1937 book on Afghanistan, René Dollot reports about a Muslim wedding which, echoing Jewish and Christian traditions, is based on the juxtaposition of God's word – and a woman's "true" image. The ritual climaxes in the bridegroom's slipping under his bride's veil where both are made to kiss the Koran; then the man is given a mirror with which he catches the reflection of his bride – often seeing her for the first time.[39] As in the Old Testament, vision and symbolic reproduction are immediately followed by defloration, impregnation, and the subsequent birth of a replica.

The significance of mirror symbolism was discovered by nineteenth-century anthropologists, ethnologists, and folklorists; the validity of their studies was reinforced by twentieth-century structuralists who have made us aware of mirrorlike configurations in religion and social organization, and by scholars of comparative philosophy, literature, and poetry who keep signaling the importance of *speculum* metaphors.[40] The prehistoric ancestors of humanity learned about reflection when they gazed into water. Its depth was transferred to all other mirrors, creating an invisible space, symbolic and magic, behind the flat surface. Mirrors seem to be the product of humanity's preoccupation with the sun. The solar culture of Egypt is the birthplace of the mirror.

The earliest proper mirrors were found in the predynastic Egypt of before 4500 BC, in El-Badari, close to the Nile and some 250 miles south of Cairo. One of them consists of a slab of selenite which shows the rests of a wooden frame, the other is a large disk of slate (which, when wetted, makes a shiny surface) with a hole for suspension. In a grave of the First Dynasty (2920–2770 BC) was discovered the first metal mirror. It was made of copper, had a pear shape and a stem for a handle. The traditional Egyptian mirror was like the sun, a disk slightly flattened by the medium of the earth's atmosphere (the hieroglyph for "sun" was a circle with a central dot). It became established only during the Fourth Dynasty (2575–2415 BC), and persisted for many centuries.[41]

Egyptian mirrors symbolized the sun and were dedicated to the cult of the sun-god Re, the chief deity of the Egyptian pantheon – a personification of energy and light, the passing of time and the beginning of language. The name of Re was the god's own creation

and was kept secret. Isis, his divine consort, devised therefore a special trick in order to learn it and thus share in his power.[42] Re was shown in constant movement. He sailed across the sky in the "Manzet" (the bark of the dawn) and stepped into the "Mesenktet" (the bark of the dusk) at sunset. After he had been received by the goddess of the West, he started his night journey through the underworld back to the East.[43] The drama of Re's daily disappearance was celebrated in an important theological book compiled at an uncertain date between the 18th and 20th Dynasties. It is entitled *The Litanies of the Sun* and contains the acclamations with which Re was greeted in the evening. Later mythology likened the sun's journey to the flight of a bird and Re to the falcon-god Horus; or it pictured him in threefold form foreshadowing the imagery of Jesus: an infant rising out of a lotus flower in the morning, an adult at noon, and a weak old man in the evening.[44] The cloudless sky of Egypt was compared to a celestial ocean, an immobile and all-encompassing passive mirror-vernicle, which was personified by the goddess Nut; her elongated body was shaped into an arch and supported from below by a small slender man, the god Show, who held her aloof from her husband Keb, the god of earth. Moving across the body of Nut, Re was interpreted as her *ka* (soul). But since she was also identified with Hathor, the cosmic cow, he was her calf – born anew every morning – or a shiny scarab hurrying through her dung.[45]

A mirrorlike position of the sun and the moon was expressed in the amorous relationship of Osiris, the god of the underworld and the personification of the setting sun, and Isis, his divine consort, an incarnation of the moon. Isis was often represented with horns, imitative of the crescent moon, and in dark garments, symbolic of "the concealments and the obscurations" in which she engaged in her pursuit of the sun.[46] The Egyptians held Isis for a goddess of love and the mother of the world. Impregnated with solar "effluxes and likenesses," she bore Horus and demonstrated that "creation is the image of being in matter" and that "the thing created is a picture of reality" (*Isis and Osiris*, 372). Isis's role was not entirely passive. Upon her insemination by Osiris, she emitted into the air her own "generative principles" (*Isis and Osiris*, 368), and she could challenge Osiris's omnipotence by eclipsing him.

The vision of the sun as the son and husband of Isis and a disk or head travelling through female matter influenced the shape of Egyptian hand-mirrors. Before the 18th Dynasty, the upper ends of

mirror handles were often decorated with the cow-head of Hathor. Later they were made into naked female figurines, Egyptian versions of our Veronica, carrying the sun-shaped mirror on top of their heads or in their hands. This symbolism was not confined to Egypt. Among a dozen copper and bronze mirrors found at Mehi in Western India and assigned to the Kulli culture (before 3000 BC), one has the form of a female figurine set in an akimbo position, her breasts naked, her head a mirror.[47] Vajrananga, the Buddhist god of love, a deity that brings to mind the Greek Eros, was equipped with a mirror-weapon used for capturing his beloved's soul.[48] In the cult of the goddess Kali, to whom in ancient times humans were sacrificed, mirrors served as catchers of people's reflections with which the actual victims were replaced.[49]

The most elaborate of the ancient mirror mythologies comes from China, where the production of bronze mirrors began ca.1200 BC (by ca.1000 BC mirrors were already used to start fire).[50] The earliest Shang mirrors had the shape of a disk held by a silk cord run through a knob of the unpolished surface.[51] The form corresponded to the archaic Chinese pictograph of the sun, a circle with a dot in its middle and a sign identical with the Egyptian hieroglyph for the sun. The Chinese associated the active aspect of the mirror with the sun and the fire, the passive part with the moon and the water. Mirrors symbolized the fusion of the male *Yang* with the female *Yin*, and their production, a high craft, required the ability to imitate nature and combine the male and female elements of creation. The mirror's masculinity was believed to draw fire from the sun (a burning mirror was called *yang-sui*, "sun igniter"), its femininity to attract water from the moon. Concave mirrors were exposed to moonlight to collect in their cups the dew.[52]

Magical mediators between elemental opposites, mirrors were given to newlywed couples whose integrity they were to guard, reminding them of the cosmic and divine harmony: "the son of Heaven dwelling with the queen like the sun with the moon."[53] In Chinese love poetry the bright and unclouded full moon was equated with reciprocated affection, the consummation of marriage, and union. The obscured or partial moon was compared to a broken mirror separating the partners. Accordingly, the backs of the marriage mirrors were decorated with mating animals and other symbols of coupling and fertility. A favorite subject was two magpies, illustrative of an old legend about a husband and wife who broke their marriage mirror into two halves before parting, with

each taking one half as a promise of faithfulness. As the woman betrayed the man, her part of the mirror turned into a magpie and flew to her husband with the bad news.[54]

An unfaithful wife loses her mirror. A faithful spouse, the eighth-century Chinese poet Li T'ai-Po tells us, never does.[55] Even after her husband has parted from her, she keeps polishing "again and again" with her "red sleeve" his "precious mirror coiled with dragons." Gazing at the mirror's "splendour lighting up everything," the deserted woman contemplates her own caged "reflection" which, like "the golden magpie . . . does not fly away;" and she compares herself to "the green Fire-Bird who, thinking of its mate, died alone."[56] The woman's "wiping" and "rubbing" of her husband's "absolutely perfect" mirror with her red dress suggests intercourse and menstruation. In Chinese sympathetic magic, cloth was identified with body, mirror with the soul, and ground mirrors were used as an ingredient in medication against irregular periods.[57] But the woman's identification with the green (feminine) Fire-Bird also brings to mind the making of fire, an activity which, according to Bachelard, has to be regarded as synonymous with love-making. He believes that the sexual "rubbing" of prehistorical humans inspired them to rub other things too – leading them to the invention of fire.[58]

Mirrors are wiped with cloth in Buddhist rituals of divine purification, which correspond to the Buddhist interpretation of the mind as a two-sided mirror consisting of the *manas* (realistic mind), troubled by appearances and reflecting the world in a distorted way, and *buddhi*, the pure supreme mind mirroring everything without error.[59] Similarly, as in the Babylonian-Assyrian tradition, in Chinese art thunder was pictured as a man. Lightning, his visual companion, was a woman with one or two mirrors in her hands, or holding a mirror over her head. China's highly developed optical industry allowed the production of truly magical mirrors in which in addition to reflections one could see reproductions of images hidden on the back of the mirror. Called *theon-kouang-kien* (mirrors which let light penetrate them), these mirrors were treated with a special polishing technique whereby the slightly convex surface of the mirror was given "imperceptible irregularities that corresponded exactly to the inscription or design on the back side of the mirror. As a consequence, the part corresponding to the raised pattern on the back became relatively concave and concentrated the light there more strongly on the remainder of the slightly convex

surface. This resulted in a bright delineation of the pattern on the screen."[60] The intricate mirrors acted as a sort of Chinese *camera obscura*. Outlining the drawing in shadow and light, they dematerialized it and projected out of matter. This type of mirror was perfected by the Japanese to the extent that it could project not only patterns but even likenesses.

There was traffic between China and Japan as early as the second century BC, when the first Chinese mirrors probably made their way to the islands.[61] The mirror occupies a central position in Shintoism, the animistic and shamanistic religion which gave the Japanese their national identity and was codified in the Japanese Holy Scriptures, the *Kojiki* (712) and the *Nihongi* (720). They begin with creation, the work of Izanagi, a male deity, and Izanami, a female. From Izanagi's right eye the sun goddess Amaterasu, from his left eye the god of the moon are born, and from his nose springs a phallic and impetuous trickster.[62]

The main attribute of Amaterasu is her mirror. The legend of the sun-goddess is constructed around the contrast between peaceful femininity busy with matter-making and male energy and aggression. As the goddess "was inside the sacred weaving hall seeing to the weaving of the divine garments," her trickster brother "opened a hole in the roof . . . and dropped down into it the heavenly dappled pony which he had skinned with a backwards skinning. The heavenly weaving maiden [a minor deity or priestess], seeing this, was alarmed and struck her genitals against her shuttle and died."[63] But in the *Nihongi* it is the sun-goddess herself who is injured, and there is strong indication that this represents the original version, while in the *Kojiki* suffering is shifted to a subordinate.[64] The wounding brings to mind defloration, beginning of menstruation, ritual murder related to sexual initiation – and the story of Medusa. Thus we are not surprised to hear that subsequently Amaterasu retired into a sky-cave, causing darkness, upsetting the other divinities, and behaving very much in accordance with a pattern observed by Eliade: "The girl who at her first menstruation spends three days in a dark hut without speaking to anyone does so because the murdered maiden, having become the moon, remains three days in the darkness."[65] We are used to a menstruating *luna*, but the Japanese tell us that one can also imagine a menstruating sun.

In order to lure Amaterasu out of her hiding, the remaining gods had an old goddess make a sun-shaped mirror which they hung on

the middle branches of a *sakaki* tree pulled up by the roots, while on the lower branches they suspended offerings of white and blue cloth. Then they began to make music, dance, sing, and enjoy themselves in a way reminiscent of carnival orgies, New Year's or spring celebrations. One of the goddesses "became divinely possessed, exposed her breasts, and pushed her skirt-band down to her genitals."[66] The astonished Amaterasu opened her cave, peeped out and, attracted by the sight of the mirror, "gradually came out of the door and approached" it.[67]

The myth suggests Amaterasu's dual nature comparable to the Minerva–Medusa doublet. On the one hand she is a "weaver" of light, pure and virginal, on the other hand, when hiding (menstruating) in her cave, she is the maker of darkness. Thus she is identified both with the sun's luminosity and with the receptive and reproductive mirror – a medium of duplication, representation, and incarnation – which she receives upon her sexual maturity. The Japanese sun-goddess procreates and sends her heavenly grandson down to Japan. He becomes the first emperor, starting an unbroken succession which still continues. Before his descent, Amaterasu hands him her mirror (remember Minerva's aegis given to Perseus), admonishes him to worship in it her "August Spirit," and has mirror-makers join him on his trip. The solar mirror becomes one of the two most important relics of Shintoism, the other being the heavenly sword, its male counterpart. Still today the Imperial Palace in Tokyo has a sanctuary where a reproduction of Amaterasu's mirror is enshrined and where, until the defeat of Japan in the Second World War, the emperor made daily obeisance.[68]

The symbolism of the divine sword and mirror resulted in the association of the first with a samurai's soul, of the second with a woman's soul. "When the mirror is dim the soul is unclean."[69] The femininity of the mirror seems to account for an old kind of marriage-mirror, which differed from the traditional Chinese type in that it did not celebrate sexual union, but was explicitly tied to the female sphere, and was presented by mother to daughter during her wedding ceremony.[70] In recollection, perhaps, of the music that accompanied Amaterasu's coming out of the cave, the early Japanese created a unique type of mirror in which vision (space) was combined with sound (time). The *suzukagami* looked like a round Chinese bronze mirror, but had five or more rigid bells attached to the rim; they rang when the mirror was shaken.[71] This curious

171

combination of the visual and acoustic rings a bell in the back of the European mind, making us recall the audio-visual affair of Echo and Narcissus.

When the Shinto mirror mythology was fused with Buddhist symbolism, new mirror-types appeared. The shiny surface, where Shintoists used to look for the face of the sun-goddess, now was covered with engravings of Buddha – becoming a Japanese variant of the vernicle. Buddhism regarded breath as the soul or spirit of a living being, and in consequence legends and rites were developed around the scrutiny of the ephemeral image appearing on the mirror surface when someone breathed onto it. The Buddhist deity Emma-O (derived from the Hindu god Yama Raja), the ruler of the underworld who sits in judgement over the dead, was usually depicted with a "soul-reflecting" crystal mirror: as the faithful breathed on it, his or her soul was pictured on the surface.[72]

The earliest mirrors found in Greece date back to the sixth century BC. They were made of bronze and show an Egyptian design, although it is unclear if they were imported from Africa or copied from Egyptian originals. It is important to remember that when Plato used mirror metaphors in his philosophy and Aristotle analyzed real and fictitious mirror phenomena, mirrors were widely used in Greece. In the Mediterranean world the widespread mythology and magic of an omnipotent solar mirror was reinforced by the first spectacular use of mirrors as fire-making weapons, an invention credited to Archimedes (ca.287–212 BC). His contemporaries must have perceived his successful destruction of the Roman fleet in the harbor of Syracuse as a confirmation of the mythical power of the sun and its association with fire.

The Greeks took the basic ideas for their mirrors from Egypt, but they injected the ancient forms with the mimetic and sensual qualities of their own culture. The handles of sixth-century Greek mirrors are often shaped into statuettes of young women, naked or dressed in light chitons and with fruits and flowers in their hands, who, like a clothed and a nude Maia, present the two sides of ideal feminine beauty, evoke Aphrodite, and suggest cosmic union and fertility, especially when animals surround the circle (Plate 28).[73] Another kind of mirror, particularly popular around 400 BC, consists of two metallic circular disks which, fitting into each other, produce a box that is sometimes fastened with a hinge. On the inside, the lid is polished to reflect the face, on the outside it is

ornamented with mythological scenes or portraits in low or high relief. Thus even before the mirror is opened and the reflection of one's face appears in it, the mirror's user is faced with a mimetic representation and provided with a sense of identity of the outside and the inside. This feeling is particularly strong when the lid carries a portrait whose features resemble the viewer's. Then it becomes an ideal illustration of the Butades legend – and the Greek fascination with *trompe l'oeil*.

A mirror hidden inside a naturalistically sculpted box can be considered a model for the coexistence of matter and spirit, the body and the mind, the phenomenal and the essential. At first glance a Greek box-mirror looks like a solid piece of sculpture. Nothing indicates that behind it a "true" image awaits us. Opening the mirror, we move inwards and discover a secret other side – and our own likeness. The spirit of Greek culture is conveyed to me as I imagine holding in my hands a box-mirror topped with the relief of a woman's face which is so illusionistic that it resembles a cast. She holds a lock in her right hand (a gesture characteristic of Aphrodite), as if she was arranging her hair in front of a mirror. Imagine, I hold the mirror in my right hand, while with my left I explore the woman's features. As my fingers touch her bronze locks, I lift my hand and arrange my own curls – experiencing identity. Were I not a woman but a *man*, or were the mirror decorated with a man's likeness, the contrast between vision and tactility would produce an erotic *frisson* – and a sense of romance similar to our Veronica–Jesus story.

On the frames, backs, lids, handles, stands, and boxes of the Greek, Etruscan, and Roman mirrors, and even on the textiles in which mirrors were wrapped, erotic themes and the figures of Aphrodite and Eros prevail.[74] The mirrors' mimetic character and erotic iconography indicate their role in love-making. Seneca tells us about a certain Hostius Quadra, a man of lust, who took a special interest in magnifying mirrors which allowed all his organs, including his eyes, to participate in the lechery.[75] No doubt ordinary Greeks and Romans made similar use of the mirrors. While the Chinese and Japanese mirror-makers symbolized the erotic aspect of mirroring, the Greek, Etruscan, and Roman craftsmen treated the mirror as a voyeuristic pupil. As if to express his gratitude for a mirror's help in duplicating reality, a mirror-maker provided the reflecting surface, a face and an eye, with an attractive *trompe l'oeil*

173

body. The mirror's appealing exterior served as erotic inspiration and, when the mirror was opened, the "true" icons of love-making were added to representation.

(iv) *Platonism, Satire, and Theology*

Plato's famous shadow–cave simile – a reflection of and a reaction to his culture's mimetism – defines the visible world as a mere projection of the ideal. Amounting to a shadow of a shadow, "mimetic art . . . is an inferior thing cohabiting with an inferior and engendering inferior offspring" (*Republic*, 10. 603B), and artists – fools pursuing phantoms – are excluded from the philosopher's perfect state. "Images in water and in mirrors" (*Sophist*, 27D) are used by Plato as another example of the merely phenomenal. But, on the other hand, since he values light and vision highest, he treasures the mirror as a medium for catching a glimpse of that "true" reality at which we can only gaze, as at the sun, through its reflection in water. Plato praises the knowledge gained by "an eye viewing another eye" (1 *Alcibiades*, 133A) and compares both a soul and God to the mirror of the pupil. "If the soul . . . is to know herself, she must surely look at a soul," and to know God, one has to focus on that center of the soul which resembles him most (1 *Alcibiades*, 133B–C). Plato's argument moves from the metaphor of a bronze mirror to that of the pupil, and from the mirror of the soul to the divine mirror on which eyes should be fixed, since ignorance is due to one's looking at "the godless and dark" (1 *Alcibiades*, 134D–E). The brightest mirror, the sun, represents supreme deity.

In the Neoplatonic and Christian philosophy Plato's mirror and sun metaphors coalesced with the ancient solar and lunar mythologies, generating a multitude of syncretic interpretations. Throughout centuries, two basic conceptions prevailed among them: the vision of a divine burning mirror, illuminating and purifying humanity, and its counterpart, an opaque mirror receiving reflections and breeding replicas.[76] Applying to Egyptian mythology Plato's idea of the void matter in which everything is reproduced and the idea of the mirror as an image-maker, the Greek writer Plutarch (ca.AD 46–120) compared the moon-goddess Isis to a "receptive" mirror of nature (*Isis and Osiris*, 372–3). Reasoning in a similar vein, Plotinus (AD 204–70), the leading exponent of Neoplatonism, created the concept of a "mirror of matter": his

matter "is like a mirror showing things as in itself when they are really elsewhere, filled in appearance but actually empty, containing nothing, pretending everything"; it "has no reality" and "no Soul; it is not intellect, is not Life, is no Ideal-Principle, no Reason-Principle . . . it lives on the farther side of all these categories and so has no title to the name of Being. It will be more plausibly called a non-being" (*Third Ennead*, 6. 7).[77]

Plotinus's mirror of matter, a female "pauper . . . destitute of The Good" (*Third Ennead*, 6. 14), is worse than nothing. She is a zero minus, since, in addition to being dumb and blank, she goes on to veil the ideal and true. But "as in the absence of a mirror . . . there would be no reflection" (ibid.), without matter, a "receptacle" and "nurse," nothing would exist. Her mirroring makes the world go around – an idea which centuries later was illustrated by a medieval statuette group of *The Visitation* from a Dominican nunnery.[78] It shows Elizabeth and Mary, whose respective pregnancies are suggested by rock crystal cabochons – oval-shaped and womb-sized mirrors which they carry on their bellies. The Platonic contempt for matter impregnated with "true" likenesses makes one grasp the paradoxes of misogyny, idealist philosophy, and paternalistic culture in which those who produce count less that those who don't.

The ancient mirror, sun, and moon mythology was derided by Lucian (ca.AD 120–80), one of the world's greatest satirist-visionaries, in his *True History*. Ridiculing the idea of worlds mirroring themselves in each other and the projection of the sexual onto the cosmic, he reversed the traditional pattern and described the sun and the moon not as an amorous couple but as rivals and enemies. The two celestial bodies, inhabited respectively by the Sunites and the Moonites, find themselves at war, and sunrays are not lovingly collected by the *Luna*, but they are used as weapons against which the Moonites have to erect walls. Dew, the mysterious female fluid, is treated as merchandise, and in the peace treaty the Moonites are obliged to pay 10,000 gallons of it as yearly tribute to the Sunites. Finally, the narrator of Lucian's "true story" uses a marvel familiar to us: he watches the earth from the moon in an audio-visual mirror:

> a large looking-glass . . . fixed above a well, which is not very deep. If a man goes down into the well, he hears everything that is said among us on earth, and if he looks into the looking-glass he sees every city and every country just as if he were standing over it. When I tried it I

saw my family and my whole native land, but I cannot go further and say for certain whether they also saw me.

(*True History*, 1. 26)[79]

Making fun of theology, mythology, and philosophy, Lucian brings cosmogonies and theogonies back to earth by disclosing the physical origins of religious sublimity. Describing the struggle between the sun and the moon armies, he derides the litanies lamenting the sun's daily disappearance in metaphors derived from battlefields, executions, and a man's bleeding to death on a bedsheet or in a woman's lap, and writes: "So much blood flowed on the clouds that they were dyed and looked red, as they do in our country when the sun is setting" (*True History*, 1. 17). Lucian's satire parodies the solar–lunar cults of late antiquity, including that of Christ, the new *Sol Invictus*, hints at the sources of religious blood martyrdom in war and sexuality, and brings to mind a biblical blood–sunlight analogy: in an Old Testament passage the King of Israel calls upon the King of Judah to suppress the rebellion of the King of Moab. To do so they must join up with the King of Edom ("redness") and make a seven-day "circuit" through his land. But as they find no water for their horses and army, Elisha, the prophet, tells them to make the land full of trenches. They dig them, and the trenches unexpectedly fill with water.

> When all the Moabites heard that the kings had come up to fight against them, all who were able to put on armor . . . were drawn up at the frontier. And when they rose early in the morning, and the sun shone upon the water, the Moabites saw the water opposite them as red as blood. And they said: 'This is blood; the kings have surely fought together, and slain one another.'
>
> (2 Kgs. 3:21–3)

The false deduction makes the Moabites attack and lose. What they have taken for male blood is, in fact, earthly water, a female fluid which has appeared in the trenches as mysteriously as menstrual blood.

In the New Testament Jesus acquires solarity at transfiguration when "his face shone like the sun, and his garments became white as light" (Mt. 17:2), and in the Apocalypse. Christianity fought Mithraism and other solar cults, but at the same time it provided Christ with a solar aura by appropriating the ancient sun and moon festivals.[80] Coincidence was established between the day of the sun (Sunday) and the day of the Lord (*domenica*, *dimanche*). Jesus'

176

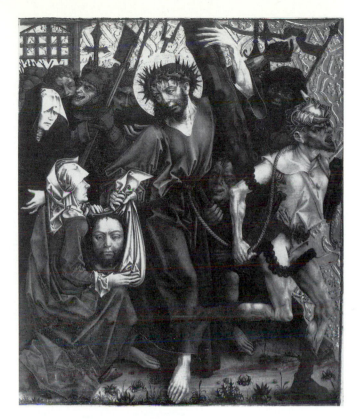

18 Hersfeld altar, German School,
late fifteenth century.

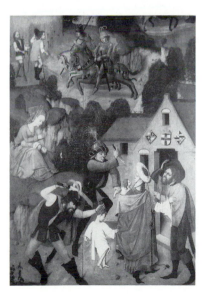

19 Pomeranian (Danzig?) painter,
The Massacre of the Innocents,
ca.1490–7.

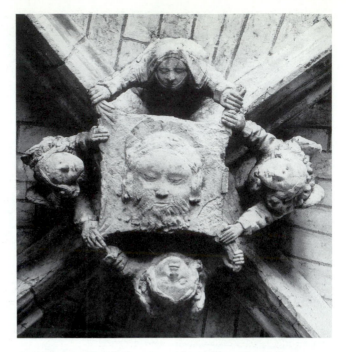

20 *Veronica and Three Angels Holding the Holy Face,*
French School, 1514.

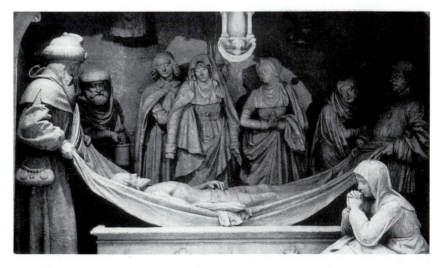

21 *The Entombment,* French School, 1496.

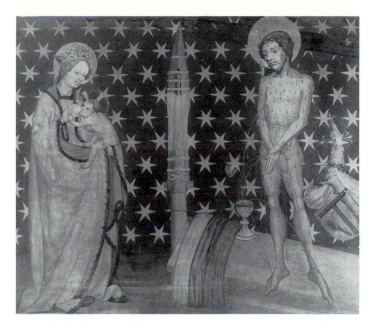

22 Workshop of two Danzig painters, *Mary Breastfeeding Jesus* and *Christ as Man of Sorrow*, ca.1435.

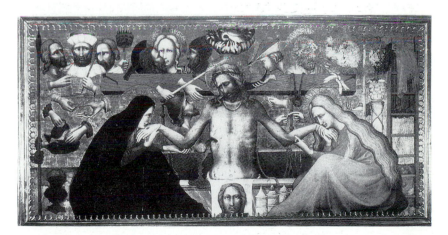

23 Master of the Strauss Madonna, *Vir dolorum between the Virgin and Mary Magdalen*, Florentine School, ca.1405.

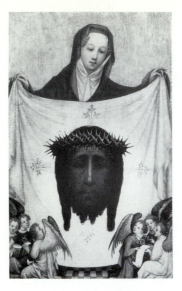

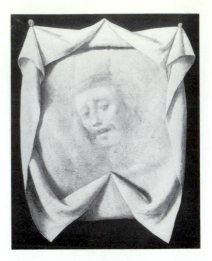

25 Francisco de Zurbarán
(1598–1664), *Veronica's
Sweatcloth.*

24 Master of the Holy
Veronica, *St Veronica with
Sweatcloth,* (*ca. 1420*).

26 Yvon Adolphe (1817–93), *Vision of Judas.*

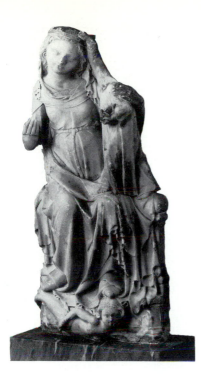

27 *Virgin Crowned by Child and
Trampling on a Siren*, Ile de France,
second quarter of fourteenth century.

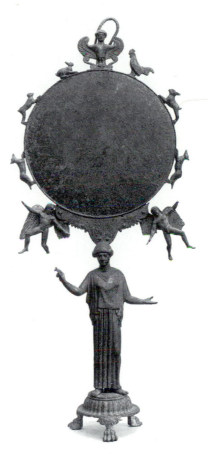

28 Mirror, Greece, fifth century BC.

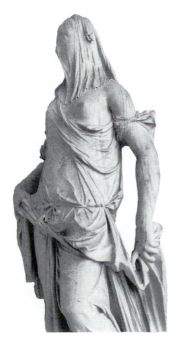

29 Antonio Corradini (1668–1752),
Veiled Woman (Allegory of Faith?).

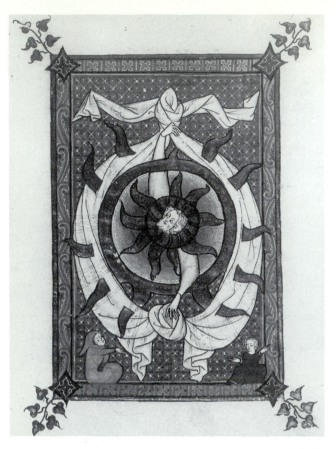

30 *The Omnipresent and
Omnipotent God*, The Rothschild
Canticles, Franco-Flemish, late
thirteenth or early fourteenth
century.

31 *Angel Holding a Cloth with the
Head of John the Baptist*, German
School, eighteenth century.

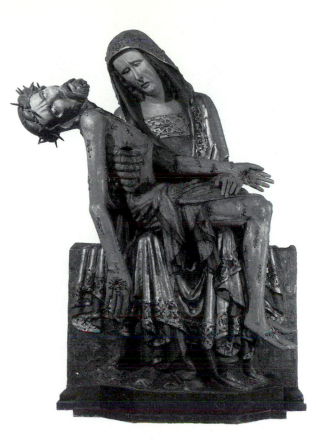

32 Silesian Master, *Pietà*, ca.1370.

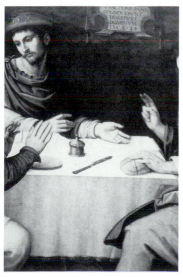

33 Giovanni Capassini (called Jean Capassin, d. 1579), *Supper at Emmaus* (detail).

34 Head of God-Phallus, broken from a vase or lamp, Hellenistic period.

35 *Deposition and Entombment of Jesus Christ*, Flanders, third quarter of twelfth century.

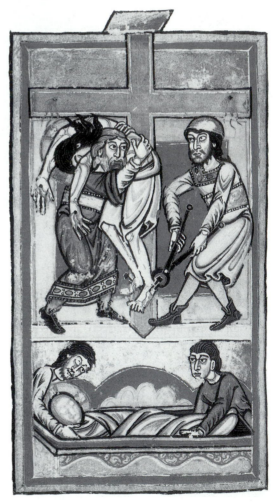

unknown birthday was set on December 25, a festival of the *Sol Invictus* (= winter solstice), and Epiphany on the birthday of the sun-god Dionysios-Aion (as well as of Osiris and Harpocrates–Horus). Following Plutarch, who interpreted the appearance of sunlight as birth (*Aetia Romana*, 2), Clement of Alexandria glorified Christ as the sun of resurrection born from the morning star and identified sunrise with birth (*Stromata*, 7. 7. 43).[81] Easter was projected onto the various pagan celebrations of the revived sun: the Egyptian Re or Osiris ascending from the depth of the ocean or underworld, or the Greek Helios coming up from Hades. In consequence, Jesus' entire life was connected to the pagan festivals of the upcoming spring and related to the position of the planets.

According to the tradition established by the Gospel of John, Christ died on the 14th of Nisan (which in this particular year fell on a Friday), the day of the Easter festival on which the Jews "kill their lambs in the evening" and then "take some of the blood, and put it on the two doorposts and the lintel of the houses in which they eat them" (Ex. 12:6–7). In the Jewish calendar, Nisan was the first month of the year, which began with the new moon, and thus the 14th coincided with the first full moon of the new year. To this was added the symbolism of the Roman calendar, which tied death to femininity, resurrection to solarity. Jesus died on Friday (the day of Venus), remained in the tomb on Saturday (the day of Saturn), and was resurrected on Sunday, the day of Helios when Selene (moon), his female consort, stood in full splendor. The decision to celebrate Easter on the day of the pagan sun-god was taken by Constantine the Great, and the news was disseminated throughout the empire soon after the Council of Nicaea.[82] Thus the power of tradition won, and the light emanating from the new "sun of justice" was received and reflected by the various lunar mirrors of matter: the *madonna* and the *ecclesia*, the *biblia* and the *anima*.[83]

In the early apocryphal *Gospel of Bartholomew* the Holy Virgin says to the apostle Peter:

Look at the sun. It shines like Adam. Look at the moon. It is full of clay, because Eve transgressed the commandment. For God placed Adam in the east and Eve in the west, and he commanded the two lights to shine, so that the sun with its fiery chariot should shine on Adam in the east, and the moon in the west should shed on Eve its milkwhite light. But she defiled the commandment of the Lord, and therefore the moon became soiled, and its light does not gleam . . . But

in me the Lord took up his abode, that I might restore the dignity of women.

(*Gospel of Bartholomew*, 4:5)[84]

The ancient sun–moon mythologies, the Platonic and Neoplatonic ideas of male (solar) energy and female (lunar) matter, and the adoption of the ancient sun and moon festivals by the Church laid the foundation for the Christian symbolism of active and passive mirrors, and their association with celestial bodies. The Platonic tradition can be traced to St Paul who declares: "For now we see in a mirror dimly, but then face to face" (I Cor. 13:12). While he regards the mirror as an imperfect medium of vision, in the Letter of James the mirror is seen in the even more negative terms of passivity and pretence and used for distinguishing Christian activists (speakers) from the passive onlookers. "Be doers of the word," the apostle admonishes his brothers,

> and not hearers only, deceiving yourselves. For if one is a hearer of the word and not a doer, he is like a man who observes his natural face in a mirror . . . and goes away and at once forgets what he was like. But he who looks into the perfect law, the law of liberty, and perseveres, being no hearer that forgets but a doer that acts, he shall be blessed in his doing.
>
> (Jas. 1:22–5)

Both passages echo the Old Testament mirror metaphors. Paul's saying brings to mind the image of the sky spread out above the earth like "a molten mirror" (Job 37:18), in which God's "golden splendor" (37:22) appears but blinds us with its brilliance: "men cannot look on the light when it is bright in the skies" (37:21). And James's remarks on the worthless character of passive (female) mirroring might have been inspired by the remembrance of women's mirrors which were melted down and used for God's sanctuary. Upon the order of Moses, the artist Bezalel "made the laver of bronze and its base of bronze, from the mirrors of the ministering women" (Ex. 38:8).

Early Christianity celebrated Jesus' birth and rebirth in images of the sun rising from the Virgin's womb. But as Christianity aged and ever more blood was shed in crusade and persecution, attention shifted to Christ's passion, and imagination was captured by the symbolism of the setting sun.

9

Cloth

Humans are born naked, but as soon as they emerge from their mothers' bodies they are wrapped in cloth. We need garments in order to survive. Most cosmogonies, as in the Japanese legend of the sun-goddess, introduce a divinity which spins, weaves, teaches humans the art of making cloth or provides them with garments, if only animal skins. The rich symbolism of thread and fabric resonates in everyone because of textiles' omnipresence in swaddling clothes, garments, bedsheets, towels, blankets, (bridal) veils, (burial) shrouds, bandages, tablecloths, curtains, tents, sails, flags, banners, canvases, screens, scrolls, sacks, bags, rugs, and other textiles that provide us with comfort and pleasure. Textiles were woven of organic materials (wool, hair, cotton, flax, silk) and worn together with animal skins. This established a sense of unity between humanity, animality, and vegetation, and prompted metaphors likening humans to beasts and plants, with men more often compared to the fauna, women to the flora.

The word "cloth" has a Germanic origin. It appears in *Kleid* (dress), *Kleidung* (clothing), and in the Dutch *kleed*, and it probably comes from the root *kli-* meaning to stick, cling to (as in "clay" or "cleave"). "Cloth" would thus be "that which clings to the body, or that which is pressed or 'felted' together."[1] In Latin "text" and "textile" have a common root in *texere, textum* (to weave, construct, compose). In Judaism "texts" and "textiles" belong to culture and are made by men. Textiles and the skins of dead animals (and humans) can be transformed into texts and pictures when an

179

external medium (juice, blood, paint) is applied to them or when they are scratched, cut, or tattooed with images and words. Then skin begins to resemble an iconic dress, canvas, relief, or the page of a book. Body-icons abound in primitive societies, and tattooing is still practiced in third-world countries and in American and European subcultures. The tattoo iconography differs from place to place, but I suspect that today, as in the past, a popular picture is still "our Saviour on the cross, in blue; with the crown of thorns, and three drops of blood in vermilion, falling one by one from each hand and foot" – a mariner's tattoo in Melville's *Mardi*.[2]

In German the noun *das Mal* (sign, mark, stain, spot) and the verb *malen* (to paint) are derived from the Latin *macula* (mark, stain, mole); and the Polish *malować* (to paint) and *malarz* (painter) have the same root. In theology and poetry *macula* also designates sin. The untouched Virgin, God's immaculate robe-skin, and the exemplary mirror of divinity are called *sine macula*. Curious and ambiguous metaphors have been inspired by analogies between cloth(es), skin, hair, mirrors (including the pupil of the eye), and the surfaces of sky, earth, and water, which lack permanence and are prone to transformations. The change of dimensions appears particularly significant. Draped, folded or inflated, cloth and skin become three-dimensional, and so does the surface of water when waves are formed. Images fixed in these mobile media are easily distorted, turned from flat portraits into semblances of bodies, reliefs, and statues.

A blank fabric is a texture; a textile with woven, embroidered, painted or written words a text; a cloth with images an icon. Each is created by a different procedure and inspires a different symbolism, but each can be used to visualize the inner dimension of remembrance and fantasy, thinking and dreaming, imagery and language. Light, portable, and flexible, cloth is ideal for picturing the flow and ruptures of inner life. Cloth, as it is folded and unfolded, stored away and unrolled, seems suitable for representing memory, both as a texture woven in a laborious process, and as a sequence of images and words impregnating the fabric with mercurial speed.

(i) *Greece*

In ancient Greece women made textiles and clothes, and legends linked the spinning of thread and the weaving of fabric to

femininity. The popular image of the three Fates spinning human destinies goes back to the Greek Moerae. Daughters of Themis, the goddess of justice and earth, by Zeus, they are lunar deities of time (Hesiod, *Theogony*, 903). Finding the right way in the labyrinth of life is associated with Ariadne.[3] She gives Theseus a ball of thread and ties one end to a pillar at the entrance. The thread unwinds, and after the slaying of the Minotaur leads Theseus out of the maze. In the grotto of Ithaca the naiads, immortal females, keep laboring inside the "living stone" on "their webs divine of purple mix'd with gold" (*Odyssey*, 13. 126–9).[4] The goddess Athena presides over female crafts. A master weaver, she makes her own vesture – the richly decorated peplos which is celebrated not only as a garment but also as a sail (*Iliad*, 5. 733–4), executes a magnificent robe for Juno (*Iliad*, 14. 178), teaches weaving to earthly women (*Odyssey*, 7. 108–10), turns Arachne, who dares to compete with her, into a spider (*Met.* 6. 5ff.), and envelops Odysseus, the husband of Penelope (the prototypical "spinner" and "weaver" of marital fabric), in thick mist (*Odyssey*, 7. 21–2) – to protect him from the attack of the Phaeacians.

Mnemosyne, the Greek personification of Memory, was a female with beautiful hair and covered with piles of cloth.[5] She belonged to the oldest generation of Greek gods. In Hesiod (*Theogony*, 135) she was born from the union of Earth and Heaven and stood originally for one memory in particular: the remembrance of Zeus's heroic victory over the Titans (881–5). His triumph was followed by an erotic *Blitzkrieg* which populated the earth with a harem of female *Kulturträger*. Zeus took Metis, the mother of Athena, as his first wife; "Next he married bright Themis who bore the Horae (Hours), and Eunomia (Order), Diké (Justice), and blooming Eirene (Peace), who mind the works of mortal men, and the Moerae (Fates) to whom wise Zeus gave the greatest honour, Clotho, and Lachesis, and Atropos who give mortal men evil and good to have" (901–5). Then Zeus lay with Eurynome who bore him the three Graces, impregnated Demeter with Persephone, and "loved Mnemosyne with the beautiful hair" (915).

The Greeks regarded memory as the birthplace of inspiration and thought, and Mnemosyne as the mother of the Muses (Thinkers). Originally spring nymphs, later the Muses were transformed into the divinities of song and the goddesses of various arts and sciences. As if to evoke the character of remembrance and art production, the girls were engendered not at once but as a work-in-progress. Zeus

kept entering Memory for nine consecutive nights and "when a year was passed and the seasons came round . . . she bore nine daughters, all of one mind, whose hearts are set upon song and their spirit free from care, a little way from the topmost peak of snowy Olympus. There are their bright dancing places and beautiful homes, and beside them the Graces and Himerus (Desire) live in delight" (*Theogony*, 58–64).[6]

Mnemosyne was usually worshipped together with the Muses, but she also had her own important cult and played a role in the rites of incubation, in which dreams and prophecies had to be remembered. At the oracle of Trophonius in Lebadeia, Mnemosyne was contrasted with Lethe, and both were symbolized by water in two fountains situated near each other. Before stepping down into the cave where the future was to be revealed to him, the inquirer had first to "drink water called the water of Forgetfulness, that he may forget all that he has been thinking of hitherto;" then he drank "the water of Memory" (Pausanias, 9. 39. 8) so that he may remember what he was to see in the cave.[7] After his ascent from Trophonius, the inquirer was seated "upon a chair called the chair of Memory," and told the priests what he had "seen or learned" (9. 39. 13). Drinking from two sources was also practiced by the followers of the Orphic mysteries who equated Mnemosyne with the life, Lethe with the death of the soul. In their holy groves the fountain of Memory was located "to the right of the cypressus," the fountain of Forgetfulness to the left of the tree.[8]

Overshadowed by her extremely popular daughters, Mnemosyne was a rare subject in Greek art. Only a few classical statues are inscribed with her name, and the authenticity of the inscriptions is doubtful.[9] Mnemosyne is shown veiled – like the Muses, but even more – often to the tips of her fingers. The veil reflected the way decent Greek women were supposed to dress, suggested chastity, and differed from the loose garments of Aphrodite and the *hetaerae*. But piles of fabric allegorized also shapeless matter that was to be covered and given form by men.[10] The veiled muses acted as the material soul-screens for poets, the actual creators of poetry, who sought them and were often depicted in their company – sparsely dressed or altogether naked.[11] Occasionally the opposition between the blankness and dreamy passivity of the veiled Muses and the raw energy of naked men was expressed with shocking directness. On a sarcophagus depicting the story of Apollo and Marsyas, for instance, a seated Apollo, his penis erect and his only garment a laurel wreath

on his forehead, faces a standing Mnemosyne, her body covered with fabric from the top of her head to the tips of her toes.[12]

Memory and her daughters can easily be confused, but there is a slight difference between them. The Mnemosyne statues convey a sense of maternal gravity which sets them apart from the livelier figures of her daughters. Even more strictly veiled than the Muses, Memory appears to consist of nothing but drapery.[13] And yet, the longer the eye wanders across Mnemosyne's covered body looking for an opening, the more the seductiveness of her figure becomes apparent, and she begins to transform from a modest matron into an obscure object of desire. Statues of Memory and the Muses epitomize the Greek artists' skill in sculpting cloth and presenting flesh, in particular female flesh, through the medium of textiles. Light fabric accentuates the sensuality of Aphrodite. The heavy veils of Mnemosyne at once spiritualize and sexualize her figure, making the goddess of memory the prototype of the "veiled lady" (Plate 29). An important subject of European art and literature, she oscillates between the vision of idealized femininity, a man's hidden anima, and Plotinus's notion of a "mirror of matter" – pure stuff bare of all meaning.

The cult of Mnemosyne was significantly transformed in Rome where she was worshipped under the name of *Moneta*, which designated not only a coin but also a stamp or die for coining money. Juno, in whose temple at Rome money was coined, was referred to as Moneta, a symbolism in which *Theogony* (921) might have had its share, since it provided an association between the two women: Zeus copulated first with Memory, then impregnated Juno, his legal wife. The picturesque female figures of Greek mythology inspired the image of the Holy Virgin, a weaver, embroiderer, knitter, and a *speculum* and *materia sine macula*, which received God's "true" imprint.

(ii) *The Old Testament*

In Judaism, the original, embryonic condition of nakedness is likened to innocence in paradise, a heavenly womb, where Adam and Eve are united with divinity and thus do not perceive themselves as individuals. Clothing symbolizes the separation from God – the birth-exile into the world – and the beginning of reflection. After Adam and Eve have tasted together of the forbidden

fruit, "the eyes of both were opened, and they knew that they were naked; and they sewed fig leaves together and made themselves aprons" (Gen. 3:7). Before expelling Adam and Eve from the garden of Eden, God clothes them in "garments of skins" (Gen. 3:21). Are animals killed to provide robes for the parents of humanity? The rabbinic tradition claims that no one could have died in paradise and that the garments must have been the shed skins of snakes. In the Egyptian *Books of Adam and Eve*, composed at an unknown date, perhaps as early as the first century AD, the first clothes given by God to the exiled couple are "skins of sheep, whose flesh was devoured by lions, and whose skins were left" (1. 50. 7).[14] The Valentinian Gnostics regard the coats of skins – in contrast to the "invisible and transcendental matter" out of which Adam and Eve are formed – as the "gross sensible body of flesh" and a proof of humanity's "two natures, the animal and the material."[15]

In Hebrew "skin" and "light" are virtual homonyms. This may be the reason why in the *Books of Adam and Eve* God explains to Adam that in paradise he was clothed in "bright light" (1. 12. 10), but on earth he'll wear a "body of flesh, over which I spread this skin, in order that it may bear cold and heat" (1. 13. 7); and why throughout the Old and New Testament light, skin, and garment are often used as synonyms.

Once dressed, the primordial couple joined in the natural cycle of conception and corruption, copulated, procreated, and became part of the skin-for-skin principle of life. Eve gave birth to two sons and called them "Cain and Abel [Hebel] to imply that man's hold on this earth (deriving *Cain* from *kinyan* 'possession') is but vanity (*hebel*)."[16] Preferring Abel, the shepherd and nomad, to Cain, the agriculturalist and future builder of cities, God caused the jealousy of the elder brother. Cain killed Abel, whose blood impregnated the soil: "the ground . . . hath opened her mouth to receive thy brother's blood from thy hand" (Gen. 4:11);[17] "And the Lord put a mark on Cain" (Gen. 4:15), which has been interpreted as either a "a letter of His Name" engraved on Cain's "forehead;"[18] or an unspecified "protective mark, perhaps a tattoo, signifying divine mercy."[19] In any case, the first blood crime produced the first natural icon – a shapeless stain on (in) the maternal ground – and the first inscription or letter on (in) male skin.

When God tells Moses to offer him "a male without blemish" (Lev. 1:10), the command suggests a white sheep or goat. When the male animal is killed, his spotless skin is stained with blood. The

divine order makes sense. Blood marks white skin most effectively, and since in ritual "truth" is revealed through semblance, red-on-white represents the optimal color combination in terms of visibility and psychological resonance. The Hebrew Bible sets the pattern for the change of Jesus' appearance in the New Testament: he is luminous until the beginning of the passion, then starts turning red (first he is dressed in a purple mantle, then his skin is injured); he dies naked, but his clothes (white) are restored at resurrection.

Clothing is given and taken away by divinity. Job acknowledges that "Thou didst clothe me with skin and flesh, and knit me together with bones and sinews" (Job 10:11), and complains when the "knitting" starts to be unraveled: "My flesh is clothed with worms and dirt; my skin hardens, then breaks out afresh. My days are swifter than a weaver's shuttle, and come to their end without hope" (Job, 7:5–6). In the same vein Isaiah proclaims: "Behold, all of them will wear out like a garment; the moth will eat them up" (Isa. 50:9). Ezekiel contains a memorable passage on clothing, God's beautiful present to Jerusalem which, however, corrupts and leads her away from the cult of the divine word to the worship of male images. The Lord reminds his unfaithful wife that when she arrived "at the age of love" (menstruation), he "spread" his "skirt" over her (Ezek. 16:8). "Then I bathed you with water and washed off your blood from you, and annointed you will oil. I clothed you also with embroidered cloth and shod you with leather, I swathed you in fine linen and covered you with silk" (Ezek. 16:9–10). But the rich outfit turned Jerusalem into a prostitute:

> You took some of your garments, and made for yourself gaily decked shrines, and on them played the harlot . . . You also took your fair jewels of my gold and of my silver, which I had given you, and made for yourself images of men, and with them played the harlot; and you took your embroidered garments to cover them, and set my oil and my incense before them.
>
> (Ezek. 16:16–18)

In the Old Testament "cloth," "clothing," and their various synonyms metaphorize attributes and qualities of divinity, humanity, and the universe.[20] God is "robed in majesty" and "girded with strength" (Ps. 93:1). Humans either put on "righteousness" and wear "justice . . . like a robe and a turban" (Job 29:14), or they are "clothed with shame and dishonor" (Ps. 35:26) and wrapped in "cursing" (Ps. 109:18–19) and "despair" (Ezek. 7:27). Light, life, and

185

health are represented by fresh and white cloth(ing). Darkness and mental obscurity, sickness and death are synonymous with black and spoilt garments, sackcloth and filthy rags. The faithful are warned that "drowsiness will clothe a man with rags" (Prov. 23:21). God threatens humanity that he will withdraw light and "clothe the heavens with blackness, and make sackcloth their covering" (Isa. 50:3).

Weaving, spinning, and clothmaking are traditionally regarded as female occupations. But the Old Testament suggests that this was not so in Jewish culture. When God commands Moses that there be woven ceremonial curtains, veils, and garments, the work is assigned to two men, Bez'alel and Oho'liab, whom God "has filled . . . with ability to do every sort of work done by a craftsman or by a designer or by an embroiderer in blue and purple and scarlet stuff and fine twined linen, or by a weaver" (Ex. 35:35). Most Old Testament references to weaving have masculine connotations: a spear is compared to a weaver's beam (1 Sam. 17:7, 2 Sam. 21:19, 1 Chr. 11:23, 20:5); the sick King Hezekiah complains that "like a weaver I have rolled up my life" (Isa. 38:12). Only in two instances are women mentioned in connection with weaving. In one case their making of fabric is linked to prostitution and idol worship, in the other to sexuality and seduction. In his struggle against idolatry King Josiah orders the destruction of "the houses of the male cult prostitutes which were in the house of the Lord, where the women wove hangings for the Ashe'rah" (2 Kgs. 23:7). And Delilah tries to subdue Samson with a web woven from "the seven locks of his head" (Jgs. 16:14). Women, however, are credited with spinning the thread for "the tent of meeting" (Ex. 35:25–6) in the temple of the Lord.

(iii) *Christianity*

In his parable of the Last Judgement, the separation of the sheep from the goats, Jesus compares altruistic people, who "clothed" him, to lambs, the egoists, "who did not clothe me," to goats (Mt. 25:32–43). But the incarnation seriously puts into question God's role as the provider of material cover. Unlike the first Adam, Jesus was clothed with skin and flesh not by his divine father, but by his human mother; and immediately after his birth (exile) from her womb, he was "wrapped" by her in "swaddling cloths" (Lk. 2:7) –

the origin of an Egyptian *acheiropoietos*, a swaddling cloth which was worshipped in sixth-century Memphis.[21]

A symbol of Christ's humanity, cloth plays a central role in the passion narratives, and in particular in the Gospel of John which specifies that Jesus wears a "tunic . . . without seam, woven from top to bottom" (Jn. 19:23) – a second skin whose removal foreshadows death. The *via crucis* begins when the Roman soldiers take away Jesus' garments, clothe him in a purple cloak, and crown him with thorns. But they put his clothes back on him before giving him the cross (Mt. 27:27–31; Mk. 15:20). On top of Golgotha Jesus is undressed again. While he is dying, his four executioners divide his garments into four parts, but decide to keep whole his tunic and cast lots for it (Jn. 19:23–4). The death of a Man-God, whose side is torn apart by the lance of the centurion, equals cloth destruction. At Christ's expiration "the curtain of the temple was torn in two, from top to bottom" (Mt. 27:51; Mk. 15:38; Lk. 23:45). Then the earthly dress – and skin – is replaced with a shroud: Jesus' corpse is wrapped by Joseph of Arimathea into a linen sheet. The cloth is shed by the resurrected God. On the morning of the Sunday after the crucifixion the linen is found in the tomb together with "the napkin, which had been on his head, not lying with the linen cloths but rolled up in a place by itself" (Jn. 20:7).[22] The transformation of Man into God, and of the earthly stuff (skin and cloth) into divine light is announced by the appearance of two heavenly messengers. On the spot where Mary Magdalen expects to find Jesus' corpse wrapped in cloth, she sees "two angels in white, sitting where the body of Jesus had lain, one at the head and one at the feet" (Jn. 20:12).

The biblical narratives inspired the Christian metaphysics of cloth and the complex iconography of white fabric stained with red. White allegorizes immaculate matter and white light – the overall divine glory-skin; red represents blood and the red effusion of the setting sun. Christ's passion, a series of *tableaux vivants* in white and red, is followed by pure whiteness. The apocalyptic Christ shines and blinds with solar splendor: "his head and his hair were white as white wool, white as snow; his eyes were like a flame of fire, his feet were like burnished bronze, refined as in a furnace . . . in his right hand he held seven stars, from his mouth issued a sharp two-edged sword, and his face was like the sun shining in full strength" (Rev. 1:14–16).

The cloth symbolism of the New Testament was elaborated by

the early Church Fathers.[23] But hardly anyone was as obsessed with cloth(ing), both as a symbol of incarnation and as real dress, as Ephraim, the founding father of Syriac literature and the forerunner of medieval mysticism. An extremely prolific defender of orthodoxy, Ephraim shaped the sensibility and the public worship of the Eastern Church. Especially influential were his *Hymns*, which accompanied the faithful throughout their Christian lives.[24] Ephraim was born in Nisibis in Mesopotamia, but as his city fell into the hands of the Persians, he settled in Edessa and made his abode at the "Mount of Edessa," a rocky hill close to the city that served as a residence for anchorites. Ephraim's extremely interesting biography, which was written soon after his death in ca.373, sheds light on his rejection of real garments and his obsession with symbolic clothing.[25] An absolute ascetic who from the time he became a monk until his death drank only water and ate nothing but barley, bread, and sometimes pulse and vegetables, he was dried to the bone and his only garment consisted of patched, dirty rags. This is the background against which his clothing metaphors have to be read. Original and beautiful, immediate and sensual, they were a source of stimulation for Eastern theologians and poets, and through their writings influenced the West.

Ephraim saw Jesus as "Thee Who didst clothe Thyself in the body of mortal Adam," so "that the needy may draw near to Him, that in touching His manhood they may discern His Godhead" (*Homily* 1.9 and 1.10). A specific piece of clothing was assigned to every stage of Christ's sojourn on earth, and appropriate meaning was derived from it:

> He was wrapped meanly in swaddling clothes, and offerings were offered Him. – He put on garments in youth, and from them there came forth helps: He put on the waters of baptism, and from them there shone forth beams: – He put on linen cloths in death, and in them were shown forth triumphs . . . All these *are* the changes of raiment, which Mercy put off and put on, – when He strove to put on Adam, the glory which he had put off. – He was wrapped in swaddling-clothes as *Adam* with leaves; and clad in garments instead of skins. – He was baptized for *Adam*'s sin, and buried for *Adam*'s death: – He rose and raised *Adam* into Glory. *Blessed be He Who came down and clothed him and went up!*
>
> (*Hymn on the Nativity*, 16. 12–13).

Ephraim's vision of the Virgin's light-vestment, which she had received from God to cover the nudity of all mortals, foreshadowed the

medieval figure of the *Mater Misericordiae* or *Schutzmantelmadonna* developed in the West at the end of the thirteenth century.[26] The Syrian monk also transformed Origen's metaphor of Jesus, who "rose up as a 'sun of righteousness' to send forth from Judaea his rays which reach the souls of those who are willing to accept him" (*Contra Celsum*, 6. 79), into the more palpable image of a solar embryo-*acheiropoietos* who "from the womb has shone on us as the Sun" (*Hymn on the Nativity*, 19. 7). In a similar vein, he had Satan remark that the fallen woman who once attracted clients with her beautiful hair now "has cut off her hair" and uses it as a clout – "to wipe the dust, off the feet of Jesus" (*Nisibene Hymn*, 60. 4).

Ephraim's fascination with cloth was reflected in his *Testament*. This memorable document, composed in metric form, alluded to the unmaking of his life's fabric and obliged his pupils to bury him with no garment save his tunic. After a lifelong celebration of metaphorical clothing, the anchorite's last will made a point about the nothingness of a man's mortal cover. He wanted his flesh to rot away in the same rags he wore during his lifetime. His last verses speak of the "spinning" that "is shortened" and the "thread" which is "nigh unto cutting," and they curse those who would dare to dress his corpse:

> Whoso lays with me a pall: may he go forth into outer darkness!
> And whoso has laid with me a shroud: may he be cast into Gehenna of fire!
> In my coat and cowl shall ye bury me: for ornament beseems not the hateful.
>
> > (*Testament*, p. 135)

Ephraim's violent condemnation of burial garments sheds light on the psychological importance of cloth(ing) for those theologians who, like him, lived a monastic life, possessed no fine dress, repressed all desires of the flesh, and saw themselves clothed not in matter but in God's glory. Their rejection of garments was compensated by fantasies of dressing and undressing, of feminine fabric and the male spirit impregnating it. The negation of actual cloth fused with the adoration of cloth as the medium of incarnation illuminates an early variation on the theme of Christ as the ruler of the universe. On two fourth-century Roman sarcophagi Christ triumphs over the material world by sitting not on a sphere but on a textile arch (the allegory of Cosmos) which a man holds above his head.[27] Grabar remarks that the figure "represents the universe

exactly as the emperors are represented on the triumphal Arch of Galerius at Salonika."[28] But Jaroslav Pelikan sees the image more in terms of Christ's victory over death, in accordance with the biblical motto: "For he must reign until he has put all his enemies under his feet. The last enemy to be destroyed is death" (1 Cor. 15:25–6).[29] His explanation takes into account the perishable nature of fabric and the attitudes of early ascetics. But the Cloth-Cosmos figure, differing only in sex from the representations of the night in early Byzantine art, also signifies concealment and darkness.

Cloth plays a role in the ritual of the Eucharist. The sacramental meal was usually prepared on a tablecloth which could be imagined as a shroud (or a swaddling cloth) onto which Christ has been laid. In the *Acts of Thomas* the apostle "commanded his servant . . . to set a table . . . and spreading a linen cloth upon it set on the bread of blessing . . . and said: 'Jesus, who hast made us worthy to partake of the Eucharist of thy holy body and blood'" (5:49).[30] A Western Eucharist ritual shared the fantasy of Christ's "true" body on cloth with the Byzantine *acheiropoietoi*. Around 558 in Gaul

> the bread was arranged on the altar in the form of a man, so that one believer ate his eye, another his ear, a third his hand, and so on, according to their respective merits! This was forbidden by Pope Pelagius I; but in the Greek church the custom survives, the priest even stabbing with "the holy spear" in its right side the human figure planned out of the bread, by way of rehearsing in pantomime the narrative of John xix. 34.
>
> (*Britannica*, 9:872)[31]

The dichotomy of cloth, a mere cover as well as the stuff of transcendence, defined the use of fabric in Christian art and climaxed in late medieval art in which cloth ties together birth, death, and rebirth. In the Last Judgement scenes the faithful rise from their graves together with their shrouds, but abandon them before ascending to heaven; naked souls are lifted up to God in textile containers reminiscent of swaddling clothes; and the godhead is wrapped in fabric like a baby. Curious visions of divinity nestled in textiles, clouds, and skin-veils are contained in the so-called Rothschild Canticles, a unique florilegium of meditations, prayers, and citations from the Bible and the patristic literature.[32] In its original state the manuscript included probably as many as 50 full-page miniatures, of which 46 survive, 160 smaller miniatures, and 41 initials, and was the work of at least three illuminators. But

the most original full-page miniatures come from one hand. This artist's fairly flat and linear style is associated with late thirteenth- or early fourteenth-century Franco-Flemish illumination. The iconography of a large portion of his (her) pictures draws on the Song of Solomon or, more specifically, on the extremely popular 86 sermons of Bernard of Clairvaux (1090–1153) included in his mystical exposition of the Song of Songs which, following in the footsteps of Cyril of Jerusalem, fashions the soul after the bride. But the Canticles illustrations, a product of monastic erudition, provide also visual equivalents for many other mystical metaphors prevailing at the time, as Hamburger rightly observes.[33] There are allusions to Mechthild of Magdeburg's "flowing godhead" and Mechthild of Hackeborn's "cross-couch of love."[34] St Tierry's comparison between a woman's wound and Jesus' side-wound is evoked;[35] and so is the side-wound–door image of Bonaventura who in his *De perfectione vitae ad sorores* advised nuns, eager to penetrate into the heart of the Lord, to slip inside through the lance-cut. The illustrations suggest the artist's knowledge of the various reinterpretations of the biblical Hemorrhissa who, according to Pseudo-Hugh of St Victor's (*De nuptiis*, 2. 3), represents a soul streaming with carnal appetite whose desire is stopped when she touches the hem of Jesus' dress – in his bedroom.[36] New cloth and dried blood are combined into a symbol of spiritual regeneration in an early thirteenth-century church song, probably written with the intention of converting the Jews, which presents Jesus as the weaver of the new fabric of life: "The Lord has woven for himself a new loincloth, wishing in this to restore what putrefied. Rejoice, barren one, for through Christ you will bring forth so many that your house will be able to supplant the Jewish one. Sooner than health is restored to Jairus' daughter is the menstruous woman healed by the touch of (Christ's) hem."[37]

The Rothschild Canticles illustrate the mystery of God's dual nature, depict Christ's love for the soul, and dwell on the spirituality of the anima and her role as a guardian against the evil (the soul of a male saint blames him for having accepted a cloak from an usurer). The soul appears alone or, more often, in the company of other souls, a whole crowd of brides or wise virgins gathered around Jesus like a class of female pupils around their mentor. His is a course in martyrdom and masochism: in *The Ascent of the Wise Virgins* (fo. 15v), one soul climbs the cross, while another is pulled up by Christ. Turning into an Amor-Longinus, the anima-bride injures the side of her beloved with a lance – and fulfills

Mechthild of Magdeburg's ideal of love: "As I wounded you, you were united with me" (*The Flowing Light of the Godhead*, 1. 3). While the soul may act cruelly, Jesus is always pictured as gentle and affectionate. A dream lover and husband, he wipes tears from the virgins' eyes (fo. 36v). A *fons vitae* (fo. 34v), he erupts with a cascade of tiny heads – turning into a water vernicle. The ecstatic vision of male fertility brings to mind Edvard Munch's *Madonna* (1895) surrounded by spermatozoa, motile male gametes with elongated heads and long flagella.[38]

A characteristic iconographic feature of the Canticles miniatures is the contrast between the phallic solar godhead – a face with rays resembling spikes or an octopus-like creature consisting of a head with flames-feelers and arms – and the enclosing and obscuring femininity of cloth, a metaphor for the Virgin and the soul. In the *Mulier amicta sole* (Plate 15), Mary, a *virgo ornans* modelled after the Blachernae Theotokos, is made of flowing cloth and serves as the background for both the sun and the moon. And in the *Arrival of the Just in Heaven* (fo. 36v) the ascending soul, a dress with a sun-face, is met halfway by God, a delightful solar monster swooping down from the sky. But the most intriguing parts of this singular pictorial program are the concentric and geometric compositions, semi-abstract and with a touch of the surreal, which Hamburger calls "Christian mandalas" and interprets as the formulations of the mystical *deus absconditus* idea.[39] They consist of cloth, which is shaped into cloudy nests and God(=head) who, transfixing the fabric with his beams, is at once hidden by and revealed through it (Plate 30).

The singular literary selection and the unique illumination of the Rothschild Canticles convey a distinctly feminine point of view. Thus one is tempted to suspect that the small but exquisitely illustrated booklet was either created by or in collaboration with a woman writer and/or artist; or, more likely, that it was commissioned by a rich female patron, an abbess, or a nunnery. There may be a hint of this in the text that accompanies the miniature of a nun kneeling at the foot of a Mary with Child, admonishing "the sinner" to pray to the Holy Virgin, since a female form -- *peccatrix* – is used for "sinner".[40]

Cloth, the most obvious link to Christ's humanity, played an important role in the imagery of female mystics. St Bridget of Sweden (ca.1302–73), an aristocratic lady, a famous mystic, and a mother of eight, one of whom was St Catherine of Sweden, remembered God Father (who had dressed Jerusalem in beautiful

garments) and received the vision of a loving God Son. He visited her in order to tell her what sort of clothes she should keep in her home: "fyrst, lynen cloth that growyth of the erth; seconde, cloth of woll, or of lether that is made of bestes; and þe iij, cloth of sylke that is made of wormes."[41] The materials, that the invisible Logos gives to Jerusalem, corrupt her. But a Christian woman is spiritualized by cloth – the stuff of incarnation. St Bridget equates linen, which covers the naked body, with peace, animal skins with mercy, and silk, drawn from worms which consume everything, with abstinence – a revelation which might have inspired pictures of delicate silk vernicles.

An important contribution to the medieval metaphysics of cloth was made by the seamless tunic of Christ. The garment must have been discovered at approximately the same time as the clothing of Mary and was mentioned by Gregory of Tours (538–94), according to whom the *immaculati Agni tunica* was kept in the basilica of the St Archangels in Galatha, some 150 miles away from Constantinople.[42] John Mandeville, who visited Constantinople in the first half of the fourteenth century, tells us that the seamless tunic was exhibited to pilgrims together with the cross, the sponge, "the reed with which the Jews gave our Lord vinegar and gall on the cross; and . . . one of the nails with which Christ was nailed."[43] Jesus wears his tunic while hanging on the cross in some early crucifixion scenes.[44] In Giotto's famous fresco cycle (ca.1305) in Padua, Mary Magdalen, kneeling at the foot of the cross, her hand caressing Jesus' wounded foot, faces the seamless tunic which two soldiers hold between themselves like two angels carrying the mandylion. In Gerard David's *Crucifixion* (1480–90), Jesus is being nailed to the cross which lies on the ground next to his tunic – an empty shell and double.[45]

Taking into account the *Book of James* and other early legends and representations of a spinning, weaving, and embroidering Virgin, it is surprising that the seamless tunic came to be interpreted as her work only in the late Middle Ages. The main inspiration for the rare depictions of Mary knitting the dress of the passion was provided by the extremely popular *Revelations* of St Bridget. She tells us about the premonition of Jesus' martyrdom received by Mary when he is still a child and, more importantly, she models her vision of Mary giving birth to Jesus – a sequence of undressings and dressings – after the Gospel of John the Apostle. Bridget has Mary wear a robe as light as a membrane, a pendant to Jesus' seamless tunic; she

changes Christ's undressing for crucifixion to the Virgin's undressing for delivery; and she replaces the shrouding of Christ's corpse with the swathing of the newborn:

> I saw an exceeding fair maiden who was with child. She was clad in a white cloak and robe that was so thin that her virginal body could clearly be seen. Her body was very swollen for the womb was full and she was about to be delivered . . . Then the maid took off her shoes, laid aside the white cloak that she wore, likewise the veil that she had on her head and laid them by her side. She was now clad only in the robe, and her hair, that was bright like gold, fell down over her shoulders. She took out two small pieces of linen and two very fine woolen cloths that she had with her to wrap the child in and two other small pieces of woolen stuff to bind about its head, and she laid it all by her side until the time should come when she would use them . . . But so sudden and instant was the movement of the Infant that I could not see or distinguish how birth came to pass. I saw at once the child lying on the ground, naked but very clean . . . And immediately the maiden's body, which had newly been very swollen, contracted and her whole body was wonderfully beautiful and delicate . . . But then the boy wept and trembled with cold on the hard floor, and stretched His little hands to His Mother, and she took Him up . . . and sat down on the floor and laid Him on her knees and began to swathe Him – first with the linen clothes and then with the woolen pieces and last wound the whole about His little body, legs, and arms in one swaddling cloth, and swathed His head in the two woolen pieces that she had brought with her.
>
> (*Rev.* 7:24)[46]

Around 1400, various allusions to the crucifixion begin to appear in the scenes of nativity and infancy. On the right wing of the Buxtehude altarpiece (ca.1410) Mary is knitting the seamless tunic with four needles on the porch of her house, while her four- or five-year-old, who must have just put aside his whip and top and begun reading a book in the grass at her feet, is being interrupted by the arrival of two angels, one holding a lance and a crown of thorns, the other a cross and three nails.[47] A Silesian wood carving (ca.1500) illustrates a similar theme, but it is permeated with the homely feel of a family-business idyll and stresses incarnation and reproduction more than the passion. Mary, a handsome young woman with long curly hair, completes her child's garment which she has put on a tailor's dummy; St Luke paints her portrait; Jesus plays at their feet with his whip and top; and a baby bull hides under the evangelist's

chair (Plate 13). Reproduction, reflection and death are linked in an enchanting fifteenth-century drawing, probably a copy after a lost painting by Konrad Witz (ca.1400–45 or 1446). The Virgin, her slight body covered with an oversized heavy dress, contemplates the seamless coat (or a fresh towel, a potential vernicle?) in her hands, while a naked infant Jesus, a mini-Narcissus and Amor, gazes at his mirror image in a round washbasin.[48] In the late fifteenth-century *Nativity* by the Master from the Lower Rhineland, a pale and serious newborn, a golden glory around his head and with his left arm across his breast, lies on the ground at his mother's feet.[49] His white swaddling cloth, on which the Virgin's melancholy gaze is fixed, is held, like a mandylion or a tiny shroud, by two butterflylike angels. In the back Joseph, wearing a purple passion coat and purple headgear, works on a cross.

Albrecht Dürer plays with the idea of a shroud-swaddling cloth in his drawing of the *sudarium* held by two putti in *The Book of Hours of the Emperor Maximilian*.[50] The two embryonic creatures and Christ's head on the cloth are executed in green and have a vegetal quality, as if the artist had imagined Jesus metamorphosing from the resurrected "gardener" into an embryo-plant returning to life every spring. Zurbarán's painting of *Virgin and Christ in the House of Nazareth* (ca.1640) combines the prophecy of crucifixion, received simultaneously by mother and son, with a hint at the son's sexual initiation. A sad middle-aged Mary embroiders white cloth with red thread, while Jesus, looking about 12 years old, pricks his finger with the crown of thorns.[51]

In late medieval art textiles and garments hide and highlight the body, serve as backgrounds for figures and objects, convey movement and calm, stress monumental drama and private romance, hint at mystery and theater. In the painting of the Italian *trecento* the interplay of cloth expresses a wide range of subtle emotions and the almost imperceptible transitions from real to false affection, from courage to cowardice, from hope to despair, from torture to death. While faces may act as masks covering up sentiments, the language of body and cloth reveals truth. New intimacy was added to the eleventh-century Byzantine Theotokos type by Duccio (ca.1255–1319) and his followers. In their pictures the child, seated on the left arm of the enthroned Virgin, clutches a fold of his mother's veil or mantle to his breast or plays with it.[52] Mary may also draw her veil around the child, let Jesus put it around his shoulders or, a later variant, have him recline on her right arm in a fold of her mantle

which she lifts up under his body. Jesus' reaching for and grasping his mother's garments are often accompanied by their touching each other. She may rest her cheek against his head, he may caress her face or breast with his hand. These gestures of reciprocated feeling are equally common in Sienese painting and the Florentine school of Bernardo Daddi (b. ca.1295). During her pilgrimages to Italy, where she went for the first time in 1341, St Bridget must have seen the Italian madonnas – and recalled them in her revelations.

We must see Giotto's famous *Kiss of Judas* mindful of the sharing of cloth as the expression of an amorous union between divinity and humanity. The scene is dominated by the yellow coat which the traitor draws over his teacher's body, covering him with the symbolic color of deceit.[53] In the fourteenth- and fifteenth-century Italian paintings of the Mocking, cloth is used to blindfold Jesus as he sits amidst his tormentors (or their emblems, faces spitting at him and hands hitting him) and signals the approaching blankness of death. The sense of passing away is further accentuated by the way his seamless tunic or coat falls down his body. Some of these pictures, for instance Fra Angelico's *Mocking* (ca.1437–45) in Florence, evoke in Christ's motionless figure the veiled statues of Mnemosyne or Lethe, and the ancient blindfolded Amor – allegories of forgetfulness and memory.[54]

In the paintings and sculptures of the Italian *trecento* and *quattrocento* cloth is treated as a subtle envelope following the contours of the body. In the contemporary art of Northern Europe the flamboyant late Gothic style makes textiles cascade and fly away, providing drapery with an expressive dynamic of its own. In his *Crucifixion* (Plate 5), Rogier van der Weyden contrasts the exuberant drapery of his angels, evocative of the ancient victories and furies, with the many-layered draperies of Magadalen and Veronica, the new Christian muses, and exploits the symbolic and formal opposition between falling garments and the fabric that rises and floats through the air. The dresses of the angels and Christ's loincloth fly up, disregarding gravity and indicating the lightness of divinity. Loss and sadness are suggested by the heavy piles of cloth which, falling on and covering the ground, join the moldings of the landscape. Only the red mantle of John the Evangelist is partly exempt from descent. It goes up in the wind like a flame, signaling the youthful energy of Jesus' beloved pupil who, standing on his toes, seems to be wanting to take off and join his Lord's ascent. Shaped into two wings, Jesus' loincloth allegorizes the victory of the

spirit preparing to leave the corpse – a sack which, as it is emptied of blood, gravitates towards the soil.

In the passion and crucifixion depictions nothing is more important than the treatment of skin and cloth and the paradoxical relation of one to the other. As skin dies, cloth may come alive and replace the body. When the body falls, garments fly up. The concept of resurrection inspires variations on the theme of cloth's corruption and reanimation. Art derives also ever-new images from the use of fabric in Christian festivals, processions, and especially the celebrations of the Easter Sepulchre when symbolic tombs were erected in churches and furnished with a variety of sheets, pillows, painted cloths, curtains, silk and damask veils, linen napkins (for wrapping the host and the cross), a pall, and a canopy.[55]

In the late Middle Ages and the Renaissance the study of drapery was an essential part of art training, and an artist's ability to render clothing a measure of his skill and talent. Giorgio Vasari tells us about an angel with a drapery over its right arm kneeling on the left of *Christ's Baptism*. It was painted by the young Leonardo da Vinci (1452–1519) during his apprenticeship in the studio of Andrea del Verrocchio, but was so superior to the figures by his teacher that it supposedly made Verrocchio forswear painting for ever after.[56] How seriously Leonardo took the rendition of cloth is exemplified by his juvenile drapery studies, small monochromatic temperas, executed in grey, greyish brown, and brownish red tones on prepared canvas or paper. Scattered and for a long time attributed to other artists, even to Dürer, Leonardo's drawings were recently reassembled at the Louvre for the first time since the sixteenth century.[57]

Once you have seen the draperies of Leonardo, you'll never forget them. Masterpieces of precision and clarity, they reflect his scientific treatment of every artistic issue. Leonardo's *Treatise on Painting* includes observations on the nature and the expressive value of folded cloth and an analysis of the specific ways in which different materials drape and fall. He discusses rules for correlating the features of a particular fabric with the character of the draped figure – its sex, social position, age, place in the composition, movement; he draws attention to the draping of each subsequent layer, from the silk creased on the skin to the coat resting on piles of underclothing, and recommends the study of drapery from living models. But in his *Lives of the Artists* Giorgio Vasari reports Leonardo's use of other methods too. "Sometimes he made clay models, draping the figures with rags dipped in plaster, and then

drawing them painstakingly on fine Rheims cloth or prepared linen. These drawings were done in black and white with the point of the brush, and the results were marvellous."[58]

The technique brings to mind the beginning of the Judeo-Christian metaphysics of cloth, with God first making Adam from dust, then clothing him – and reveals a paradox. A Renaissance artist-scientist, Leonardo is interested in the exact rendition of the cloth–body unit, not in religious meaning. But his matter-of-fact approach combined with the ease of a great master make him succeed better than any artist before or after him in conveying the metaphysical sense of the draped body – the nothing and the everything there is to meet the eye. Leonardo's draperies are imbued with a crystalline quality. Their sight turns the eye tactile, and induces the beholder to dream the essence behind the substance.

10

Skin

Skin for Skin!

<div align="right">Job 2:4</div>

*Give me my wife Michal, whom I betrothed at the price of a
hundred foreskins of the Philistines.*

<div align="right">2 Sam. 3</div>

*It would be somewhat difficult to fix a date when what we
know as "photographic action" was first recorded. No doubt
the tanning of the skin by the sun's rays was first noticed, and
this is as truly the effect of solar radiation as is the darkening
of the sensitive paper which is now in use.*

<div align="right">Britannica</div>

Skin is everything. It contains our physical substance as well as the
"spirit" or "soul." The ultimate test to which Job should be
submitted, Satan suggests to God, is the destruction of his skin:
"Skin for skin! All that a man has he will give for his life. But put
forth thy hand now, and touch his bone and flesh, and he will curse
thee to thy face" (Job 2:4–5). Afflicted "with loathsome sores from
the sole of his foot to the crown of his head" (2:7), Job was totally
transformed, so that friends who came to visit him "did not

<div align="center">199</div>

recognize him" (2:12). "After this Job opened his mouth and cursed the day of his birth" (3:1).

Human sacrifice is a sacrifice of skin. In the *Golden Legend* Jacques de Voragine points out that in order to redeem humanity, Christ suffers his skin to be hurt fives times: first, at his circumcision; second, during his prayer in the Garden when he sweats blood; third, at his flagellation; fourth, at his crucifixion; fifth, when the centurion pierces his side.[1] The dual nature of Jesus' sacrifice is defined in the Eucharist: he offers his body and blood. Since blood is the content, the body then is equated with the skin, the container, and the Eucharistic bread transforms into the host, a wafer as thin as a membrane. Skin, the blank, visible, and tangible surface, can be imagined as an overall canvas or book, or as cut to pages and shreds. Catherine of Siena (1347–80) described the ring with which she was mystically married to Christ as his foreskin, the first bit of skin Jesus offered to humanity.[2]

The leakiness of skin represents a central obsession of the early Jews. Their culture seems to have been stigmatized by the experience of leprosy which eats away the skin. Susan Sontag is right: illness is a metaphor. Skin diseases, in particular leprosy and skin cancer, are metaphors of the absence of skin and vision – the lack of surface, perceptible, iconic (=inscribed with individual features), and sensitive to stimuli – and the presence of undifferentiated raw flesh, dumb and blind. Skin absence is so horrible to sight and touch that lepers become outcasts. They are supposed to neglect themselves and signal their condition from far away. "The leper . . . shall wear torn clothes and let the hair of his head hang loose, and he shall cover his upper lip and cry, 'Unclean, unclean.' . . . he shall dwell alone in a habitation outside the camp" (Lev. 13:45–6). But skin does not disappear all at once. It is a gradual process of turning the inside out, which begins with marks and discharge: "But if there is on the bald head or the bald forehead a reddish-white diseased spot, it is leprosy breaking out" (Lev. 13:42). This may explain why laws for lepers are immediately followed by rules regarding other forms of epidermal leakiness.

The sudden appearance of physiological blood is feared most of all. Sacrificial blood, on the other hand, is believed to have a healing quality and in consequence is viewed as the most potent antidote against natural bleeding. This pattern of tabooing and sanctifying blood can be found in most religions, but in Judaism it is formulated with exceptional clarity. What is polluted by blood can be purified

by blood alone, to the extent that circumcision appears to be, among other things, a cleansing of the male child from the unclean blood his mother has shed at delivery:

> If a woman conceives, and bears a male child, then she shall be unclean seven days; as at the time of her menstruation, she shall be unclean. And on the eighth day the flesh of his foreskin shall be circumcised. Then she shall continue for thirty-three days in the blood of her purifying; she shall not touch any hallowed thing, nor come into the sanctuary . . . And when the days of her purifying are completed . . . she shall bring to the priest at the door of the tent of meeting a lamb a year old for a burnt offering, and a young pigeon or a turtledove for a sin offering, and he shall offer it before the Lord, and make atonement for her; then she shall be clean from the flow of her blood.
>
> (Lev. 12:1–7)

Similarly, a leper healed from leprosy is purified in a complicated procedure which involves the blood of a "bird that was killed over the running water" (Lev. 14:6), scarlet stuff, hyssop, and cedarwood. The purifying of leprosy with blood and red cloth points to yet another reason for choosing blood as the most appropriate pigment for painting Christ's "true" portrait – a healing icon.

(i) Sharing and Transplantation

The flesh of Jesus is the flesh of Mary.
The Golden Legend[3]

Sudarium Christi quod vocatur Veronica.
Benedictus, *Liber pollicitus*[4]

King Abgar is cured from leprosy by Christ's portrait, the vernicle cures lepers and skin cancer sufferers, and in some medieval versions of the legend, Veronica herself is a leper, healed by contact with Jesus' skin. In a French variant of the *Savior's Vengeance* Beronique is so "full with leprosy" (the expression "pleine de lèpre" suggests the opposite of "pleine de grâce," i.e. pregnant) that she does not dare to go near people.[5] She has hoped to be cured by Jesus and therefore laments his crucifixion, but she stays away from the cross, where the Virgin stands. Catching a glimpse of the weeping

woman, Jesus' mother walks over to Beronique, takes the kerchief from her head and wipes her son's face with it. When she returns the cloth impressed with his likeness, the woman's skin is restored. The biblical Hemorrhissa is an outcast because of her leaky skin, the medieval Beronique because of her lack of skin. The leak of the first is repaired, the second is given a new skin. The idea of skin transplantation is even more obvious in a mid-twelfth-century German text.[6] In *De ueronilla et de imagine domini in sindone depicta*, Veronilla possesses a shroud with Christ's full figure impression; when it covers Tiberius's entire body, he recovers from leprosy.

The healing by means of Jesus' cloth-epidermis which envelops raw flesh with new skin is modelled after the New Testament. The miracles of Jesus' curing of lepers usually follow the same pattern. As lepers beseech him, he is moved by pity, stretches out his hand, and as he touches them, leprosy falls off their bodies like an unclean dress. This looks like the factual replacement of hideous masks with proper faces – and is recalled in the medieval legend of the "mask of the leper." This famous relic, kept in St-Denis, was believed to represent skin removed by Christ from the face of a leper who had shut himself in the royal basilica in the night preceding its dedication, and whom the Lord cleansed for the celebration.[7] Masks were worn during the Mardi Gras festivals of St Veronica in medieval France, a habit which an eighteenth-century scholar of folklore explains in terms of the discrepancy between the blind and sick folly of the carnival (=masks) and the "true" vision of salvation (=Holy Face).[8] In analogy to Christ's vernicles also the head of John the Baptist was occasionally represented in forms evocative of flayed skin – and of the contrast between the rising (=baby) and the setting sun (Plate 31).

The absence of a surface creates a negative tension between the non-face of a leper (skin cancer sufferer) and a mirror. How the two are related to each other is demonstrated by Marcel Schwob, a *fin de siècle* French writer. His *Le Roi au masque d'or*, a story based on the Narcissus–Echo fable as well as on ancient and Christian leper and mirror legends, tells us about a king who from childhood wore a mask and lived in a palace where everyone was masked too.[9] This status was interrupted by a blind beggar who sowed doubt in the king's mind and made him leave the palace. On his way out, the monarch encountered a young girl and removed his mask. Then, having heard her cry out in horror, he looked for the first time at his

face reflected in the river, and "just as the sun was vanishing behind the brown and blue hills of the horizon, he had glimpsed a pallid, swollen face, its flaking skin distended by hideous protuberances, and he knew at once, remembering what he had read in books, that he was a leper."[10] Instantly the king understood why he had always been masked: where others had faces and where he expected to find his own face, he had just rotten flesh that had to be covered. He also realized that his lack of skin made him blind to the surface of the world from which his face was hidden.

Without a surface, there is no face; without a face, there is no sight. The mirroring membranes of the eyes are part of the face, the face is part of the sensory skin envelope. Restoring (sur)face and sight, God's touch resembles a magical transplantation of skin. Covering the dumb and opaque flesh with purity and shine, he cures both leprosy and blindness. Accordingly, legends are dominated by pairs of opposites, skin—raw flesh, face—mask, blindness (darkness, blackness)—sight (white, light, mirror). Each leper imitates King Abgar who

> receiving the likeness from the apostle and placing it reverently on his head, and applying it to his lips, and not depriving the rest of the parts of his body of such a touch, immediately . . . felt all the parts being marvelously strengthened and taking a turn for the better; his leprosy cleansed and gone, but a trace of it still remained on his forehead.
> ("Story of the Image of Edessa," 13)

As Christ's luminous skin, a surface-effusion, covers a leper's mortal flesh, divinity and humanity coalesce in a physical—spiritual union – an amorous sun- and bloodbath. But acting as the donor – Jesus loses his own skin. The late medieval art revels not only in vernicles. It is equally fascinated by Christ's damaged skin – revealing raw flesh and bones (Plate 32).

Medieval vernicles – human skins impregnated with divinity – function as intermediaries between humanity and divinity, by acting at once both as receptive and enveloping pure veils and as solar mirrors – with Jesus' *facies praeclara* shining from Veronica's snow-white (head)kerchief (*kerchy*), veil, napkin, apron, towel, blanket, or (burial)sheet.[11] Each garment corresponds to a skin part: a headkerchief or veil points to her face and hymen; an apron alludes to her vagina and womb; a sheet or blanket designates her entire body. The character of each vernicle is defined by the material.

A light, small and transparent piece of silk or fine muslin is associated with other types of skin – and relationships – than large pieces of thick linen. The fabric's nature, the part of Veronica's body that is covered by the cloth, and the position of Jesus' face (head) vis-à-vis the female figure determine the degree of eroticism that is conveyed to the beholder.

The vernicle itself is created in a procedure strongly reminiscent of the removal and replacement of skin. The wiping of the Lord's face is seen as a dual transplantation, with the woman giving the Lord her skin and receiving his from him. Covered with Veronica's napkin, Jesus is Veronica, Veronica Jesus, and everyone to whom the Veronica–Jesus cloth is applied becomes transformed into a Veronica–Jesus too. These fusions and confusions, typical products of magic and mythology which never stop associating one thing with another, are reflected in popular customs and in the language of the medieval texts referring to the woman, her cloth, and Christ's face as the *Veronica* and calling both the fabric and the likeness a *vera icon* and *vernicle*.[12] Small vernicles were sewn onto clothes and attached to hats and caps. In the *Prologue to Canterbury Tales* Chaucer tells us about the Pardoner who "a vernicle hadde he sewed upon his cappe," and in Giovanni Capassini's *Supper at Emmaus* (1555) the man seated to Christ's right wears a tiny vernicle on his hat (Plate 33).[13]

Capassini's picture, the left wing of a *Resurrection* triptych, which on the reverse (in *grisaille*) shows the women at the tomb, represents a subtle and illuminating study of the intricate relations between cloth, skin, vernicle, the Eucharistic bread, blood, and the resurrected Christ.[14] Seated at the table covered with white cloth, Christ lifts his right hand, while the left, marked with a wound, reposes on a loaf of bread inscribed with a red cross. A decisive role in the painting's composition is played by the breadknife, which is placed diagonally on the table in such a way that it creates a visual connection between the crossed loaf, the injured hand, and the tiny vernicle, a brilliant reflection of Christ's face shimmering at the top. The knife, ready to cut the symbolic body, suggests the injury of skin and the release of blood – responsible for marking Jesus' body and the bread, and for "painting" the vernicle, a miniature mirror-mask prolonging God's presence on earth.

(ii) *Masks, Heads, and Shrouds*

Thy head shall not be carried away from thee after [the slaughter], thy head shall never be carried away from thee.
 Book of the Dead[15]

In many cultures dead bodies were covered with masks and shrouds. Preventing the corpses from disintegrating, they provided the deceased with new dresses and skins. Masks, tightly fitted over the faces of the dead and executed in gold, silver, bronze, terracotta, wax, cloth, and other materials, have been found in burial sites all over the world. In Egypt masks of thin gold foil were pressed onto the faces of the mummies and reproduced on the covers of the human-shaped sarcophagi. Gold masks were found in the tombs of Nineveh, along the coast of ancient Phoenicia, in the graves of Mycenae (where the famous "mask of Agamemnon" was excavated by Schliemann), and in the burial tumuli of Kertch in the Crimea. Masks made of gold, a metal associated with sun, light, divinity, permanence, manhood, and royalty, likened dead heads to solar disks and mirrors, and assimilated them to the godhead. Besides masks accompanying the dead, casts, destined as memorabilia and relics for the living, were taken of the faces of the deceased by members of their clan or family.

Anthropological studies point to the origins of the cult of masks, heads, and facial depictions in head-hunting and such cannibalistic customs as those of the Issedones who, according to the *History* (4. 26) of Herodotus (ca.484–425 BC), consumed the bodies of their dead fathers, preserving only the heads, which they stripped bare, cleansed, and gilded, and to which they offered yearly sacrifice. Claude Lévi-Strauss observed a link between decapitation and menstruation, between the woman "stained with blood below" and the beheaded or scalped man "stained with blood above," and concluded that "throughout the world, the philosophy of head-hunting, either ritually or by direct representation, suggests the same tacit affinity between trophy-heads and the female sex."[16] From the legends of North American Indians about women going to bed with a man's scalp, and from his other studies in mythology and primitive customs, he derived the idea of a connection between head-hunting and hunting for women and of a relationship between war and marriage.

The Jewish legend of Holofernes and the Christian story of John the Baptist, the two enemy-lovers either directly or indirectly decapitated by women, confirm Lévi-Strauss's theory, as does my own work on the origin, symbolism, and artistic representation of the Salome myth.[17] But since male heads are universally associated with penises, decapitation is also linked to castration, which in turn is related to menstruation and defloration. Statuettes of male demons in the form of phalluses ending in heads were executed in fifth-century BC Greece, and terracotta figurines of the god-phallus (Plate 34) were part of Hellenistic iconography, still common in Christian days.[18] These art and cult objects resembled the artificial penises which in antiquity were used by women for masturbation and were occasionally depicted in the hands of Aphrodite. Hence the popular symbolism of a male head (face, mask) on top of and/or penetrating female fabric.

The magic power of masks and heads resulted in their omnipresence in ancient arts, crafts, and architecture. In addition to the masks of Medusa, armor, utensils, and the walls of Greek cities were decorated with various other heads.[19] Portraying nobody in particular, they served at once as ornaments and talismans. Some of the bearded masks (with hair falling in curls on both sides of the face) on buildings of Edessa of the second and third centuries AD, according to Grabar, bear a striking resemblance to the Christ *keramidia*.[20] Their existence makes us realize that Edessa, like every other city of the Hellenistic world, was filled with realistic, masklike, and amuletic portraiture and was thus well prepared to accept and worship the head of Christ.

Deathmasks as *memento mori* for the living played an important role in Rome and might have contributed to the extreme naturalism of Roman portrait sculpture. "The true homeland of the portrait," writes Hilde Zaloscer, "is Rome: the Roman art."[21] She regards the sculpted Roman portraits – indebted to deathmasks and belonging to the same "real space" (*Realraum*) as the face from which the mask was cast – as "true" replicas rather than works of art.[22] In order to preserve the faces of the dead from corruption, which progressed rapidly in the hot climate, the Romans covered them with wax masks. The masks were later used as models for wax figures, the *imagines*, which, like the dolls of the contemporary wax cabinets, were painted by a *pollinctor* in natural colors, equipped with hair, and dressed.[23] Pliny (*NH* 35. 2. 6) tells us that wax models of faces were set out on separate sideboards and carried in procession

at funerals. To make the illlusion complete, actors played the deceased. After the funeral the likenesses were exhibited in sarcophaguslike boxes in the *atrium*, *alea*, or *vestibulum* of their family houses. Portrait-busts and statues as well as portrait-shields of military leaders and heroes were derived from the *imagines* and shown in temples, public places, and private homes. Particular prestige belonged to portrait-shields, which were associated with the fighters at Troy. The Roman gladiators wore facial helmets similar to those found in ancient Greek tombs.[24]

In the first four Christian centuries the faces of the Egyptian dead were covered with painted masks and their bodies wrapped in painted shrouds. Hundreds of funeral portraits, painted on wood and originally attached to the faces of mummies, were found at the end of the last century at the oasis at Fayum. This tradition was terminated by the edict against pagan rites issued by the Emperor Theodosius in AD 392. The Egyptian masks were painted in a highly spiritual, luminous and impressionistic style at first, later darker and more linear, by professional, at some time probably foreign artists who worked for the Greek or Roman colonizers.[25] The pictorial Egyptian masks shared verisimilitude and frontality with the Roman deathmasks and *imagines* but, on the other hand, they lacked the solidity of sculpture. Was their spirituality due to Christian influence? Most art historians doubt it. But Zaloscer believes that Judeo-Christianity played a role in shaping this particular genre of funeral representation. She may overestimate this role, but on the other hand, she is right to point out that the translation of the Bible into Coptic and the founding of monasticism in the Egyptian desert were the outward signs of a far-reaching Christian influence. "It was only natural that this national growth produced an art of its own, very different from that of the Hellenistic centres of civilization . . . It is a kind of 'vulgare,' a *koine*, but its stylistic principles, deeply akin to the spirit of Christianity, were accepted by Christian art and gradually assumed monumental form in Byzantine art."[26]

In her interpretation of Egyptian funeral art Zaloscer applies the same criteria to the wooden masks of Fayum and to the painted shrouds with the entire figures of the deceased. She sees both forms as expressions of an illusionist and yet spiritualized mode of portraying the dead, and ignores a basic difference between the masks and the shrouds. While they may look similar in our museums, one has to remember that when the dead were wrapped

in shrouds depicting them, their bodies provided the third dimension, transforming painting into sculpture. In the case of the painted shrouds the spiritual was then turned back into the material. However, enveloping a corpse in a lifelike skin strikes me as perfectly symbolic of the Christian idea of resurrection. Of course the argument could and should run the other way too. The funeral art of ancient Egypt, which provided the dead with the simulacra of their original covering, reflected their faith in an afterlife and contributed to the Christian concept of resurrection. But, on the other hand, the representations of Lazarus emerging from his bandages, so popular in early Christian art, demonstrate the senselessness of mummification in the face of a God whose word and touch make the dead rise. Oscillating between flat and full, portrait and mask, skin and body, the painted Egyptian shrouds are imaginary relatives of the Byzantine *acheiropoietoi* as well as the Latin *sudaria* and vernicles of Christ. All of these iconic textiles mediate between painting and sculpture, magic and art, spirituality and materiality, divinity and humanity, life and death, and can be interpreted as either second skins, relics, and talismans or as illusionist portraits and works of art.

(iii) *The Flayed Skin*

> . . . *when he saw that Amaterasu no Oho-kami was in her sacred weaving hall . . . he flayed a piebald colt of Heaven, and breaking a hole in the roof-tiles of the hall, flung it in. Then Ama-terasu no Oho-kami started with alarm, and wounded herself with the shuttle.*
>
> *Nihongi*[27]

The vernicle, an almost plain piece of cloth, is ideally suited for projection – for seeing what we want to see in it. Suspended between the Hemorrhissa's outstretched hands or on a cross, it can provoke sublime visions of beauty and union. Hanging on a wall or cross, it can appear as an abominable piece of dead skin, a dirty rag, or a canvas from which the colors have faded.[28] To Julian of Norwich "the holy vernicle of Rome, upon which he imprinted his own blessed face, when he was in his hard passion and going willingly to his death," seems disgusting.[29] Wondering why it shows an image "so discoloured and so far from fairness," and not "that blessed face which is the fairest in heaven" – Julian concludes that Christ

208

wished to resemble humanity and therefore presented us with "the image and likeness of our unclean mortal flesh, wherein our fair bright blessed Lord hid his Godhead."[30]

The vision of Christ's dried-up skin reflects the nature of mystical experience which, oscillating between the extremes of fullness and nothingness, ecstasy and mortification, empties out and annihilates the object of its desire. But, on the other hand, Julian's revelation can also be taken as a response to the increasing popularity of the Roman *sudarium* with Jesus' dead likeness and the growing cult of his shroud at Lirey. At the beginning of the sixteenth century yet another empty skin gained renown – that of St Bartholomew, one of the twelve apostles, whose original name, according to a Syrian tradition, was Jesus (he dropped it in order to avoid confusion with the Lord). Bartholomew went on a missionary tour to India and was flayed alive and crucified in Armenia with his head downwards. St Bartholomew's skin, the main item in the Wittenberg collection of relics assembled by Frederick the Wise, the Elector of Saxony and protector of Luther, was depicted by Lucas Cranach, Hans Baldung, and other artists associated with Lutheran circles.[31]

The interest in flayed skin was stimulated by the growing preoccupation with anatomy in medical, scholarly, and artistic circles and the increasing number of anatomical theaters, frequented by Leonardo, Michelangelo, and Rabelais, and anatomical books filled with illustrations of flaying and dismemberment.[32] The preoccupation with anatomy influenced mystical and artistic visions and contributed to the late fifteenth- and sixteenth-century obsession with flayed skins and to the iconography of the *Arma Christi*, the Five Wounds, and the Sacred Heart of Jesus – assemblages of dismembered body parts. In consequence of the anatomy lessons a womb-shaped Heart with a baby Jesus came to resemble a pregnant female uterus and resulted in the creation of the most naturalistic of all *acheiropoietoi*: the vision of Mary's full womb – cut out and suspended on the cross.[33]

A flayed skin may be pressed flat and look like a drawing, engraving, or painting. It may be folded or draped, taking on the appearance of a relief. It may fly in the wind like a flag or banner or be filled with air and imitate full sculpture. Flexible and portable, the flayed skin moves between dimensions and genres, at once representing and negating them all, and, as such, indicates one way of reading Michelangelo's famous self-portrait as flayed skin in his *Last Judgement* fresco, completed on the altar wall of the Sistine

Chapel in 1541.[34] Leo Steinberg notices that the artist's skin is positioned on the low end of the painting's diagonal axis, and concludes that the strange self-representation alludes to Michelangelo's own trial: "the Last Judgement – as I believe Michelangelo pondered it – is not staged for generic mankind but for each self within mankind. And how shall this eachness be tested but on this only-known body in its own dear corruptible hide?"[35]

According to Steinberg, in the *Last Judgement* St Bartholomew acts as the artist's intercessor, asking God not to cast away the artist's earthly cover but to preserve it until the last judgement, so that he can rise, like Christ himself, clothed in his own skin. But I would like to suggest a different interpretation. The aged skin of Michelangelo may be meant not as gesture of piety, but of defiance and mockery of the "skinning" to which divinity submits humanity. Contemporary tradition saw in Bartholomew a portrait of Pietro Aretino, the vehement critic of Michelangelo. I agree with Steinberg, who finds this explanation too flat for the drama of the *Last Judgement*, but I see the artist's hide as a combined metaphor created from the remembrances of Marsyas, skinned by Apollo, Jesus, the Son "skinned" by the Father, Bartholomew, a close associate of Christ, skinned in the name of God, and as a possible allegory of the mystical skin-soul.

Marsyas was a Phrygian silenus or satyr who could play the flute better than anyone else. Jealous of his fame, Apollo forced Marsyas to enter a musical contest whose winner would be rewarded with his opponent's skin. The judges, gods or muses, were equally taken with both players. This angered Apollo, who suggested that each competitor turn the instrument upside down and then try again. This could be done with the lyre, but not with the flute. Marsyas lost, was bound by Apollo to a tree and flayed alive. His skinning suggested the making of his instrument, the shepherd's pipe, produced from an aldershoot from which the entire bark has been removed.[36] Marsyas's fate might have been commemorated in his name which comes, perhaps, from the Greek word of Semitic origins meaning "sack" or from the Avestic *marsu* (belly).[37]

Marsyas's sacrifice was not futile. His hide proved incorruptible and out of his blood a river originated or, alternatively, a stream was created from the tears of his mourners:

> the skin was torn off the whole surface of his body; it was all one raw wound. Blood flowed everywhere, his nerves were exposed, unprotected,

his veins pulsed with no skin to cover them. It was possible to count his throbbing organs, and the chambers of the lungs, clearly visible within his breast. Then the woodland gods, the fauns who haunt the countryside, mourned for him; his brother satyrs too, and Olympus . . . and the nymphs, and all who pasture woolly sheep or horned cattle in these mountains. The fertile earth grew wet with tears, and when it was sodden, received the falling drops into itself, and drank them into its deepest veins. Then from these tears, it created a spring which it sent gushing forth into the open air . . . It is the clearest river in Phrygia, and bears the name of Marsyas.

(Met. 6. 388–401)[38]

The contest and punishment of Marsyas were favorite subjects of Greek painting and sculpture, but classical art mostly refrained from portraying the skinning and usually represented Marsyas, as in the famous Roman copy at the Louvre, as an old, bearded man bound to a tree or as the flayed skin hanging over the shoulder of a youthful Apollo.[39] The contrast between the two figures suggests a father defeated by his son.[40] Indeed, the myth seems to reflect the Greek conquest of Phrygia, with the Olympic gods, luminous messengers of civilization, triumphing over the old forest demons.[41] Their resistance was commemorated by the statues of Marsyas, symbols of liberty, which stood in the Roman forum and were set up in the colonies.[42] In Hellenistic art Marsyas transformed from "the impertinent satyr . . . into the outstanding image of tragic suffering. The face of a man hanging from a tree has now lost any traces of the satyr. Though furrowed and convulsed by pain, it is deeply human and pensive. Marsyas has become an image of the silently suffering creature, clearly the prototype of the crucified."[43]

The legend of Marsyas was remembered through the Middle Ages, and his skinning was allegorized as the purification preparing the soul for its union with God in the first canto of Dante's *Paradiso.* At the close of the fifteenth century, with the vogue of great solo performers, more popular, however, became the interpretation of the Apollo–Marsyas conflict as the antagonism between stringed and wind instruments. In the period preceding Michelangelo's *Last Judgement* the flaying of Marsyas was depicted in the *Ovidio volgare* (Venice, 1497 and 1501). Later, we find the subject in an engraving by Benedetto Montagna, in a drawing by Andrea Schiavone, and in the *Contest between Apollo and Marsyas,* a magnificent, narrative panel by Michelangelo Anselmi (ca.1492–1554/6).[44] It shows the whole sequence of the dramatic competition: an angelic Apollo, a

domineering figure dressed in a short white tunic, playing the violin; a rustic, bearded Marsyas, seated and attentively listening to him; and the flaying of the older satyr by the juvenile god.

In his *Last Judgement* Michelangelo paints God as a victorious youthful Apollo, and he portrays himself as the flayed skin of an old, bearded satyr. Like Marsyas, he is a great artist, and like God he is a creator. But he is mortal and therefore to be "skinned" and to lose the competition against divinity. Steinberg's analysis of the *Last Judgement* implies that the composition is a dialogue with God. Possibly, but I hear the artist speaking a different text. Look at this poor skin of mine, says Michelangelo to God. It is just an empty shell, like the skin of Jesus which is being traded in Rome:

> He should not come again into this province;
> Up to the very stars the blood would spread,
> Now that in Rome his skin is being sold,
> And they have closed the way to every goodness.[45]

If you want my skin, like Apollo, I'll give it to you, like Marsyas. My mortal sack is nothing, a mere relic. But, on the other hand, it's a painting and a relief – a token of my profession and my artistic credo. On the last day I want to be remembered as one who could both paint and sculpt as well as Marsyas could play; as a master of the skin – the "true" likeness of us all; and as the one who immortalized beauty: "So that a thousand years after our death / They'll see how you were beautiful, I faint, / And that I was no fool in loving you."[46]

Michelangelo offers his skin to God; he shows it to his contemporaries, whose worship of scraps of skin he derides, and to the critics who keep "skinning" the artists. Finally, he presents his hide to the fair judges of the future who will proclaim him a "Marsyas" – a recreator of youth and beauty that come through the eyes:

> You came in through the eyes, through which I shower,
> Like a bunch of green grapes into a flask,
> Spreading beyond the neck, where it is wider;
> Your image thus outwardly makes me moist
> And grows inside the eyes, then I grow broader,
> As skin will do when fatness makes it vast.
> Entering me by such a narrow path,
> I can't believe you'll ever dare go forth.[47]

Michelangelo's poetry contradicts Steinberg's idea of the artist wanting to be reborn in his own old skin – "loaded down with my years, and filled with sin."[48] There is a satirical tongue-in-cheek quality to Michelangelo's grotesque self-presentation at the Last Judgement that seems to fit the injured pride of a great artist better than Christian piety. The iconography of his painting transcends conventional devotion and represents a half-profane and half-sacred, half-Platonic and half-Christian dialogue, full of disdain for orthodoxy. In Marsyas's legend an old god is vanquished and killed by a new one, a father's skin is removed by a son. The Christian myth has it the other way around. God Son is sacrificed on the altar of God Father, the young one is skinned by the old. Michelangelo's vision seems to echo the ancient tradition of flayed animals and humans offered to solar divinities, a mythology we can trace in Japan and Greece, in Judaism and Christianity. The victims' bleeding was seen in analogy to solar effusion, defloration, and menstruation, and those in turn were related to fertility, duplication, and representation. The experience of skin made red ("painted") by the sun could have inspired the notion of a skin-soul – popular with the Gnostics and Christian mystics – an idea based on the realization that there is no soul without a skin. Michelangelo's self-portrait – an epidermal *acheiropoietos* – possesses a mystical quality and one of his poems mentions the soul's "stripping" from the body and hints, perhaps, at the artist's wish to be resurrected in a new envelope:

> It's not enough, my Lord, that you dispose me
> To go again there where the soul can be
> Created, not from nothing as before;
>
> Before you strip and draw it from the body
> Reduce by half, I beg, your high steep way,
> And make my coming back more bright and sure.[49]

(iv) The Skin-Soul

Wise men of old gave the soul a feminine name. Indeed she is female in her nature as well. She even has her womb . . . but the womb of the soul is around the outside like the male genitalia, which are external.

Exegesis on the Soul[50]

213

Both the Eastern Christ *acheiropoietoi* and the Western vernicles were perceived and described in terms of God's soul-image conveying divine essence through a "true" (sur)face. Abgar wished to possess "a portrait accurately drawn of Jesus' appearance so that he might be informed as it were by a shadow . . . what he was like" ("Story of the Image of Edessa," 5). In the *Hortulus animae,* a medieval collection of sacred verse, Jesus' likeness impressed on Veronica's cloth is called, as in many other writings, the "figure of the divine glory" and "the mirror of the holy" – common metaphors for the soul.[51] In an Anglo-Saxon variant of the Veronica legend, the napkin is a piece of Christ's garment and appears as animate as skin and as elusive as a soul.[52] Like an exposed film, the cloth contains Jesus' image which, however, can be "developed" only when the proper light is "switched on," i.e. under the gaze of a few true believers who, like Veronica, Volusianus, and the Emperor Tiberius, see in it the Lord's soul. In Comenius's *Orbis pictus* (1658), a popular illustrated encyclopedia, the entry "The Soul of Man" (*Anima hominis*) is illustrated by a large hanging cloth on which a figure is outlined in dots.[53] The *anima hominis* resembles a shroud and an outstretched skin – no doubt the source of inspiration for the encyclopedia's illustrator.

Most mythologies have a notion of the soul as some sort of double (Frazer calls it a "mannikin") that imitates a person's body but possesses little solidity, and seems like a reflection (in water, a pupil, or in a mirror), a shadow, a miniature copy – a veil of a likeness.[54] The Hurons imagined the soul as a complete little model of a man, the Eskimos as an ethereal replica of the body.[55] A relief of the birth of Amenophis III in the temple at Luxor shows the arrival of two goddesses bringing two babies identified by the inscriptions above their heads: one is the newborn pharaoh, the other his soul.[56] In Egypt everything, including gods, animals, plants, inanimate and manmade objects, was equipped with a soul which, however, consisted of such subtle stuff that it "made no impression on ordinary eyes" and could be seen only by priests or seers.[57] Normally, the soul remained hidden, but occasionally it flew out of the body, leaving it in a state of trance. In Greek art the soul is depicted either as a tiny human being, sometimes naked, sometimes clothed and armed, usually furnished with butterfly wings, or as a butterfly (a night butterfly was called *psyche*).[58] But she was also pictured as a charming woman, a mistress of Amor – and thus predestined to be each man's beloved. The dying Emperor

Hadrian (AD 117–38) addressed his soul as *animula* and asked where she, his little "guest," "pale" and "naked," is now:

> Animula vagula, blandula,
> Hospes comesque corporis,
> Quae nunc abibis in loca
> Pallidula, rigida, nudula;
> Nec, ut soles, dabis jocos?[59]

The Christian idea of the soul was influenced by Platonism and Neoplatonism, in particular by Plotinus's "mirror of matter," a concept perfectly suitable for developing the notion of a passive, non-intellectual and feminine soul in which a man can see himself mirrored and which conveniently keeps enlarging his reflection. This type of anima was attributed to Mary, who says about herself: "My soul magnifies the Lord" (Lk. 1:46). In the Graeco-Roman as well as the Christian tradition the soul (*anima*) is related to spirit (*spiritus, intellectus*), but *she* is also seen in opposition to *he*. Alternatively, a physical (female) soul is contrasted with an intellectual (male) soul. "The transmission of the semen," writes St Thomas Aquinas (ca.1227–74), "is directed to the generation of the body. Therefore the nutritive and sensitive souls begin to exist through the transmission of the semen; but not the intellective soul" (*Summa contra gentiles*, 2. 86).[60]

The soul lacks the energy of spirit, and *she* is interpreted in spatial rather than temporal, and natural rather than cultural terms. Spirit is identified with (sun)light, movement, and language, soul with lunar opaqueness, continuity, and the image. *Spiritus* erupts with energy, the *anima* flows with an imperceptible and yet material film. An idealized female, she is conceived as superior to earthly femininity but inferior to the masculine *Spiritus Sanctus* – the First Cause and the organizing principle of the universe. The cosmic soul, an emanation, effusion, reflection, shadow, and likeness of divinity, mediates between God (creator, original) and his creation (reproduction). An *anima hominis* mediates between a man's human condition (material = female) and his metaphysical aspiration (spiritual = male = divine).

Given the traditional notion of the soul as a delicate double and the role of feminine cloth(ing) in Jesus' incarnation, death, and resurrection, it is not surprising that garment and skin came to be regarded as the symbols of the soul. In *The Exegesis of the Soul*, a

Gnostic treatise originally written in Greek perhaps as early as AD 200, the soul, a virgin, originally lives in heaven in the company of her father. Upon entering a body, she becomes a prostitute abused by her lovers. But she repents, prays to her father, is baptized, and returns to paradise where she marries her brother. The soul's most astonishing feature is her womb. It is not hidden inside, but envelops her like the skin and can be therefore easily "cleansed of the external pollution which was pressed upon it, just as [garments, when] dirty, are put into the [water and] turned about until their dirt is removed and they become clean."[61] In the *Apocryphon of John* (2. 1:15) Adam is furnished with seven material souls: a *bone-soul*, a *sinew-soul*, a *flesh-soul*, a *marrow-soul*, a *blood-soul*, a *skin-soul*, and an *eyelid-soul*.

An enchanting fantasy of a Jesus-like skin–robe–soul is evoked in *The Hymn of the Soul* (or *The Hymn of the Pearl*). The famous poem, written in Syriac in the region of Edessa in the early third century, is contained in the apocryphal *Acts of Thomas*, the apostle of the East. A tradition going back to Origen portrayed Thomas as the evangelist of Parthia, the *Acts* placed him in India, the Abgar legend made him responsible for sending the apostle Addai to Edessa, and from the fourth century Edessa was known for possessing the bones of Thomas.[62] Jesus gives Thomas the cloth impressed with his blood in the Garden, instructing him to send it to Edessa. "After our Lord Jesus Christ had ascended into heaven, Thomas gave the divine portrait of Christ's face to Thaddaeus and sent him to Abgar" ("Story of the Image of Edessa," 11).

The *Acts of Thomas* was composed in a Gnostic milieu and used by Gnostic sects. The *Hymn* itself originated in "the pre-Manichean Gnosis of East Syria and Mesopotamia."[63] But the poem's metaphors seem to have been shaped by traditions coming from further East. The central image of the heavenly skin–robe and its symbol, a flying textile letter, point to China, with its long tradition of verses, letters, and portraits painted on silk, although Syria also was known for its silk industry, and in the *Doctrine* Aggai was described as a maker of silks. The *Hymn* relates the story of the Soul which is born in heaven, sent to the earth, and after fulfilling its mission – the finding and bringing of the pearl – returns home.[64] The Soul, the story's narrator, is personified by the king's son, who is modelled after Christ.

The son, who first dwelt in his father's house, was sent by his parents "down to Egypt" where "in the midst of the sea, / In the

abode of the loud-breathing serpent" the pearl had been hidden.[65] Before descending to earth, the young prince was obliged to take off his heavenly garments – reminiscent of Christ's seamless tunic and his scarlet coat of passion – and evocative of the Eucharist. The Soul's clothing consisted of: "the splendid robe / Which in their love they had wrought for me, / And the purple toga, / Which was woven to the measure of my stature" (*Hymn*, 9–10).

The son is promised that upon his return with the pearl he will be able to put on his splendid clothing, and he departs. During his sojourn on earth, Soul consorts with impurity, wears an ordinary Egyptian outfit (so that no suspicion arises about his divinity), and forgets about the pearl. But he is reminded of it by his family: his father, "the king of kings," his mother, "the mistress of the East," and his brother, a symbol of the Holy Spirit. This trinity sends him a letter which is written with red sulphur on Chinese silk, thus combining the medium with the message and acting as a token of the Soul's Eucharistic garment. Like the legendary Chinese magpie (which transformed itself from a mirror engraving into a real bird in order to inform the husband about his wife's infidelity), the letter "flew in the form of an eagle . . . and alighted beside me / And became all speech" (*Hymn*, 51–2). The linguistic bird makes Soul fulfill his duty. He snatches the pearl and ascends to heaven, where his clothes await him. The meeting between the son and his dress has an oriental touch and belongs among the unforgettable scenes of love poetry. It captures the instant when two people, who have known and loved each other forever, find themselves face to face after a long separation, and before falling into each other's arms, stand still – mirrored in each other's eyes.

> The [splendid robe] became like me, as my reflection in a mirror;
> I saw it [wholly] in me,
> And in it I saw myself [quite] apart [from myself],
> So that we were two in distinction
> And again one in a single form. (*Hymn*, 76–8)

> And again I saw that all over it
> The motions of [knowledge] were stirring.
> And I saw too
> That it was preparing as for speech.
> I heard the sound of its songs
> Which it whispered [at its descent]:
> "I belong to the most valiant servant,

For whom they reared me before my father,
And I [perceived] also in myself
That my stature grew according to his labours."
And with its royal movements
It poured itself entirely toward me,
And in the hands of its bringers
It hastened, that I might take it;
And my love also spurred me
To run to meet it and receive it,
And I stretched out and took it.
With the beauty of its colours I adorned myself.
And my toga of brilliant colours
I drew [completely] over myself.
I clothed myself with it and mounted up
To the gate of greeting and homage.
I bowed my head and worshipped
The splendour of the father [who] had sent it [the robe] to me.

<div align="right">(Hymn, 88–99)</div>

Soul's dress is double-layered, white next to the skin, purple outside, and a reflection of his father, since it is "embroidered all over" with "the likeness of the king of kings" (*Hymn*, 86). Only when the son puts it on is he ready to be received by the father. Burkitt suggests that the idea of the heavenly robe (as different from an earthly garment) might have been inspired by Paul's concept of the "earthly tent" as opposed to the house in heaven "not made with hands" (2 Cor. 5:1).[66] This makes sense, but the poetic dream of the Soul-Savior dressed on earth in ordinary Egyptian garments and in heaven in a Eucharistic robe–skin strikes me as more than that. The *Hymn of the Pearl* assimilates into an ancient tradition the new theology of Jesus' incarnation, resurrection, and transfiguration by transforming Christ into a Soul. His dual nature is rendered by his splitting into a humanlike anima – a son clothed in skin – and into a divine soul, an iconic dress of paradise. In the Syrian poem the essence of divinity resides in God's clothing – a heavenly double of the mortal human skin.

Incarnation turns God into a sack of skin – and tactility into a central issue. Jesus can be touched, touches others, and is presented as quite a toucher and kisser, such a good kisser that his passion begins with the kiss (of death) he receives from his pupil Judas (whom he has taught the kiss of peace).[67] Most of Jesus' miracles are based on tactility, and thus he is constantly followed by people eager

to touch him. He also uses tactility as a form of teaching, for instance when he washes his pupils' feet, and in general behaves as if he knew what we certainly know today: that certain memories are retained best by the skin. This is manifested in his contacts with women, in particular with the unclean or disreputable ones. The closer the passion, the greater the care taken of his skin by women. "Two days before the Passover," when "the chief priests . . . were seeking how to . . . kill him" (Mk. 14:1), Jesus' skin is smoothed out and his head is anointed at the house of a skinless man, Simon the leper. The anointment, protested by Judas who sees it as a waste, presents a prelude to the subsequent skin injury. Jesus' way to Golgotha starts with the touch of Judas' treacherous lips, which is immediately followed by another bad tactility. The soldiers, led in by the traitor, "laid hands on Jesus and seized him . . . And . . . one of those who were with Jesus stretched out his hand and drew his sword, and struck the slave of the high priest, and cut off his ear" (Mt. 26:51). The Lord intervenes and undoes the skin damage, using, for the last time, the power of his salvatory tactility: "he touched his ear and healed him" (Lk. 22:51).

The contrast between skin care and skin injury continues throughout the crucifixion and after Jesus' death: while wicked pagans pierce his skin and tear his clothes, Jesus' followers prepare to preserve his bodily envelope: Joseph of Arimathea wraps Christ's corpse in linen, women come to the tomb to anoint it. The biblical contrast between skin soothing and skin damage represents the division line between goodness and evil. Skin destruction is considered a predominantly male business. Skin preservation is pursued by both men and women of compassion, but mostly it is entrusted to femininity. After a brief disappearance inside the shroud and the tomb, Christ returns from his trip into matter in his own skin. A twelfth-century miniature of the entombment shows Jesus shrouded in a veil which gives him the appearance of an embryo (Plate 35) and thus hints at his coming back from the dead. The passion narratives juxtapose feminine caress, which involves surfaces and fluids (hair and cloth, ointment and tears), to the phallic instruments of skin annihilation. Out of this juxtaposition symbolic pairs develop: the lance, spear, rod, which cause Jesus' bleeding, and the shroud, vernicle, or the Holy Grail which catch his blood.[68]

One of the New Testament's most sublime episodes, the meeting between the resurrected Christ and Mary Magdalen, who rushes to

embrace him but is stopped by his *noli me tangere* (Jn. 20:17), indicates the transition from human tactility to untouchable divinity. In his book *The Skin Ego*, Didier Anzieu misunderstands the meaning of Jesus' words, and then argues that Christ introduces the taboo against touching – central to Christian culture.[69] The French psychoanalyst disregards the fact that up to now Christianity has remained extremely tactile – with priests embracing each other, the faithful kissing the rings and hands of priests, and the Pope kissing the cement of international airports, naked black children, and kangaroos. His misreading of the *noli me tangere* scene is astonishing in view of his Skin Ego theory, which suggests that because of the epidermal unity of the mother and her embryo and the intensity of skin contacts in motherhood and love-making, our center is "situated at the periphery" – and our Ego has "the structure of an envelope."[70]

Anzieu's concept of the Skin Ego is more than problematic. But I appreciate his effort to draw attention to skin and tactility, which play an essential role in religion and mythology, and in language and art, but have been neglected by scholarship. The Christian centrality of touch, a consequence of the incarnation, was established by the New Testament. Without Jesus' extensive tactility, Christianity would be a different religion. It would hardly have developed the cult of saints, relics, and icons, or invented a textile *acheiropoietos* – a skin–cloth–icon created through the touching of Christ and with the purpose of touching others. The sharing of Mary's and Jesus' skin conveys the essence of tactility, as does his skin's destruction. Skin contacts link faith and ritual to affection and aggression, and relate the sexual to the cosmic. Tactility provides the sensual bridge to elemental desires, primitive instincts, and archaic beliefs – to the primordial abyss hidden under our thin civilized skins.

Epilogue

Helen (to Faust):
> An ancient word, alas, is now fulfilled in me,
> That happiness and beauty are not mated long.
> The link of life is wrenched apart, like that of love;
> Mourning them both, with aching heart I say farewell,
> And cast myself this last sad time upon your breast.
> Persephone, I come, take now the child and me.
> > (*She embraces Faust; her bodily form vanishes,
> > her robe and veil are left in his arms.*)

Phorkyas (to Faust):
> What things remain from all you had, hold fast.
> The robe, release it not! . . .
> > (*The garments of Helen dissolve into clouds;
> > enveloping Faust they lift him on high and
> > bear him from the scene.*)
> > Johann Wolfgang von Goethe, *Faust. Part Two*[1]

Our journey through space and time – from Palestine to Babylonia, from Christian Byzantium to ancient Greece and Egypt, from Rome to China, from obscure French villages to the sacred pantheon of Japan – in pursuit of the origins and meanings of a non-existent piece of cloth with a "true" likeness of Christ has yielded results. We have discovered patterns, seen images emerge under the threat of absence, and realized that the most threatening of all absences is

in the disappearance of the sun. The rhythm of our life is still set by the sun, but we can only speculate about its significance before the invention of fire, when, with sunset, warmth and vision were withdrawn. The daily spectacle of the rising and setting sun inspired complex systems of analogies, metaphors, symbols, of magical formulas and religious ideas in which the sun was associated with every individual's central parts – the head or, more specifically, the face and the eyes, as well as with the reproductive organs, insofar as procreation was attributed to them. Community leaders have, no doubt, been identified with the sun since time immemorial, and the sun was perceived as masculine because of the further support in the emitting character of male sexuality as opposed to the receptive faculty of females. But the example of the Japanese sun goddess shows that the sun could also be metaphorized as a mirroring surface or membrane and thus connected to the skin, the hymen, the vagina, the womb – and menstruation.

Bright sunlight blinds. Hence the notion of concealment, which goes hand in hand with that of vision and reinforces the idea of a divine leader's unbearable brilliance. The sight of him has to be mediated, and whenever the sun is regarded as masculine, the medium is considered feminine. Rays acquire phallic features, while the receptive substance resembles a feminine blank. In the imaginary process of marking or reproducing, sunlight is often treated as a fluid and likened to blood, the juice and agent of life. Although both sexes bleed, male and female bleeding is regarded differently: "A man produces blood when he dies; a woman produces blood when she creates."[2] Part of nature, female bleeding has little transcendental value. Male blood, on the other hand, is extolled as a main carrier of culture and men's link to light's eternity.

Early humans were terrified of the prospect of the sun's permanent disappearance. Their fear was reinforced by the recurring eclipses of the sun, moments of horror that were bridged by worship and prayer, sacrifice and magic. In Japan mirrors were probably used to attract the sun out of its cave; in Greece the head of Medusa, the solar monster hiding in the west, was caught by the shiny shield of Minerva. The pursuit of the sun was a hunt, the hunt implied killing, and thus the bringing back of the sun involved bloodletting, beheading, and flaying alive. The mythology of light required the sacrifice of life. In order to assure the sun's presence, humans presented the divinized celestial head with their own heads and skins.

Since sacrifice was believed to make the world go around, ritual death was tied to sexuality and procreation. The Minerva–Medusa legends and the Amaterasu cult suggest a connection between solarity, human sacrifice, and sexual initiation; and so does the sequence of events in the Gospel of Mark, as it begins with the revival of a twelve-year-old girl, continues with the arrest of menstruation, and ends with the decapitation of John the Baptist. In religion *eros* and *thanatos* come in pairs, and sexual potency coincides with the ability to kill. Both the dead and the newborn represent "true" portraits and, when reduced to heads, appear as images of the rising and sinking sun. The Christian story of Jesus' *vera icon* has its counterparts in other religions dedicated to incarnation and solarity – to divine duplicates obtained through sight and tactility.

At the center of the Christian *vera icon* mythology lies the dual idea of the sun and its light. The sun, the first cause, burns with fire and spirit, streams with semen and blood, drips with ink and paint. But the sun's pure white light is also compared to cloth and skin and possesses the secondary, passive, feminine character of a "mirror of matter." In order to accomplish his incarnation, God creates his own matrix, a light-sensitive film which he then activates. In the process of representing the sun as humanity's male head and Christ as the son of the sun, the utopia of photographic portraiture is born. The cloth (=sky, space) shows God's solar face, but the vernicle – a mirror-membrane and a mask – also stands for the skin-soul of Jesus, the divine-human scapegoat sacrificed to solarity.

In early Christianity the sun rises, in late Christianity it sets. What the Theotokos is to Byzantium, Veronica, the Iconotokos, becomes to the West. Like the Virgin, the healed Hemorrhissa is a sun-bearer, only she documents not the beginning but the end. Hers is the last snapshot of God's sojourn on earth, hers is the final "true" image of his mortal humanity. The career of St Veronica implies Jesus' destruction through tactility – his transformation into a faceless, skinless, eyeless non-icon of degradation and darkness – and his resurrection as an intact and luminous anima-veil.

The impact of mimetic representation cannot be overestimated. Still today individuals and masses can be manipulated into belief, obedience, and revolt by means of a "true" image, an assumed token of presence which fuels desire and fear, a simulacrum which at once stimulates and combats a sense of absence by evoking death and rebirth. Our language and art, our psychology and politics, our

eroticism and reverie reflect this fantasy, and the *vera icon* flourishes in the contemporary world – saturated with "true" images to a degree no other culture has ever known. Magic persists in our relations to modern *acheiropoietoi*, and electronic reproduction and simulation pose in an ever more drastic way the old question of "truth".

Seeing Chinese students confront foreign reporters with a contemporary vernicle – the snapshots of their friends massacred on Tiananmen Square – we welcome the historical truth it conveys. Yet we cannot but remember that every *vera icon* may be a fabrication, and that a picture sanctified into an *acheiropoietos* fogs the mind's clarity. Still, the dream of a "true" duplicate, be it a photo or a piece of clothing that survives the beloved and helps us overcome grief, is essential. We derive from it encouragement and inspiration: the dress of Helena, Faust's departing wife, metamorphoses in his hands into clouds which clothe and carry this steel "fist" of a superman to the top of the world – and to his career as humanity's head.

Cultural patterns charm and trap us. We often deplore our personal and collective inability to change them, hoping that one day thinking and imagination will be free of the mythical male–female duality. But before stereotypes can be altered they must be understood. We cannot transform tradition by obliterating the past. What is swept out the front door returns through the back. It is only one step from an ignorant to a captive mind. Enlightening us about the origin and symbolism of mimetic representation, the Veronica legend renders us sensitive to our own perpetuation of the archaic: to the pictures of the brides accompanied by the names of their bridegrooms in the wedding section of the *New York Times*, and to the many vernicles which keep displaying – even while the progress of technology turns them thinner and "truer" – the same old stuff: the body of a woman and the face of a man.

Notes

Introduction

1 The impressions were reported by Bishop Arculf, (ca.670). "The Travels of Bishop Arculf in the Holy Land," *Early Travels in Palestine*, ed. Thomas Wright (London: Henry G. Bohn, 1848), pp. 4–5. The plural for masculine and feminine gender is *acheīropoīetoi*, for neutral gender *acheīropoieta*. In reference to images it is *acheīropoietoi*, the form I use.

2 The shroud was first heard of in France in 1353. Initially it was kept in the collegiate church of Lirey. It then went to the house of Savoy, and in 1578 came to Turin. Ian Wilson, *The Shroud of Turin. The Burial Cloth of Jesus Christ?* (Garden City, NY: Image Books, 1979), p. 192–220.

3 The most popular of them was Wilson's *Shroud of Turin*, a well-written and decently researched book. Its main value comes from the fact that it contains (pp. 272–90) the first complete English translation of the "Story of the Image of Edessa" (AD 945), Migne, *PG* 113:423–54, a crucial document in the history of the Byzantine *acheiropoietos*. Unfortunately Wilson wants so badly to prove that the Turin shroud is the burial cloth of Christ that he jumps to many unjustified conclusions.

4 The new results were published by all major newspapers around the world. I rely on the report by Yvonne Rebeyrol, *Le Monde*, October 14, 1988.

5 Wilson, *Shroud of Turin*, pp. 26–7.

6 *La Sindone e la Scienza, Atti del II Congresso Internazionale di Sindonologia* (Turin: Centro Internazionale di Sindonologia, Edizioni Paoline, 1978).

7 Rebeyrol, *Le Monde*.

8 We possess a description of the imperial collection of relics from the years 1203–4 where a cloth impressed with Jesus' face and the reproduction of this impression on a tile are mentioned. Robert de Clari, *The Conquest of Constantinople*, trans. Edgar Holmes McNeal (New York: Columbia University Press, 1936), pp. 104–5.

9 It is likely that the Edessene mandylion was identical with the *toella* listed among the relics from the Pharos chapel in Constantinople which Baldwin II sold to St Louis of France after 1239. The *toella* was kept at the Sainte Chapelle in Paris until the Revolution, when the Chapel was sacked. Averil Cameron, "The Sceptic and the Shroud," *Continuity and Change in Sixth-Century Byzantium* (London: Variorum Reprints, 1981), pp. v, 14.

10 *The Holy Bible*, Revised Standard Version Containing the Old and New Testaments, ed. Herbert G. May and Bruce M. Metzger (New York: Oxford University Press, 1971); further references are to this edition, unless otherwise stated.

11 The *acheropsita* (a Latinized form of *acheiropoietos*) was mentioned in the *Life* of the Pope Stephen II. [Anastasius bibliothecarius], *Vita Stephani II*, Dobschütz, pp. 64–5 and 136*.

12 Edmund Leach, *Genesis as Myth, and other Essays* (London: Jonathan Cape, 1969), p. 8.

13 On duality and symmetry in Christian mythology see E. Kuryluk, "The World of Adam and Eve," *Formations*, 1 (1987):68–78.

14 Verses 43–4 were probably not part of the original Gospel of Luke, since they are lacking in important early manuscripts. But they were known to Christian writers of the second century and reflect a first-century tradition.

15 "Head and Maidenhead," in *Salome and Judas*, pp. 227–8.

16 Ernest Will, "Le Culte de Mithra en Asie Mineure," in *Le Relief cultuel gréco-romain* (Paris: E. de Boccard, 1955), pp. 154–234.

17 Hans Peter L'Orange, "Kleine Beiträge zur Ikonographie Konstantins des Grossen" and "Sol Invictus Imperator. Ein Beitrag zur Apotheose," in *Likeness and Icon* (Odense: Odense University Press, 1973), pp. 27–31 and 333–44.

1 Image and Word – Greeks and Jews

1 St Gregory the Great, *Epistle* 47, to Bishop Quiricus, in *Nicene and Post-Nicene Fathers*, 13:83.

2 *Plato in Twelve Volumes*, Loeb Classical Library (Cambridge, Mass.: Harvard University Press, 1969–70). Further references are to this edition.

3 *A Vision of the Last Judgement* is a title given by Dante Gabriel Rossetti to William Blake's personal notebook, which in 1847 Rossetti

bought for ten shillings from the brother of an artist who as a young man befriended the old Blake. The notebook is now in the British Museum. *The Note-Book of William Blake Called the Rossetti Manuscript*, ed. Geoffrey Keynes (London: Nonesuch Press, 1935). See also Albert S. Roe, "A Drawing of the Last Judgement," in *The Visionary Hand. Essays for the Study of William Blake's Art and Aesthetics*, ed. Robert N. Essick (Los Angeles: Hennessey & Ingalls, 1973), pp. 201–32.

4 Marina Warner, *Monuments & Maidens. The Allegory of the Female Form* (New York: Atheneum, 1985).

5 *Aristotle, Generation of Animals*, Loeb Classical Library (Cambridge, Mass.: Harvard University Press, 1979). Further references are to this edition.

6 "On the Cnidian Aphrodite of Praxiteles," 16. 159, in *The Greek Anthology*, trans. W. R. Paton, Loeb Classical Library, 5 vols (Cambridge, Mass.: Harvard University Press, 1969). Further references are to this edition.

7 Artemidorus, *The Interpretation of Dreams*, trans. Robert J. White (Park Ridge, NJ: Noyes Press, 1975), 2. 45, p. 125.

8 Leonardo da Vinci, *Treatise on Painting*, trans. A. Philip McMahon, 2 vols (Princeton: Princeton University Press, 1956). Further references are to this edition.

9 See W. J. T. Mitchell's excellent book, *Iconology. Image, Text, Ideology* (Chicago: University of Chicago Press, 1986).

10 Joseph Gutmann, "The 'Second Commandment' and the Image in Judaism," *No Graven Images. Studies in Art and the Hebrew Bible*, ed. Joseph Gutmann (New York: KTAV Publishing House, 1971), p. 5.

11 *Saint Joseph Edition of the Holy Bible* (New York: Catholic Book Publishing Company, 1963).

12 Pliny, *Natural History*, trans. H. Rackham, Loeb Classical Library, 10 vols (Cambridge, Mass.: Harvard University Press, 1952). Further references are to this edition = Pliny, *NH*. Aristotle regarded menstrual blood as the substance responsible for generation. Out of it not only were embryos "concocted," but also uterine moles (tumors) which come into being when women "produce an excess of menstrual evacuations and cannot concoct them; and so, when the fetation has been 'set,' formed out of a liquid which is difficult to concoct, then what is called the mola is produced" (*Generation of Animals*, 4. 7.10). An embryo consists of blood that has been completely concocted into a well-done piece of meat. The mola, on the other hand, represents "meat, when it is undercooked," a defect which is due to a woman's insufficient heat. Her innate coldness makes the mola hard, and "the cause of its hardness is the lack of concoction, just as underdone meat is another instance of lack of concoction" (ibid.).

13 *Encyclopaedia Judaica* (New York: Macmillan, 1971), 5:567–75.
14 Ibid.
15 Ephraim Syrus, *Nicene and Post-Nicene Fathers*, vol. 13, Part II. Further references are to this edition.
16 Pierre Guiraud, *Sémiologie de la sexualité* (Paris: Payot, 1978), p. 50.
17 Morris Jastrow, *The Civilization of Babylonia and Assyria* (Philadelphia: J. B. Lippincott, 1915), p. 440.
18 Ibid., p. 195.
19 Hymn no. 7, in *Sumerisch-Babylonische Hymnen*, after Jastrow (see n. 17, above).
20 Arthur Darby Nock, *Essays on Religion and the Ancient World* (Cambridge, Mass.: Harvard University Press, 1972), p. 91.
21 Scholars of this controversial topic have been able to show to what extent the acceptance and rejection of imagery might have resulted from political struggles and economic pressures, or served the goals of a national and religious renewal. See Joseph Gutmann, "Deuteronomy: Religious Reformation or Iconoclastic Revolution?" *The Image and the Word. Confrontations in Judaism; Christianity and Islam* (Missoula, Mont.: Scholars Press, 1977), pp. 5–14. The Dura Europos fresco is reproduced by Alfred Werner in "Chagall's Jerusalem Windows," Gutmann, *No Graven Images*, p. 535.

2 Depictions of Christ – Early Christianity

1 *Apocryphal New Testament*, p. 516.
2 Clement of Alexandria, *Exhortation to the Greeks*, trans. G. W. Butterworth, Loeb Classical Library (London: W. Heinemann, 1919), ch. 4, p. 139.
3 Lampridius, *Alexander Severus*, 29; Frederic W. Farrar, *The Life of Christ as Represented in Art* (New York: Macmillan, 1895), pp. 71–2.
4 Farrar believes that it was such a votive statue erected to the Emperor Hadrian, *Life of Christ*, p. 82.
5 Macarius Magnes, *The Apocriticus*, trans. T. W. Crafer (London: SPCK, 1919), p. 31.
6 *A Greek-English Lexicon of the New Testament and Other Early Christian Literature*, a translation and adaptation of Walter Bauer's *Griechisch-Deutsches Wörterbuch zu den Schriften des Neuen Testaments und der übrigen urchristlichen Literatur* by William F. Arndt and F. Wilbur Gingrich (Chicago: University of Chicago Press, 1957), p. 127.
7 Dobschütz, pp. 37–9.
8 Homer, *The Iliad*, trans. Samuel Butler (Chicago: Encyclopaedia Britannica, 1952), p. 24. Further references are to this edition.

Notes

9 "Athena," Pauly-Wissowa, 1:1945.
10 "Numa Pompilius," *Britannica*, 19:847.
11 Dobschütz suggests that the older version of the Camuliana icon story
 was written after 560 and gives the German translation of the Syrian
 text on pp. 4**–7**.
12 Ibid., pp. 42–3.
13 On the cross from Apameia see Evagrius, *Church History*, chapter 26.
14 Dobschütz, pp. 47–9.
15 Ibid., p. 49.
16 Ibid., pp. 72ff.
17 Jaroslav Pelikan, *Jesus through the Centuries* (New Haven: Yale
 University Press, 1985), p. 95.
18 London, British Museum. Reproduced in *Age of Spirituality*, figure 452,
 pp. 502–3, and Volbach, *Christian Art*, figure 98.
19 *Salome and Judas*, pp. 267–8.
20 The plaque has suffered damage and the lance is missing.
21 Florence, Biblioteca Medicea-Laurenziana. Schiller, *Iconography*, 2,
 Plate 327.
22 Carlo Cecchelli, "Christ" in *Encyclopedia of World Art* (New York:
 McGraw-Hill, 1972), 3:601.
23 The Utrecht Psalter comes from Reims and its illustrations are
 executed in pen and ink. Utrecht, Bibliotheek der Rijksuniversiteit.
 Schiller, *Iconography*, 2, Plates 357–9.
24 Vittorio Lanternari, "Symbols of Christ," *Encyclopedia of World Art*,
 3:602.

3 Icon Addicts – Icon Foes

1 In the Bible the only Thaddaeus was one of the 12 apostles. Luke calls
 him "Judas son of James," while Matthew and Mark refer to him as
 "Thaddaeus."
2 *Ancient Syriac Documents Relative to the Earliest Establishment of
 Christianity in Edessa and the Neighbouring Countries, from the Year
 after Our Lord's Ascension to the Beginning of the Fourth Century*,
 discovered, edited, translated, and annotated by the late W. Cureton,
 with a preface by W. Wright (1864; reprinted, Amsterdam: Oriental
 Press, 1967), pp. 6–23.
3 W. Cureton, "Preface" to *Ancient Syriac Documents*, p. i.
4 George Phillips, "Preface" to *Doctrine of Addai*, p. vii.
5 Richard Adelbert Lipsius, *Die Edessenische Abgar-Sage* (Brunswick:
 C. A. Schwetschke und Sohn, 1880), p. 61 and *passim*.
6 Phillips, "Preface" to *Doctrine of Addai*, p. ix; Lipsius, *Die Edessenische
 Abgar-Sage*, p. 71.
7 L.-J. Tixeront, *Les Origines de l'église d'Edesse et la légende d'Abgar*

229

(Paris: Maisonneuve and Ch. Leclerc, 1888), p. 94, author's trans.

8 Ibid., p. 121.

9 Steven Runciman, "Some Remarks on the Image of Edessa," *The Cambridge Historical Journal*, 3 (1931):241.

10 "Lerubna" is the name of the king's scribe in the *History of Armenia* (ca.700) by Moses of Chorene, who repeats the account given by the *Doctrine of Addai*. For Moses's text see *Collection des historiens anciens et modernes de l'Arménie*, ed. Victor Langlois (Paris: Librairie de Firmin-Didot, 1880), 1:317–31.

11 Alfred von Gutschmid, "Untersuchungen über die Geschichte des Königreichs Osroëne," *Mémoires de l'Académie Impériale des Sciences de Saint-Pétersbourg*, 35 (1887): 1–49.

12 Rubens Duval, *Histoire politique, religieuse et littéraire d'Edesse jusqu'à la première croisade* (Paris: Imprimerie Nationale, 1892), pp. 74–80.

13 F. Crawford Burkitt, *Early Eastern Christianity* (London: John Murray, 1904), pp. 47–8.

14 Ludwig Hallier, *Untersuchungen über die Edessenische Chronik* (Leipzig: J. C. Hinrichs'sche Buchhandlung, 1892), p. 76.

15 Most historians disbelieve Edessa's early christianization. But Runciman dismisses their scepticism and writes: "there is no reason why King Abgar V should not have suffered from the religious curiosity fashionable at that time, and should not have heard of the Messiah in Palestine and sent to learn more." "Some Remarks," p. 239.

16 *Egeria's Travels*, trans. John Wilkinson (London: SPCK, 1971), p. 117.

17 Ibid., p. 226.

18 Procopius, *History of the Wars* (2. 26), trans. H. B. Dewing, Loeb Classical Library, 7 vols (London: W. Heinemann, 1914), 1:489.

19 Dobschütz, pp. 116–20.

20 Hallier, *Untersuchungen*, p. 81.

21 Hefele, 2:233–47, 410–578.

22 Dobschütz, p. 145.

23 Gibbon, 4:252–3.

24 Dobschütz, pp. 142–3.

25 Ibid., pp. 147–8.

26 In *Nicene and Post-Nicene Fathers*, vol. 1. Further references are to this edition.

27 André Grabar, *L'Iconoclasme byzantin* (Paris: Flammarion, 1984), p. 29.

28 Ibid., p. 30.

29 Hypatius of Ephesus, "Mixed Enquiries" in the Codex Parisinus 1115 (ann. 1276), fos 254v–255v. A fragment of Hypatius's text was published in *Orientalia Christiana Analecta*, ed. Franz Diekamp (Rome: Pont. Inst. Orientalium Studiorum, 1938), 117:127–9. Trans.

after Norman H. Baynes, "The Icons before Iconoclasm," *The Harvard Theological Review*, 2 (1951):95.

30 For the Rufinus translation see Dobschütz, pp. 172*–173*.

31 Theodosius, "De Terra Sancta" and Antoninus Martyr, "Perambulatio locorum sanctorum," both in *Itinera hierosolymitana et descriptiones terrae sanctae bellis sacris anteriora*, reprint of the 1879 edition (Osnabrück: Otto Zeller, 1966), pp. 89ff. and 61ff.

32 Dobschütz, p. 139*.

33 Ernst Kitzinger, "The Cult of Images in the Age before Iconoclasm," *Dumbarton Oaks Papers*, 8 (1954):105.

34 A. Papadopoulos-Kerameus, in *Zapiski of the Hist.-Phil. Faculty of the Imperial University of St Petersburg*, 95 (1909):16.

35 Kitzinger, "The Cult of Images," p. 108.

36 Baynes, "Icons before Iconoclasm," p. 96.

37 Leontius, after Baynes, ibid., p. 98.

38 Ibid., p. 100.

39 Ibid., p. 101.

40 Jaroslav Pelikan, *The Christian Tradition. A History of the Development of Doctrine*, 2 vols (Chicago: University of Chicago Press, 1974), 2:37–145.

41 Bazon Brock, "Zur Geschichte des Bilderkrieges um das Realismus-Problem," *Aesthetik als Vermittlung. Arbeitsbiographie eines Generalisten* (Cologne: DuMont, 1977), p. 318.

42 Grabar, *L'Iconoclasme byzantin*, p. 125.

43 The Greek texts of John of Damascus dealing with the defense of images are contained in *De fide orthodoxa* (Abgar is mentioned in Book 4. 281) and in *De imaginibus orationes* (Abgar is mentioned in *Oratio* 1. 320), Migne, *PG* 94. English translation after St John of Damascus, *On the Divine Images*, trans. David Anderson (Crestwood, NY: St Vladimir's Seminary Press, 1980). All quotes from this edition.

44 Eusebius, *Epistola ad Constantiam Augustam*, *PG* 20:1545; and Epiphanius of Salamis, Letter to John of Jerusalem contained only in the Latin translation of Hieronymus, *Opera*, ed. Petavius (1682), Dobschütz, pp. 102*–103*.

45 St John of Damascus, A Commentary following *Oratio* 1, *On the Divine Images*, p. 35.

46 Dobschütz, pp. 57–8.

47 "Canticle of Mar Jacob [= Jacob of Sarug, d. 521] the Doctor, upon Edessa, when she sent to our Lord to come to her," *Ancient Syriac Documents*, p. 106.

48 Gibbon, chapter 49, 4:254.

49 Dobschütz, pp. 160ff.

50 For the original text of Constantine's homily see Migne, *PG* 113:423–54. For the edited version of the feast homily and the *menaeon* and, in

addition, a liturgical treatise, a hymn to the image, and a chronicle of the translation see Dobschütz, pp. 29**–129**.

51 Kurt Weitzmann, "The Mandylion and Constantine Porphyrogennetos," *Cahiers archéologiques*, 11 (1960):184. Previously the icon was dated to the late ninth century and a localization in Edessa by G. and M. Sotiriou, *Icones du Mont Sinai*, 2 vols (Athens, 1958), 1:figures 34–6; 2:49–51.

52 Dobschütz, pp. 138–9.

53 There is a similar hint in another text. In a Syriac hymn from around the mid-sixth century, the marble of the Edessene cathedral resembles an "image not made by hand." A. Dupont-Sommer, "Une hymne syriaque sur la cathédrale d'Edesse," *Cahiers archéologiques*, 2 (1947):31.

54 Weitzmann, "The Mandylion," p. 167.

55 Ibid.

56 Dobschütz, p. 169.

57 Today in Bibliothèque Nationale, Paris, cod. gr. 1528.

58 Today in the Historical Museum, Moscow, cod. 382. See also Weitzmann, "The Mandylion," pp. 171–2.

59 The abbreviated version of the legend was written about 1032, the year when the original letter of Jesus to Abgar was transferred to the imperial collection of relics in Constantinople. The miniatures were first published and discussed by Sirarpie Der Nersessian, "La Légende d'Abgar d'après un rouleau illustré de la bibliothèque Pierpont Morgan à New York," *Actes du IV Congrès International des Etudes Byzantines*, in *Bulletin de l'Institut Archéologique Bulgare*, 9 (1935; reprinted, Nendeln/Liechtenstein: Kraus-Thomson Organization, 1978), pp. 98–106.

60 After Nersessian, "La Légende d'Abgar," p. 106, author's translation.

61 *Sainte Face*, pp. 16–17.

62 Ibid., pp. 24–5.

4 Women and Icons

1 Eusebius, "Letter to Constantia," after Mango, p. 18.

2 Judith Herrin, "Women and the Faith in Icons in Early Christianity," *Culture, Ideology and Politics*, ed. Raphael Samuel and Gareth Stedman Jones (London: Routledge & Kegan Paul, 1982), pp. 68–9.

3 Judith Herrin, *The Formation of Christendom* (Princeton, NJ: Princeton University Press, 1987), p. 309.

4 Caroline Walker Bynum, " '. . . And Woman His Humanity': Female Imagery in the Religious Writing of the Later Middle Ages," *Gender and Religion: On the Complexity of Symbols*, ed. Caroline Walker

Bynum, Stevan Harrell and Paula Richman (Boston: Beacon Press, 1986), p. 280.

5 José Grosdidier de Matons, "La Femme dans l'empire byzantin," *Histoire mondiale de la femme*, 4 vols. (Paris: Nouvelle Librairie de France, 1967), 3:28–30.

6 Hefele, 2:186–90.

7 Theodore Lector, *Hist. eccles*. I. 1 (ca.530) as excerpted by Nicephorus Callistus Xanthopoulos, *PG* 86:165A, after Mango, p. 40. For the feasts of Mary introduced in the sixth and seventh centuries see Martin Jugie, *La Mort et l'assomption de la Sainte Vierge* (Rome: Biblioteca Apostolica Vaticana, 1944), *passim*.

9 Clement of Alexandria, *Exhortation to the Greeks* (2. 12 and 19), trans. G. W. Butterworth, Loeb Classical Library (London: W. Heinemann, 1919), pp. 33 and 45.

10 Eustratius Presbyter, *Vita S. Eutychii*, 53, Migne, *PG* 86: 2333ff., after Mango, p. 133.

11 Grosdidier de Matons, "La Femme," p. 40. See also J. Herrin, "Women and the Church in Byzantium," *Bulletin of the British Association of Orientalists*, 11 (1980):8–14.

12 Grosdidier de Matons, "La Femme," p. 13. The Roman vestals were punished by burial alive for their breach of the vow of chastity.

13 In the fourth century several aristocratic women devoted their fortunes to the founding and directing of monasteries: Olympias, confidante of John Chrysostom; Melania the Elder, monastic companion of Rufinus of Aquileia; and Paula, the friend of Jerome. Olympias, for instance, who was ordained a deaconess in the early 390s, contributed to the Church of Constantinople "ten thousand pounds of gold, twenty thousand of silver, all her real estate in Thrace, Galatia, Cappadocia Prima, and Bithynia" (*Vita Olimpiadis*, 5) and several houses in the capital and its suburbs. After Elizabeth A. Clark, "Authority and Humility: A Conflict of Values in Fourth-Century Female Monasticism," *Byzantinische Forschungen*, 9 (1985):20 and *passim*.

14 Herrin, "Women and the Faith in Icons," p. 72.

15 Eustratius, *Vita S. Eutychii* in Migne, *PG* 86:2325–8.

16 Turtura is shown on a fresco panel (528) in the Catacomb of St Comodilla in Rome. See also Herrin, *Formation of Christendom*, p. 308.

17 *Greek Anthology*, 16. 62, see Mango, pp. 117–18.

18 On an ivory diptych (AD 480) of the consul Basile, for instance, Victory displays the oval buckler of the consul. See André Grabar, *L'Iconoclasme byzantin* (Paris: Flammarion, 1984), p. 41.

19 Weitzmann, *Icon*, pp. 9–10.

20 A. Cameron, *Continuity and Change in Sixth-Century Byzantium* (London: Variorum Reprints, 1981), pp. xvi, 97.

21 The encaustic icon from St Catherine's Monastery on Mount Sinai is reproduced by Weitzmann, *Icon*, Color Plate 2.

22 Grabar, *L'Iconoclasme byzantin*, p. 104, and Cameron, *Continuity and Change*, pp. xvi, 97–101.

23 Nikodim P. Kondakov, *The Russian Icon* (Oxford: Clarendon Press: 1927), pp. 66–7 and 176. The Virgin with Christ as clipeus is known as the *Platytera* (an allusion to her womb). In Italy the type was reinvented in the eleventh century. A well-known example is a marble relief in the church of Santa Maria Mater Domini in Venice. Weitzmann, *Icon*, p. 24.

24 Antoine Wenger, *L'Assomption de la T. S. Vierge dans la tradition byzantine du VIᵉ au Xᵉ siècle* (Paris: Institut Français d'Etudes Byzantines, 1955), pp. 111–39.

25 The text was published by Cameron, *Continuity and Change*, pp. xvii, 53–4.

26 Ibid., pp. xvii, 43–8.

27 There were two painters who went by the name Aristides, a grandfather (ca.400–350 BC) and his grandson (ca.340–290 BC). But it is unlikely that they invented the encaustic.

28 Gervase Mathew, *Byzantine Aesthetics* (London: John Murray, 1963), p. 117.

29 Asterius of Amaseia, "Description of a Painting of the Martyrdom of St Euphemia" (3–4), after Mango, pp. 38–9.

30 *Vita S. Mariae iunioris*, 18, after Mango, pp. 211–12.

31 The dates of Eulalios are not certain. Some believe that he lived in the sixth, others that he flourished in the twelfth century. However, the latter seems to be much more likely. "Nikêphoros Kallistos Xanthopoulos," ed. A. Papadopoulos-Kerameus, *BZ*, 11 (1902):46f., no. 16, after Mango, pp. 231–2.

32 Boccace du duc Jean de Berry, Bibliothèque Nationale, Paris, MS fr. 598.

33 The manuscript illuminated by Herrade was kept in Strasbourg and destroyed there in 1870, but it is known through copies.

34 The Theotokos image was mentioned in the *Life* of St Basil the Younger (d. ca.952) written by his pupil Gregory. Dobschütz, pp. 83 and 147*–148*.

35 Weitzmann, *Icon*. p. 97; Annemarie Weyl Carr, "Women and Monasticism in Byzantium: Introduction from an Art Historian," *Byzantinische Forschungen*, 9 (1985):2.

36 Epiphanius of Salamis, "Letter to the Emperor Theodosius," ed. G. Ostrogorsky, *Studien zur Geschichte des byzantinischen Bilderstreites* (Breslau: M. and H. Marcus, 1929), pp. 23–7, after Mango, p. 42.

37 Paulus Silentiarius, *Descriptio Sanctae Sophiae*. This poem was recited in 563, after the second consecration of the church on December 24, 562. After Mango, p. 89.

Notes

38 In the collection of Museo Nazionale, Florence. Reproduced: Ostrogorsky, *Byzantine State*, figure 17.

39 Asterius of Amaseia, *Homilia* I, Migne, *PG* 40:165–8, after Mango, pp. 50–1. See also Pauline Johnstone, *The Byzantine Tradition in Church Embroidery* (Chicago: Argonaut, 1967), p. 8.

40 Charles Diehl, *Figures byzantines* (Paris: Librairie Armand Colin, 1925) 1:115; E. A. Wallis Budge, *Amulets and Superstitions* (Oxford: Oxford University Press, 1930), *passim*. The Metropolitan Museum in New York possesses a sixth- or seventh-century hematite amulet with Christ curing the Hemorrhissa, whose origin points to the Eastern Roman Empire. See *Age of Spirituality*, Plate 398.

41 Klaus Parlasca, *Mumienporträts und verwandte Denkmäler* (Wiesbaden: Franz Steiner Verlag, 1966), Plate D: 1, 2 and *passim*. See also Josef Strzygowski, *Orient oder Rom. Beiträge zur Geschichte der spätantiken und frühchristlichen Kunst* (Leipzig: J. C. Hinrichs'sche Buchhandlung, 1901).

42 Cleveland, Museum of Art. Weitzmann, *Icon*, Color Plate 4, p. 46.

43 For the original text of Arculf's description of the cloth which "sancta Maria contexuit" see "Relatio de locis sanctis ab Adamnano scripta," in *Itinera hierosolymitana et descriptiones terrae sanctae bellis sacris anteriora*, reprint of the 1879 edition (Osnabrück: Otto Zeller, 1966), p. 156.

44 Diehl, *Figures byzantines*, 1:128.

45 Angeliki E. Laiou, "The Role of Women in Byzantine Society," *Internationaler Byzantinistenkongress Akten*, I/1 (1981):243.

46 Ibid., p. 244.

47 Ibid.

48 Jean Darrouzès, *Georges et Dèmètrios Tornikès. Lettres et Discours* (Paris: CNRS, 1970), p. 229, trans. by the author.

49 Diehl, *Figures byzantines*, 1:81.

50 Ibid., 1:136.Translation from French by the author.

51 Ibid., 1:137.

52 Ostrogorsky, *Byzantine State*, pp. 156–65.

53 Alfred Rambaud, *L'Empire grec au dixième siècle* (Paris, 1870; reprinted: Burt Franklin Research and Source Works Series, 42, New York: Burt Franklin, n.d.), p. 58.

54 Byzantine *typica* for nunneries, the equivalent of the Latin *ordinarii*, liturgic books regulating the order of every day, tell us about nuns working and praying, but not writing or painting. Hippolyte Delehaye, "Deux typica byzantins de l'époque des Paléologues," *Mémoires de l'Académie Royale de Belgique*, ser. 2, vol. 13 (1921).

55 Ilse Rochow, *Studien zu der Person, den Werken und dem Nachleben der Dichterin Kassia* (Berlin: Akademie-Verlag, 1967), p. 31 and *passim*.

56 J. Herrin, "In Search of Byzantine Women: Three Avenues of

Approach," *Images of Women in Antiquity*, ed. A. Cameron and A. Kuhrt (Detroit: Wayne State University Press, 1983), p. 180.

57 Herrin, *The Formation of Christendom*, p. 310.

58 Hefele, 3:397.

59 *The Chronicle of Theophanes* (September 1, 718–August 31, 719), trans. Harry Turtledove (Philadelphia: University of Pennsylvania Press, 1982). Further references are to this edition.

60 *Vita Stephani*, in *Analecta graeca* of the Maurists (1686), 1:507ff.; Hefele, 3:422.

61 Stephen Gero, "Byzantine Iconoclasm and the Failure of a Medieval Reformation," *The Image and the Word. Confrontations in Judaism, Christianity and Islam*, ed. Joseph Gutmann (Missoula, Mont.: Scholars Press, 1977), p. 55.

62 Mango, p. 167. See also M. V. Anastos, "The Argument for Iconoclasm as Presented by the Iconoclastic Council of 754," *Late Classical and Mediaeval Studies in Honor of A. M. Friend, Jr.*, ed. K. Weitzmann (Princeton, NJ: Princeton University Press, 1955), pp. 177–88.

63 Hefele, 3:441–87.

64 Diehl, *Figures byzantines*, 1:81.

65 Herrin, *Formation of Christendom*, p. 411.

66 "Irene," *Britannica*, 14:792.

67 Hefele, 3:489.

68 Horos of the Iconoclastic Council of 815 preserved in fragments in a treatise by the Patriarch Nicephorus known as *Refutatio et eversio*, ed. P. J. Alexander, *Dumbarton Oaks Papers*, 7 (1953):58ff., after Mango, pp. 168–9.

69 Rambaud, *Empire*, p. 57; Diehl, *Figures byzantines*, 1:44–5.

70 Ostrogorsky, *Byzantine State*, p. 219.

71 Diehl, *Figures byzantines*, 1:143.

72 For the exact history of the Chalke image see Grabar, *L'Iconoclasme byzantin*, pp. 150–63.

73 Diehl, *Figures byzantines*, 1:140–1.

74 Photius, "Homily XVII. Image of the Virgin," *The Homilies of Photius, Patriarch of Constantinople*, English Translation, Introduction and Commentary by Cyril Mango (Cambridge, Mass.: Harvard University Press, 1958), p. 291.

75 Cyril Mango, "Note on Homily XVII," ibid., p. 285.

76 Ibid., p. 290.

77 *Adversus Constantinum Caballinum*, Migne, *PG* 95:333D–336A, here attributed to John of Damascus, after John R. Martin, "The Dead Christ on the Cross in Byzantine Art," in Weitzmann, ed., *Late Classical and Mediaeval Studies*, p. 192. The Khludov Psalter is in the Historical Museum, Moscow. See Weitzmann, *Icon*, Plate I, p. 9.

5 From the Hemorrhissa to Berenice

1 W. B. Yeats, *The Collected Poems* (New York: Macmillan, 1946), p. 276.

2 Gaston Bachelard, *The Poetics of Reverie*, trans. Daniel Russell (Boston: Beacon Press, 1971), p. 113.

3 On Jesus' attitude towards women see Ronald W. Graham, *Women in the Ministry of Jesus and in the Early Church* (Lexington, Ky.: Lexington Theological Seminary, 1983); Ben Witherington III, *Women in the Ministry of Jesus* (Cambridge: Cambridge University Press, 1984).

4 This was reported in the Babylonian Talmud, *Pesahim* 118a. After Raphael Loewe, *The Position of Women in Judaism* (London: SPCK, 1966), pp. 22–3.

5 *Salome and Judas*, pp. 189ff.

6 Dobschütz, pp. 199–200.

7 On severed male heads see *Salome and Judas*, pp. 227–35 and *passim*.

8 Dobschütz, p. 200.

9 Ibid., see also N. Kondakov, *Geschichte und Denkmäler des byzantinischen Emails* (Frankfurt, 1892), p. 277.

10 Dobschütz quotes his *Homily* on p. 254*.

11 Dobschütz, p. 199.

12 Such an interpretation is given by André Grabar, *Christian Iconography* (Princeton, NJ: Princeton University Press, 1968), Plate 325. The casket is in Brescia, Museo dell'Età Cristiana.

13 *Book of James*, or *Protevangelium*, *Apocryphal New Testament*, pp. 38–49. Further references are to this edition.

14 For the symbolism of blood as red thread and cloth see Eva Wunderlich, *Die Bedeutung der roten Farbe im Kultus der Griechen und Römer* (Giessen: A. Töpelmann, 1925), *passim*.

15 Marina Warner, *Monuments & Maidens. The Allegory of the Female Form* (New York: Atheneum, 1985), p. 242.

16 "Salome" is a symbolic name, since it is associated with Herodias's daughter who made John the Baptist "flow," as he was decapitated. *Salome and Judas*, p. 223.

17 Clementis Homiliae III, 73, Dobschütz, pp. 251*–252*.

18 Claude Gaignebet, "Véronique ou l'image vraie," *Anagrom*, 7 & 8 (1976):57.

19 Ps.-Ambrosius, *Sermo XLVI de Salomone*, Migne. *PL* 17:721.

20 *The Gospel of Mary*, in *Nag Hammadi Library*, p. 472.

21 St Cyril of Jerusalem, *Nicene and Post-Nicene Fathers*, 7:97.

22 Gregory the Great, *Hom.* 33.1, Migne, *PL* 76:1238.

23 Marjorie M. Malvern, *Venus in Sackcloth. The Magdalen's Origins*

and Metamorphoses (Carbondale and Edwardsville: Southern Illinois University Press, 1975), p. 27.

24 On Adonis as god of vegetation see *Adonis, Attis, Osiris*, vols 5 and 6 of *Golden Bough*, and *Salome and Judas*, pp. 202–3.

25 Warner, *Monuments & Maidens*, p. 257.

26 *Apocryphal New Testament*, p. 183.

27 Malvern, *Venus in Sackcloth*, pp. 55 and 69.

28 Gaignebet, "Véronique," pp. 63–4.

29 Worcester, Museum of Art. Reproduced in *La Maddalena tra Sacro e Profano*, Exhibition Catalogue, Florence, Palazzo Pitti, May 24 through 7 September 1986 (Milano: Arnoldo Mondadori, 1986), p. 32, Plate 3.

30 London, British Museum.

31 Callimachus, *Aetia*, 110. 67–75, *Aetia–Iambi–Lyric Poems* . . ., trans. C. A. Trypanis, Loeb Classical Library (Cambridge, Mass.: Harvard University Press, 1978), p. 85.

32 Catullus, "The Lock of Berenice," *The Poems of Catullus*, trans. F. W. Cornish, in *Catullus, Tibullus and Pervigilium Veneris*, Loeb Classical Library (Cambridge, Mass.: Harvard University Press, 1976), p. 131. Further references are to this edition.

33 "Berenice," *Britannica*, 3:769.

34 Flavius Josephus, *The Great Roman–Jewish War: A.D. 66–70*, trans. William Whiston, revised D. S. Margoliouth (New York: Harper & Brothers, 1960), p. 91.

35 "Queen Berenice showed equal spirit in helping Vespasian's party: she had great youthful beauty, and commended herself to Vespasian for all his years by the splendid gifts she made him." Tacitus, *The Histories*, trans. Clifford H. Moore, Loeb Classical Library, 5 vols (Cambridge, Mass.: Harvard University Press, 1980), 2:291. Tacitus also mentions that Titus returned from Greece to Rome "because of his passionate longing to see again Queen Berenice" (2.2, p. 163). Berenice is mentioned by Suetonius, *The Lives of the Caesars*, "Titus," 7, trans. J. C. Rolfe, Loeb Classical Library (Cambridge, Mass.: Harvard University Press, 1979), p. 329. Juvenal's Satire 6 mentions "a diamond of great renown, made precious by the finger of Berenice. It was given as a present long ago by the barbarian Agrippa to his incestuous sister". *Juvenal and Persius*, trans. G. G. Ramsay, Loeb Classical Library (Cambridge, Mass.: Harvard University Press, 1979), p. 95.

36 John Malalas, *Chronographia*, ed. Ludwig Dindorf (Bonn: Weber, 1831), pp. 236–9.

37 See Dobschütz, pp. 200 and 265*.

38 "Preface" to *Doctrine of Addai*, pp. vi and ix.

39 André Grabar observed that a Roman or Byzantine emperor was "like a relic" functioning at once like a man and a god. *Martyrium. Recherches sur le culte des reliques et l'art chrétien antique*, 2 vols (London: Variorum Reprints, 1972) 1:13.

40 Since the ninth century the principal center of Helena's cult has been the abbey of Hautvilliers, near Reims. Therefore the invention legend is often depicted in French art.

41 Peter Brown, *The Cult of the Saints* (Chicago: University of Chicago Press, 1981), p. 91.

42 Alfred Maury, *Croyances et légendes de l'antiquité* (Paris: Didier, 1863), pp. 341–2; Gaignebet, "Véronique," pp. 55–8.

43 Henry Longueville Mansel, *The Gnostic Heresies of the First and Second Centuries* (London: John Murray, 1875), p. 188; see also C. W. King, *The Gnostics and their Remains* (London: Bell and Daldy, 1864), pp. 27–31.

44 Martin P. Nilsson, "Sophia-Prunikos," *Eranos. Acta Philologica Suecana*, 45, 1–2 (1947):169–72; Maury, *Croyances*, pp. 338–9; Mansel, *The Gnostic Heresies*, p. 189.

45 Origenes, *Contra Celsum*, trans. Henry Chadwick (Cambridge: Cambridge University Press, 1953), p. 350. Further references are to this edition.

46 On Judas see Irenaeus, *Against the Heresies*, 2. 20. 2; on the Gnostic Hemorrhissa ibid., 1. 3. 3 and 1. 4. 1. On the general problems of Gnosis see Wilhelm Bousset, *Hauptprobleme der Gnosis* (Göttingen: Vandenhoeck and Ruprecht, 1907).

47 *The Apocryphon of John* (2.1.4–5), in *Nag Hammadi Library*, p. 101.

48 *Trimorphic Protennoia*, ibid., p. 470.

49 *Eugnostos the Blessed* and *Sophia of Jesus Christ*, ibid., pp. 218 and 222–4.

50 Irenaeus, *Against the Heresies*, 2. 10. 3.

51 Ibid.

52 Ibid., 1. 30. 3–13.

53 Ibid., 1. 3. 3.

54 *Bundahishn*, ch. 4, after R. C. Zaehner, *The Teachings of the Magi* (New York: Oxford University Press, 1975), pp. 45–6.

55 Ibid., pp. 47–8.

56 Female leakiness as a sign of badness has been studied by Marina Warner, who points out that in Aeschylus's drama *The Suppliant Women* (ca.470–460 BC) evil female unsoundness is personified by the Danaids who kill their husbands on their wedding night and are condemned to pour water into leaky vessels until the end of time. *Monuments & Maidens*, p. 245.

6 St Veronica

1 Matthaeus Paris, *Historia Angliae*, ed. W. Wats (1640), pp. 37–47: *ad a. 1216, De veronica et eiusdem autenticatione.* Dobschütz, p. 297*.

2 Pearson, p. 2.

3 "February," *Britannica*, 10:231.

4 For instance in the St Gilles church in Valenciennes, in Bois-Guillaume near Rouen, or in Tournai. Claude Gaignebet, "Véronique ou l'image vraie," *Anagrom*, 7 & 8 (1976):63–5. Officially, the Catholic Church celebrates St Fiacre on August 30. August 29 is the day of St John the Baptist, whose decapitation is associated with the harvest. See also "Candlemas," *Britannica*, 5:179. On the solarity of the Baptist see *Salome and Judas*, pp. 199–212.

5 Giraldus Cambrensis, *Speculum ecclesiae*, chapter VI, in *Opera*, ed. J. S. Brewer, 8 vols (London: Longman, 1861–91), 4:278.

6 Gervase of Tilbury, *Otia Imperialia*, 3. 25, in *Scriptores rerum Brunsvicensium*, vols 1 and 2, ed. G. Leibnitz (Hanover, 1707), 1:968.

7 Pearson, p. 15.

8 "Schweisstuch der Veronika," in *Lexikon der Kunst*, 5 vols (Leipzig: Veb. E. A. Seemann Verlag, 1968–78), 4:422.

9 *La Sainte Face*, p. 15.

10 Volbach, *Christian Art*, p. 22.

11 The *Acts* are mentioned twice in Justin's *First Apology*, but there is a strong suspicion that he just assumed the existence of such documents. Fifty years later a letter from Pilate to Tiberius is mentioned in the *Apologeticus* of Tertullian, who on the basis of its sympathetic tone considers Pilate a Christian by conviction. Thus it is assumed that Tertullian must have known an apocryphal Christian document which went under Pilate's name. But this document was probably related not to the Acts of the trial, but to the so-called *Letter of Pilate*. F. Scheidweiler, *NT Apocrypha*, 1:444. *Letter of Pilate*, ibid., 1:476ff.

12 *NT Apocrypha*, 1:444–5.

13 Ibid., 1:447. All further references are to *Acts of Pilate* in *NT Apocrypha*.

14 The oldest extant version, a Vatican MS entitled *Cura sanitatis Tiberii Caesaris Augusti et Damnatio Pilati*, dates probably from the eighth century. It was published by J. D. Manso, *Miscellanea Stephani Baluzii* (Lucca: 1764), 4:56. See Pearson, pp. 4–5; *Apocryphal New Testament*, p. 158; and Dobschütz, pp. 209ff.

15 For medieval versions of the *Vindicta* see *La Vengeance de Nostre-Seigneur, The Old and Middle French Prose Versions: The Version of Japheth*, ed. Alvin E. Ford (Toronto: Pontifical Institute of Mediaeval Studies, 1984); and *Kaiserchronik, Gedicht des zwölften Jahrhunderts*, ed. Hans F. Massman (Quedlingburg: G. Basse, 1848), vol. 4, Part I, pp. 64ff., and Part III, pp. 572ff.

16 Reinhold von Röhricht, *Geschichte des ersten Kreuzzuges* (Innsbruck: Wagner, 1901).

17 A summary of *The Vengeance or Avenging of the Saviour*, is given in

Apocryphal New Testament, pp. 159–61.

18 Ibid., p. 159.

19 *La Vengeance de Nostre-Seigneur*, pp. 29–35 and *passim*.

20 "Et quant ele fu garie, de la grant amor qu'ele out vers lui, si fist paindre un ymage del semblant Jesu" (MS Bib. Nat. fr. 19525, thirteenth century); or: "Et quant elle se vit guerie, pour l'amour de lui, elle print s'ymage a sa semblance et la maiesté de Nostre Seigneurs endementiers qu'il vivoit en une touaille" (MS Bib. Nat. fr. 413, end of fourteenth century) after *La Vengeance de Nostre-Seigneur*, pp. 5–6.

21 "La Passion du Seigneur," *Golden Legend*, 1:404.

22 Wilhelm Grimm, "Die Sage vom Ursprung der Christusbilder," *Nachrichten der Akademie der Wissenschaften. Philos.-histor. Klasse* (1842):127–8, and Dobschütz, p. 268*.

23 MS Bib. Nat. fr. 181 (fifteenth century); in *Vengeance de Nostre-Seigneur*, p. 7.

24 It is the *Cura* published by Manso, *Miscellanea*. See also Charles Wycliffe Goodwin, Introduction to *The Anglo-Saxon Legends of St. Andrew and St. Veronica*, ed. for the Cambridge Antiquarian Society by C. W. Goodwin (Cambridge: Deighton; Macmillan, 1851), p. viii.

25 *The ME Prose Translation of Roger d'Argenteuil's Bible en François*, ed. Phyllis Moe, from Cleveland Public Library MS Wq 091.92–C 468 (Heidelberg: Carl Winter Universitätsverlag, 1977). Further references are to this edition.

26 "The blood and sweat / across his face ran / Feronica pressed through all the men / and swept his precious face," author's trans. MS cgm. 841, Bayrische Staatsbibliothek, late medieval. After Karl-Ernst Geith, "Zu einigen Fassungen der Veronika-Legende in der mittelhochdeutschen Literatur," in *Festgabe für Friedrich Mauer* (Düsseldorf: Pädagogischer Verlag Schwann, 1968), p. 284.

27 A typical example is the verses spoken by Veronica in a *Donaueschingen Passionsspiel* (1450–1500): "O Jhesus liebster herre min, / muss ich von dir gescheiden sin, / so bit ich dich doch umb ein gab, / da mit ich din gedechtniss hab, / die bildung von diner angesicht, / das ich din herre vergesse nicht" in *Schauspiele des Mittelalters*, ed. Franz Joseph Mone, 2 vols (Karlsruhe: C. Macklot, 1846), 2:311.

28 In an English mystery play Jesus says to Veronica: "Remembyr me." *Ludus Coventriae. A Collection of Mysteries, Formerly Represented at Coventry on the Feast of Corpus Christi*, ed. James Orchard Halliwell, printed for the Shakespeare Society (London, 1841), p. 318.

29 *Mistère de la Passion*, in Louis Paris, *Toiles peintes et tapisseries de la ville de Reims* (Paris, 1848), No. 20, pp. 530–1.

30 Quoting St Bernard, Jacques de Voragine writes in "La Passion du Seigneur" that the "lovely face" of Jesus, which "angels liked to look at," was dirtied with spit. *Golden Legend*, 1:393.

31 Elisabeth Roth, *Der volkreiche Kalvarienberg in Literatur und Kunst des Spätmittelalters* (Berlin: Erich Schmidt Verlag, 1958), pp. 61ff.

32 Lugano, Thyssen-Bornemisza Collection.

33 Ghent, Musée des Beaux-Arts.

34 For the Baptist triptych see *Salome and Judas*, pp. 197–8.

35 Master of Flémalle, *Holy Veronica*, Frankfurt/Main, Städelsches Kunst-institut.

36 The altar comes from the Jerusalem Brotherhood Chapel, St Mary's Church, Gdansk (Danzig).

37 Cariani, *The Way to Calvary*, Milan, Gallery of the Biblioteca Ambrosiana.

38 One of the oldest and most important of the Italian "holy hills" is the Sacro Monte (1486) at Varallo in Piedmont. There is also a beautiful 1530 fresco of Jesus (in red) climbing the Golgotha, and Veronica (blond, in a yellow dress and a light-blue mantle), by Bartolomeo Neroni in the Abbazia di Monte Oliveto Maggiore (Siena).

39 "The Travels of Bishop Arculf in the Holy Land," *Early Travels in Palestine*, p. 2.

40 Pamela Sheingorn, *The Easter Sepulchre in England*, Medieval Institute Publications (Kalamazoo, Mich.: Western Michigan University, 1987), p. 9.

41 The same book also contains the first depiction of the dead Jesus on the cross, which has been mentioned before. See Schiller, *Iconography*, 2, Plate 643.

42 Schiller, *Iconography*, 2: 184–97.

43 *The Flowing Light of the Godhead* (*Das Fliessende Licht der Gottheit*) is the title of Mechthild of Magdeburg's revelations, loose notes written in the *mittelniederdeutsch* dialect, which were edited and made into a volume by the Dominican monk Heinrich von Halle. Mechthild survived him, received the edited manuscript (six books), and added a seventh book. The original was lost, but an Alemannic translation by Heinrich von Nördlingen survived. The only German version of Mechthild's "Revelations" is preserved in Switzerland, in the Cod. 277 at the library of the Einsiedeln monastery. In 1869 the *mittelhochdeutsch* text was published by its librarian: *Offenbarungen der Schwester Mechthild von Magdeburg oder Das Fliessende Licht der Gottheit*, ed. P. Gall Morel (Regensburg, 1869; reprinted, Darmstadt: Wissenschaftliche Buchgesellschaft, 1963). My translation of Mechthild's verses is based on this edition as well as on a modern German translation: Mechthild von Magdeburg, *Das Fliessende Licht der Gottheit*, introduced by Margot Schmidt, with a study by Hans Urs von Balthasar (Einsiedeln: Benzinger Verlag, 1956). My translations are numbered after the 1956 edition.

44 "Blood," in Clinton Morrison, *An Analytical Concordance to the Revised Standard Version of the New Testament* (Philadelphia: The

Westminster Press, 1979), pp. 66–7.

45 William Robertson Smith, *Lectures on the Religion of the Semites* (New York: Macmillan, 1927), p. 230.

46 Jaroslav Pelikan, *Jesus through the Centuries* (New Haven: Yale University Press, 1985), p. 83 and *passim*.

47 Theodoret, "Proof that the Divinity of the Saviour is Impassible" (15), *Demonstrations by Syllogisms*, trans. Blomfield Jackson, in *Nicene and Post-Nicene Fathers*, 3:249.

48 The beak of the white pelican is equipped with a sack where fish with which he feeds his young are kept. As the bird feeds them, it presses the sack against its neck in such a way that it looks as if it were opening its breast with its bill. The pelican's breast plumage is tinted with red, and so is his beak. This fostered the folkloric idea that the bird drew blood from its body. Under the influence of the *Physiologus*, the pelican as the symbol of the Savior was already familiar to St Augustine, and has been widely used in literature (for instance, Dante, *Paradiso*, 25. 113) and visual arts from the late Middle Ages to the baroque period. From the Middle Ages the pelican was also used as a symbol of the Eucharist and placed on altars, pyxes, chalices, tabernacle doors, and humeral veils. See M. R. P. McGuire, "Pelican," *New Catholic Encyclopedia* (New York: McGraw-Hill, 1967), 11:60.

49 "On the Pelican," *Physiologus*, trans. Michael J. Curley (Austin: University of Texas Press, 1979), pp. 9–10. The date of the *Physiologus* is much disputed. But it was probably compiled around AD 200. See "Introduction," ibid., pp. xvii–xxi.

50 Caroline Walker Bynum, "'. . . And Woman His Humanity': Female Imagery in the Religious Writings of the Later Middle Ages," *Gender and Religion: On the Complexity of Symbols*, ed. C. W. Bynum et al. (Boston: Beacon Press, 1986), p. 268 and *passim*.

51 Hildegard von Bingen, *Heilkunde* (Salzburg: Otto Müller Verlag, 1957), pp. 176–82.

52 The same text. English trans. after Peter Dronke, *Women Writers of the Middle Ages* (Cambridge: Cambridge University Press, 1984), p. 180.

53 Ibid., p. 181.

54 The manuscripts in which Marie's poems are preserved date from the late thirteenth century. They were first published in 1819 by B. de Roquefort.

55 She is possibly the woman referred to as Matelda in Dante's *Purgatorio*. On Mechthild's symbolism of fluids see James C. Franklin, *Mystical Transformations. The Imagery of Liquids in the Work of Mechthild von Magdeburg* (Rutherford: Fairleigh Dickinson University Press, 1978).

56 Translation after Franklin, ibid., p. 131.

57 On medieval mysticism see Denis de Rougemont, *Love in the Western*

World, trans. Montgomery Belgion (New York: Pantheon, 1956); Mary Anita Ewer, *A Survey of Mystical Symbolism* (London: SPCK, 1933); *Life in the Middle Ages*, selected, trans., and annotated by G. G. Coulton, 2 vols (Cambridge: Cambridge University Press, 1967); Emil Spiess, *Ein Zeuge mittelalterlicher Mystik in der Schweiz* (St Gallen: C. Weder Rorschach, 1935); Conrad Bergendorff, "A Critic of the Fourteenth Century. St. Brigitta of Sweden," *Medieval and Historiographical Essays in Honor of James Westfall Thompson*, ed. James Lea Cate and Eugene N. Anderson (Chicago: University of Chicago Press, 1938); Angela of Folignano, *The Book of Divine Consolation*, trans. Mary G. Teegmann (London: Chatto and Windus, 1909); *The Dialogue of the Seraphic Virgin Catherine of Siena. Dictated by her while in a State of Ecstasy to her Secretaries, and Completed in the Year of our Lord 1370*, trans. Algar Thorold (London: Kegan Paul, Trench, Trübner, 1896).

58 Mechthild's "soul is the stuff out of which God forms images which he impresses into her." Hans Urs von Balthasar, "Mechthilds kirchlicher Auftrag," in Mechthild von Magdeburg, *Das Fliessende Licht der Gottheit*, p. 28, author's trans.

59 Mrs Jameson is the pen name of Anna Brownell Jameson (1794–1860).

60 Mrs Jameson, *Legends of the Madonna as Represented in the Fine Arts* (London: Longmans, Green, and Co., 1899), p. xlvii.

61 Julian of Norwich, *The Revelations of Divine Love*, trans. J. Walsh (St Meinrad, Ind.: Abbey Press, 1975), pp. 166–7. Further references are to this edition cited as *Revelations*.

62 Examples of solarity: Brescian Master, *Veronica with Sweatcloth* (1408), fresco, Pinacoteca Cosio Martinengo, Brescia; *Horae* (Paris, 1514), Princeton University Library; engraving by Claude Mellan, 1642, executed with one line starting at the tip of the Lord's nose, Chicago Art Institute; anonymous German metalcut (ca.1450–60), Chicago Art Institute (solar Trinity). On the solar symbolism of John the Baptist see *Salome and Judas*, pp. 189–207.

63 In the *Horae* (MS. lat. 1595), Chantilly, Musée Condé. For a solar icon of the Baptist, see for instance Jan Mostaert (ca.1475–1555/6), *Angels Deplore the Death of Saint John the Baptist*, National Gallery, London. Reproduced in *Salome and Judas*, p. 249.

64 The most famous example of this theme is to be found on a series of tapestries with the Lady and the Unicorn, made around 1500, in the Musée de Cluny, Paris. *Salome and Judas*, pp. 142–6.

65 The tapestry was executed after a cartoon by Hennequin de Bruges and is today in the Château d'Angers (Maine-et-Loire).

66 Strasbourg, Musée des Beaux-Arts. On the motif of the Vanity–Venus with mirror and animals see *Salome and Judas*, pp. 111–59.

67 The other *Holy Faces* by Zurbarán are in Coll. Juan Pereira Gonzáles,

Madrid, cat. 554; Trafalgar Galleries, London, cat. 556; Coll. Angel
Avilès, Madrid, cat. 557; San Miguel Church, Jerez de la Frontera, cat.
559. They are all reproduced in Julián Gállego and José Gudiol,
Zurbarán (Paris: Editions Cercle d'Art, 1987), figures 495–9, from
where the catalogue numbers are taken.

68 "Véroniques et les héros de l'arène" (no author named), *Libération*,
 August 1, 1986, p. 13.
69 *Salome and Judas*, pp. 97–238.
70 In twentieth-century art the St Veronica and Holy Face themes were
 taken up by Georges Rouault, Oscar Kokoschka, Paul Klee, and Otto
 Dix. But their pictures do not enrich the *vera icon* iconography, nor do
 they deal with its magic.

8 Mirrors

1 Mircea Eliade, *The Sacred and the Profane*, trans. Willard R. Trask
 (New York: Harcourt, Brace & World, 1959), p. 193.
2 *Sainte Face*, p. 34.
3 Ovid, *Metamorphoses*, trans. Frank Justus Miller, third edn, revised by
 G. P. Goold, Loeb Classical Library 2 vols, (Cambridge, Mass.: Harvard
 University Press, 1977). Further references are to this edition.
4 Ludwig Preller, *Griechische Mythologie*, 2 vols (Leipzig: Weidmannsche
 Buchhandlung, 1854), 1:131.
5 The Gorgons (plural of *Gorgo* or *Gorgon*) were three sisters of whom
 one was called Medusa ("ruleress"). On the etymology of "Gorgo" see
 Pauly-Wissowa. In contrast to her sisters, immortal and age-
 less, Medusa was considered mortal. See also "Athena," "Minerva,"
 "Poseidon," and "Perseus" in Pauly-Wissowa.
6 For Hesiod's *Theogony* and *To Athena*, see Hesiod; *Homerica*. Further
 references are to this edition.
7 Preller, *Griechische Mythologie*, 1:55, 125, 131.
8 "Athena," Pauly-Wissowa, 1:1997.
9 On snakes and great goddesses see Mircea Eliade, *Patterns in Com-
 parative Religion*, trans. R. Sheed (New York: Meridian Books, 1974),
 pp. 167–9; Gertrude Jobes, *Dictionary of Mythology, Folklore and
 Symbols* (New York: Scarecrow Press, 1961), under "Snake;" Marija
 Gimbutas, *The Gods and Goddesses of Old Europe. 7000 to 3500 BC.
 Myths, Legends and Cult Images* (Berkeley: University of California
 Press, 1974).
10 "Poseidon," Pauly-Wissowa. On the mythical identity of penis=fish=
 god see Edmund Leach, "Fishing for Men on the Edge of the
 Wilderness," *Literary Guide to the Bible* (see n. 21, below), pp. 579–99.

11 Preller, *Griechische Mythologie*, 1:126–33.

12 "Athena," Pauly-Wissowa, 1:1976.

13 Edwyn Bevan, *Holy Images. An Inquiry into Idolatry and Image-Worship in Ancient Paganism and in Christianity* (London: George Allen & Unwin, 1946), p. 25.

14 Preller, *Griechische Mythologie*, 1:131.

15 British Museum. It is reproduced in Carl Kerényi, *The Gods of the Greeks* (Harmondsworth: Penguin Books, 1958), Plate Ib, opposite p. 112.

16 Edwin Sidney Hartland, *The Legend of Perseus*, 3 vols (London: David Nutt, 1894), 1:1–10.

17 Pindar, *Pythian Ode* 12, 7–8, *The Odes*, trans. John Sandys, Loeb Classical Library (Cambridge, Mass.: Harvard University Press, 1978), p. 309.

18 Pierre Guiraud, *Sémiologie de la sexualité* (Paris, Payot, 1978), p. 69.

19 Sigmund Freud, "Medusa's Head" (1922), *The Standard Edition of the Complete Psychological Works*, ed. and trans. J. Strachey and A. Freud (London: Hogarth Press and the Institute of Psychoanalysis, 1966), 18:273; *Salome and Judas*, pp. 227–35. E. Kuryluk, "Mirrors and Menstruation," *Formations*, 2 (1984):64–77.

20 Pausanias, *Description of Greece*, 8. 47. 5, trans. W. H. S. Jones, Loeb Classical Library, 4 vols (Cambridge, Mass.: Harvard University Press, 1979), 4:135.

21 John Drury, "Mark," *The Literary Guide to the Bible*, ed. R. Alter and F. Kermode (Cambridge: The Belknap Press of Harvard University Press, 1987), p. 402.

22 The plate comes from Lameira Larga, Portugal, and is reproduced by G. F. Hartlaub, *Zauber des Spiegels. Geschichte und Bedeutung des Spiegels in der Kunst* (Munich: R. Piper, 1951), Plate 190, p. 189.

23 A connection between Melusine and the Hemorrhissa has been pointed out by Claude Gaignebet, "Véronique ou l'image vraie," *Anagrom*, 7 & 8 (1976):55–60. A Melusine with a mirror has been attributed to Hieronymus Bosch (Douai, Museum); a bronze relief of a Melusine with a mirror (in which a ghost appears) by Peter Vischer the Younger can be seen in the Sebaldus church, Nuremberg. Both are reproduced by Hartlaub, *Zauber des Spiegels*, Plates 164, 165.

24 "The Book of Sir John Maundeville," *Early Travels in Palestine*, ed. Thomas Wright (London: Henry G. Bohn, 1848), pp. 138–9.

25 Ibid., p. 139.

26 Ibid.

27 I am indebted for this information to Deniz Senegel.

28 Aristotle, "On Dreams," 2. 459–60, in *On the Soul, Parva Naturalia, On Breath*, trans. W. S. Hett, Loeb Classical Library (Cambridge, Mass.: Harvard University Press, 1964), pp. 357–9.

29 Aristotle was first married to Pythias, the niece of his friend Hermias,

the tyrant of Atarnea, and after her death to Herpyllis.

30 *Golden Bough*, vol. 3, Part II, pp. 26–100.

31 For the Aztecs the stabbing of a man's reflection equalled his destruction; so in order to keep sorcerers out of their homes, they would set up an imaginary trap for them by leaving behind the door a vessel of water with a knife in it. When a sorcerer entered he would see the device, fear that his reflection would be wounded, and flee. Frazer, *Golden Bough*, vol. 3, Part II, p. 93.

32 Edgar Morin, *L'Homme et la mort* (Paris: Seuil, 1970), p. 135.

33 Jean Piaget, *The Child's Conception of Physical Causality*, trans. M. Gabain (London: Kegan Paul, 1930), pp. 180–1.

34 Ibid., p. 187.

35 Ibid., p. 189.

36 Ibid., p. 187.

37 Ibid., p. 194.

38 *Acta Thaddaei* in *Acta apostolorum apocrypha*, ed. R. A. Lipsius, 3 vols (1891; reprinted, Hildesheim: Georg Olms Verlagsbuchhandlung, 1959), 1:273–8.

39 René Dollot, *L'Afghanistan* (Paris: Payot, 1937), p. 232.

40 Herbert Grabes, *Speculum, Mirror und Looking-Glass. Kontinuität und Originalität der Spiegelmetapher in den Buchtiteln des Mittelalters und der englischen Literatur des 13. bis 17. Jahrhunderts* (Tübingen: Max Niemeyer Verlag, 1973).

41 Flinders Petrie, *Objects of Daily Use* (London: British School of Archaeology in Egypt, 1927); William C. Hayes, *The Scepter of Egypt*, 2 vols (New York: Harper, 1953); Benjamin Goldberg, *The Mirror and Man* (Charlottesville: University Press of Virginia, 1985), pp. 26–31.

42 Adolf Erman, *Die ägyptische Religion* (Berlin: Georg Reimer, 1905), pp. 154–5.

43 Ibid., p. 11.

44 H. O. Lange, "Die Aegypter," in *Lehrbuch der Religionsgeschichte*, founded by P. D. Chantepie de la Saussaye, 4th edn, 2 vols (Tübingen: J. C. B. Mohr, 1925), 1:480–1.

45 The Egyptian sun-theology was developed out of Heliopolis, and as it came to dominate the whole country many local gods were either coalesced with Re or transformed into sun divinities. The most common fusion resulted in the creation of the doublet Re–Horus. As a god of sky Horus was pictured as an enormous face in which the sun was his right, the moon his left eye; as a sun-god he was regarded as the son or soul of Re and symbolized by a falcon or a winged solar disk. The sun was also worshipped under the name of Aton (sun disk) and depicted as a circle with rays ending in hands. Erman, *Die ägyptische Religion*, pp. 6–7, 29–31, 65–7.

46 Plutarch, *Isis and Osiris*, 372, *Moralia*, trans. Frank Cole Babbitt, Loeb Classical Library, 15 vols (Cambridge, Mass.: Harvard University Press,

1962), 5:129. Further references are to this edition.

47 P. Singh, *Burial Practices in Ancient India* (Varanasi, India: Prithivi Prakashan, 1970), p. 36.

48 Benoytosh Bhattacharyya, *The Indian Buddhist Iconography* (Calcutta: K. L. Mukhopadhyay, 1958), p. 115.

49 Goldberg, *Mirror and Man*, p. 35.

50 At the close of the fourth century BC the features of plane, concave, and convex mirrors were described in the *Mo Ching*, the canon book of the Mohist philosophy. For excerpts from it see Joseph Needham, *Science and Civilization in China*, 4 vols in 6 (Cambridge: Cambridge University Press, 1954–71), 4:81–6.

51 Friedrich Hirth, "Chinese Metallic Mirrors," *Boas Anniversary Volume, Anthropological Papers* (New York: G. E. Stechert, 1906), pp. 208–56; Hartlaub, *Zauber des Spiegels*, Plates 17 and 18.

52 Goldberg, *Mirror and Man*, pp. 40ff.

53 Michel Soymié, "La lune dans les religions chinoises," *La Lune. Mythes et rites, Sources orientales* (Paris: Seuil, 1962), pp. 298–9.

54 Goldberg, *Mirror and Man*, p. 47.

55 Li T'ai-Po (AD 701–62), "Written in the Character of a Beautiful Woman Grieving before her Mirror," in *Fir-Flower Tablets*, trans. Florence Ayscough, English versions by Amy Lowell (Boston: Houghton Mifflin, 1926), pp. 14–15.

56 Ibid.

57 Hirth, "Chinese Metallic Mirrors," p. 232.

58 Gaston Bachelard, *La psychoanalyse du feu* (Paris: Gallimard, 1989), pp. 50–1.

59 The observation of the lunar cycle, water, mirror, cloth, and mirror cleaning were involved in ancient Chinese rituals commemorating the first bath of Buddha, which supposedly took place on the fifteenth day of the ninth month. On this day the fourth-century Chinese Buddhists performed a ceremonial bathing of Buddha's images, a custom which seems to survive until today in the rituals of the Tibetan Buddhists, which involve images of a Buddhist deity, mirrors, flasks fllled with water, small basins and pieces of cloth. The image faces the mirror, the basin and flask are placed between them, and at certain intervals a priest pours water from the flask into the basin, "holding the flask so that the emanations imagined as flowing from the image pass through the water to the mirror, from which they are reflected back to the flask. Then the lama dabs the mirror in four places with the piece of cloth." Goldberg, *Mirror and Man*, p. 63.

60 Ibid., pp. 54–5.

61 Doris M. Roger, "The Divine Mirror of Japan," *Asia*, 36 (1936):651.

62 The *Kojiki* and the *Nihongi* complement and elucidate each other and thus should be read together. Occasionally a *Nihongi* version may be

the older one. Donald L. Philippi, "Translator's Introduction," to *Kojiki* (Princeton, NJ: Princeton University Press, 1969), pp. 15–18.

63 *Kojiki*, 1. 16. 7–8, p. 80.

64 See translator's note 9 on p. 80 of *Kojiki* and compare to *Nihongi*, trans. W. G. Aston (Rutland, Vt.: Charles E. Tuttle Company, 1972), p. 41.

65 Eliade, *The Sacred and the Profane*, pp. 101–2.

66 *Kojiki*, 1. 17. 17–18, p. 84.

67 Ibid., 1. 17. 22, p. 85.

68 When the court was in Kyoto a new shrine for the mirror and sword was built there. But the tenth emperor worried about the safety of the relics and erected for them a special new sanctuary at Kasanui in Yamato. The 11th emperor moved the treasures to Ise, and the 12th emperor finally separated the two relics, building a shrine for the sword at Atsuta in Owari, and leaving the mirror in Ise, where it remains to this day – enclosed in the shrine and hidden away from view. The Ise mirror is supposedly wrapped in a brocade bag, or rather in the remnants of many bags, since when one begins to disintegrate, another is put over it, so that the package does not have to be opened; and it is further protected by a wooden cage ornamented with pure gold and covered with a large silk cloth falling all the way to the floor. The invisible relic is represented by a visible double: a round mirror standing in front of the altar in a wooden frame carved with images of clouds and water, symbols of flux and purity. David Murray, *Japan* (New York: Putnam's, 1894), p. 308.

69 Roger, "Divine Mirror," p. 657.

70 Goldberg, *Mirror and Man*, p. 76.

71 Ibid.

72 Roger, "Divine Mirror," p. 652.

73 Gisela M. A. Richter, *Greek, Etruscan and Roman Bronzes* (New York: The Metropolitan Museum of Art, 1915), pp. 252–90.

74 Eduard Gerhard, ed., *Etruskische Spiegel*, 5 vols. (Berlin: G. Reimer, 1843–97).

75 Seneca, *Naturales Quaestiones*, 1. 16. 1–5, trans. Thomas H. Corcoran, Loeb Classical Library (London: W. Heinemann, 1971–2), 7:87.

76 Norbert Hugedé, *La Métaphore du miroir dans les Epîtres de saint Paul aux Corinthiens* (Neuchâtel and Paris: Delachaux and Niestlé, 1957), *passim*. Grabes, *Speculum, Mirror und Looking-Glass, passim*.

77 Plotinus, *The Six Enneads*, trans. Stephen MacKenna and B. S. Page (Chicago: Encyclopaedia Britannica, 1952). Further references are to this edition.

78 *The Visitation*, attributed to Master Heinrich of Constance, ca.1310, wood, polychromed and gilt, set with cabochons, from the Dominican nunnery, Katharinental, near Diessenhofen, Switzerland. New York, Metropolitan Museum of Art, gift of J. Pierpont Morgan, 1917.

79 Lucian, trans. A. M. Harmon, Loeb Classical Library, 8 vols (Cambridge, Mass.: Harvard University Press, 1979), 1:281. Further references are to this edition.

80 The nimbus, for instance, corresponded to the solar crowns of the Roman emperors, the *radiis corona*, in which Nero is often shown on coins. Theodor Mommsen, *Römisches Staatsrecht*, reprint of the third edition (Graz: Akademische Druck- u. Verlagsanstalt, 1952), 1:426–7.

81 Hugo Rahner, *Griechische Mythen in Christlicher Deutung* (Zurich: Rhein-Verlag, 1945), pp. 174–5. See also Franz Cumont, *Textes et monuments figurés relatifs aux mystères de Mithra*, 2 vols (Brussels: H. Lamertin, 1896), 1:355–6.

82 Rahner, *Griechische Mythen*, pp. 150–1.

83 Ibid., p. 126.

84 *NT Apocrypha*, 1:495.

9 Cloth

1 "Cloth," *Britannica*, 6:557.

2 Herman Melville, *Mardi* (Boston: St Botolph Society, 1923), p. 130.

3 Charles F. Herberger, *The Thread of Ariadne: The Labyrinth of the Calendar of Minos* (New York: Philosophical Library, 1972).

4 Alexander Pope, *The Odyssey of Homer*, ed. M. Mack (London: Methuen; New Haven: Yale University Press, 1967). In early Christian times the passage attracted the attention of Porphyrius (AD 233–ca.304) who popularized the weaving nymphs by writing an extensive commentary on their Cave. Porphyrius, *De antro nympharum*, trans. Seminar Classics, No. 609 (Buffalo: State University of New York at Buffalo, 1969).

5 "Mnemosyne," Pauly-Wissowa, 15:2265–9; Ludwig Preller, *Griechische Mythologie*, 2 vols (Leipzig: Weidmannsche Buchhandlung, 1854), 1:40, 278–89.

6 In Hesiod, *Homerica*.

7 Pausanias, *Description of Greece*, trans. W. H. S. Jones, Loeb Classical Library, 4 vols (Cambridge, Mass.: Harvard University Press, 1979), 4. 351. All references are to this edn. See also Pliny, *NH* 31. 11.

8 Pauly-Wissowa, 15:2268.

9 Oscar Bie, *Die Musen in der antiken Kunst* (Berlin: Weidmannsche Buchhandlung, 1887), p. 102. See also H. Dütschke, "Das Musenrelief Chigi der Villa Cetinale bei Siena," *Jahrbuch des Kaiserlich Deutschen Archäologischen Instituts*, 27 (1912):129–45.

10 Bie, *Musen*, p. 84.

11 This contrast is beautifully displayed in a relief based, perhaps, on a

work by Praxiteles. It presents poets, loosely dressed or half-naked, in the company of veiled women – Mnemosyne and the Muses. Chigi Collection, Villa Cetinale, Siena. The drawing of the relief is reproduced in Salomon Reinach, *Répertoire de reliefs grecs et romains*, 3 vols (Paris: Ernest Leroux, 1912), 3:419.

12 Paris, Louvre, reproduced by Reinach, ibid., 2:249.

13 Drawings of statues showing Mnemosyne and the Muses can be studied in Salomon Reinach, *Répertoire de la statuaire grecque et romaine*, 3 vols (Paris: Ernest Leroux, 1897–8), 1:167, 256–68.

14 *The Book of Adam and Eve,* trans. S. C. Malan (1882), in *The Forgotten Books of Eden*, ed. R. H. Platt (Cleveland, Ohio: World Publishing Co., 1927; reprinted, New York: Bell Publishing Co., 1981). Further references are to this edition. See also Kuryluk, "The World of Adam and Eve," *Formations*, 1 (1987):70.

15 H. L. Mansel, *The Gnostic Heresies of the First and Second Centuries* (London: John Murray, 1875), p. 191.

16 Commentary on Gen. 4:2 in *The Soncino Chumash*, ed. A. Cohen (London: Soncino Press, 1985), p. 17.

17 Ibid., p. 18. Quoted after the Hebrew Bible in order to stress the femininity of the ground.

18 Commentary on Gen. 4:15, ibid., p. 19.

19 Commentary on Gen. 4:15, Revised Standard Version of the Bible, p. 6.

20 See "cloth," "clothing," "garment," "dress," "robe," etc. in Robert Young, *Analytical Concordance to the Bible* (Grand Rapids, Mich.: Wm. B. Eerdmanns, 1970).

21 Antoninus Martyr (ca.570), "Perambulatio locorum sanctorum," 44, in *Itinera Hierosolymitana et descriptiones terrae sanctae bellis sacris anteriora* (Osnabrück: Otto Zeller, 1966), p. 116. In the Egyptian evangels of Jesus' childhood, swaddling cloths play an important role and work various miracles. Dobschütz (pp. 61–2) suggests that the appearance of the Memphis *acheiropoietos* might have been additionally inspired by these apocryphal gospels. Swaddling cloths become important relics and turn up in Byzantine collections.

22 The gospels specify three kinds: the "linen cloth" (*othonion*, Lk. 24:12, Jn. 20:5); the "fine cloth," "linen" (*sindon*, Mk. 14:51–2); and the "napkin" or "towel" (*soudarion*, Jn. 11:44) in which the face was wrapped.

23 Adolf Harnack, *Dogmengeschichte*, 3 vols (Tübingen: J. C. B. Mohr, 1905), 3:219–22.

24 John Gwynn, "Ephraim the Syrian," *Nicene and Post-Nicene Fathers*, 13:120–52.

25 For Ephraim's *Life* see ibid., pp. 121–37.

26 Marina Warner, *Alone of All Her Sex* (New York: Vintage Books, 1983), pp. 326–7.

Notes

27 Both sarcophagi are at the Vatican Grottoes of St Peter's; one of them is the Junius Bassus sarcophagus.

28 André Grabar, *Christian Iconography* (Princeton, NJ: Princeton University Press, 1968), p. 43, Plate 111.

29 Jaroslav Pelikan, *Jesus through the Centuries* (New Haven: Yale University Press, 1985), p. 59.

30 *NT Apocrypha*, 2:470.

31 The tradition was influenced by a literal interpretation of Paul's words proclaiming the unity of Christ and Church: "Because there is one bread, we who are many are one body, for we all partake of the one bread" (1 Cor. 10:17).

32 Detailed information is provided by Jeffrey Francis Hamburger, "The Rothschild Canticles (Yale University, Beinecke Rare Book and Manuscript Library, MS 404): Art and Mysticism in Flanders and the Rhineland ca.1300," unpublished dissertation, Yale, 1987. I am obliged to Elizabeth H. Dailinger whose kindness made it possible for me to read this excellent piece of scholarship.

33 Ibid., pp. 509–10 and *passim*.

34 *Select Visions of S. Mechthild Taken from the Five Books of her Spiritual Grace* (London, 1875), Part V, section 12.

35 St Tierry, Migne, *PL* 184:156A.

36 Migne, *PL* 176:1217A.

37 I am most grateful to Janet Knapp who brought this text to my attention and translated it for me. The song originated in clerical circles, possibly in Notre Dame in Paris, and was sung in church. Here are the first 15 lines of the original poem: "Novum sibi texuit / dominus lumbare, / volens quod computruit / in hoc compensare, / sterilis letare, / nam tot Christo paries / ut Iudeum supplantare / tuus possit paries. / Prius tactu fimbrie / menstrua curatur, / Yairi quam filie / sanitas reddatur. / Per acum intratur camels gentilium, / nec Helyas aspernatur / vidue tugurium." The manuscript sources for the song are: Biblioteca Laurenziana, Plauteus 29.1, fo. 306; Wolfenbüttel, Herzog-August-Bibliothek, 628, fo.163; St Gallen, Stiftsbibliothek, 383, p. 165.

38 There exist several versions of the Madonna. The most macabre, with an aborted embryo and sperm, is an 1895 lithograph.

39 Hamburger, "Rothschild Canticles", p. 481.

40 Ibid., p. 133.

41 *The Revelations of Saint Birgitta*, ed. William Patterson Cumming from the fifteenth-century MS in the Garret Collection, Princeton University Library (London: Humphrey Milford, 1929), p. 17.

42 Gregory of Tours, *De gloria martyrum*, chapter 8, in *Les livres des miracles et autres opuscules* (Latin and French), ed. and trans. H. L. Bordier (Paris: Jules Renouard, 1857), p. 26.

43 "The Book of Sir John Maundeville," *Early Travels in Palestine*, ed. Thomas Wright (London: Henry G. Bohn, 1848), p. 131.

44 In the crucifixion miniature in the *Rabbula Gospels*, 586, Zagba, Mesopotamia, Biblioteca Laurenziana, Florence; *Crucifixion* wall painting, mid-eighth century, remains of the fresco decoration in the chapel of Theodotus, Santa Maria Antiqua, Rome. Eleventh-, twelfth- and thirteenth-century Italian, Spanish, French, and German wooden crucifixes also show him dressed, for instance the *Volto Santo* from Lucca, an early thirteenth-century copy of the late eleventh-century wood carving. Schiller, *Iconography*, 2, Plates 327, 328 and 471.

45 Probably the central panel of a small altar of which the wings are in Antwerp, Koninklijk Museum. The central panel is in the National Gallery, London. See Schiller, *Iconography*, 2, Plate 316.

46 After Anthony Butkovitch, *Iconography. St. Brigitta of Sweden* (Los Angeles: Ecumenical Foundation of America, 1969), pp. 49–50.

47 Buxtehude Altar, style of Master Bertram, right side wing, bottom, Hamburg, Kunsthalle. Schiller, *Iconography*, 2, p. 196 and Plate 680.

48 *The Virgin and Child in the Chamber*, Berlin, Kupferstichkabinett.

49 Eger, (Hungary). Dobó István Museum.

50 The Emperor Maximilian's *Book of Hours* containing psalms, prayers, hymns, and excerpts from the Bible, was illustrated by the greatest German artists of the period: Albrecht Dürer, Hans Baldung Grien, Hans Burgmair the Elder, Jörg Breu, and others. Complete facsimile edition: *The Book of Hours of the Emperor Maximilian*, ed. Walter L. Strauss (Pleasantville, NY: Abaris Books, 1974). Dürer's *sudarium* is on p. 111.

51 Cleveland Museum of Art.

52 Dorothy C. Shorr, *The Christ Child in Devotional Images in Italy during the XIV Century* (New York: George Wittenborn, 1954), pp. 153–60.

53 Part of the fresco cycle in Padua.

54 Fra Angelico, wall painting in Cell 7, Convent of San Marco, Florence.

55 Pamela Sheingorn, *The Easter Sepulchre in England* (Kalamazoo, Mich.: Western Michigan University, 1987), p. 56.

56 The painting is today in the Accademia in Florence.

57 Leonardo da Vinci, "Studies of Drapery," at the Louvre, December 8, 1989 through February 26, 1990.

58 Giorgio Vasari, *Lives of the Artists*, trans. George Bull, 2 vols (Harmondsworth: Penguin Books, 1987), 2:256.

10 Skin

1 "La circoncision du Seigneur," in *Golden Legend*, 1:138–9.

2 Caroline Walker Bynum, "'. . . And Woman His Humanity': Female

Imagery in the Religious Writings of the Later Middle Ages," *Gender and Religion: On the Complexity of Symbols*, ed. C. W. Bynum et al. (Boston: Beacon Press, 1986), p. 275.

3 "L'Assomption de la Bienheureuse Vierge Marie," in *Golden Legend*, 2:455, trans. by the author.

4 Benedictus, basilicae Petri canonicus, *Liber pollicitus ad Guidonem de Castello* (Celestine II, 1143–4), after Dobschütz, p. 283*.

5 *La Vengeance de Nostre-Seigneur*, ed. Alvin E. Ford (Toronto: Pontifical Institute of Mediaeval Studies, 1984), p. 8. "Plaine" is the old spelling.

6 In *Kaiserchronik*, ed. H. F. Massman (Quedlingburg: G. Basse, 1854), vol. 3, pp. 579–80.

7 C. Gaignebet, "Véronique ou l'image vraie," *Anagrom* 7 & 8 (1976): 63.

8 Jean-Baptiste Thiers, *Traité des superstitions qui regardent les sacrements* (Amsterdam: J. F. Bernard, 1733), p. 91.

9 Marcel Schwob, *Le Roi au masque d'or* (Paris: Crès, 1917), p. 13.

10 English translation after Jean Pierrot, *The Decadent Imagination* (Chicago: University of Chicago Press, 1981), p. 210.

11 In Latin: *pannum, panniculum, linteum, lint(h)eolum, sudarium;* in German *tu(e)ch, duch, düchlein, sleier, blencket;* in French: *quevrechief, cuvrechief, crevichié, linge, drap*. For medieval texts see Pearson, pp. 17–39 and *passim;* Grabes, *Speculum, Mirror und Looking-Glass. Kontinuität und Originalität der Spiegelmetapher in den Buchtiteln des Mittelalters und der englischen Literatur des 13. bis 17. Jahrhunderts* (Tübingen: Max Niemeyer Verlag, 1973), *passim*.

12 She is also called *Vironice, Vironica, Fronica, Verona, Verrone, Vérone, Verrine, Véroine, Veronilla, Venisse, Marie la venissiene,* etc., while her cloth is referred to as *verronnicle, vernacle, vernakyll, warnacoll, vernacul, vernacule,* etc. Pearson, p. 50 and *passim*.

13 Still in the eighteenth century a Maltese *chevalier* wore on the left sleeve of his cloak two embroidered passion scenes: above, the kiss of Judas; below, the vernicle. *Portrait d'un Chevalier de Malte de la famille de Fay-la-Tour Maubourg,* eighteenth century, Musée Gadagne, Lyon. For other examples of vernicles worn on clothes see Pearson, p. 43.

14 Giovanni Capassini was born in Italy but worked in France, where he was known as Jean Capassin (d. 1579). The triptych was commissioned by Cardinal François le Tournon for the chapel of a college founded by him in 1537. The central part, signed and dated 1555, is still in Tournon, in the chapel of the Lycée Gabriel Fauré.

15 *Book of the Dead*, trans. E. A. Wallis Budge, 2nd edn, 3 vols (London: Kegan Paul, Trench, Trübner, 1909), vol. 3, chapter 166, p. 545.

16 Claude Lévi-Strauss, *The Origin of Table Manners*, trans. J. and D. Weightman (New York: Harper and Row, 1978), pp. 349 and 399.

17 *Salome and Judas*, pp. 227–38.

18 For examples of phallus-heads see *Eros grec. Amour des dieux et des hommes*, catalogue of the exhibition organized by the Greek Ministry of Culture at the Grand Palais, Paris, November 6, 1989 through February 5, 1990 (Athens: Ministry of Culture, 1989), pp. 146–53.

19 *Sainte Face*, p. 34.

20 Ibid.

21 Hilde Zaloscer, *Porträts aus dem Wüstensand* (Vienna: Anton Schroll, 1961), p. 33, trans. by the author.

22 Ibid., pp. 33–4.

23 Otto Benndorf, "Antike Gesichtshelme and Sepulcralmasken," *Denkschriften der Kaiserlichen Akademie der Wissenschaften*, Philosophisch-Historische Classe, Vienna, 28 (1878):371.

24 Ibid., pp. 310–13.

25 H. Zaloscer, "The Mummy-Portrait: An Interpretation," *Apollo*, 79 (1964):102.

26 Ibid.

27 *Nihongi*, trans. W. G. Aston (Rutland, Vt.: Charles E. Tuttle Company, 1982), p. 41.

28 Typically: "Wie is dein clar antlit verblichen, / verspiben, sein farb entwichen!" in *Augsburger Passionspiel*, fifteenth century, after Pearson, p. 19.

29 Julian of Norwich, *Revelations*, p. 63.

30 Ibid., pp. 63–4.

31 For details on representations of Saint Bartholomew's skin see Leo Steinberg, "The Line of Fate in Michelangelo's Painting," in *The Language of Images*, ed. W. J. T. Mitchell (Chicago: University of Chicago Press, 1980), p. 121, n. 14.

32 On anatomical theaters see *Salome and Judas*, pp. 28–9.

33 For examples of the *Arma Christi* and *Heart* iconography see Schiller, *Iconography*, 2, Plates 668–76.

34 The face was not identified as Michelangelo's self-portrait until 1925, although it seems to have been a well-known secret in his day. Steinberg suggests that it had become a taboo subject because of the association with Protestantism. "The Line of Fate," p. 109 and *passim*.

35 Ibid., p. 109.

36 Ludwig Preller, *Griechische Mythologie*, 2 vols (Leipzig: Weidmannsche Buchhandlung, 1854), 1:147, 175, 406, 408, 456, 462. Robert Graves, *The Greek Myths* (Harmondsworth: Penguin Books, 1960), 1:81.

37 "Marsyas," Pauly-Wissowa, 14:1994.

38 Exceptionally not after the Loeb edition but after Ovid, *The Metamorphoses*, trans. Mary M. Innes (Harmondsworth: Penguin Books, 1955), p. 145.

39 *Marsyas Bound to the Tree* is a Roman replica of a Greek original in the style of the Pergamon School at the end of the third or the beginning of

the second century BC. Louvre, MQ 542. 9880218 AGR.

40 See, for instance, the young and titanic *Apollo Tortor* in Galleria Giustiniana, Rome, drawing in Reinach, *Répertoire de la statuaire grecque et romaine*, 3 vols (Paris: Ernest Leroux, 1897), 1:285. Other Marsyas representations in ibid. pp. 22, 249, 418, 423.

41 Pauly-Wissowa, 14:1987–91.

42 "Marsyas," and "Greek Art," *Britannica*, 17:784 and 12:480ff., figure 54.

43 Emanuel Winternitz, "The Curse of Pallas Athena. Notes on a 'Contest between Apollo and Marsyas' in the Kress Collection," *Studies in the History of Art. Dedicated to William E. Suida on his Eightieth Birthday* (Oxford: Phaidon Press, 1959), p. 186.

44 Washington, National Gallery of Art, Samuel H. Kress Collection, 1939, No. 443. This is a new attribution, different from the one given by Winternitz.

45 Michelangelo, Sonnet 10, in *Complete Poems and Selected Letters*, trans. Creighton Gilbert (New York: The Modern Library, 1965), p. 8. Further references are to this edition.

46 Sonnet 237, ibid., p. 133.

47 Octave Stanzas 10, (1531–2), ibid., p. 35.

48 Sonnet 291, ibid., p. 163.

49 Ibid.

50 *The Exegesis on the Soul*, trans. W. C. Robinson, Jr., in *Nag Hammadi Library*, pp. 180 and 183.

51 See the first translation of the *Hortulus animae* into German, entitled *Hortulus anime* (Strassburg: Grüninger, 1501), 11. 1–2 and *passim*.

52 The MS in the Cambridge University Library appears under the title *Nathanis Judei Legatio*. It was published in *The Anglo-Saxon Legends of St. Andrew and St. Veronica*, ed. for the Cambridge Antiquarian Society by C. W. Goodwin (Cambridge: Deighton; Macmillan, 1851).

53 John Amos Comenius, *The Orbis Pictus* (Syracuse, NY: C. W. Bardeen, 1887), p. 54.

54 *Taboo and the Perils of the Soul*, vol. 3, Part II of *Golden Bough*, pp. 26ff.

55 Ibid., p. 27.

56 Ibid., p. 28.

57 Ibid., pp. 28–9. Frazer refers to G. Maspero, *Etudes de mythologie et d'archéologie égyptiennes* (Paris, 1893), 1:388ff. and to A. Wiedemann, *The Ancient Egyptian Doctrine of the Immortality of the Soul* (London, 1895), pp. 10ff.

58 Frazer, *Golden Bough*, vol. 3, Part II, p. 29, n. 1. See also "Iconography of the Soul," in Adolphe Napoléon Didron, *Christian Iconography*, trans. Margaret Stokes, 2 vols (London: George Bell, 1886), 2:173ff.

59 "Hadrian," *Britannica*, 12:802.

60 St Thomas Aquinas, *The Summa Contra Gentiles*, trans. by the

English Dominican Fathers from the latest Leonine edition (London: Burns Oates & Washbourne, 1923), p. 255.

61 *Nag Hammadi Library*, p. 183. In the *Golden Legend* Mary's soul is assumed into heaven not naked, but wearing a girdle. "L'Assomption de la Bienheureuse Vierge Marie," 2:424.

62 G. Bornkamm, "The Acts of Thomas," *NT Apocrypha*, 2:425–42; F. Crawford Burkitt, *Early Eastern Christianity* (London: John Murray, 1904), pp. 193–228.

63 Bornkamm, "Acts of Thomas," *NT Apocrypha*, 2:435.

64 One finds, perhaps, a distant echo of the Gnostic pearl metaphor in the account of John of Ephesus, a sixth-century leader of the Monophysite Syriac-speaking Church. He reports that the Empress Sophia called "pearls" the pieces of bread consumed during the communion. John Bishop of Ephesus, *The Third Part of the Ecclesiastical History*, II. 10, trans. R. Payne Smith (Oxford: Oxford University Press, 1860), p. 105.

65 *N T Apocrypha*, 2:499. Further references are to this edition.

66 Burkitt, *Early Eastern Christianity*, p. 215.

67 *Salome and Judas*, pp. 260–5.

68 The romances of the Holy Grail go back to the late twelfth century and form part of the Round Table cycle. The story often takes off from the Last Supper and focuses on Simon the leper, the anointment (attributed to Mary Magdalen), Christ's washing of his pupils' feet, the kiss, etc. See *Le Saint-Graal ou le Joseph d'Arimathie*, ed. E. Hucher, 3 vols (Le Mans, 1875; reprinted, Geneva: Slatkine Reprints, 1967), pp. 167–8. For general information consult the preface. Around 1250 the monk Alberich reports that at the siege of Antioch in 1098 the holy spear was found together with a tin vessel which contained Jesus' shroud (he does not specify if it was blank or impressed with the Lord's likeness). See Pearson, pp. 72–3.

69 Didier Anzieu, *Le Moi-peau* (Paris: Bordas, 1985); in English: trans. Chris Turner, *The Skin Ego* (New Haven: Yale University Press, 1989), pp. 141–4.

70 Anzieu, *The Skin Ego*, p. 9.

Epilogue

1 J. W. von Goethe, *Faust. Part Two*, Act III, trans. Philip Wayne (Harmondsworth: Penguin Books, 1975), pp. 209–10.

2 Wendy Doniger O'Flaherty, *Women, Androgynes, and Other Mythical Beasts* (Chicago: University of Chicago Press, 1982), p. 40.

Index

258